Marriage, Migration and Gender

Other volumes in the series

Women and Migration in Asia, Volume 5
Series Editor: Meenakshi Thapan

Marriage, Migration and Gender

Editors
Rajni Palriwala
Patricia Uberoi

$ SAGE Los Angeles • London • New Delhi • Singapore
www.sagepublications.com

First published in 2008 by

 SAGE Publications India Pvt Ltd
B1/I-1 Mohan Cooperative Industrial Area
Mathura Road, New Delhi 110 044, India
www.sagepub.in

SAGE Publications Inc
2455 Teller Road
Thousand Oaks, California 91320, USA

SAGE Publications Ltd
1 Oliver's Yard, 55 City Road
London EC1Y 1SP, United Kingdom

SAGE Publications Asia-Pacific Pte Ltd
33 Pekin Street
#02-01 Far East Square, Singapore 048763

Published by Vivek Mehra for SAGE Publications India Pvt Ltd, typeset in 11/13 pt Minion, printed at Artxel, New Delhi.

Library of Congress Cataloging-in-Publication Data Available

ISBN: 978-0-7619-3675-6 (Pb) 978-81-7829-841-2 (India–Pb)

The SAGE Team: Sugata Ghosh, Anushree Tiwari and Rajib Chatterjee
Cover design by Yawedo

Contents

Section IV Marriage Transactions and Transnational Contexts

Section V The Strains of Marriage Migration

Series Introduction

Migration and the movement it entails has always accompanied civilisation in every stage of its development. Historically, people have moved from one place to another either by force in terms of slavery, or for reasons of colonisation. Towards the late 19th and early 20th centuries, international migrations began to be prompted by industrialisation and urbanisation. A shift in base and settlement, prompted by varied reasons and sponsored by different agents, is thus not a new concept. Unlike the early migrations, which were largely directed towards the north and the west, migration today cannot be understood in linear terms but rather in terms of fluid movements within structural constraints and continuities, the movements being marked by turbulence and change and undertaken in multiple directions. In the contemporary context of globalisation, as has often been noted, the world is in a constant state of flux. People are presented with multiple worlds, images, things, persons, knowledge and information at the same time and at an ever-increasing pace. Moreover, the life cycle of each of these has been drastically shortened, such that the world we encounter is perceived and consumed largely in temporary terms. Change is then the only constant and the changes that characterise this external world we inhabit are internalised by us and have a significant impact on our lives and our perceptions about time and space. Individuals are forced in one way or the other to respond to the larger forces operating on them, since no one remains completely removed from the turmoil that surrounds them; the world having come closer, globalisation has facilitated the process of migration considering the forces of demand and supply, needs and gratifications, and the increased and easier possibility of movement and communication.

In this process of movement, one undoubtedly leaves behind a familiar world to explore one's chances in an alien land. The process of migration may thus have a constraining effect on us not only in structural terms, of the choices made available, or cultural terms, but also in the sense in which it may include abuse and exploitation, and emotional and psychological distress. However, migration is largely

undertaken with the positive hope of a better life in an unseen world. There is therefore a need to investigate the nuances and complexities entailed in this process and the way in which it impacts the lives and identities of the individual migrants in a world which is in constant flux and movement.

Migration has earlier been explained in dual terms of the push and pull factors, i.e., the voluntarist perspective. It has also been understood from a structuralist perspective, whereby migration is mapped in dichotomous terms of centre-periphery, industrialised-peasant based, west and north-east and south. However, both perspectives have limitations since the former has understood it in simplistic terms of an individual's rationally calculated decision while the latter ended in economic determinism. In order to understand the phenomenon in all its complexity, a more holistic approach is required. Any theory of migration must account for it in terms of race, religion, nationality, sense of belonging and nostalgia. More significantly, much of the early literature on migration has been silent on the issue of 'gender' and there is thus a need to analyse the migration process and the differential experience of women and men in the context of a gendered world. Migration no doubt constitutes a complex subject of study, and an understanding based on the gender dimension serves to further enhance the complexity when we consider the multiple and heterogeneous backgrounds and experience of migrant women and the very complex category of 'woman' herself.

Within this framework, the initiative to publish the five volumes on aspects of 'Women and Migration in Asia' emerged from the ongoing programme on Gender Perspectives on Asia located at the Developing Countries Research Centre, University of Delhi. The first activity of this programme was the international conference on Women and Migration in Asia in December 2003. The conference was attended by participants from all over the world including representatives from Canada, Australia, Pakistan, Nepal, China, Singapore, France, Italy, Bangladesh, the UK, Israel, the Netherlands, Philippines, Japan, Korea, Taiwan, Trinidad and from within India.

The five volumes are based on themes that emerged from the conference. It was proposed that the publication of these volumes would disseminate the deliberations, and their publication is a collective enterprise aimed at understanding the gender implications of migration processes, for women, within and across Asian societies and globally.

Women and Migration in Asia

Essentially, the endeavour to publish these five volumes is a critical response to migration theories that have failed to take into consideration the gender aspect thereby failing to account for the complex experience of migrant women. Migration is often perceived as being mainly a male movement, with women either being left behind or following their men folk as dependents. However, figures suggest that women have migrated in almost the same numbers as men, i.e., in the year 2000, there were 85 million female migrants as compared to the 90 million male migrants (Zlotnik as quoted in Jolly et al. 2003: 6). Women account for 46 per cent of the overall international migration from developing countries (ibid.).

In addition, as compared to other continental regions, Asia has the maximum number of international migrants. There exist, however, disparities within the region in the sense that countries in Southeast Asia allow greater mobility for women owing to relatively more liberal attitudes than other South Asian and Arab countries. While men still form the majority of international migrants in Asia, there is an ever increasing number of women migrating in the region, as shown in Table 1:

Table 1 Proportion of Female Migrants as a Percentage of Total International Migrants by the Region

	1990	2000
South Asia	44.4	44.4
East and Southeast Asia	48.5	50.1
West Asia	47.9	48.3

Source: Zlotnik in Jolly et al. 2003.

Despite the rising number of female migrants, women are not given equal importance as compared to men in migration, since they are still not perceived as equal actors worthy of being accounted for. According to the official records, the majority of women migrate legally merely as a part of family reunions. Those who migrate for employment purposes, thus find themselves doing so illegally, considering the rigid cultural and state ideologies and limiting visa policies and work permits regarding the movement of women, especially in countries like Bangladesh and

Pakistan. Thus, while viewing women migrants as dependents, we may often ignore their individual economic contributions, and an analysis based solely on official figures would give an inadequate account of the actual migration flows pertaining to women.

Women may migrate alone or along with their families or community. Their migration may be associational (for example, through marriage) or women may be independent migrants. Women may be compelled to migrate owing to their economic condition, in search of better work opportunities, or they may opt to migrate as an escape from an oppressive marriage and the traditional patriarchal norms. They may be driven by individual needs and aspirations, which most often coincide with those of the family, or migration may be structured and facilitated by the state. Whichever the case may be, migration has undeniably become a prominent reality in the modern world and the feminisation of migration is an even more significant although less explored aspect of this reality.

Poverty and a search for employment have been the predominant propellants of the migration of people, which affords them the opportunity to explore their life chances. The decisions of women to migrate are informed by the twin forces of opportunities and constraints and are taken primarily by the family and, when taken independently, familial and cultural considerations have a great influence. Apart from the cultural and societal restrictions, structural factors like the demand for female labour and the trends in industry and agriculture, also affect their decision to migrate. In migration, women, owing to their structural position in society, have limited access to information and resources, which determines the differential experience of men and women on transit and entry. Women are more vulnerable to physical and sexual abuse, lower wages and other forms of exploitation. Migration is thus undertaken with the aim of betterment, in terms of employment and economic gains, and as an escape from cultural and societal constraints in terms of achieving greater autonomy and independence. However, while it may afford them material gains, whether migration enables women to completely break away from the binding patriarchal and traditional norms remains questionable.

Migration: Themes and the Volumes

The volumes in the present series bring out the extent to which a gender perspective makes a contribution to migration theory and the manner

in which it aids a comprehensive understanding of women's experience of migration, and how in the process, migration simultaneously emphasises certain gender related aspects pertaining to the specific contexts addressed by each volume. It is the migration flow of women in South Asia around which most of the papers in the five volumes are centred. At the same time, the comparative dimension is present in all the volumes that are essentially concerned with the Asian region but provide cross-cultural and regional diversity in their understanding of the issues under consideration. The five volumes are clearly also the result of an attempt to address the issues in an interdisciplinary perspective while being rooted in their particular disciplinary domains. This has in fact resulted in the volumes using very eclectic theoretical approaches as well as a focus on particular issues in their complexity and variety. It is also the case that the subject of study is rather complex and cannot be wholly dealt with in terms of a single volume. In order to understand and encompass the multiple realities and identities of migrant women, analyses from different perspectives and vantage points become important and necessary. All the volumes are held together around a set of common themes and each volume must be viewed as providing a significant insight into the larger picture and the series should be seen as a coherent whole.

While migration viewed along the axis of gender is the overall focus of this series, the aim is to address the issue in terms of particular contexts like conflict, family and marriage, transnationalism, work, poverty, and to do justice to each. Thus, while all the volumes are interconnected owing to the common issues they address within the larger framework, each volume makes a valuable contribution in terms of their particular vantage point and the specific context they aim to address and emphasise.

Situated in the larger context of globalisation and the ever increasing rate of cross-border movements thereof, the volumes serve to analyse the varied motivations that propel a woman to migrate, discovering the gap between the migrant woman's aspirations and expectations and the resulting reality. Most of the papers in the volumes point to the fact that the migrant woman's experience cannot be understood merely in terms of the material benefits that may accrue as a result of migration. The social structures and relations that inform the migrant's experience to a great extent also need to be considered for a holistic understanding of the complex experience of such women.

The volumes find common ground in examining the difference between forced and voluntary migration in general (common to men

and women), and serve to highlight the voluntary and independent aspect of women's migration, exploring the element of 'choice' and the extent of agency they have in framing their own experience. Woman's agency in different contexts is, in fact a critical component of the analyses across the volumes. The notion of 'agency' is thus problematised and examined in terms of personal experience, and in relation to the state and legal systems.

The focus is on women on the move. Through their papers, the volumes question the assumption that women essentially migrate as dependents, their migration being seen as largely associational. Women even in the most empathetic discourse are thus at best represented as victims. The indifference towards or denial of the independent aspect of migration of women, in the dominant discourses, as has been argued across the five volumes, serves to ignore the dialectics between these women and the larger social structures and gender relations both in the home and host countries, in terms of the reciprocal impact that each has on the other. It is this dominant, official discourse which has predominated in various disciplinary approaches to migration within which women are inadequately represented and assumed to form one homogeneous category characterised, in traditional terms, as being submissive, dependent and largely confined to the household sphere. The volumes in this series provide an insight into the gap between the dominant narratives and those of the women themselves, attempting to reach reality as closely as possible.

The collection of papers on 'Transnational Migration and the Politics of Identity' highlights the fact that migration today does not imply a complete break from the past; rather the migrant must be understood as inhabiting two worlds simultaneously. It explores the ways in which a migrant woman constructs her identity in an alien land, the problems she confronts and the strategies she deploys in making life in the host country more liveable. There is not only fluidity in the experience and construction of identity but also in the manifold ways in which there is a 'back-linking' with the past, the country of origin, whether this is in terms of rituals, practices and values, relationships and family ties, or even in the 'idea' of the country that is carried to the new lands. At the same time, however, the migrant woman is constrained by the structures of the host country, its regulatory regimes and practices, and the limits imposed on her. The volume thus brings out the significance of the fluid nature of a migrant's identity without, however, ignoring the fact that this fluidity itself and her identity are regulated and structured

to a certain extent by the state and other social institutions. Moreover, it examines the manner in which she negotiates with the larger structures and institutions such as the state, patriarchy, family, welfare institutions, etc., which impinge on her everyday personal experience, and how this struggle helps in defining and re-constructing her identity in different ways.

In the context of internal migration, and even more in terms of transnational migration, the impact of state policies on the experience of the migrant becomes crucial and has been examined in most of the volumes in terms of the motives of the state in facilitating or curtailing migration outflow and inflow respectively, and the extent to which the state carries out its responsibilities. The volume on 'Poverty, Gender and Migration' focuses on the relationship between state policies and poverty, and the manner in which shifts in state policies bring about corresponding changes in patterns of migration. It explores how transnational migration has unfolded as a continuing process of exclusion and deprivation, whereby state policies have promoted migration, but on the other hand withdrawn from assuring protective support. Internal migrations too, in the light of the shifts and continuities, show a similar link between state policies, poverty and migration. The volume further argues that the experiences of poor women in migration are informed not only by poverty but also by the ideological dimensions of work expressed in women's concentration in jobs in the informal sector that are characterised by a sexual division of labour. The volume thus highlights the common theme that the larger structures affect the personal experience of migrants, and that there is a strong social, cultural and political context to migration by women. In the transnational context, not only do the social and structural categories of the recipient country affect the migrant's experience, the culture, tradition and customs of the home societies and the dominant familial discourse grounded in patriarchy also continue to inform the construction of the migrant woman's identity and experience.

The volume on 'Gender, Conflict and Migration' attempts to break through the homogeneous 'victimhood' image, presented in the dominant discourse, of women migrants affected by war and conflict and seeks to explore the space for women's agency in these situations. It simultaneously highlights the suffering that women are subjected to in a conflict situation as well as the survival strategies adopted by them. The volume thus attempts to break the homogeneity of state discourses by bringing in women's experiences, which make it more complex. It raises

a methodological issue in questioning the extent to which recording women's testimonies empowers them, or whether it is a traumatising experience, since it rips open the memories of their 'traumatic pasts'. Further, the volume also examines the ethical dilemma of the researcher's subjective involvement in the 'manipulation of their memories' to serve their own ends and its impact on the researchers themselves. The volume seeks to contribute to the literature on migration in terms of the 'cyclical' character of most 'conflict' and 'peace' situations, the phenomenon of 'internally displaced persons' and to some extent, forced migrants as well.

Migration may thus be either voluntary or forced, may involve individuals or families and even whole communities. One therefore needs to consider the life choices and circumstances of all categories of migrant women while simultaneously addressing the range of gender-specific types of work and their impact on women. Feminisation of the labour force gained momentum after the Second World War when immigration became a state sponsored project, undertaken in response to the labour shortage in the developing and industrialising countries which was to be filled by the Third World countries supplying labour. Women thus migrated to work in export processing zones in the Asian region, as domestic labour, and in the entertainment and sex industries. This highlights the ways in which women in different circumstances and owing to different reasons cross the boundaries of home and community to engage in work in completely different surroundings.

The volume on 'Migrant Women and Work', by focusing upon women who migrate for work, provides indicators to the patterns that are discernible in the migration of women. The volume highlights the specific conditions under which they migrate, the preponderance of women in certain sectors of the labour market, specifically the reproductive and the care sector, the social, economic and political discrimination that particular groups of women are confronted with and the strategies they adopt to cope with such circumstances. It also makes an important contribution to the literature on migration in terms of studying gender and migration in the significant context of women who migrate alone or are the primary migrants, citing case studies of women who are 'solo' migrants. The volume also puts forth the idea that the structural ramifications of women's migration extend beyond the lives of migrant women themselves insofar as the labour of such women is an important factor in shaping the gender relations found in the societies of both the migrants and their hosts, thereby suggesting new ways of

looking at issues such as gender equality, household division of labour and the state policies regarding welfare provisions.

The collection of papers on 'Marriage, Migration and Gender' focuses on several aspects of marriage and migration in intra- and transnational contexts. It poses questions as to how the institution of marriage in and of itself may often effectively imply women's migration through the operation of 'kinship' rules of marriage and (post-marital) residence; how marriage can become a strategy to enable individuals and their families to migrate; the dynamics of matchmaking and marriage negotiations in the context of migration, including the transfer of resources through marriage payments; and, more broadly, how intra- and international migration affects the institution of marriage and wider relations within the family in the Asian context.

The chapters in this volume contend that marriage in new contexts of migration may unravel euphemised and gendered practices and relationships. Migration may also impinge on the institution of marriage and transform familial relationships in a variety of ways. It may introduce new considerations into the process of matchmaking, reinforce or amplify traditional patterns of family and marriage and, in many cases, put the conjugal relationship and relationships between the generations under particularly severe strain, resulting in domestic violence and international custodial disputes. This raises the important question of policy orientations and commitments, in an international dimension, towards women migrants.

Policy Implications

Migration and the focus on women demands that the policies of the sending and receiving countries regarding migration be reviewed and restructured keeping in mind the migrant's interest. While there do exist laws aimed at safeguarding the interest of migrant women and their protection, they are either inadequate or lack effective implementation. In this light, the conference proposed that the distinction between voluntary and forced migration be emphasised such that the policies for each are based on the specific considerations of their particular context. Further, in order to effectively protect the rights and ensure the well-being of specific groups, their particular motivations for migration must be assessed.

The complexity of the process, the multiple and heterogeneous backgrounds of the migrants, and the differential experiences of women and men make policy analysis difficult in this area. Moreover, the countries involved may have different policy goals, the concerns of one may not concern the other. While one country may encourage migration for the positive economic benefits in terms of remittances, the other may do so for acquiring cheap labour. In this sense, both the sending and receiving countries have their regulatory mechanisms to protect and enhance worker welfare. Women, like men, contribute through their labour and remittances; however, the restrictions on migration imposed by the two countries limit the benefits that migration may accrue both to the migrant as well as to the involved countries.

Migration has been institutionalised to an extent, in terms of the employment brokers managing the entire process for the migrants; however, by curtailing movement, these governments, in a sense, serve to strengthen and perpetuate the exploitation and abuse of women. These women in turn migrate illegally, in search of work, and are thus left to the whims and fancies of these middlemen in transit and employers on arrival. In order to make migration beneficial for the two countries as well as the migrant woman, there is a need to rid the existing laws of their restrictive features and to incorporate in the policies protective measures that would ensure women their rights and welfare. Further, to reduce the power of the mediating agencies, the governments of these countries must devise policies to regulate and standardise the recruitment procedure so that these agencies cannot harass potential migrants (Labour Watch in Jolly et al. 2003).

Considering the increased movement in the region, the sending and receiving states may be called upon to build networks between them and share the relevant information with each other and with the women, so as to ensure that migrants move in a well-planned environment whereby their experience is not left to fate and chance and they are aware of the migration channels in the receiving country. The governments of the host regions must endeavour to assist migrants in adjusting to the new world, by creating conditions approximate to those in their home nations. In order to help them cope with the social/psychological consequences of migration, the sense of dislocation, alienation and loss of a sense of belonging, the governments in both regions must have policies regarding certain provisions of skill training, for instance, in the language of the destination country, that would equip these women to find their way about in the new situation.

The heterogeneous aspect of the migrant population and their backgrounds highlights the need for a group specific and country specific pproach, as that would view the migrant woman's problems more realistically, accounting for her particularities. A holistic approach towards migration is called for that would include, apart from the lower classes, the situation of the middle class migrant as well. The analysis must be based on a complete consideration of the specific context within which the migrant is located, in order to effectively formulate policies. Moreover, there is a need to focus attention on the manner in which women migrants are represented in the official discourse, their movement having been rendered invisible by law. These women in reality engage in negotiations with the larger institutions and the state; however, the latter by silencing them makes their agency negligible. While formulating policy, there is a need to therefore ensure a just and visible representation of women.

<div align="right">

Meenakshi Thapan
Series Editor
Women and Migration in Asia

</div>

Reference

Jolly, Susie, Emma Bell and Lata Narayanswamy. 2003. *Gender and Migration in Asia: Overview and Annotated Bibliography*. No. 13. Bridge, Institute of Development Studies, UK.

Acknowledgements

In this volume of chapters on different aspects of marriage and migration in the Asian region, we seek to mesh our long-standing sociological interest in family, kinship and gender with the phenomena of intra- and international migration. The volume derives from a panel on the theme of 'Marriage and Migration' in the international conference on 'Women and Migration in Asia', organised at the India International Centre, New Delhi, in December 2003 under the auspices of the Developing Countries Research Centre (DCRC), University of Delhi. Select proceedings of the panel have been published as a Special Issue of the *Indian Journal of Gender Studies* (Volume 12, Numbers 2 & 3, 2005). To these we have now added Kirti Singh's highly topical paper on child custody issues in the context of international migration (which was also presented in the conference panel), and a substantially reworked introductory essay. We are grateful to the *IJGS* editors, Malavika Karlekar and Leela Kasturi (Centre for Women's Development Studies, New Delhi) who encouraged this collaboration.

We are grateful to the convenors of the other four panels of the 'Women and Migration in Asia' conference—Anuja Agrawal, Sadhna Arya, Navnita Chadha Behera, Anupama Roy and Meenakshi Thapan—whose encouragement, fellowship and criticism made our work on this volume both stimulating and thoroughly enjoyable. Above all, we thank Meenakshi herself who, as the dynamic organiser of the conference and Series Editor of the five volumes of proceedings, has brought this collective effort to fruition.

The 'Women and Migration in Asia' Conference received generous funding from a number of sources—the University of Delhi, the Department of International Development (British High Commission), the Japan Foundation, the Friedrich Ebert Stiftung, the Indian Council of Social Science Research, and the India International Centre—to all of whom we are extremely grateful. We would also like to thank the faculty, staff and library of the Institute of Economic Growth for institutional support; the faculty and staff of the Developing Countries

Research Centre, especially Manoranjan Mohanty, Neera Chandhoke, Manindra Thakur and Ashish Ghosh; and colleagues in the Department of Sociology of the University of Delhi and the Institute of Chinese Studies (ICS), Centre for the Study of Developing Societies, Delhi. We are especially grateful to Swargajyoti Gohain at ICS for her cheerful assistance with the editing and preparation of the manuscript, as well as to Aradhya Bhardwaj at IEG who helped with the follow-up. Many other individuals have in various ways played a role in the making of this volume, among whom we would like to thank Mary John in particular. A Ford Foundation grant (No. 1035-1140) to the Institute of Chinese Studies enabled us to invite Delia Davin to lead a post-Conference Workshop on 'Gender and the Political Economy of Domestic Service: Comparative Perspectives from India and China', the proceedings of which have been issued as an ICS Occasional Study.

Though we were ultimately unable to include in this volume all of the chapters presented in the 'Marriage and Migration' panel, we are grateful to all the participants for making this panel an extremely lively engagement. Finally, we express our special thanks to the 12 contributors to this volume from whom we have learnt so much and whom we now count among our friends.

Rajni Palriwala
Patricia Uberoi

SECTION I
INTRODUCTION

Section 1
INTRODUCTION

1

EXPLORING THE LINKS: GENDER ISSUES IN MARRIAGE AND MIGRATION

Rajni Palriwala and Patricia Uberoi

Transnational family life is a theme that receives considerable media attention worldwide. Much of it is negative. There are tales of hapless girls and women trafficked across international borders for marriage and/or sex work; of young men who use the proceeds of their dowries to finance emigration—never to be heard of again; of serial grooms who enjoy a few nights' intimacy and vanish with the bride's jewellery; of 'Mail-Order Brides' whose love lasts as long as it takes to ensure permanent residency in desired destinations; of immigrant grooms who fail in the husband-provider role and vent their frustration on their wives and children; of cowed victims of domestic violence who suffer in silence rather than compromise the migration strategies of other family members; of visa and immigration rackets involving 'fake' marriages; of flagrant abuses of human dignity by over-zealous immigration officials seeking to discriminate between 'real' and mercenary marriages; and of international legal battles to recover children 'abducted' by non-custodial parents. Similarly, within national boundaries, the nexus of marriage and migration is acknowledged primarily as a factor contributing to the victimisation of poor and marginalised women in contexts of uneven social and economic development.

Yet this is not the whole story. It is also evident that migration may encourage the rescripting of gender roles within the family and offer women economic security and escape from subjection and persecution, as well as enhanced autonomy and respect in both the family and community. In particular, women's *'marriage migration'*—that is, migration within or as a result of marriage—may often be the most efficient and

socially acceptable means available to disadvantaged women to achieve a measure of social and economic mobility (see Del Rosario 1994; Fan and Huang 1998; Fan and Li 2002). Clearly, and without discounting the ubiquity of the abuses just mentioned, social scientific attention to the intersection of issues of marriage and migration needs to go beyond 'victimisation' to a more balanced and context-sensitive consideration of changing dynamics in the nexus of marriage and migration.

The chapters in this volume seek to bring a gender-sensitive per-spective to bear on aspects of marriage and migration in intra- and transnational contexts. In particular they consider: (1) how, given specific rules of marriage and (post-marital) residence, the institution of marriage *itself* may entail women's migration; (2) how marriage can be used as an individual and family strategy to facilitate migration and, conversely, how migration may become a strategy to enable a desired marriage; (3) the fluid boundaries between matchmaking and traffick-ing in the context of migration; (4) the political economy of marriage transactions; (5) the impact of intra- and transnational migration on the institution of marriage, family relations, and kinship networks; and (6) the impact of state laws and immigration procedures on marriage and on family relations.

While most of the chapters here concern marriage in the context of *transnational* migration—which is also the major thrust of the social science literature on marriage and migration—we consider it important, given the reality of uneven development *within* countries in the Asian region, to emphasise the overlap and commonality of issues in both intra- and international contexts (cf. Fan and Li 2002: 619, 621).

The contributors to this volume come from a variety of disciplinary backgrounds—mostly from sociology and social anthropology—and several of them have also been engaged as social activists with the issues that they write about. Unlike many of the earlier, demographically focused migration studies, most of them have based their papers on ethnographic fieldwork or interviews and primary, micro-level data. This has enabled a more nuanced understanding of the imbrication of marriage and migration in a variety of socio-economic and political circumstances. Drawing their inspiration eclectically from family studies, gender studies, migration studies and political economy, probably few of them would care or dare to locate themselves theoretically in *kinship studies*, that dauntingly arcane sub-field of the discipline of anthropology. All the same, we believe that the engagement with migration studies helps to stretch kinship studies in productive new directions, as indeed

the engagement with gender studies had done earlier. Conversely, and building on the rapidly expanding literature on gender and migration, we see that the understanding of migration processes and settlement patterns stands to benefit from a serious engagement with family and kinship studies.[1] Equally important, we are convinced that the comparative dimension introduced by juxtaposing case studies from the Asian region as a whole will pose a further challenge to Euro-centrism in family studies and generate new insights in regional kinship studies as well. The importance of the comparative perspective is a theme that we will revert to in due course.

I. Rethinking Marriage Migration

According to current estimates of global migration, women and girls comprised nearly 49 per cent of global migrants in 2000, and an overwhelming preponderance of migrants in specific migration streams—family members, domestic workers and caregivers, sex-workers, etc. (Zlotnik 2003).[2] Yet, until relatively recently, the arche-typal migrant in demographic thinking was assumed to be male, with women seen as entering migration flows primarily as 'dependents' and subjects of 'family reunification'—as 'passive', 'tied', or merely 'associative' movers.[3] Women's *marriage migration* was seen as a social institution determined merely by kinship and custom and to this extent outside the realm of political economy and the operation of modern market forces. Presuming the economic role and agency of marriage migrants to be self-evidently inconsequential, married women (and their children) were routinely excluded from consideration in otherwise reputable migration studies.[4]

While seeking to make women 'visible' in migration studies, as in other arenas of social life,[5] feminist scholars have been ambivalent in their acknowledgement and interpretation of the phenomenon of women's marriage migration. On the one hand, they have challenged the denigration of women's economic roles embedded in their categorisation as 'marriage migrants', and sought to focus instead on the historical and present reality of women's independent work participation and work-related migration. Others, for reasons connected with the theorising of bargaining power within patriarchal frameworks, have endorsed the

supposed passive and secondary role of women as migrants, observing
that typically it is 'the woman who bridges the distance [rather] than the
man because the man's occupation is considered more important' (Fan
and Li 2002: 620). 'Patriarchy within marriage and the larger society',
in this reading, is realised in the greater power of the husband, the
undervaluation of women's work and careers relative to men's and the
implicit norm of the male breadwinner/woman homemaker.

A number of factors have contributed to qualifying this routine
polarisation of economics and modernity *versus* marriage and tradition
as contradictory motivations for women's migration. First, in the very
process of elaborating the economic dimensions of migrant women's
activities, feminist scholars have come to recognise the impossibility,
empirically speaking, of making a meaningful distinction between
'marriage' or 'family migration' on the one hand, and 'labour migration'
on the other.[6] Given women's role in family subsistence production,
'wives' are typically also 'workers', though their 'work' may not be
adequately acknowledged as such. Fan and Li have demonstrated, in the
case of marriage migration in China's Guangdong province (ibid.), that
labour migration may itself often result in marriage migration as young
migrant workers find their spouses among their workmates; in turn,
women's marriage migration may enable the further out-migration of
male workers, leaving their wives—immigrants from even poorer rural
localities—to manage the farm, the household and childcare. Another
example is that of Filipina contract migrants to Canada (see McKay
2003). Many women who initially migrate as paid workers in the
domestic and home care sectors in due course marry Canadian men,
not least because they hope that marriage will be a route out of unskilled
work. However, since part of the attraction these Asian brides hold for
their husbands is their presumed domesticity, they may remain engaged
in the same sort of work as before, but now as unpaid housewives.

Second, the new scale and visibility of independent female labour
migration and the well-advertised global traffic in wives, sex workers
and domestic workers have challenged the assumption that men
migrate for work and women simply follow.[7] In pointing to the 'care
deficit' that has emerged in the developed world as a result of shifts in
marriage and familial structures and women's increased engagement
in paid work, Hochschild (1995) had suggested that the deficit would
be overcome in due course through a combination of gendered sharing
at home, new work schedules and public care institutions. Less than
a decade later, however, it appeared that the gap was being filled by

the international migration of female domestic workers and/or wives, creating a 'global care chain' and transferring the care deficit to the developing world (Ehrenreich and Hochschild 2003). In effect, it is argued, the recent so-called 'feminisation of migration' in Asia involves the 'systematic extraction' of the reproductive labour of domestic workers and caregivers from the poorer countries of the region (particularly the Philippines, Indonesia and Sri Lanka) through the 'internationalisation of householding' and marriage (Del Rosario 1994; Ito 2003; Ochiai 2006; Oshikawa 2006).[8]

This transnational care work not only sustains the social reproduction of middle class families in the economically advanced countries (including those in East and Southeast Asia), but is also crucial to maintaining the economic competitiveness of the receiving countries. The immigration policies of many states in the developed world are thus constrained to perform a fine balancing act between twin economic anxieties—on the one hand, the care deficit and paucity of low-paid labour to meet the demand; and on the other, domestic unemployment and a growing financial strain on public welfare facilities as a result of liberalised immigration. Reciprocally, the remittances of migrant women workers go to support the social reproductive labour of paid careers or family members who remain at home and—at a macro-level—contribute to mitigating economic crises in the source countries. These intermeshing processes highlight, in a manner critical for both political economy and family studies, the deep connections between migration, marriage, and householding.

We should be careful, therefore, not to throw out the baby with the bathwater. While conceding that the reality of women's labour migration has been obscured by the perception of women's migration as essentially secondary and associative, it is also crucial that we recognise the social and institutional character of marriage *in itself*, as well as its role in ensuring the reproduction of community. Indeed, this is the balance that this volume seeks to restore. As the empirical case studies presented here indicate, aspects of marriage systems underwrite migration, contributing in significant ways to labour flexibility and economic growth in destination countries as well as livelihoods and status strategies in the places of origin. In its turn, migration may (*i*) liberalise or exacerbate features of the traditional system of kinship and marriage;[9] (*ii*) transform the gendered division of labour in the family, the marital equation, and the relations between generations; (*iii*) complicate the relations of intermarrying families of 'wife-givers' and 'wife-takers';

(*iv*) modulate normal life-course trajectories; or simply (*v*) bring to the surface taken-for-granted aspects of marriage and family life which were hitherto obscured. Critical as they are to the life experiences of both migrants and those who stay behind, these dynamic social phenomena are of interest in and of themselves, and not merely in their relation to women's roles as workers or transnational caregivers.

II. Marriage Rules: Patrilocality and Territorial Exogamy

In anthropology, rules of post-marital residence, which prescribe which (if either) spouse will move on marriage, are an important feature distinguishing one type of kinship system from another. A newly married couple may set up house together (neolocal residence), as is the common norm/practice in the West today; the wife may move to live with her husband or with his paternal kin (virilocal or patrivirilocal residence respectively);[10] or a man may move to live with his wife (uxorilocal residence).[11] Among these several types, the rule of patri(viri)locality entails a woman's movement upon marriage—a *migration* of sorts.[12] Moreover, in such societies, marriage rules might also specify marriage outside a particular kin grouping (such as the patrilineage or clan) and certain principles of *territorial exogamy*, that is ensuring a spouse from beyond circumscribed spatial boundaries (the village, for instance). As a result of these 'kinship' rules of residence and exogamy, operating separately or together, territorial dislocation, at times over a considerable distance, has been integral to the life trajectories of young women in many parts of Asia. In both China and India, for instance, where the rule of patri(viri)local marriage is predominant, marriage for women entailed a new home and work environment, and possibly even different types of work, structured by new people, relationships, and authorities to submit to.[13] The incomer was expected to follow the local mores and ways of doing things rather than those of her natal family or locality, and it would take time for her to be accepted and incorporated as an insider, if ever. Even as she made her home with her husband, she rarely forsook the idea of a home left behind. In effect, and simply by virtue of her marriage, she was the epitome of the permanent migrant discussed

in the literature on population movements, diasporas and ethnicity, and labour flows.

Rules of post-marital residence do not generally find a place in discussions of the bargaining that decides which partner migrates and which partner follows—perhaps because—from a Western perspective at least—neolocality is assumed as axiomatic. Nor, given the ubiquity of the 'male breadwinner' model, are such rules deemed relevant in understanding the disavowal of women's work participation embedded in the category of 'marriage migration'. Statistically speaking, however, in societies where patri(viri)locality is the rule, women's 'marriage migration' has usually constituted a large proportion of total migration and the overwhelming bulk of female migration. The gendered implications of this residence rule become even sharper when, as frequently happens, the rule of patrivirilocal residence combines with kinship rules of patrilineal descent, inheritance and succession. The result is a *patriarchal* kinship system in the proper anthropological sense of the term—that is, a kinship system that structurally affirms and enables the authority of senior men over both women and junior men in the family (see Kandiyoti 1988; Uberoi 1995).[14]

At this point it might be remarked that the gendered nature of migration on marriage has not been a focus of attention in traditional kinship studies either. Here, notions of blood relationship, the descent principle and prescriptive rules of marriage have been privileged over the commonplaces of residence and connectedness—in the process, it must be said, leaving women's experiences of family life more or less outside the frame. Patri(viri)locality was seen as simply one type in a formidable checklist of post-marital residence rules and the rule of territorial exogamy as a sort of spatial equivalent to or extension of genealogical rules of lineage or clan exogamy, both rules contributing to the smooth functioning of a patriarchal kinship system (see earlier section).

In recent years, however, a number of feminist scholars have identified the kinship rules of patrilocal residence and territorial exogamy as *themselves* critical factors in determining the political economy of gender relations in societies characterised by patrilineal kinship organisation.[15] In particular, they have pointed to three implications of these rules that may adversely affect women's autonomy of action, their 'bargaining' position in the family, and their 'fall back' position in case of widowhood or marital breakdown (see Agarwal 1997). The *first* is in relation to women's inheritance rights as daughters, especially in respect

to property in agricultural land, which is a critical productive resource throughout rural Asia. Since land is a non-portable asset, a daughter's inheritance rights in land, even when legally recognised by the state, are difficult to assert against the claims of male agnates if a woman is required to move away from her natal locality upon marriage. Or, in the obverse, the rule of territorial exogamy and the out-migration of daughters may be violently asserted so as to prevent daughters from inheriting land (Chowdhry 2007: esp. Ch. 7). *Second*, the presumption that in-marrying wives will be unfamiliar with local customs and the family traditions of their husbands weakens the say young women have in matters within their marital family, while suspicions regarding their loyalty and contribution to the place/home to which they have 'migrated' curtail their rights within it, especially rights to property (Palriwala 1996). *Third*, the security or vulnerability of women after marriage and the constraints and potentialities of their agency are critically related to the proximity (or otherwise) of effective support networks, in particular, networks of natal kin. Indeed, a number of articles in this volume confirm that the geographical location of natal kin is an important key to women's (and men's) experiences of marriage, and also of separation, divorce and widowhood.

Contemporary social processes, including rural-urban, inter-regional and international migration, have contributed substantially to enlarging the distance between the natal and the marital homes for ever-increasing numbers of women worldwide. As Delia Davin's chapter (this volume) on marriage and migration in China indicates, this may be a double-edged process. On the one hand, long-distance marriage migration, like long-distance labour migration, may enable individual women to fulfil their social and material aspirations for a better life and to escape the constraints of family surveillance and community pressure. At the same time, with the disruption of traditional marriage networks, the reordering of marriage preferences and the growth of commercial marriage brokerage services, a migrant woman seeking a more comfortable life through marriage with a man from a more prosperous background may end up in a very vulnerable position in her new home, totally isolated from her natal kin and familiar environment (see Section VI).

III. Marriage for Mobility

Migration—or, to be more precise, voluntary migration[16]—is typically motivated by the desire for upward social mobility and better economic opportunity. Likewise, in many societies across the globe, marriage continues to be central to the materialities and intangibles of life strategies, and to the desires of women, men and their respective families for a better life. As regional and international economic disparities widen, and as the global development discourse designates some cultures as modern and others as backward, global and national hierarchies of place are mapped by spatial economies and flows of labour migrants seeking opportunities for themselves and their families on a national and world canvas (see Del Rosario 1994; Fan and Li 2002; Piper and Roces 2003). Marriage migration tends to parallel the flows of labour migration as the differential social evaluations of women and men combine with culturally embedded notions of 'hypergamy'[17] to channel the direction of marriage and generate streams of brides to desired destinations. Indeed, given the residential restrictions of various governments (China's hukou [household registration] system, for instance, or ration cards and voter registration in India), visa and immigration regimes, citizenship stipulations and entitlements, and rules of professional accreditation, marriage may appear to be a relatively efficient means of ensuring permanent migration to favoured destinations (cf. Fan and Huang 1998; Fan and Li 2002)—especially, but not only, for women and, through them, for other members of their families (see McKay 2003). Women and men may accept spouses who, though otherwise not very eligible, are well-located (Fan and Li 2002).

In most societies, marriage provides an important arena for the achievement, consolidation and affirmation of upward social mobility, and for enhancing a family's 'social capital' in both the short and the long run (cf. Bourdieu 1977: 70). Historically, the Tamil Brahman community of South India was particularly agile and well placed in seizing the opportunity for social and economic improvement through higher, technical and professional education. U. Kalpagam's chapter (this volume) shows how Tamil Brahman families seek to enhance their status in their own community and bank 'social capital' for the

future by arranging the marriages of their children with partners studying or working in North America. They call it 'America *varan*', the American 'boon/marriage alliance'. Grooms are ranked in terms of the likelihood (or otherwise) of their achieving permanent settlement abroad. Brides are selected to fit the traditional requirements of wives of breadwinner husbands—beautiful, domesticated and familiar with the ritual and culinary mores of 'home'—of the right sub-caste and sectarian affiliation, and with matched horoscopes. Simultaneously, their educational qualifications and training are carefully scrutinised in the light of the grooms' anticipated career options and visa statuses. The amount of dowry to be given[18] and the lavishness of the wedding ceremonies are finely calibrated.

In the serious business of status mobility and international migration, traditional Tamil Brahman matchmaking preferences (such as cross-cousin or uncle-niece marriage) are set aside,[19] even as kin and other local networks are tapped for information on eligible migrant partners. Paradoxically, and perhaps to counter the new uncertainties, horoscope matching remains an abiding priority, a service now provided by new agencies and ways born of the times. In the competition for the American 'boon', the bride's kin must duly supplicate before the groom's, reiterating—indeed, perhaps exaggerating—gender asymmetries and the traditional hierarchical superiority of bride-takers over bride-givers.

The concerns of parents are not only tied to their local status priorities, which are of course extremely important for them. They also hope that marrying their sons or daughters to *émigré* partners will ensure continuity in the mobility process and enable other family members to migrate—whether for education, work or marriage. The interlocking of mobility, migration and marriage strategies is illustrated in a number of chapters in this volume, including Kalpagam's chapter (just referred to) on transnational Tamil Brahman marriages, Charsley's chapter on the migration of Pakistani grooms to the UK and Ester Gallo's case study of the transnational marriages of Malayali women migrants in Italy. As Gallo details, the original 'pioneer' migrants, women of the Syrian Christian community from Kerala, India, had gone to Italy in the late 1960s and early 1970s with the intention of becoming nuns, their decisions spurred not only by piety but by the inability of their relatively humble families to ensure them 'good' marriages and handsome dowries. Some of the women subsequently left their convents, took up employment of various kinds, and eventually got married (often in the early days to non-Malayali men). Materially comfortable and rehabilitated in the eyes of their families, they were then in a position

to sponsor the migration of their relatives (typically female, rather than male), to contribute substantially to the resources of their natal households, and to arrange the marriages of junior kin in Kerala and transnationally. There is surely much irony in the fact that women who had once migrated to avoid the ignominy of spinsterhood or the burden of dowry marriages now visibly and proudly engage in the 'work of kinship' and contribute in a major way to their own and their female relatives' dowries, bringing much prestige to their families as a result. In this sense, as Gallo remarks, marriage payments 'represent a relatively "traditional" framework through which families can express "modern" achievements in terms of educational, social or geographical mobility and access to consumer goods' (page 191).

In the case Gallo describes, and in others presented here, the implications of migration for gender and inter-generational relations are clearly mixed. While gender hierarchies in the conjugal tie are for the most part reasserted through the transnational traffic in wives, earning, migrant daughters may enjoy more freedom in selecting their own partners and spending their own income, and in continuing to provide financial and other support to their natal families, before and even after marriage,[20] as well as gain a say in the selection of spouses for female kin. The question of women's agency is an important preoccupation in feminist discussions on marriage *per se*, and in the literature on women's migration—whether for marriage, as workers or as providers for their families in conflict situations.[21] In the first place, taking the case of 'arranged marriage' (widely prevalent in countries of the Asian region), the discussions of Kalpagam, Gallo, Charsley and Xiang elucidate how marriage migration reflects not merely *individual* but especially *family* aspirations and mobility strategies. Second, given national and global economic disparities, a woman's marriage to a man in a desired location may appear to be compelled more by the structural constraints of her situation than by her willing exercise of choice and agency.

Teresita del Rosario's case studies (this volume) of Filipina-American Internet romances explicitly question the last conclusion. Undoubtedly, the US has a higher standard of living than the Philippines, but del Rosario's interviewees are by no means women in need of a 'ticket out of poverty'. They are mature, educated, professional and working women seeking 'romance on a global stage', to borrow the title of Nicole Constable's book (2003). Economic structures and differentials are thus only a partial and imperfect explanation for the asymmetrical flow of Internet-matched brides from the Philippines to North America. Equally important is what del Rosario calls, following Constable (ibid.:

Ch. 5), the 'cultural logic of desire'—the 'white love' that indexes post-colonial Philippines' long and admiring relationship with the United States. For the Filipinas, the new Internet technology provides the opportunity for romance beyond the constraining and often prurient gaze of family and community; unwelcome relationships can be terminated at the press of a button; and yet the family and community can be brought back in to approve and celebrate the final match. For the North American partners, there is a complementary 'cultural logic of desire', as many of them seek to restore, through their Filipina brides, the sense of 'family' that they believe the West has long since lost (cf. Constable 2003: esp. Ch. 4; Del Rosario 1994: 188–97, 208; McKay 2003). That this mismatch of desires may be subsequently played out in the conjugal relationship at the cost of the migrant wives may also be a reason for the denigration of women's exercise of agency in their choice of marriage partners that characterises so much of the literature on the so-called 'Mail-Order Bride' (MOB) phenomenon.[22]

The disparagement of women's agency in marriage migration in the public discourse and academic (especially feminist) literature on 'Mail-Order Brides' is predicated on a split between economic aspirations and status-enhancing strategies on the one hand, and love and romance on the other, as contradictory and distinct motivations for relationships (see Section VII). That is, it is assumed that becoming an MOB is an 'economic' strategy pursued perforce by very poor women in contravention of the proper moral and emotional bases of marriage (Constable 2003: 4–5; Del Rosario 1994: 3). True, the male-centredness and profit-making aspects of MOB matchmaking would seem to construct the wife as a mere 'commodity' (Del Rosario 1994: 119–20), to be picked off the shelf for the delectation of the Euro-American husband turned on by 'Asian babes'. Seen close-up, however, the MOB phenomenon is clearly much more complex, and the dividing line between women's exercise of agency, their cold-blooded self-seeking, and their exploitation by commercial interests more blurred.

IV. Commercially Negotiated Marriage

As noted, much of the academic and activist interrogation of transnational marriages has been predicated on the assumption that the introduction

of material calculations or commercial operations into the process of spouse-selection self-evidently impugns the authenticity of the marital relationship. It is taken as transforming marriage from a domestic arrangement in the domain of kinship to a form of human 'trafficking', within and across national boundaries. As a number of chapter in this volume illustrate (Davin/Lu/Blanchet), the gendered interpretation of commercial matchmaking is much complicated in the case of those societies where marriage transactions customarily take the form of 'bridewealth'/'bride price' (payment to the bride or to her kin in consideration of the marriage). China, many Muslim communities, and a number of caste groups in India are cases in point. In such instances, the marriage transaction can all too easily be construed as the 'sale' of a daughter (or the 'buying' of a wife); and sometimes that is what it is, especially in long-distance and cross-border, commercially-mediated marriages. A woman so bought may be further traded by her husband— to another man, into sex work or into other forms of servitude. Indeed, there is only a thin line separating mediated, commercial marriage arrangements, the abduction and 'trafficking' of women, and bonded labour.

Traditional 'arranged marriage', negotiated by parents and guardians, customarily relies on networks of neighbours and kin to suggest the matches or on local 'professional' matchmakers. Romantic marriage, by contrast, is dependent on the opportunities for personal interaction and emotional bonding between the two partners prior to the marriage, the 'choice' being made by the young couple themselves. Long-distance marriage migration, though sometimes arranged through international kinship networks among diasporic populations, is typically facilitated by *commercial intermediaries* of one type or another—including newspaper advertisements, introduction agencies and matchmaking services, purpose-specific tour companies, as well as, nowadays, Internet dating sites. Women, men and their families turn to these commercial resources for many and complex reasons: in last resort, when the local possibilities of marriage are fast diminishing, due perhaps to women-adverse sex ratios; because of economic and/or other disadvantages and social handicaps which cannot be concealed in the local context; on account of the inability to meet local demands in marriage prestations (dowry or bride price);[23] or because the local expectations of marriage are not to their liking.[24] Or they may 'risk' these relatively chancy arrangements simply to better their lifestyles (see Section III), or in the hope of finding romance. As with other types of labour and immigration brokerage,

there is often little regulation of these services, or redress for those who are cheated by them.

The importance of distinguishing various types and modalities of commercial matchmaking in relation to wife-'trafficking' as the limiting case is highlighted in Melody Lu's finely-textured ethnographic study (this volume) of the marriages of Taiwanese men with women from the Chinese mainland or Southeast Asia (the latter being mostly ethnic Chinese). Marriage migration has reached striking proportions in Taiwan since the 1990s, with some 27.4 per cent of marriages in 2002 being cross-border marriages. The proportions are even higher in those rural areas that have high female-adverse sex ratios (due to both son-preference and female out-migration to urban areas). In Taiwan, Lu emphasises, the traffic in wives is quite distinct from the traffic in women for domestic work and for sex work.[25] There are also differences in the procedures for acquiring brides from mainland China, as against Southeast Asia, on account of the different legal regimes under which the transactions take place (see Section VII). The modalities of marriage brokerage are also quite various. These range from commercial marriage bureaus (whose services include travel, introduction, engagement and marriage ceremonies, visa procurement, etc.), to individual marriage brokers and entrepreneurs, to relatively informal arrangements, often brokered by women who were themselves marriage migrants and who seek to recreate the kinship and extra-domestic networks they had lost by recruiting their own kinswomen and neighbours (cf. Davin, Gallo, this volume; Nakamutsu 2003). The boundaries between these types are fluid, and a combination of modalities is quite common.[26]

It is easy to assume that increasing global economic disparities will encourage and exacerbate the commercialisation of transnational marriage and the commoditisation of women in the process. Lu's account indicates the need for a more nuanced understanding of commercialised matchmaking, however. First, as Davin, del Rosario and others also demonstrate, material interest, considerations of social status and the search for love and emotional satisfaction may not be neatly demarcated, either for the women concerned or for their families.[27] Second, the demand for 'after-sales service'—a sort of guarantee of long-term and continued support to the marriage migrant even after her marriage—is not usually part of the package deal offered by the big commercial marriage agencies, but is common in the operations of local entrepreneur-brokers and informal, personalised brokerage arrangements. In this sense, Lu suggests, the latter

arrangements resemble traditional Chinese matchmaking forms (albeit extended to the Chinese diaspora) more than the lurid media image of international bride-'trafficking'.

Unlike the Taiwan case discussed by Lu, in other contexts the recruiting agents for long-distance marriage and sex work may overlap. Commercial sexual services (and domestic and care services) are often the easiest avenues of employment for migrant women, due to constraints they have experienced in accessing education and work opportunities. Furthermore, 'marriage' may often be just a bait to lure women from poor areas and in bad marriages into sex work in distant destinations, and to convince their families to part with them. Thérèse Blanchet's chapter (this volume) describes the generally pathetic condition of Bangladeshi girls sold as wives in Uttar Pradesh, often to very poor or elderly men who require both their labour and their reproductive services. In this case, the lines between forced or slave marriage, purchased wives, bride price marriage and a marriage made doubly oppressive by the combination of distance and 'sale' appear to be quite blurred.[28]

As already remarked (see Section II), under the kinship rule of patrivirilocal marriage, a young married woman in North India to a large extent loses her rights in her natal 'home'. The ties, however, are not completely severed. Where distances and costs of travel allow, she may frequently visit her natal family on one excuse or another, and she may enjoy the right of return in case of widowhood or marital breakdown. In the case of 'bought' wives, however, the ties of affinal reciprocity are not acknowledged, and the wife's isolation from her natal kin becomes complete. This is all the more so, as in the cases Blanchet describes, when the girls have suffered the stigma of being married to men of a different religion. Overall, it seems, it is not the 'purchase' aspect of these long-distance marriages *per se*, so much as their irrevocable nature—the virtual 'entrapment' of the women—that aligns these brokered arrangements with forms of human trafficking.

While the great distance can mean lack of protection for the women against abuse and violence, for the husbands it reduces their fear that the women might run away. For Bangladeshi women married to men of a different language, religion and country, the latter are additional obstacles to 'escape'. And, once they realise that they have been 'bought', they not only know that they will be forcibly prevented from leaving, but may even question their own right to do so. Moreover, exit from long-distance and transnational marriages is further complicated by

the issue of the care and custody of children, and of shifting them across international borders (see Singh, this volume). By contrast, Chinese women in long-distance brokered marriages may have better access to economic independence, due to the growing demand for women's non-household labour in the destination areas. They may also have somewhat better resources to call on (the All-China Women's Federation, for instance, and of late a growing number of Non-Governmental Organisations [NGOs] working for women's causes), and perhaps higher expectations of treatment in marriage than their often much younger South Asian counterparts. After all, China has experienced numerous campaigns to change the face of gender and family relations through five decades or more.

V. The Political Economy of Marriage Transactions

For those who associate marriage payments—whether bridewealth or dowry—with 'custom' and 'tradition', it may come as something of a surprise that these supposedly hoary practices, as well as conspicuous consumption and display on the occasion of marriage, may actually be *enhanced*, rather than discontinued, in the contemporary context of liberalisation and globalisation (see, e.g., Palriwala 2003; Siu 1993). Thus, in the case of China, where the quantum of bride price, of dowry, and the overall costs of marriage have escalated very sharply in the post-reforms period, we see that the demand for brides from interior provinces is in part encouraged by the inability of poorer men in more developed regions to raise the requisite bride price to acquire local wives (Davin, in this volume). Similarly, mainland and Southeast Asian brides were reputed to be a much 'cheaper' option for the rural Taiwanese men who undertook this relatively risky venture into the transnational marriage market (Lu, in this volume).

The chapters by Ranjana Sheel and Xiang Biao (this volume) illustrate the complex ways in which the Indian 'dowry system' is linked not only with transnational marriage migration, but also with the creation of a global labour force. In the first place, dowry payments constitute a fluid fund that can be used to directly finance the migration process. There are many tales of women who have been deserted immediately after marriage by husbands who use the proceeds of their marriages to

emigrate; or of women duped by non-resident bridegrooms, some of whom—in notorious cases—have made a business of marrying local women, collecting the dowries and disappearing soon thereafter.[29] While these may appear to be exceptions, against which due precautions can be taken, Xiang's chapter goes further to argue, more abstractly, that dowry payments actually play a substantial role in the reproduction of a flexible and globally competitive Indian Information Technology (IT) labour force.

For many Indian male migrants from the upwardly mobile Kamma and Reddy castes of Andhra Pradesh (the subjects of Xiang's case study in India and Australia), their dowries enable their IT education and subsequent emigration. In turn, their prestige as IT professionals and their earnings through migration-linked employment augment their value in the marriage market, pushing up the dowries given for their sisters and creating a snow-balling, imitation effect among less prosperous, lower caste and tribal groups. Often, the initial migration is through what is called a 'body-shop', a firm which moves IT labour to where it will be required, retaining it unpaid and dependent on savings or family support during idle periods ('benching'). The profits of mobile international capital rest on highly-trained, flexible, relatively cheap and mobile labour which, as Xiang's discussion suggests, is enabled through local practices: in this instance, the exorbitant dowries associated with caste-endogamous marriages and gender hierarchies which ensure that women will undertake paid and unpaid work to maintain families and, with their IT husbands, take the risks which capital is assumed to take. Thus, Xiang argues, the gender relations of marriage and migration ultimately subsidise global capital.

Where women are the migrant earners, however, the gender implications of the nexus between local dowry and global capital may take on a somewhat different meaning, as Gallo's study of Malayali women migrants in Italy (referred to earlier) indicates. The women's foreign earnings contribute to widening the field for spouse selection and enabling 'good' marriages for themselves and their female kin (cf. Gamburd 2002). Malayali women in Italy, many of them domestic workers and nurses, can now offer a visa sponsorship as dowry or choose their own partners in the light of the living conditions and employment opportunities in Italy, rather than acquiescing in their families' local status preoccupations in Kerala. Later cohorts of similar migrants, building on the experiences of their predecessors, may combine marriage and migration differently. However, while the new-found economic independence of women migrants has led to shifts in their models

of conjugality and possibly a renegotiation of gender roles within the household, their remittances also contribute actively to the perpetuation and exacerbation of the 'dowry system' and conspicuous consumption *per se*, adversely impacting the lives of other women and gender relations in the society as a whole. In other words, the gender 'accounting' in this case, as in cases of migrant female labour (e.g., Gamburd 2002), produces a rather mixed picture: good for some individuals, perhaps, but bad for others and for society; good in some aspects of a person's life, not in others.

Expectations of dowry and, even more, of conspicuous consumption at weddings, are also factors in marriages among the Indian diaspora. The often extravagant dowry 'earned' in India by a non-resident Indian groom can add substantially to a young man's working capital as he struggles to establish himself in a foreign locale; or it can be commuted for a match with a woman with highly portable and potentially remunerative qualifications—in nursing, for instance. Even for second generation immigrants, as Sheel (this volume) illustrates with material from British Columbia, Canada, the costs of a daughter's marriage may be unconscionably high. As lavish weddings in the Indian diaspora turn into aggressive displays of ethnic affluence and assertions of community identity, as well as of status claims *within* the community, women of the family tend to take a backseat in the proceedings, while daughters are burdened with the awesome responsibility of upholding family and community honour and a reinvented tradition of gender relations (see Thapan 2005a and 2005b).

VI. Stresses and Transformations in Family Relations

Migration impinges on the institution of marriage and transforms familial relations in a variety of ways. The various articles in this volume take up the challenge to detail and draw out the gender implications of these changes in different instances. Obviously, this is not an easy task, given the heterogeneous scenarios of marriage and migration. For instance, an interesting aspect of matchmaking on behalf of Pakistani male marriage migrants in the UK, described by Charsley in her chapter, is the increasing heed paid to the 'traditional'

claims of close kin in settling the marriages of their children, whether with partners from Pakistan or within the Pakistani diaspora. This contrasts with the situation of Tamil Brahmans, described by U. Kalpagam, who clearly consider a prospective groom's visa status as much more important than the traditional obligation to reinforce the relations of affinity between intermarrying local groups (cf. Dumont 1983).[30] Yet the intermarrying cousins and their families in Charsley's case study may rarely have met, and are as likely to be strangers to each other as the non-kin Tamilian affines.

Ethnic communities can only continue to exist *as such* via community-endogamous marriages, which may be within the locally settled community or—and this is sometimes the preferred option—with men or women of the place and community of origin. Endogamous marriages ensure the transmission of the community's values and culture to the younger generation. For South Asian migrants, marriage is both a channel of communicating and relating with 'home', an expression of obligations to those left behind, and a strategy of reproduction of community identity in diasporic settings.[31] The experience of racism, fears of deracination and of the loss of tradition, and stereotypes of the lack of 'family' in the host society and of the loose, locally brought-up daughters of early immigrants persuade many that a daughter-in-law/wife from back home is preferable (see Sinha-Kerkhoff 2005). In some cases, as Charsley describes here in a counter-example, migrant *husbands* may also be viewed as instruments for the transmission and reproduction of religious orthodoxy and normative cultural values. However, the young women and men themselves may prefer a second generation immigrant from their own community to ensure compatibility; or, more problematically, they may assert the right to select their own partners, even from outside the ethnic community. In consequence, inter-generational conflict in spousal selection, as between first and second generation migrants, has become increasingly visible. In many cases, well-publicised in the media, the insubordination of the younger generation, young women in particular, is visited with violent reprisal by male patrikin avenging the 'dishonour' to family and community (e.g., Das 1976; Kang 2003). Thus the younger immigrants, in particular, seem to be caught in a dilemma. On the one hand, their rejection of what is claimed as traditional marriage and familial practice by community elders may not be accepted by the state unless or until it comes to the point of violence (Bano 1999). On the other hand, though many young, South Asian women and men actively endorse the practice

of arranged marriage, the British immigration service appears to equate arranged marriage with 'forced' marriage and assumes the inevitability of inter-generational conflict on this account (Hall 2002: 63).

As the chapters here detail, migrants have changing and varied expectations of their new lives and their links with their places of origin, tied to marital and familial relations and obligations, and plural projects of modernity. Thus, migrant women may simultaneously desire to settle into the ways of being of their host societies, valuing their escape from the powers and authorities of the domestic domain and social life left behind; yet, along with their male compatriots, they may also yearn for the same kin and friends, and take pride in fulfilling their obligations to the family back home (Gallo, Mand, this volume; also Uberoi 1998). They may win respect in their natal families and communities for their ability to sponsor the migration of their near kin; at the same time they may feel used and exploited by their families, at home or in the diaspora (see Rozario 2005). They may achieve an improved standard of living and economic independence; or they may become dependants in the worst sense of the word, prisoners in their own homes, far from friends and relatives, and perhaps silent victims of domestic violence. In every case, their experiences are modulated by factors of caste, class, religion and race; by legal regimes and immigration procedures; by contingent events, such as '9/11' or more recently '7/7', provoking racist and anti-immigrant responses; by the upsurge of ethnic identity movements, whether among the diaspora or among the majority population in the country of settlement; and also, very importantly, by a woman's stage in her life-course.

Migration has the potential to transform the culturally normative sexual division of labour within the family. There is a growing literature describing the delicate reallocation of familial roles when married women migrate for work, leaving their husbands and children behind (Gamburd 2002; Ito 2003; Parrenas 2006). This may result in extra strain on the conjugal relationship, not least on account of the reversal of provider-dependent roles, as well as encourage the reinvention of 'joint family' arrangements to support childcare (e.g., Gamburd 2002; Thangarajah 2003). Shifts in normative divisions of labour are also evident in situations of male out-migration, where the women left behind must shoulder the grind of routine work and day-to-day management, though they may ultimately have little say in the major investment of repatriated resources (Gulati 1993; Naveed-I-Rahat 1990). An important outcome of migration in many cases is the doubling, if

not tripling, of the migrant woman's burden—as paid worker, parent and wife, and providing daughter. In counterpoint are the cases where couples and families migrate and professionally trained women have to put their own careers on hold to support their husbands' entry into the job market on an uneven playing field (Kalpagam, this volume); or work at menial or 'grey-market' jobs to enable their husbands to requalify themselves for employment in competitive new locales (Abraham, Gallo, this volume).[32] Thus, gendered-racist work regimes in the place of destination may combine with cultural norms from 'home' to reverse emerging shifts in the gender patterns in paid work. The inability of sons and husbands to fulfil their normative role as breadwinners can have harsh consequences for their families and themselves (see Xiang, Charsley, Abraham, this volume). In any case, norms of material support and caregiving—especially for children and the elderly—are being constantly re-negotiated in the context of migration, both within the migrant community and vis-à-vis the families left behind (Singh 2006), producing thereby new norms of domestic life.

As mentioned earlier, diasporic communities often seek brides from the home country, assuming that these women will be more docile, or trusting that this will assure the reproduction of community identity in foreign lands. However, in some cases, as with recent Pakistani marriage migrants to the UK, *male* migrants may seek to emigrate by contracting marriages with the daughters of earlier migrants in their destination countries (Ballard 1990: 237, 242; Charsley, this volume).[33] These men may then experience the social and emotional difficulties which are usually the lot of in-marrying women in patrilineally-structured societies—the burden of asymmetrical 'adjustment'. Their difficulties are compounded and reinforced by the idea that they are following a familial trajectory—that of the *ghar damad* or resident/in-married son-in-law—which is derided and belittled in their own cultures. Minimally, they may feel that their 'masculinity' has been seriously compromised by their inability to take on the normative male 'provider' role in societies which recognise their race but not their qualifications, pushing skilled and qualified workers into menial and manual occupations, if not into long-term unemployment. Sadly, as Charsley details, reassertions of masculinity may be at the cost of the male migrants' wives, their children and their marriages (see also Abraham, this volume; Das Gupta 2006).

Kanwal Mand's chapter in this volume, focusing on the experience of widowhood, separation and divorce for 'twice-migrant' Sikh women—immigrants from Tanzania to the UK—is a timely reminder

of the importance of taking a 'life course' approach to issues of gender and family. Her case studies illustrate how migration can be a means for women to escape the inauspicious mark and dependency of widowhood, difficult in-laws or bad marriages, or obscure socially disapproved exits from such marriages (such as through long-term separation without divorce). Mand also describes, however, the social embarrassment and family tensions that result from the inversion of traditional kinship norms when an elderly widow is constrained to take up residence with her married daughter and her family. In the North Indian kinship system into which she has been socialised, a senior woman is expected to rely on her sons for support in her old age (they are, after all, the normal heirs to the paternal estate), and not on her married daughters (see Note 20). In the case that Mand presents, even the woman's unpaid duties as grandmother, enabling her daughter to go out to work, and the affection of her grandchildren, can hardly redeem her fractured self-esteem.

In many cases, the dynamics of new contexts and the distances from kin and community put conjugal and inter-generational relationships under very severe, even intolerable, strain. Migrant couples are more dependent on their own resources, emotional, social and economic, with little of the buffer which family and kin can provide. For the Chinese, Indonesian, Pakistani, Bangladeshi and Indian brides in foreign lands, whose experiences are recounted here, increased marriage distance has often meant the loss of the protection of the social and kinship relations, which are normally mobilised in spouse selection (see Section IV). The periodic and customary visits home—recognised as holidays from the in-laws—become rare if not impossible and are mourned by the married, migrant daughter and her parents left behind. While this may be a case of 'more so', rather than a qualitative shift from conditions in their societies of origin, a newly married migrant woman may nonetheless be doubly isolated and vulnerable to abuse—akin to the trafficked wife, in fact—with little hope of remedy (Abraham, Blanchet, Davin, Lu, this volume). At the same time, she may be unaware of her commonality with victims of domestic violence in the host society, or unwilling or unable to avail of the welfare services that she requires (Abraham, this volume; also Kang 2003).

An assumption often made in migration literature and popular discourse is that migrant women from poor or backward countries will necessarily experience emancipation through their settlement in countries with apparently more liberal social values, or through their participation in paid work in the destination countries. This, as Mirjana

Morokvasic (1984) argues in an early article on the theme, is often an unwarranted assumption that ignores the likelihood of women's participation in paid work in their home countries, prior to migration. It also discounts the double burden of housework and paid work in the new situation, the experience of racism in the host societies, and the new social controls often imposed on women in a migrant-'enclave' situation (cf. Abraham 1998; Dossa 2005). However, with the displacement of migration, the tensions, fault-lines and contradictions in cultural and social practices tend to come readily to the surface.[34] The domestic violence which Abraham discusses, the vulnerabilities of old or widowed women which Mand focuses on, the custody conflicts after separation or divorce which Singh discusses, or the psychological stress for uxorilocal husbands in a patrivirilocal community (Charsley), are not phenomena and experiences exclusive to the migration context, but their effects may certainly be exacerbated on account of migration.

VII. Immigration Rules, State Laws and Marriage

Critical to the nexus of gender, migration and marriage are state laws, ideologies and practices in which economic, racialised and ethnocentric impulses interweave with patriarchal norms of gender and family of both the majority and immigrant communities. International conventions, such as the 1975 ILO Convention No. 143 and Article 8 of the European Convention of the Rights of Man, have recognised the right of family reunion on humanitarian and integration grounds, based on an assumption of the family as the natural and fundamental unit of society (see Jastram 2003; Sassen 1999: 128–29, 132). The governments of destination countries are, however, alert to the fact that procedures of family 'sponsorship' may be a means of entry for what they deem to be purely 'economic' migration, opening a door to floods of immigrants. Individual states therefore seek to limit the right of family reunion through their immigration rules and procedures—for instance, by prescribing conditions for the sponsor, such as 'adequate' income and housing. Ethnocentric definitions of family membership and of 'genuine' marriage and assumptions regarding the dependency of wives also shape these procedures.[35]

→ e.g. British assumption that all arranged marriages are forced

As a special case of 'family reunion', marriage migration has been a significant concern of both migrant communities and of the state in the destination countries.[36] In consequence, much effort is spent (with sometimes comical, sometimes traumatic consequences) on devising legal definitions and administrative procedures to determine whether or not a marriage is 'genuine' (see, Gell 1994: 376–80). Such tests of 'genuine' marriage tend to express the cultural values of the host society, which typically presume that individual free choice and romantic love, in dichotomous opposition to pragmatic family-building strategies and economic calculation, are the basis of a genuine conjugal relationship.[37] Alternatively, as with the cat-and-mouse games played out between would-be immigrants and the immigration authorities of destination countries (see, e.g., Ballard 1990; Gell 1994), immigration rules and procedures may purport to operationalise the perceived 'traditional' gender, marriage and family norms of the migrant's own community. The notorious 'virginity tests' administered to South Asian brides by British immigration officials between 1979 and 1982 were a much-publicised example of this misplaced zeal, an attempt to curb opportunistic marriage migration by application of the culturalist assumption that 'genuine' South Asian brides making arranged marriages would necessarily be virgins (Hall 2002; Wilson 1978).[38] Incoming South Asian husbands are another example, such marriages being viewed with particular suspicion on the grounds that they represented a departure from 'tradition' (Hall 2002: 64–65).

As emerges from a number of the chapters in this volume, particularly Margaret Abraham's analysis of domestic violence in the South Asian diaspora in the US, visa regulations meant to keep out illegal immigrants, residence permits, notions of the conjugal contract in which the dependency of wives and the altruism of husbands are assumed, the conception of genuine marriage as based on affection/ sexual attraction, the assumption of the normalcy of the nuclear rather than the extended family, stereotypes of backward cultures and fears of terrorist infiltration from the East, act against all Asian migrants, but have specifically gendered impacts on wives and on the women of migrant communities. In particular, the wife on a 'dependent' visa is often constrained to stay in an abusive relationship and remain house bound for fear of deportation (Abraham 1998: 231–33; Morokvasic 1984: 891).

With international migration and the creation of minority enclaves, laws relating to family and the personal sphere frequently become the

site of conflict between 'community' and individual rights (Bano 1999: 166). A number of immigrant women's groups have struggled—even (or especially) against the leaders of their own communities[39]—to win recognition of the problem of spousal abuse within immigrant communities in the US and to enact laws for the protection of victims of domestic violence. Under the circumstances, as Margaret Abraham notes (this volume), it is both sad and ironic that success in these efforts came at a time of heightened anti-immigrant sentiment in the US following '9/11', threatening to undo the hard-earned gains of decades of struggle.

Migration and international immigration have made more sharply evident a range of familial and marital issues, not necessarily born of migration, in which existing state practice may be counter-productive and legislative action is urgently required (see Section VI). Kirti Singh's chapter in this volume points to one such area. She highlights the traumas which the end of marriage may entail for children when one parent (typically the father) forcibly abducts the child to another place or another country. This can happen where either one spouse (oftentimes the wife, given the rule of patrivirilocality) or the couple are migrants. Especially in the case of those countries which are not signatories to the Hague Convention on the Civil Aspects of International Child Abduction (1980)—and India is a case in point—legally restoring the abducted child to the custodial parent and to his/her country of habitual residence may be a time-consuming, expensive and sometimes infructuous process. Studies have indicated the possible dire consequences for the well-being of the child concerned. The importance of implementing international legal instruments to deal effectively with cases of parental child abduction, as well as with marriage, divorce and forms of marriage transactions,[40] has become increasingly urgent as migration flows and distances increase.

VIII. Marriage Migration in Comparative Perspective

Read together, the chapters in this volume enable insights from the *comparative* experience of Asian peoples' intra- and international migration—both similarities and differences—particularly in gender terms. Not only are Asian women and men much on the move, but

the significance of the institution of marriage in its cultural and social forms, economic and status strategies, and gendered agency is a theme that traverses the many different contexts of Asian migration. There are several issues here that deserve social scientific attention and warrant further empirical investigation. First, it is evident that the institution of marriage, despite varied and flexible practices, continues to be deeply gendered and invested with immense cultural value across much of Asia. As such, it is critical in the playing out of a host of local and global, economic, social and political processes.

Second, these processes come together in the lives of individuals and families in linking their aspirations for marriage and social mobility. In this, the dynamics of the local and international marriage and labour markets interlock, both moderating and moderated by local kinship and marriage practices and norms. The opposing trends in marriage practices described in two chapters in this volume (Charsley, Kalpagam) illuminate this: the norm of intra-kin marriage in designating the proper spouse is revived in a community with a long history of migration, where it enables men to migrate (Pakistanis), but it is given the go-by in the mobility strategies of a group who have taken to international migration relatively recently and where opportunities for male professionals stimulate the migration process (Tamil Brahmans).

Strategies of matchmaking become a third important issue in a comparative sociological context. A number of chapters in this volume examine the effects of gendered opportunities and state regulations on modalities of matchmaking and marriage migration. It would be worthwhile to examine more rigorously what differences, if any, the contrast between the patrilineal systems of South and East Asia and the more bilateral systems of Southeast Asia make in the gendered interweaving of labour and marriage migration and matchmaking practices.

This leads us to a fourth issue on which the comparison is compelling: namely, the transfer of resources effected through marriage (whether bride price or dowry). Supposedly 'traditional' practices, such as bride price and dowry payments as well as conspicuous consumption and 'ethnic' display on the occasion of marriage, may actually be *enhanced*, and not discontinued, in the context of migration. Not only do families and communities continue to make status claims through substantial marriage payments and opulent festivities in their new environments but, as noted in the discussion of Sheel's chapter, ethnic marriages have become an extremely important focus of community and ethnic

identity vis-à-vis both the migrant and the host communities. Moreover, marriage payments may serve as a fluid fund enabling migration, or may be generated by the migration of family members (men and also women).

A fifth and related issue pertains to the relationship between types of marriage payment and women's status in society. Feminist social scientists in India have traced a malign nexus between female-adverse sex ratios, low levels of female education and employment, women's disadvantaged property rights and high or enhanced rates of dowry (see Agarwal 1994). According to received wisdom, *dowry* in South Asia is a form of enticement or compensation paid in a tight marriage market to the husband and his family for taking on an 'unproductive' woman; conversely, *bride price* is interpreted as a positive valuation of women's productive capacity and a form of compensation to the woman's family for the loss of her productive labour. Given these assumptions, the long-term decline in bride price practices in various communities and regions and the increase and expansion of the 'dowry system' are read as indicative of women's low and declining status in the South Asian context (e.g., Miller 1980, 1989; Srinivas 1984; Tambiah 1973).

The comparative perspective offered in this collection of papers commends a refinement of these assumptions regarding the relation of marriage payments and women's status. For instance, China—like India—*also* has a notably adverse female-to-male sex ratio, a preference for patrivirilocality, growing regional economic disparities, a prosperous overseas community and a tight marriage market. In China, however, these features are combined with a high female work participation rate and the predominance of bride price, the rate for which has grown astronomically as a result of the expansion of the commodity economy, overall economic prosperity and the increasing demand for women's non-household labour (Han and Eades 1995).[41] In order to circumvent this, poorer men in the more prosperous areas are 'importing' wives. Though the latter may welcome escape to more prosperous destinations, and their families benefit from the bride price payment at the same time, the 'bought' woman traded to a distant destination may find that she is worse off, socially isolated and with a bad bargain in her husband (see Section IV).

As with bride price in China, dowry in India has also grown astronomically as the effects of liberalisation unfold (Palriwala 2003). On the other hand, hefty marriage payments and adverse sex ratios seem not to be an issue in the more bilateral societies in other parts of

Asia. In the latter, the marital bond is also accepted as more fragile. This contrast commends further analysis of the gendered consequences of the complex of marriage transactions between families—whether dowry *or* bride price—and their imbrication with patrilineal descent, patrivirilocal residence rules and lifelong marriage in the context of existing and growing socio-economic inequalities.

Last, is the question of the constraints and opportunities for women's exercise of agency in decisions concerning migration, marriage and the family. The areas and forms in which women and men exercise agency are limited by political-economic processes, by historical and symbolic determinations and by cultural constructions of gender, sexuality, class, race and ethnicity. Women may be constrained to just make the best of what their situations offer. They exercise agency in choosing and finding the means to migrate; in delaying, rejecting, ensuring or escaping marriage through migration; and in dealing with or moulding new forms of familial relationships. In the process, as is well illustrated in the existing literature on the marriage-migration nexus, they may easily jump from the frying pan into the fire. Nonetheless, as the various chapters in this volume confirm, 'victimhood' is by no means the whole story.

As in the broader feminist literature, the chapters included here use the concept of women's agency in many and diverse ways. These range from passive on active resistance, to the exercise of choice, to the ability to work for change in current family norms and kinship structures.[42] While we do not claim that this volume is the last word on the subject, it certainly points to the need for further empirical and nuanced studies of the intersection of marriage and migration in Asia from both a gender-sensitive and a comparative intra-Asian perspective.

Notes

1 A relevant example is Roger Ballard's comparison of the contrasting migration and settlement patterns of two Punjabi communities—Moslems from Mirpur district, Pakistan, and Sikhs from Jullundur, Indian Punjab. Ballard argues, *inter alia*, that the kinship preference of Mirpuris for cross- and parallel-cousin marriage (mediated by changing UK labour market requirements and immigration controls) explains the Mirpuris' relatively slow rate of family reunion in Britain—as compared to the Punjabi Sikhs who have a taboo on marriage with close relatives (Ballard 1990: 240; cf. Gell 1994).

2 Asian countries are both receivers and senders of increasingly large numbers of female migrants, depending on features of both the receiving and sending countries (Asis 2003; Gulati 2006; Ito 2003; Lim and Oishi 1996).

3 See for instance Boyd and Grieco (2003); Morokvasic (1984); Thapan (this volume); Youssef et al. (1979); Zlotnik (2003).

4 For instance, to take a random example, Oberai and Singh's well-known early study of migration in the Indian Punjab defined 'out-migrants' and 'in-migrants' so as to exclude from consideration both children below the age of 12 years and women who had out-migrated/in-migrated 'for marriage' (Oberai and Singh 1983: 11).

5 One area recently opened up by scholars, feminists in particular, is the social, cultural and political history of colonialism traced through the stories of European women who emigrated to the colonies—whether as wives or as single women in search of husbands ('fishing fleets'). Both their absence and their presence were significant in the creation and stabilisation of colonial regimes. Even as they made new spaces for themselves, however, these European women became participants in the subjection of the colonised and in bringing their gendered models of home and marriage to these societies. See, e.g., Alavi (1999); Ballhatchet (1980); Ghose (1998); MacMillan (1996); Stoler (2002).

6 See, among other references, Joshi (2003); Karlekar (1995); Piper (1999); Piper and Roces (2003) and Sen (2004).

7 There is a growing literature on this theme. See, e.g., Agrawal (2006); Arya and Roy (2006); Gulati (1993, 2006); Ito (2003); Jeffreys (2006); Karlekar (1995); Lim and Oishi (1996); Lingam (1998); Morokvasic (1984) and Stalker (2000). For a longer historical perspective on women's labour migration in South Asia, see Sen (2004).

8 This further exemplifies Sassen's argument that migrations do not just happen, but are patterned productions wherein the 'economic, political and social conditions in the receiving countries set the parameters for immigration flows' in ways which do not allow emigration regions to catch up (Sassen 1999: 155, 136–37, 140).

9 See Boyd and Grieco (2003); also Gardner and Osella (2003: xiii–xiv) who, citing Ann Whitehead, make the point that 'spatial disruption challenges and relativises existing social relations. Even if this is not always the intended effect, the exposure to new places, ideas and practices which migrants experience often seems to lead to a questioning of existing forms of hierarchy or a reinvention of the self's place within the social order.'

10 The terms patrivirilocal and virilocal are commonly, if somewhat inaccurately, collapsed under the term 'patrilocal residence'.

11 Several of these definitions of residence types are subject to dispute and many more types have been distinguished, but this is not a question which need detain us further here.

12 Of course, the kinship rule of patrivirilocal residence does not entail migration if the woman's natal and marital families live in close proximity, as would be the likely case in societies where the patrilateral parallel cousin is the preferred spouse.

13 While the 'marriage distance' in India and China was traditionally quite small (say, within 25 km radius), except among the elite (cf. Gould 1960), it would indeed be a 'migration' from the psycho-social perspective of the women involved. For a summary tabulation of marriage distance from South Asian ethnographies, see Agarwal (1994: esp. 325–35, Table A8.1, 379–89) and Libbee (1980). For China see,

e.g., Fan and Li 2002: 622; Han and Eades 1995: 846ff; Lavely and Ren 1992; Selden 1993 and Zhang 2000.

14 On the whole, the kinship systems of Southeast Asia are much more bilateral in their rules of inheritance and descent than those of both East Asia and South Asia (excluding Sri Lanka), features associated with residence patterns and gender relations that are less harsh on women (see Dube 1997).

15 See, for instance, in the South Asian case, Agarwal (1994: esp. Ch. 8); Kolenda (1987: Ch. 1); Palriwala (1991). According to some scholars, efforts at improving women's access to productive resources in rural China have foundered on account of the continued hold of the rule of patri(viri)local post-marital residence (Smith 2000: 290).

16 For a discussion problematising the conventional distinction between voluntary and forced migration, see Behera (2006) and Manchanda (2006).

17 'Hypergamy', in anthropological parlance, refers to women marrying 'up' in the social hierarchy; it is contrasted with 'isogamy', the marriage of social equals, and with 'hypogamy', where women marry down. In the Indian context, hypergamy refers to the marriage of a woman with a man of higher caste status, but there are also overlapping, territorially-based hierarchies of direction and of place, arising from the fact that—among Hindus in North India in particular—daughters must not be given in marriage to the kinship groups or local communities from whom brides have been taken. In the context of Hindu culture, the ideology of *kanyadān* (the 'gift of the virgin') ensures that, even with the marriage of status equals, the bride-takers assume superior status in relation to their bride-givers (see, e.g., Trautmann 1981: 377ff). Fan and Li (2002) use the term 'spatial hypergamy' for the marriage migration of women from backward provinces and counties of China to the relatively well-off Guangdong province.

18 U. Kalpagam's Tamil informants actually deny giving 'dowry' as such, but confirm that the securing of an 'America *varan*' match will require substantial gifts to the bride and groom in addition to opulent ceremonies.

19. On the other hand, Charsley's paper on Pakistani marriage migration to the UK reports an increase in kin marriage. See also Ballard (1990).

20 In general, in the South Asian system of asymmetrical exchange (see note 17), a married woman's parents are expected only to *give*, and never to *receive*, gifts and hospitality from their daughter's conjugal family. See Mand (this volume) for a discussion of this issue in the context of elderly women's life-choices.

21 See Behera (2006: 43–47); Constable (2003: esp. Ch. 6); Piper and Roces (2003: 8–15).

22 The term is conventionally specialised to refer to the service agency-mediated marriage of a non-Western woman with a Western man. See Del Rosario 1994: Ch. 1.

23 This is illustrated in the chapters in this volume on China (Davin) and Taiwan (Lu), and also in the case of Bangladeshi women married in Uttar Pradesh, India (Blanchet). See also Kaur (2004), who gives details of two distinct sets of marriage networks through which brides from poor areas of Assam and West Bengal/Bihar escape dowry and marry 'less eligible' men in the women-deficient but economically better-off regions of Haryana and UP respectively.

24 Filipinas, for instance, have a poor opinion of Filipino men as 'husband-material'—they are thought to be promiscuous and irresponsible compared to American men. Conversely, American men see Filipinas as feminine, caring, domesticated and loving, and American women as unattractively assertive (Constable 2003; del

Rosario, this volume). Nakamutsu, in her study of immigrant Filipina brides who had arrived in Japan through marriage brokers (2003), also points to a multiplicity of motivations on the part of the migrant women: desire to escape from an unpleasant or difficult situation at work or at home; hopes for a better life, in particular a stable marriage, children, family and love; the pleasure of being 'chosen' in preference to other candidates; and a sense of adventure.

25 See Agrawal 2006 (also Ito 2003) for a discussion on domestic work and sex work as two major occupational categories for migrant women.

26 For instance, in one of the cases discussed by Lu, an Indonesian marriage migrant brokers a further marriage between one of her husband's kinsmen and her own relatives, but utilises the services of a local Indonesian marriage broker/entrepreneur to complete the paper work. See also Kaur (2004).

27 Of course, women or men who immigrate as workers, domestic or otherwise, may ultimately marry locally. See also McKay (2003).

28. While outside agencies considered all these women as having been 'trafficked', local communities apparently reserved this term for women transported for commercial sex work. Ravinder Kaur (2004: 2598) also asserts the analytical distinction between trafficking, buying of brides and bride price marriages.

29. The problems of marriage between diasporic Indians and partners from the homeland have recently been taken up at the official level by the Ministry of Overseas Indian Affairs of the Government of India, with recommendations for legal remedies in addition to counselling and intervention by social welfare agencies, to prevent the abuse of women and the exploitation of their families by Indian grooms resident abroad. See items posted on the official MOIA Website, e.g., 'Report on National Consultation on Marriages to Overseas Indians' (http://moia. gov.in/showinfo1.asp?linkid=320); 'NRI Marriages' (http://moia.gov.in/shoifo1. asp?linkid=131); 'Report on the Workshop Regarding "Problems Relating to NRI Marriages and Suggested Measures" in Chandigarh on 20th and 21st June 2006' (http://moia.gov.in/shoinfo1.asp?linkid=317); and press items, 'Govt Will Provide Legal Help to Women Left in the Lurch Abroad' (*Times of India* 30/12/06); 'Marriage is Talking Point of PIO Meeting' (*Times of India* 8/01/07); 'Marry-and-Dump NRIs May Face Indian Law' (*Times of India* 9/01/07). The interactive columns of the official website (http://moia.gov.in./dfmainviews.asp?tid=1), however, carry many strongly worded complaints of the exploitation of foreign-resident grooms by greedy and manipulative affines and general dismay at the measures being planned by the Ministry to protect Indian women married to NRI grooms.

30 As noted earlier, however, 'tradition' is not altogether rejected for, even in their feverish search for American grooms, the Tamil Brahmans take pains to ensure the horoscopic compatibility of a match.

31 See Charsley, Sheel, Abraham, Gallo, this volume; Sinha-Kerkhoff, Rayaprol and Gedalof in Thapan (2005a); also Ballard (1990) and Gell (1994) for various elaborations of this theme.

32 See Dossa (2005) for an especially compelling example of a professionally trained Iranian woman caring for a brain-damaged daughter.

33 Ballard (1990) also emphasises the reciprocal aspect of the arrangement: the social obligation of the emigrant to arrange the marriage of his sons/daughters to the children of his own siblings left behind in Pakistan. Such an arrangement reinforces familial

ties and enables kin to benefit from the spatial and economic mobility experienced by the emigrant, whose original emigration had likely been the outcome of collective investment by the kin group.

34 Ålund (1999: 150) analyses the dynamics of this process: 'What is usually not recognised is that cultures are formed within the frameworks of both pre- and post-migratory antagonisms and related to emergent struggles in the pre-political contexts of everyday life, as well as in wider public arenas.'

35 Hall (2002: 57) points out that in the 1970s the wife and children of a man deported from the UK were also deported, but not the husband of a deported woman. Moreover, prior to the 1981 British Nationality Act, a woman could not pass on her British citizenship to her children. A specific handicap is that faced by gay women and men seeking to immigrate under provisions for family reunion to countries, such as the USA, where lesbian and gay relationships are not acknowledged legally (see Das Gupta 2006), though in some other cases being gay may be a ground to obtain asylum (Germany, the Netherlands, etc.).

36 The Select Committee on Race Relations and Immigration, reporting to the UK House of Commons in 1978, fuelled public suspicion of arranged marriage between UK residents and partners from the home country, noting that, 'Male fiancés are prospective heads of families: their settlement or marriage results in both primary and secondary immigration.' The Report expressed the hope that, 'in the long term, as families become more fully assimilated in the United Kingdom and adopt Western mores, *attitudes may change and arranged marriages decrease*' (quoted in Gell 1994: 365, emphasis added).

37 See Cohn (2001); Del Rosario (1994: 278); Gedalof (2005); Gell (1994); Giddens (1992); Hall (2002: 63)). In her study of Mail-Order Brides, Nicole Constable (2003: 64–67, 82–86) also discerns such assumptions in Western feminist critiques of Asian family life, especially of the institution of arranged marriage and the phenomenon of Mail-Order Brides.

38 Another curious example, reminiscent of British colonial interpretations of Indian customary law, is the requirement by British and Canadian immigration authorities of evidence of 'social' and 'community' recognition of the marriage (as in a wedding reception, photographed and videotaped), in addition to the material evidence of its legal regularisation (see Gell 1994: 367–68; also Hall 2002; Sheel, this volume).

39 Bano (1999) points to the non-recognition of the individual's 'right to dissent' where the argument for the rights of a 'community' to its own practice in the private sphere presupposes the internal homogeneity of the immigrant community represented by 'community leaders' recognised by the state. See among a large number of studies of family violence in the South Asian diaspora, Abraham (1998); Bannerji (2000: Ch. 5); Bhattacharjee (1992); Das Gupta (2006: esp. 109–58); Kang (2003); Southall Black Sisters (1992); Wilson (1978).

40 See 'Cross-border Marriage Disputes: Child Suffers Most, say Jurists', *The Tribune* (Chandigarh), 7 May 2006.

41 As in India, where bride price and dowry were both practised (see Vatuk 1975), the predominance of bride price in China does not exclude dowry, a portion of which may be what Goody (1973) has termed 'indirect dowry', that is, items funded out of the bride price payments which then become part of the 'conjugal fund'. On dowry and bride price transactions in relation to social structure and status claims, see,

for China, Han and Eades (1995: 842–43); Siu (1993); Whyte (1993); and for India, Parry (1979); Van der Veen (1972).
42 See, e.g., the *Indian Journal of Gender Studies* Special Issue on *Feminism and the Politics of Resistance* (Volume 7, Number 2, 2000), edited by Rajeswari Sunder Rajan; also Kabeer (2000: esp. Chs. 2 and 10).

References

Abraham, Margaret. 1998. 'Speaking the Unspeakable: Marital Violence against South Asian Immigrant Women in the United States', *Indian Journal of Gender Studies*, 5 (2): 215–41.

Agarwal, Bina. 1994. *A Field of One's Own: Gender and Land Rights in South Asia.* Cambridge: Cambridge University Press.

———. 1997. '"Bargaining" and Gender Relations: Within and Beyond the Household', *Feminist Economics*, 3(1): 1–50.

Agrawal, Anuja. 2006. 'Women, Work and Migration in Asia', in Anuja Agrawal (ed.), *Migrant Women and Work*, pp. 21–45. New Delhi: Sage Publications.

Alavi, Seema. 1999. 'Of Badshahs, White Sahibs and Black Natives', *The Hindu* (Time Out: Special issue with the Sunday Magazine), 2 May 1999. Available online at http://www.hinduonnet.com/folio/fo9905/99050240.htm (accessed on 12 December 2006).

Ålund, Aleksandra. 1999. 'Feminism, Multiculturalism, Essentialism', in Nira Yuval-Davis and Pnina Werbner (eds), *Women, Citizenship and Difference*, pp.147–61. London: Zed Books.

Arya, Sadhna and Anupama Roy (eds). 2006. *Poverty, Gender and Migration.* New Delhi: Sage Publications.

Asis, Maruja M.B. 2003. 'Asian Women Migrants: Going the Distance, But Not Far Enough', *Migration Information Source.* Washington: Migration Policy Institute. Available online at http://www.migrationinformation.org/Feature/display.cfm?ID=103 (accessed on 6 January 2007).

Ballard, Roger. 1990. 'Migration and Kinship: The Differential Effect of Marriage Rules on the Processes of Punjabi Migration to Britain', in Colin Clarke, Ceri Peach and Steven Vertovec (eds), *South Asians Overseas: Migration and Ethnicity*, pp. 219–49. Cambridge: Cambridge University Press.

Ballhatchet, Kenneth. 1980. *Race, Sex and Class under the Raj: Imperial Attitudes and Policies and their Critics, 1793–1905.* London: Weidenfeld and Nicolson.

Bannerji, Himani. 2000. *The Dark Side of the Nation: Essays on Multiculturalism, Nationalism and Gender.* Toronto: Canadian Scholars Press Inc.

Bano, Samia. 1999. 'Muslim and South Asian Women: Customary Law and Citizenship in Britain', in Nira Yuval-Davis and Pnina Werbner (eds), *Women, Citizenship and Difference*, pp. 162–77. London: Zed Books.

Behera, Navnita Chadha. 2006. 'Introduction', in Navnita Chadha Behera (ed.), *Gender, Conflict and Migration*, pp. 21–71. New Delhi: Sage Publications.

Bhattacharjee, Ananya. 1992. 'The Habit of Ex-nomination: Nation, Women and the Indian Immigrant Bourgeoisie', *Public Culture*, 5 (1): 19–43.

Bourdieu, Pierre. 1977. *Outline of a Theory of Practice*. Cambridge: Cambridge University Press.

Boyd, Monica and Elizabeth Grieco. 2003. 'Women and Migration: Incorporation into International Migration Theory', *Migration Information Source*. Washington: Migration Policy Institute. Available online at http://www.migrationinformation.org/Feature/display.cfm?ID=106 (accessed on 6 January 2007).

Chowdhry, Prem. 2007. *Contentious Marriages, Eloping Couples: Gender, Caste and Patriarchy in Northern India*. New Delhi: Oxford University Press.

Cohn, Steve. 2001. *Immigration Controls, the Family and the Welfare State*. London: Jessica Kingsley Publishers.

Constable, Nicole. 2003. *Romance on a Global Stage: Pen Pals, Virtual Ethnography and 'Mail Order' Marriages*. Berkeley: University of California Press.

Das, Veena. 1976. 'Masks and Faces: An Essay on Punjabi Kinship', *Contributions to Indian Sociology*, 10 (1): 1–30.

Das Gupta, Monisha. 2006. *Unruly Immigrants: Rights, Activism and Transnational Asian Politics in the United States*. Durham: Duke University.

Del Rosario, Virginia O. 1994. *Lifting the Smoke Screen: Dynamics of Mail Order Bride Migration from the Philippines*. The Hague: Institute of Social Studies.

Dossa, Parin. 2005. 'Breaking the Silence: Identity Politics and Social Suffering', in Meenakshi Thapan (ed.), *Transnational Migration and the Politics of Identity*, pp. 181–209. New Delhi: Sage Publications.

Dube, Leela. 1997. *Women and Kinship: Comparative Perspectives on Gender in South and South East Asia*. Tokyo: United Nations Press/New Delhi: Vistaar.

Dumont, Louis. 1983. *Affinity as a Value: Marriage Alliance in South India, with Comparative Essays on Australia*. Chicago: University of Chicago Press.

Ehrenreich, Barbara and Arlie R. Hochschild (eds). 2003. *Global Woman: Nannies, Maids and Sex Workers in the New Economy*. London: Granta.

Fan, C. Cindy and Ling Li. 2002. 'Marriage and Migration in Transitional China: A Field Study of Gaozhu, Western Guangdong', *Environment and Planning A*, 34 (4): 619–38.

Fan, C. Cindy and Youqin Huang. 1998. 'Waves of Rural Brides: Female Marriage Migration in China', *Annals of the Association of American Geographers*, 88 (2): 227-51.

Gamburd, Michele Ruth. 2002. *Transnationalism and Sri Lanka's Migrant Housemaids*. New Delhi: Vistaar.

Gardner, Katy and Filippo Osella. 2003. 'Migration, Modernity and Social Transformation in South Asia: An Overview', *Contributions to Indian Sociology* (Special Issue on *Migration, Modernity and Social Transformation in South Asia*), 37 (1 & 2): v–xxviii.

Gedalof, Irene. 2005. 'Women, Home and Belonging in UK Immigration Policy', in Meenakshi Thapan (ed.), *Transnational Migration and the Politics of Identity*, pp. 210–27. New Delhi: Sage Publications.

Gell, Simeran Man Singh. 1994. 'Legality and Ethnicity: Marriage among the South Asians of Bedford', *Critique of Anthropology*, 14 (4): 355–92.

Ghose, Indira (ed.). 1998. *Memsahibs Abroad: Writing by Women Travellers in Nineteenth Century India*. New Delhi: Oxford University Press.

Giddens, Anthony. 1992. *The Transformation of Intimacy: Sexuality, Love and Eroticism in Modern Societies*. Cambridge: Polity Press.

Goody, J.R. 1973. 'Bridewealth and Dowry in Africa and Eurasia', in J.R. Goody and S.J. Tambiah (eds), *Bridewealth and Dowry* (Cambridge Papers in Social Anthropology No. 7), pp. 1–58. Cambridge: Cambridge University Press.

Gould, Harold A. 1960. 'The Micro-demography of Marriages in a North Indian Area', *Southwestern Journal of Anthropology*, 16 (4): 476–91.

Gulati, Leela. 1993. *In the Absence of their Men*. New Delhi: Sage Publications.

————. 2006. 'Asian Women Workers in International Migration: An Overview', in Anuja Agrawal (ed.), *Migrant Women and Work*, pp. 46–72. New Delhi: Sage Publications.

Hall, Rachel A. 2002. 'When is a Wife Not a Wife? Some Observations on the Immigration Experiences of South Asian Women in West Yorkshire', *Contemporary Politics*, 9 (1): 55–68.

Han, Min and J.S. Eades. 1995. 'Brides, Bachelors and Brokers: The Marriage Market in Rural Anhui in an Era of Economic Reform', *Modern Asian Studies*, 29 (4): 841–69.

Hochschild, Arlie R. 1995. 'The Culture of Politics: Traditional, Postmodern, Cold-modern, and Warm-modern Ideals of Care', *Social Politics*, 2 (3): 331–45.

Ito, Ruri. 2003. 'Inter-Asian Migration and Gender Regimes: Questioning "Feminization of Migration".' Keynote address, Conference on 'Women and Migration in Asia', New Delhi, 10–13 December. Mss, p. 19.

Jastram, Kate. 2003. 'Family Unity: The New Geography of Family Life', *Migration Information Source* (Washington: Migration Policy Institute). Available online at http://www.migrationinformation.org/Feature/display.cfm?ID=118 (accessed on 6 January 2007).

Jeffreys, Sheila. 2006. 'The Traffic in Women: Human Rights Violation or Migration for Work', in Anuja Agrawal (ed.), *Migrant Women and Work*, pp. 195–217. New Delhi: Sage Publications.

Joshi, Seema. 2003. 'Marriage, Migration and the Labour Market: A Case Study of a Slum Area in Delhi.' Paper presented at the Conference on 'Women and Migration in Asia', New Delhi, 10–13 December.

Kabeer, Naila. 2000. *The Power to Choose: Bangladeshi Women and Labour Market Decisions in London and Dhaka*. London: Verso.

Kandiyoti, D. 1988. 'Bargaining with Patriarchy', *Gender and Society*, 2 (3): 274–90.

Kang, Neelu. 2003. 'Women's Action Groups: Protective Action in the Indian Diaspora.' Paper presented at the International Conference on 'Women and Migration in Asia', New Delhi, 10–13 December.

Karlekar, Malavika. 1995. 'Gender Dimensions in Labour Migration: An Overview', in Loes Schenk-Sandbergen (ed.), *Women and Seasonal Labour Migration*, pp. 23–78. New Delhi: Sage Publications.

Kaur, Ravinder. 2004. 'Across-Region Marriages: Poverty, Female Migration and the Sex Ratio', *Economic and Political Weekly*, 39 (25): 2595–603.

Kolenda, Pauline. 1987. *Regional Differences in Family Structure in India*. Jaipur: Rawat Publications.

Lavely, William and Xinhua Ren. 1992. 'Patrilocality and Early Marital Co-Residence in Rural China', *China Quarterly*, 130: 378–91.

Libbee, Michael J. 1980. 'Territorial Endogamy and the Spatial Structure of Marriage in Rural India', in David E. Sopher (ed.), *An Exploration of India: Geographical Perspectives on Society and Culture*, pp. 65–104. Ithaca, NY: Cornell University Press.

Lim, Lean and Nana Oishi. 1996. 'International Labour Migration of Asian Women: Distinctive Characteristics and Policy Concerns', *Asia and Pacific Migration Journal*, 5 (1): 85–116.

Lingam, Lakshmi. 1998. 'Locating Women in Migration Studies', *Indian Journal of Social Work*, 59 (3): 715–27.

MacMillan, Margaret. 1996. *Women of the Raj*. New York: Thames and Hudson.

McKay, Deidre. 2003. 'Filipinas in Canada: De-skilling as a Push toward Marriage', in Nicola Piper and Mina Roces (eds), *Wife or Worker? Asian Women and Migration*, pp. 23–50. Lanham: Rowman & Littlefield.

Manchanda, Rita. 2006. 'Contesting "Infantilisation" of Forced Migrant Women', in Navnita Chadha Behera (ed.), *Gender, Conflict and Migration*, pp. 205–26. New Delhi: Sage Publications.

Miller, Barbara D. 1980. 'Female Neglect and the Costs of Marriage in Rural India', *Contributions to Indian Sociology*, 14 (1): 95–129.

————. 1989. 'Changing Patterns of Juvenile Sex Ratios in Rural India, 1961 to 1971', *Economic and Political Weekly*, 24 (22): 1229–36.

Morokvasic, Mirjana. 1984. 'Birds of Passage are also Women', *International Migration Review*, 18 (4): 886–907.

Nakamutsu, Tomoko. 2003. 'International Marriage through Introduction Agencies: Social and Legal Realities of "Asian" Wives of Japanese Men', in Nicola Piper and Mina Roces (eds), *Wife or Worker? Asian Women and Migration*, pp. 181–201. Lanham: Rowman & Littlefield.

Naveed-I-Rahat. 1990. *Male Outmigration and Matri-weighted Households*. Delhi: Hindustan.

Oberai, A.S. and H.K.M. Singh. 1983. *Causes and Consequences of Internal Migration: A Study in the Indian Punjab*. New Delhi: Oxford University Press.

Ochiai, Emiko. 2006. 'Restructuring Family Networks in the Era of Modernization and Globalization: Population Bonus and Experience of Japan and Other Asian Societies.' Paper presented at the Conference on 'Lines of Convergence: China, India and Japan and the Future of Asia', Institute of Chinese Studies, Delhi, 13–14 December .

Oshikawa, Fumiko. 2006. 'Introduction of Foreign Care Workers in Taiwan: Changing Taiwanese Family in an Aging Society.' Paper presented at the Conference on 'Lines of Convergence: China, India and Japan and the Future of Asia', Institute of Chinese Studies, Delhi, 13–14 December.

Palriwala, Rajni. 1991. 'Transitory Residence and Invisible Work: A Case Study of a Rajasthan Village', *Economic and Political Weekly*, 26 (48): 2763–77.

————. 1996. 'Negotiating Patriliny: Intra-household Consumption and Authority in Rajasthan (India)', in Rajni Palriwala and Carla Risseeuw (eds), *Shifting Circles of Support: Contextualising Kinship and Gender Relations in South Asia and Sub-Saharan Africa*, pp. 190–220. New Delhi: Sage Publications.

————. 2003. 'Dowry in Contemporary India: An Overview', in *Expanding Dimensions of Dowry*, pp. 11–27. New Delhi: AIDWA and ISWSD.

Parrenas, Rhacel Salazar. 2006. 'Caring for the Filipino Family: How Gender Differentiates the Economic Causes of Labour Migration', in Anuja Agrawal (ed.), *Migrant Women and Work*, pp. 95–115. New Delhi: Sage Publications.

Parry, J.P. 1979. *Caste and Kinship in Kangra*. London: Routledge & Kegan Paul.

Piper, Nicola. 1999. 'Labor Migration, Trafficking and International Marriage: Female Cross-border Movements into Japan', *Asian Journal of Women's Studies*, 5 (2): 69–99.

Piper, Nicola and Mina Roces. 2003. 'Introduction: Marriage and Migration in an Age of Globalization', in Nicola Piper and Mina Roces (eds), *Wife or Worker? Asian Women and Migration*, pp. 1–21. Lanham: Rowman & Littlefield.

Rayaprol, Aparna. 2005. 'Being American, Learning to be Indian: Gender and Generation in the Context of Transnational Migration', in Meenakshi Thapan (ed.), *Transnational Migration and the Politics of Identity*, pp. 130–49. New Delhi: Sage Publications.

Rozario, Santi. 2005. 'Singular Predicaments: Unmarried Female Migrants and the Changing Bangladeshi Family', in Meenakshi Thapan (ed.), *Transnational Migration and the Politics of Identity*, pp. 150–80. New Delhi: Sage Publications.

Sassen, Saskia. 1999. *Guests and Aliens*. New York: The New Press.

Selden, Mark. 1993. 'Family Strategies and Structures in Rural North China', in Deborah Davis and Stevan Harrell (eds), *Chinese Families in the Post-Mao Era*, pp. 139–64. Berkeley: University of California Press.

Sen, Samita. 2004. '"Without his Consent"?: Marriage and Women's Migration in Colonial India', *International Labour and Working Class History*, 65 (Spring): 77–104.

Singh, Supriya. 2006. 'Sending Money Home: Money and Family in the Indian Diaspora,' *Contributions to Indian Sociology*, 40 (3): 375–98.

Sinha-Kerkhoff, Kathinka. 2005. 'From India to an Indian Diaspora to a Mauritian Diaspora: Back-linking as a Means for Women to Feel Good Locally', in Meenakshi Thapan (ed.), *Transnational Migration and the Politics of Identity*, pp. 63–98. New Delhi: Sage Publications.

Siu, Helen F. 1993. 'Reconstituting Dowry and Brideprice in South China', in Deborah Davis and Stevan Harrell (eds), *Chinese Families in the Post-Mao Era*, pp. 165–88. Berkeley: University of California Press.

Smith, Christopher J. 2000. *China in the Post-Utopian Age*. Boulder, Co.: Westview Press.

Southall Black Sisters. 1992. *Domestic Violence and Asian Women: A Collection of Reports and Briefings*. London: Southall Black Sisters.

Srinivas, M.N. 1984. *Some Reflections on Dowry*. New Delhi: Oxford University Press.

Stalker, P. 2000. *Workers without Frontiers: The Impact of Globalisation on International Migration*. Geneva: International Labour Organisation.

Stoler, Ann. 2002. *Carnal Knowledge and Imperial Power: Race and the Intimate in Colonial Rule*. Berkeley: University of California Press.

Tambiah, S.J. 1973. 'Dowry and Bridewealth and the Property Rights of Women in South Asia', in J.R. Goody and S.J. Tambiah (eds), *Bridewealth and Dowry*, pp. 59–169. Cambridge: Cambridge University Press.

Thangarajah, C.Y. 2003. 'Veiled Constructions: Conflict, Migration and Modernity in Eastern Sri Lanka', *Contributions to Indian Sociology*, 37 (1 & 2): 141–62.

Thapan, Meenakshi (ed). 2005a. *Transnational Migration and the Politics of Identity*. New Delhi: Sage Publications.

———. 2005b. 'Introduction: "Making Incomplete": Identity, Woman and the State', in Meenakshi Thapan (ed.), *Transnational Migration and the Politics of Identity*, pp. 23–62. New Delhi: Sage Publications.

Trautmann, Thomas R. 1981. *Dravidian Kinship*. Cambridge: Cambridge University Press.

Uberoi, Patricia. 1995. 'Problems with Patriarchy: Conceptual Issues in Anthropology and Feminism', *Sociological Bulletin*, 44 (2): 195–221.

———. 1998. 'The Diaspora Comes Home: Disciplining Desire in DDLJ', *Contributions to Indian Sociology*, 32 (2): 305–36.

Van der Veen, Klass. 1972. *I Give Thee my Daughter: A Study of Marriage and Hierarchy among the Anavil Brahmins of South Gujarat*. Assen: Van Gorcum.

Vatuk, Sylvia. 1975. 'Gifts and Affines in North India,' *Contributions to Indian Sociology*, 9 (2): 155–96.

Whyte, Martin King. 1993. 'Wedding Behavior and Family Strategies in Chengdu', in Deborah Davis and Stevan Harrell (eds), *Chinese Families in the Post-Mao Era*, pp. 189–216. Berkeley: University of California Press.

Wilson, Amrit. 1978. *Finding a Voice: Asian Women in Britain*. London: Virago.

Wong, Diana. 2006. 'The Rumor of Trafficking', *IIAS Newsletter* (Leiden), 42: 11.

Youssef, N.H., M. Buvinic and A. Kudat. 1979. *Women in Migration: A Third World Focus*. Washington DC: International Centre for Research on Women.

Zhang, Weiguo. 2000. 'Dynamics of Marriage Change in Chinese Rural Society in Transition: A Study of a Northern Chinese Village', *Population Studies*, 54 (1): 57–69.

Zlotnik, Hania. 2003. 'The Global Dimensions of Female Migration', *Migration Information Source*. Washington: Migration Policy Institute. Available online at http://www.migrationinformation.org/Feature/display.cfm?ID=109 (accessed on 6 January 2007).

Section II
MARRIAGE AS MIGRATION

Section II
MARRIAGE AS MIGRATION

2

Marriage Migration in China: The Enlargement of Marriage Markets in the Era of Market Reforms

Delia Davin

The study of internal migration in China tends to focus heavily on economics. Marriage migration is often ignored or mentioned only as a factor that inflates migration statistics. The implication is that somehow marriage migration is not 'real' migration. Yet, under the definition of migration most usually employed in China, that is, *a move across administrative boundaries*, marriage migration is a major form of migration and the primary cause of female migration. In the collective era when peasants were virtually tied to the land, marriage migrations probably outnumbered all other migrations. As the Chinese marriage system is patrilocal, rural men tended to be less mobile than women until the great increase in labour migration in the 1980s. Today, however, despite the changes that have produced a great increase in migration for other reasons, marriage remains a significant cause for migration. According to 1990 Census figures, 14 per cent of both intra- and inter-provincial migration recorded by the Census could be attributed to marriage.[1] Between 1985 and 1990, 2.9 million women migrated across provincial boundaries because of marriage.

As one might expect in a country with a strong tradition of patrilocal marriage, marriage migration is highly gender specific. Census figures for 1990 show that 28 per cent of female migrations within the same province, and 30 per cent of female migrations between provinces were attributed to marriage (Table 2.1). By contrast, it accounted for only 2 per cent of male migration. Marriage was much more important as

Table 2.1 Marriage as a Cause of Migration (1990) (%)

Destination	Both Sexes	Men	Women
Intra-provincial			
All	14.0	2.0	28.0
City	3.0	1.0	6.0
Town	8.0	1.0	15.0
Rural areas	19.0	3.0	35.0
Inter-provincial			
All	14.0	2.0	30.0
City	2.0	1.0	6.0
Town	8.0	1.0	18.0
Rural areas	20.0	3.0	40.0

Source: Calculated from the 1990 Census, vol. IV, Table 11.16 (Population Census Office under the State Council 1993).

marriage migration is gendered

a cause of female migration to rural area destinations than to urban ones. It accounted for 35 per cent of rural-to-rural female migrations within the same province and 40 per cent of those between provinces. Where the destination was urban, only 21 per cent of female migration within the same province and 24 per cent to other provinces was due to marriage. Marriage was a minor cause of male migration, both intra- and inter-provincial, whether the destination was rural or urban (see Table 2.1).

Out-marriage: Choices and Calculations

Marriage in China almost always involved the woman moving to the man's home. Exceptions to patrilocality were rare. They usually came about when a couple without sons sought a 'marrying-in son-in-law' for one of their daughters in order to continue the family line. Whereas a patrilocal marriage was isogamous (with bride and groom enjoying the same status) or perhaps hypergamous (the bridegroom somewhat higher in status), in the case of uxorilocal marriage the husband usually had lower social status. He agreed to what was perceived as a humiliating arrangement of joining his wife's family in order to make a match that was in other respects advantageous to him.

Village exogamy, or marrying outside the village, used to be a general rule in much of China, although the strictness with which it was observed varied considerably. The introduction of consensual marriage after 1949 may have increased the incidence of marriages within villages, but exogamy or out-marriage remained the norm. For most women, therefore, marriage meant leaving their natal village. Exogamy has advantages to peasant families. It enlarges the choice of marriage partners and allows families to extend their network of contacts beyond their own villages. Affines in other villages may supply useful market information, and can be called upon for help with house building and harvesting, or for loans during an emergency. Marriage within the village confers no such advantages. It does not enlarge the network from which help can be sought as fellow villagers already belong to a 'circle of obligation' (Potter and Potter 1990: 205). Exogamy also facilitates risk-sharing. Disasters are likely to strike whole villages simultaneously, but others, not far away, may be spared. Aware of this, peasants try to reduce their risk by extending their circle of obligation beyond the village (Ma et al. 1997).

Out-marriage may give a woman a better life. Lavely's (1991) work on the Shifang county in Sichuan province at the beginning of the 1980s showed that the inflow of brides to this exceptionally prosperous county far exceeded the outflow. Women from other counties were happy to marry into Shifang, but Shifang women were reluctant to marry out. The in-marrying women tended to be from low-income counties, whereas women who married out went to other high-income counties. In-marrying women moving up the spatial hierarchy also tended, according to Lavely, to be better educated than average, whereas those who 'married down' had fewer years of schooling. The workings of the market could be seen in other ways. Men in Shifang who married women from poorer areas had incomes lower than the average for Shifang. This probably made it harder for them to find a local bride. Moreover, the bride price paid for women from poorer areas was only about 60 per cent of what had to be paid for a Shifang woman. In Zengbu brigade in Dongguan county, Guangdong, some young women expressed a preference for marrying out in order to better themselves economically (Potter and Potter 1990: 206). A father explained that he and his wife had married their daughter into a neighbouring village because 'in Wentang, production and living standards are high—they have more land than here'.

Marriage Migration, Labour Migration and the Spatial Hierarchy

All types of migration in China have increased enormously since the economic reforms of the early 1980s. Before the reforms, the Chinese government deliberately sought to restrict population movement through a system of registration. Each person was entered in a *hukou*, a household registration book that indicated the household to which they belonged. No one was supposed to live permanently away from the place where they registered. *Hukou* transfers were difficult to obtain and were allowed only for a limited range of reasons, including job allocation by the state, higher education and marriage. It was particularly difficult to transfer a *hukou* from rural to urban areas, so the system served as a means to keep peasants in the countryside, deprived of the superior entitlement to education, health, social security and better job prospects of the urban population. The system was underpinned by food rationing. Only those with an urban *hukou* could buy grain-based food in the cities and it was, therefore, extremely difficult for peasant migrants to survive for long in urban areas.

From the 1980s onwards, the demand for labour in urban areas that came about with rapid economic growth combined with the introduction of a free market in food to erode these strict controls. The *hukou* system no longer prevents rural people from seeking better livelihoods in cities because they can now obtain temporary resident rights by registering at a police station and paying a fee. However, the *hukou* retains considerable importance in contemporary China. *Hukou* status marks out peasant migrants from their urban fellow citizens and facilitates the maintenance of a dual labour market. It also discourages labour migrants from permanent settlement in the destination areas as it legitimates various forms of discrimination against them. This is the context in which both labour and marriage migration developed in the last two decades of the 20th century.

Although marriage migration is not new, it should not be seen as some sort of unchanging phenomenon left over from the past, to be considered separately from the greatly increased labour migration flows of the reform era. Like labour migration, marriage migration has shown itself to be highly responsive to the changing economic, social and political climate of post-reform China. It has also grown and adapted to new

circumstances. Whereas in the past marriage migration might have meant a move to a neighbouring county, in recent years a new long-distance inter-provincial marriage market has emerged and women may move across several provinces to marry. This long-distance marriage migration is the focus of the present study. As Table 2.2 shows, the richer coastal provinces tend to draw brides in, while the poorer inland ones suffer a net loss of women through marriage migration.

Table 2.2 Marriage as a Reported Cause of Inter-provincial Migration of Both Sexes (%)

Destination or Origin	Out-migration from	In-migration to
National	14.0	14.0
Beijing	2.0	6.0
Tianjin	7.0	10.0
Hebei	10.0	34.0
Shanxi	7.0	15.0
Neimenggu	17.0	16.0
Henan	10.0	15.0
Hubei	16.0	9.0
Hunan	12.0	17.0
Guangdong	6.0	11.0
Guangxi	27.0	13.0
Liaoning	10.0	10.0
Jilin	12.0	9.0
Heilongjiang	10.0	11.0
Shanghai	2.0	3.0
Jiangsu	7.0	25.0
Zhejiang	3.0	24.0
Anhui	10.0	30.0
Fujian	3.0	23.0
Jiangxi	11.0	10.0
Shandong	9.0	20.0
Hainan	4.0	9.0
Sichuan	24.0	15.0
Guizhou	50.0	14.0
Yunnan	51.0	11.0
Tibet	2.0	No data
Shaanxi	17.0	6.0
Gansu	14.0	10.0
Qinghai	7.0	7.0
Ningxia	11.0	13.0
Xinjiang	4.0	9.0

Source: Calculated from SSB (1991), sampling Tabulation of the 1990 Census.

The development of long-distance marriages seems closely linked to the more discussed development of labour migration. The 1990 Census showed that four provinces for which marriage is an important cause of out-migration are all important origin areas for labour migration. Of the total female out-migration, marriage was the cause in 72.7 per cent cases for Yunnan. For Guizhou it was 71.2 per cent, for Sichuan 48.6 per cent, and for Guangxi 42 per cent. The provinces receiving the highest proportion of marriage migrants among total female migrants were Hebei (63 per cent), Anhui (59.1 per cent), Jiangsu (54.5 per cent), Fujian (50.6 per cent) and Zhejiang 47.2 per cent (Fan and Huang 1998: 241). The flow was clearly from the less developed west to the more developed east. Of all female inter-provincial marriage migration, 84.8 per cent was from the western and central regions, and the eastern region was the destination for 60 per cent. However, this does not mean that all the developed areas have large numbers of marriage migrants. Marriage migration is predominantly a rural phenomenon. Factors other than development play a part in the marriage market. The *hukou* system still presents a formidable obstacle to marriage migration to cities. Moreover, the strong position that city residents enjoy in the marriage market makes them unlikely to be interested in a peasant bride. The great municipalities have among the lowest proportions of marriage migrants among total female in-migrants in China: Beijing 11.3 per cent, Tianjin 10.5 per cent and Shanghai 5.1 per cent (ibid.). Nonetheless, the geographical pattern of marriage migration is instructive. We can see that women are using marriage to escape poverty and to move up the spatial hierarchy to more prosperous areas. Marriage into a wealthier area is thus a form of upward mobility for women and this explains the strong correspondence between marriage migration and the spatial hierarchy of development in China.

Agency in Marriage Migration

As we have seen, the national trend is for the poor inland provinces to suffer a net loss of women to the rich coastal ones. Increased marketisation and monetisation of the economy have promoted the growth of this type of marriage in post-reform China. Transport and communications

have improved knowledge of conditions and of the market elsewhere, including the demand for brides, and have made it easier to move women around physically. There is little research to show the relative importance of the various agents in the organisation of marriage migration, although it is clear that a variety of links may be used.

Traders or even specialised marriage brokers bring groups of women, sometimes 10 to 15 at a time, to the destination areas to seek husbands (Han and Eades 1995). Increased private trade and labour migration have also contributed here. Traders who have brought goods from one area to another may branch out into marriage brokering when they see an opportunity. Advertisements by men and women seeking spouses are now commonplace in the Chinese press and these no doubt play some part. Labour migrants themselves act as middlemen in supplying the necessary introductions for marriage migration. Like other forms of migration, marriage migration generates migration chains. Marriage migration from one area to another can snowball as successive cohorts of brides arrange matches for their husbands' kin or other villagers with women from their old homes (Fan and Huang 1998; Huang 2000; Wang and Hu 1996).

The Human Impact of Marriage Migration

Sending Areas

The development of this form of marriage migration in which the permanent leavers from the poorer areas are almost all female create problems for poor communities by aggravating the shortage of brides. The sex ratio is distorted in favour of men everywhere in China because son preference, the higher status of men and their superior entitlements to food have given them better survival chances. This distortion was exacerbated in the 1980s and 1990s by the impact of the one-child family policy. Inevitably, therefore, some Chinese men fail to marry despite the strong cultural imperatives that they should do so.

Historically, poverty and a failure to marry were closely associated. It was the poorest men who lost out in the marriage market. They might be physically or mentally disabled, belong to an outcast family or suffer from a severe character defect, but they also tended to be poor. Other men

with such handicaps might have to offer a higher bride price or accept a less eligible bride, but men without resources could not compensate for their shortcomings.

Prior to the reforms, the shortage of marriageable women already tended to be worse in the poorest areas. The contemporary development of large-scale marriage migration over a huge geographical area will concentrate such shortages further, making them particularly serious in areas from which women are regularly 'exported'. The result could be that in the most prosperous areas even the least well-off men will be able to afford a wife who migrates from a poor area, but in the poorer areas the number of men unable to marry will increase.

Labour migration, especially when it is circulatory in form, with successive cohorts of migrants returning to their villages to be replaced by new migrants, has profound impacts on the sending areas. Not only do migrants enrich their home areas by sending back remittances and bringing savings home with them, they are also likely to return with new entrepreneurial ideas, and different aspirations for themselves and their children (Davin 1999: 78–97). Marriage migration is quite different, especially where it has taken place over very long distances. Contact between the bride and her natal family is likely to be very limited, visits home would be extremely expensive, and she is likely to invest most of her effort and resources in building up her position in her new home rather than in maintaining links with her old one.

Destination Areas

In the Chinese marriage market, good-looking young women from well-to-do families tend to be in a strong position while those disadvantaged by poverty, disability, age or looks must expect a smaller bride price or a bridegroom with some disadvantage. Men seeking a bride will similarly know that they hold a strong or a weak hand in the marriage market according to such factors as earning ability, wealth, health, connections and education. Long-distance marriage has developed within this system of balancing of disadvantages and advantages.

Men who seek wives from other provinces usually do so because they have been unable to find a local bride (Tan and Short 2004). Their families are likely to be among the poorest in their own community, and they may be unable to afford the gifts and bride price expected in

their area (Huang 2000). The custom of paying bride price was severely discouraged from the 1950s, but it never disappeared; in fact, with increasing prosperity, it has grown since the economic reforms. The amount that the man's family now has to find to 'bring in a bride' has soared, making it more difficult for the least fortunate to marry. Men who marry migrant brides are not only poorer than the rest, they also tend to be older, unsurprisingly, since a high age at first marriage is a symptom of poverty for a rural man. Such men may also suffer from poor health or disability, or be considered poor workers. Because their disadvantages will be widely known, it will be difficult for them to find a local bride and this will be another reason for seeking a bride from far away. Another motive is control. Men and their families always fear that a bride will run away. A woman who has travelled a very long way will find it difficult to do this however disappointed she is in her bridegroom and his circumstances. Women who have come from distant areas are seen as easier to control because they are so dependent.

In a conventional match each side tries to maximise its advantage. Both families will try to make the most of their good points and to conceal information that does not show them to good advantage. However, the scope for serious deception is limited where there is geographical proximity. Each family will make enquiries through a network of friends and acquaintances. It is also customary to employ the good offices of a go-between, often known to both families, whose reputation would be damaged by any extreme deception.

In long-distance marriage, things are different. The marrying-in bride may be ignorant of her prospective bridegroom's disadvantages. The broker or the man and his family may exploit the fact that once she has made the long journey it is difficult for her to change her mind. On the other hand, women from poorer areas may knowingly settle for a man with some handicap on the marriage market in the belief that the move will be enough to compensate. Regional economic disparities are so great that a poor man in a prosperous area will probably seem a good match to a woman from a poor area of the country.

In some cases, bridegrooms and their families may suffer disappointments in their attempts to obtain long-distance brides. Their anxiety to arrange a match may make them gullible and because the broker is not local and the bride's family is unknown to them, they will have none of the traditional sanctions against confidence tricksters. Han and Eades (1995: 861–65) were told of many cases where men had paid money to brokers for women who never appeared or who ran away after only a short time. Some brokers apparently move from village to village

extracting bride prices from ageing bachelors. The 'bride' stays in the house only for a few days before running off to rejoin the broker. Han and Eades report that, 'The villagers conclude that in the post-commune market, marriages with outside wives are cheap but risky: they cost only a third or a quarter as much as marriages with local women, but there is no assurance that the woman will stay.' The Women's Federation in Xiao county, Anhui province, found that wives from outside provinces complained they were not allowed to stay in touch with their families for fear that they might arrange to run away (1995: 864–65).

However, in the majority of cases where the arrangements turn out badly for one party, the victim is the woman. There are many anecdotes about women from faraway provinces being tricked into marriage with men who are sick, old or disabled. Migrant brides are more isolated than other married women. They may arrive in their husbands' villages without friends or even acquaintances, and with little chance of appeal to their own far distant families if they are ill-treated, abused or merely given subservient status. They are unable to use the customary stay at their mother's home (niangjia) if they wish to negotiate problems with their in-laws.[2] They suffer from low status because they have no network of relations on whom to call for support and cannot provide their husbands with useful local connections through their relatives. Not understanding the local dialect and not knowing how to cultivate the local crops or cook local dishes may also be a disadvantage.

The greatest sufferers from these problems are the first marriage migrants to arrive in an area. They are also the ones most likely to have been brought in by brokers. Women who arrive later as part of a migration chain will be better informed about what they are coming to and can enjoy the help and companionship of the sisters or other relatives or friends who arrange for them to come.

There is official concern about the possible abuses of long-distance marriage arrangements. Local branches of the Women's Federation have made attempts to help migrant wives return to their natal homes if they choose to, and to overcome the difficulties of settling in otherwise (1995: 860). There are reports of brokers convicted of tricking, abducting or selling women. They are often arrested and may be dealt with quite harshly, but the ambiguities in these cases make them difficult to pass judgement on. Rural people are accustomed to the idea that a man must hand over money to get a wife and that in so doing he acquires rights over her. In rural areas, local officials themselves belong to a world where this is seen as natural. The payment of bride price is

officially discouraged, but in practice tolerated and nearly universal in the
countryside, whereas the sale of women is supposed to be severely punished.
The distinction between these practices is not necessarily easy to make.

Marriage Migration and Trafficking in Women

There are undeniable connections between marriage migration and
trafficking in women. There is a whole spectrum of situations in which
women are transferred from their homes to men who give money for
them. Many women are, as marriage migrants, willing participants in
this transfer. If they are lucky, they get the better lives they hoped for.
But young village women being taken hundreds or even thousands of
miles are vulnerable to unscrupulous brokers ready to marry them to
the man who offers the best price. There are cases where women are
abducted and then sold as brides so far away from their homes that they
have difficulty in contacting their relatives again. Naïve women hoping
for a good marriage may fall into the hands of traders who are in fact
procuring for the sex trade.

The Chinese press carries many reports of young women being tricked
or abducted and sold into prostitution by agents who had promised them
a husband or a job in some wealthy area hundreds of miles from their
homes.[3] Trafficking in women appears to be astonishingly widespread.
According to a Chinese source, 33,000 women were abducted and sold
between mid-1993 and 1995 (Evans 1997: 170–71). Another report
claimed that 70,000 abductions of women and children were discovered
between 1991 and 1994, leading to the arrest of 100,000 gang members.
The practice is, of course, widely condemned in the press and by the
authorities. Severe sentences have been passed on those found guilty.

Chinese discussion of the re-emergence of these forms of abuse of
women's rights tend to focus on poverty, ignorance and the marketisation
of the economy in the search for explanations. As Evans (1997) observes,
it should also be recognised that such abuse is grounded in hierarchical
gender structures and ideologies. It is perhaps only in a setting where
even normal marriage arrangements are in large part economic
transactions that it is possible for women to be sold by themselves or

by others, willingly or against their will, into marriage or sex work in such large numbers.

These phenomena are not, of course, peculiar to China. The globalisation of the world economy and the greater ease of communication and travel have led to greatly increased transfer of women across international frontiers in recent years. Some of these, like the marriage migrants of China, seek to improve their economic position by marrying into a community richer than their own. These include the 'mail-order brides' who come from the Philippines, Thailand and, more recently, the countries of the ex-Soviet Union and Eastern Europe to the rich countries of the industrialised West, as well as the Filipina, Korean, Vietnamese and Chinese women who go to marry farmers in rural Japan and Taiwan (see Lu, this volume). The men in these cases usually have some disadvantage of age, character or occupational status that makes it hard for them to find a partner in their own country. The women are prepared to accept these disadvantages in return for residence in a country better off than their own.

Although Chinese marriage migrants do not cross an international frontier, their position is in some ways comparable to these other women who do. Both groups hope to find happiness and prosperity through marriage to a man better off than any in their own community. Both take big risks by marrying someone of whom they know little or nothing and who has for some reason, been unable to find a local woman to marry. Both go to a situation where they will be heavily dependent and lack friends or family to support them and where the culture and way of life is strange. Both are vulnerable to being duped and to finding themselves coerced into prostitution.

The problems must be balanced against the fact that marriage migrants are adults who have to be allowed to make an informed choice. Indeed, some Women's Federation officials offer a strong defence of marriage migration, arguing that the women are free agents and that they have a right to try to improve their lives in this way. They claim marriage migration can offer women the same chances of economic improvement that labour migration offers men.[4] In material terms this may be realistic, but in terms of the status, autonomy and control they confer, the options are not comparable.

Conclusion

Marriage migration should be taken seriously as a form of migration. In Maoist China, it was numerically the most important form of population movement. Even now, it accounts for a large proportion of population movement in China and is particularly important in female migration (see Tables 2.1 and 2.2). Unlike labour migration, it normally results in permanent settlement in the destination area. Although it has its own specific dynamics, it has, like labour migration, been affected by the economic reforms. In particular, the incidence of long-distance marriage migration has increased, and so has the incidence of marriage migration.

The great majority of marriage migrations involve movement by women from one rural area to another. The rapid but uneven economic growth of the 1980s created prosperity not only in the towns and cities of the eastern seaboard provinces, but also in those parts of their rural areas that developed industries or produce lucrative cash crops. There are great differences between rural living standards in different regions of China and this is reflected in the inter-provincial marriage market. The differences will come to be reflected in local sex ratios. Migrant brides are permanent leavers. As their natal villages tend to be unattractive to other women, the growth of long-distance marriage migration could, therefore, have considerable impact on the sex ratios in the poorest areas, creating groups of men who will be unable to find wives.

For women in the poorest areas marriage migration may seem to offer the promise of a better life, but migration over very long distances can isolate them. Like 'mail-order brides' who come to the West from areas such as the Philippines or the ex-Soviet Union, these young Chinese women are vulnerable to loneliness, abuse or simple disappointment. Young women may adopt the strategy of recruiting other brides from home to deal with these problems. The migration chain is important in marriage migration, as it is in other types of migration. A migrant bride can counter her isolation by recruiting other women from her kinship circle and her natal village to join her as brides for members of her husband's family or her new neighbours.

However, social policies must be developed that recognise and can deal with the plight of the more unfortunate of these young women. It is also desirable that the Women's Federation and other agencies monitor the situation of migrant brides and be ready to offer them help, counselling and refuge when necessary.

Notes

1 The Census figures have shortcomings as a source of migration data. The general principle of the Census was de facto, with people registered where they were at the time of the enumeration, but a de jure element remained. Of those living away from their place of registration, only those who had been away for more than a year were registered where they were actually living. The Census should thus cover all permanent formal migration involving a change of *hukou*, and also the longer-term informal migration involving prolonged absences from home. It would have failed to capture the millions of temporary and seasonal migrants who move backwards and forwards between the sending and destination areas without spending a complete year away from their places of origin. As most marriage migration does ultimately result in a change of *hukou* for the spouse who moves, the Census should be a better source for marriage migration data than for labour migration data. The reader should bear in mind that when marriage is compared with other causes of migration in this chapter, the Census data used essentially refer to longer-term migration.
2 For an interesting discussion of the use of returns to the *niangjia* and for variations in the way that rural reforms have affected gender relations in the countryside, see Judd (1989, 1994).
3 The problem of this trade in women is recognised and discussed in academic circles. See Zhuang Ping (1993).
4 Discussion with Women's Federation officials, Kunming and Beijing, June 1995.

References

Davin, D. 1999. *Internal Migration in Contemporary China*. Basingstoke: Macmillan.
Evans, H. 1997. *Women and Sexuality in China: Dominant Discourses of Female Sexuality and Gender Since 1949*. Cambridge: Polity Press.
Fan, Cindy and Huang Youqin. 1998. 'Waves of Rural Brides: Female Marriage Migration in China', *Annals of the Association of American Geographers*, 88 (2): 227–51.
Han Min and J.S. Eades. 1995. 'Brides, Bachelors and Brokers: The Marriage Market in Rural Anhui in an Era of Economic Reform', *Modern Asian Studies*, 29 (4): 841–69.
Huang Xiyi. 2000. 'Power, Entitlement, and Social Practice: Resource Distribution in North China Villages'. Unpublished Ph.D. thesis, University of Leeds.
Judd, Ellen R. 1989. 'Niangjia: Chinese Women and their Natal Families', *Journal of Asian Studies*, 48 (3): 525–44.
———. 1994. *Gender and Power in Rural North China*. Stanford: Stanford University Press.
Lavely, W. 1991. 'Marriage and Mobility under Rural Collectivisation', in Rubie S. Watson and Patricia Ebrey (eds), *Marriage and Inequality in Chinese Society*, pp. 286–312. Berkeley: University of California Press.
Ma Z., K.L. Liaw and Zeng Y. 1997. 'Migration in the Urban/Rural Hierarchy of China: Insights from the Micro Data of the 1987 Migration Survey', *Environment and Planning*, 29 (4): 707–30.

Population Census Office under the State Council. 1993. *Zhongguo 1990 Nian Renkou Pucha Ziliao* (Tabulation of the 1990 Population Census of the People's Republic of China). Beijing: China Statistical Publishing House.

Potter, S.H. and J.M. Potter. 1990. *China's Peasants: The Anthropology of a Revolution.* Cambridge: Cambridge University Press.

State Statistical Bureau (SSB). 1991. *Zhongguo 1990 Nian Renkou Pucha 10% Chouyang Ziliao* (10 per cent Sampling Tabulation of the 1990 Population Census of the People's Republic of China). Beijing: China Statistical Publishing House.

Tan Lin and Susan Short. 2004. 'Migrant Women's Experiences of Marriage in a County Level City', in Arianne Gaetano and Tamara Jacka (eds), *On the Move: Women in Rural to Urban Migration in Contemporary China*, pp. 151–74. New York: Columbia University Press.

Wang Jianmin and Hu Qi. 1996. *Zhongguo Liudong Renkou* (China's Floating Population). Shanghai: Shanghai University of Finance and Economics Press.

Zhuang Ping. 1993. 'On the Social Phenomenon of Trafficking in Women in China', *Chinese Education and Society*, 26 (3): 33–50.

3

BRIDAL DIASPORA: MIGRATION AND MARRIAGE AMONG FILIPINO WOMEN

Teresita C. del Rosario

Introduction

On a summer's visit to San Francisco in late 1998, Nanette met Rob, captain of a small cruise ship docked on the San Francisco Wharf. She was there with Steve, her long-standing American boyfriend, and together they were to tour the San Francisco Bay while mulling over the possibility of a life together. This was a wonderful time to be in the US, Nanette thought. She was on holiday from her routine duties as assistant to a training programme at a centre in the Philippines where she had been working for over a decade. With Steve there was time to think and talk about the future—their future. After all, she and Steve had been together for over a year now, and there had been ample time to get to know each other.

The cruise was pleasant enough and Rob paid unusual attention to Nanette, asking her about her home country, her family and her work. He seemed like a terribly kind and mild-mannered man, Nanette thought. Quite older than she was, a little more bulky compared to her sinewy frame, but healthy and bronzed by the famed California sun. But she was with Steve, and so she dispelled those other thoughts that crept into her mind. She did hand him her calling card, however, and though the cruise was over a few hours later, the contact that was fleetingly made that day would unexpectedly come back to change her life years later.

When Nanette retuned to Manila a few months later, Rob sent an e-mail. She ignored it. Not long after that, he sent a second message, and she pressed the 'delete' button. And then there was a long silence. A year later Rob was again back on the Internet. By then Nanette's future with Steve had dematerialised and her life was once more held hostage by the dreariness of her work. During office hours, when she could spare the time, she logged on to the chat rooms of AOL and Yahoo and found a few Internet male pals or navigated the Web for the chance of an Internet romance. No one seemed that promising, and the daily grind of her job was the only reason she was left with for waking each morning to face the world.

All this while Rob's message was summoning her, almost pleading with her to reply to him. This was all the encouragement she needed—part pathos, part thrill, part promise. A year after her cruise and Steve's departure from her life, here was a potential resurrected dream, albeit an electronic one. And so she responded, the first of many mails that were to flourish and blossom into an Internet romance, finally culminating in a proposal of marriage from Rob, six years after she had first handed him her calling card at the San Francisco Wharf. Nanette was 41 years old.

Nanette's migration to the United States is by no means atypical. In fact, hers is part of a long historical queue of Filipino migrants presumably in search of a better life abroad, preceded by the four waves of migration that have punctuated Philippine history since its birth as an independent republic a century ago.

Modernisation theorists have traditionally resorted to economics to explain the driving force behind footloose Filipinos seeking proverbial greener pastures. Nanette's departure would have been regarded as standard rational behaviour in response to opportunities posed by a locale in which land, labour and wage differentials provide stark contrasts between the country about to receive her and the country she has left. Further, they argue that bridal migrants like Nanette succumb to what Du Toit (1990) terms the 'bright lights' theory. That is, the attraction of a more cosmopolitan lifestyle against the backdrop of her dreary administrative work provides the setting for her electronic romance. Last, modernisation theorists arguing from an assimilationist perspective are optimistic about Nanette's incorporation into American culture where she will in due course move up the occupational hierarchy, contribute to the propagation of American values, and ultimately blend

into the overall cultural woodwork that is so distinctively American. In short, this linearist perspective is underlined by a modernist bias in which optimism, both for the migrant and the migratory process, results in an ideological celebration of American 'pioneerism'.

In this chapter I argue against this modernist bias, posing instead a historical-cultural approach that puts the colonial past of the United States and the Philippines squarely into the heart of the analysis. It is a relationship that dates back at least a hundred years, in which the doctrine of 'exceptionalism' underlined America's specific brand of colonialism—a curious blend of military and administrative occupation by a colonial force coupled with a humanitarian mission to 'civilianise' their overseas 'brown brothers and sisters'. The dictates of an American moral vision, Elliot (1917: 224) wrote, 'rests on race superiority and the possession of a higher civilization . . . a civilization so superior as to justify its imposition upon the ancient system by force. Like the American rule in the Philippines, English rule in India is justified by the moral and political superiority of the rulers.'

Further, I argue that this historical relationship provides the setting for what I term 'post-colonial love', that is, a state of embodied thought and feeling that configures among Filipinas a predisposition towards white men, particularly American men, what the Filipino-American historian Vicente Rafael (2000) refers to as 'white love'. I unpack the elements of white love by making extensive reference to the theoretical framework of Nicole Constable (2003) in which she refers to the 'cultural logic of desire' that informs the decisions of Filipinas to seek marriage with American men.

Last, I investigate sources of agency for bridal migrants, rejecting an over-deterministic view that migrants are mere objects of historical and structural forces. Rather, I believe in their perennial ability to mobilise their inner resources to adapt, adjust, protect, even to reinvent themselves in a strange and sometimes hostile environment. These sources range from social networks to rituals of church-going, and even the sequestration of 'safe spaces' where they freely congregate. In an electronic age, information and communication technologies (ICTs) themselves provide, enhance and shape what I call 'cyberspatial agency' to afford migrants the forging of electronic communities across the globe and to create networks that are of their own making. As the Filipino diaspora[1] shows no signs of letting up under a hastening globalisation process, Filipina bridal migrants navigate their new-found dual

identities as Filipina bride and American resident as a strategy to straddle two worlds, both of which they legitimately claim as their 'home'.

A Note on Methodology

Interviews with 10 Filipina migrants were conducted within a six-month period. All of them were professionals with long-term careers, some spanning nearly a decade. They had access to computers and were literate in the use of ICT. Their introduction to the Internet was made possible in their workplace, where part of their professional duties required facility in the use of computers. They also owned personal cellphones, and in the pre-cellphone days of the early 1990s they carried pagers. It is safe to assume that they are predominantly well-educated and of middle-class backgrounds, unlike their other female counterparts who migrate as domestic help, entertainers and sex workers.

Not all of the women were single. A few had been married before. One had an American husband, but later divorced him. Because of their work, most of them had prior exposure to foreign men, even while their workplace was predominantly Filipino. All of them were way past the traditional marrying age of 25 years; and a few were nearly 40 years old at the time of the interview. All of them would invariably refer to themselves as 'prospective old maids' and 'past their prime'. Therefore, marriage at the time of the interviews was both a matter of 'lucking it out' in the narrowing marriage market, and a 'personal project that could be pursued through the wonders of information technology'. All of them intended to marry. None of them entertained the thought of maintaining relationships out of wedlock or the possibility of divorce.

My introduction to these bridal migrants was through a chain of acquaintances. I got to know one of them personally over the last 10 years, including a few elements of her personal life. She also directed me to other co-workers and their acquaintances, who also navigated the Web in an earnest search for husbands. In effect, these bridal migrants knew of each other and were connected via an informal network of Filipinas who share the same aspirations of leaving the Philippines and seeking foreign spouses. While willing to speak openly, all of them desired that their anonymity be preserved, and that there be no follow-up interviews. They preferred that communication with me be stopped once they left the country.

The Filipino Diaspora in
Historical Perspective

It began with predominantly male plantation workers bound for Guam, Hawaii and California in the early 1900s. They filled in the labour gaps in the US territories to work in the pineapple fields and the apple orchards, even while many of them lived in isolation and were prevented from marrying American women (David 2001: 70; del Rosario 2001: 7).

The second wave occurred in the 1950s in the aftermath of the American colonial period and Second World War, when the first *pensionados* (so-called because of the generous pensions [stipends] they received during their stint in the United States) were sent abroad by the American colonisers to train as a first generation of Filipino teachers and public servants (David 2001). They were a post-war generation, infused with the combined sense of enthusiasm and responsibility to rebuild a country destroyed by war. Some returned years later, as converts to the gospel of Parsonian functionalist sociology whose upbeat message of modernisation would soon seep into the universities' teaching curricula and research projects. Those who remained joined the ranks of medical professionals, from the nursing wards of Seattle and Chicago to the physicians' clinics of New York and Massachusetts. By the 1970s they had joined the Asian-American ethnic category and contributed to swelling the statistics of a relatively new influx of migrants from across the Pacific.

In the 1980s the oil boom in the Middle East pulled Filipino men, both skilled and semi-skilled, to the Gulf countries. Construction proceeded at a frenetic pace in these countries, awash then as now, with oil revenues. An economic crisis at home and a demand for overseas construction labour fuelled the out-migration. Government policy, albeit unofficial, supported the outflow to raise badly needed domestic revenues via remittances from overseas contract workers (OCWs). Within a decade close to a million workers were deployed in the Gulf region. Today, it is still common to refer to materially transformed communities as having been the result of '*khatas ng Saudi*' (Saudi sap), whether these be a newly-bought jeepney for starting a transportation micro-enterprise or a load of consumer appliances finding their way into Filipino homes.

As construction projects finished, the demand for semi-skilled workers was reduced. The onset of globalisation generated a new

demand for a different type of labour domestic helpers, caregivers, even sex workers and entertainers—the latter euphemistically referred to as guest relations officers (GROs). Sociologist Rachel Parrenas (2001: 243) describes the Filipino labour diaspora in the context of the global economy as 'global servants of late capitalism', being dispersed throughout the globe in a total of 130 countries.

As migration intensified, migrant women's experiences diversified. Domestic helpers abroad fended off isolation and loneliness through penfriends. Others discovered the 'catalogue route' to migration where their photos and selected segments of their biography were posted and circulated in magazine shops overseas. Thus the term 'mail-order bride' entered the Philippine lexicon alongside DH (domestic help) and GROs. They often blur into one another, depicted as unwitting players in the global sex trade industry, ignorant, abused and victimised. They are 'foreigners' whores', and some of them are drugged and forced into prostitution while the most unfortunate ones are murdered.

In the late 1990s and into the new century, migration among Filipinas took yet another turn to correspond with the arrival and the explosion of information and communication technologies. Penfriend correspondences were speeded up through electronic servers and chat rooms provided spaces where intimacies could be turned on and off with the tools of usernames and passwords. The bridal migrant of the new millennium was forced into cyber-space, thanks to the proliferation of over 350 electronic dating and introduction services throughout the world (Constable 2003: 3).

At the close of the century an estimated 7.2 million Filipinos lived abroad. Today that number has increased to over 8 million, suggesting that perhaps close to 10 per cent of the Philippine population has left the country. The United States continues to be the preferred destination of migrants, followed by Canada, Australia, Japan and Germany (UN 2002).

US–Philippine Relations

Filipinas' fascination for American spouses cannot be understood without reference to their colonial past. It dates far back to the early 20th century when, following the cessation of hostilities after the three-year Filipino-

American War, a provision for universal public education was made. The pacification campaign was initially carried out by 600 teachers—the second army of occupation—aboard the ship *USS Thomas*; thus, the term 'Thomasites' to identify the first American educators to set foot on Philippine soil. Filipino-American social anthropologist Mary Racelis would later eulogise them through an anthology of collected memoirs which she jointly edited and published as a book along with Judy Celine Ick, aptly entitled *Bearers of Benevolence* (2001).

English lessons throughout the islands were augmented with American films—that ubiquitous piece of paraphernalia which brought a third wave of invasion, this time by the likes of Elvis Presley and James Dean. Along with imported American goods (Filipinos refer to them as 'stateside' items) that flooded Philippine markets in the pre- and post-war eras of free trade, the 20th-century Filipino emerged out of the long shadow of Spanish colonial rule. The de-secularisation process was complete, thanks to the efficacy of the teacher, the Hollywood actor and the American entrepreneur.

The net effect of American rule in the Philippines was the creation of a 'reservoir of goodwill' among Filipinos. Democratic principles were disseminated throughout the islands. Education promised social mobility for a literate population. Succeeding generations of Filipinos were inculcated with the concepts of American altruism and fair play, of liberal democracy and free enterprise, and of America as the highest embodiment of learning and civilisation. Films celebrated the culture of promise and initiative, underscored individualism and choice. Images of American society portrayed as the land of limitless possibilities dominated classrooms and permeated screens. In short, the American colonial experience was less about imposition than it was about seduction.

In the post-colonial era, fascination for America did not wane. Despite a strong nationalist movement in the 1990s, which centred around the struggle for the removal of the American bases on Philippine soil, the everyday sentiment among most Filipinos was a desire for better-quality American products, more polished American films and higher standards of American education. The Green Card became an organising symbol for the aspiration for a better life, and immigration to America constituted a grand adventure to the 'land of milk and honey'. These aspirations were best served and most efficiently realised through marriage.

The Cultural Logic of Desire

In her study of marriages through correspondence between Filipinas/ Chinese women and American men, Constable (2003: 117) argues against a reduction of such marriages to a perspective of pure pragmatism in which romantic love is absent and where material considerations take precedence over passion and desire. She warns against 'privileging or prematurely dismissing a notion of romantic love, and against categorically opposing practical and material desires to emotional ones'. But Constable is likewise concerned about the linkage between political economy and emotions. She frames her enquiry on the intertwining of political economy with love and emotion through what she terms the 'cultural logic of desire' (ibid.: 119). In the Philippine context, I argue that this logic is the outcome of the specific historical relationship between the US and the Philippines, and that love and emotion towards American spouses are filtered through the mystification of American benevolence and American superiority.

Interestingly, the same cultural logic applies to American males who seek in Filipino women the 'lost traditions' of conservatism, the hankering for the old-fashioned nuclear family ties and the attendant loyalties and devotions. The mixture of two narratives—one of the benevolent and superior white male, the other of the loyal Asian wife—blend into an idealised notion of what constitutes a 'successful marriage', aided and abetted by the electronic media.

One element in this logic is that of social status. Marriage to a white man, particularly an American man, is considered an 'improvement' over marrying a local, regardless of his social class affiliation. Of course, the rise in status is 'doubled' if the white man is *also* known to be wealthy. Among Filipinos whiteness is viewed as an automatic measure of affluence; thus, an international marriage already sets the prospective bride a rung higher in the status ladder. The more the number of socially desirable traits ascribed to the white groom, the higher the Filipina bride rises in status. Thus, marriage to a white 'man of letters' (doctor/ lawyer/professor/novelist/engineer/etc.) would immediately quadruple the migrant Filipina bride's social status compared to marrying just any unqualified white male—the kind who works, for example, as a gas station attendant or a postal clerk. In the Philippines, 'status matches' (ibid.) are a concern among families, particularly in co-ethnic marriages.

Apart from the economic advantage of international marriages, there is the perceived superiority, both social and genetic, of Americans. A witticism among Filipinos is that marrying a white person will 'improve the genes' and their offspring will be a far more improved version over the 'pure breeds'. A 'mixed offspring' is considered to be physically more attractive, carrying only the very best features of both parents. They are also supposedly more cosmopolitan, having been brought up in two cultures, linguistically adept in both languages of their parents and, therefore, more broad-minded, 'hip', 'cool', 'modern'. In Philippine showbiz culture a new generation of personalities and celebrities of mixed parentage dominates the entertainment industry. They are known as 'Fil-Ams', the current rage on both television and films, and they are the object of fascination in a society whose notion of marriage migration seems to have paid off very handsomely.

However, this status logic does not apply to Filipino men, that is, they are not predisposed to seek white (and in general non-Filipino) brides. It is widely believed that Filipino men are intimidated by the directness, forwardness and aggressiveness of white women. Also, there is an unstated view that it is acceptable for Filipino women to marry white men even for purely material motives. However, the same economic logic when applied to men will cause a substantial drop in the Filipino male's status, and he will be viewed as less 'manly' for having married a woman who is presumably 'better' (that is, wealthier, taller, whiter, more educated, more fluent in English, etc.). In brief, for Filipino men to 'marry out' is much less prevalent, and indeed far rarer, than it is for women.

Further, the behavioural traits of white married men are presumably better than those of married Filipinos. There is a general view that while Filipinos are more outwardly affectionate than white men, they are also less emotionally reliable and faithful. An old Filipino saying, 'Fifty yards outside of my house I am a bachelor', has given married Filipinos a bad name. Filipinas who marry white men feel more secure that their husbands will not keep a mistress on the side or indulge in mindless flirtation with other women even in the public presence of their spouse. Nor will they be cajoled by their *barkada* (that infamous male social circle of perpetually prowling Romeos) to frequent nightspots like massage parlours and girly bars for which Filipino men have become notorious. Equality between the sexes is a dictum that Filipinos learned from the Americans early enough in their socialisation process. This has seeped into the consciousness of females in their choice of a presumably better spouse.

A prospective Internet bride whom I interviewed, Tina, related to me her bitterness in discovering that her Filipino fiancé was two-timing her. Her emotional recovery was made easier by a chance meeting on the Internet with an American who was looking for an Asian wife to whom he could 'dedicate his life'. She 'met' her American fiancé, courtesy a fellow office worker who was chatting online during their lunch break. She decided to give in to her curiosity and start up an electronic correspondence:

> This guy, my boyfriend for almost two years, was seeing someone else behind my back. One of my friends at that! No we're not close friends but I know her. How *kapal* [thick faced]!
>
> So after I broke off with him, I started to date others, but problem was I am no longer sure about them. They might do the same thing again to me.
>
> You know these Pinoys, they are so fond of keeping more than one girlfriend. Maybe they like to brag about it to their friends.
>
> When I met Bernie online, I felt this was different. He is older [*may edad na*] and more mature. He didn't ask me about my past. He was interested in my family and me, and whether I would mind living in the States.
>
> We have been writing for almost a year now. I told him maybe it's time for him to come visit the Philippines and meet my family. He's planning a trip this year. *Sana* [hopefully].

For Filipinas who have postponed early marriage in favour of careers—often accompanied by an obligation to fulfil family responsibilities—the electronic bridal route is often an inevitable, if not a favoured one. Filipina women beyond the age range of 25 to 30 years are considered difficult cases. They are facing the prospect of spinsterhood, and that, coupled with their lucrative careers, poses a threat to Filipinos who might be frightened away by overachieving women.

American men, on the other hand, are not so easily disillusioned by older women; nor do Filipina achievers intimidate them. American men subscribe to the notion of gender equality—or so the white love ideology goes—and therefore might even find comfort with Filipinas who, at the very least, are competent enough to carry on a conversation in English, and perhaps even assume the status of equal partner.

Cris, a teller at a large local bank, related her experience of meeting her fiancé online. He was rather impressed with her background, she says, her college education, her fluency in English and even her ability to 'spell' correctly. She thought this was amusing, and also flattering that her Internet pal should think so highly of her.

> He asked me once online, 'How come you speak English so well?' The question surprised me. Of course, I told him, we were all educated in English. I even speak and write English better than I do my own language.
>
> He also asked me if I had travelled abroad before. I said yes, but only to Hong Kong and Singapore. Not to the US, but I would, of course, love to go there.
>
> He said that was good because many Americans have not even stepped out of the state they were born. He thinks travel must have made me very broad-minded.

Yet, increasingly, American men seek Filipinas because they are not only competent and knowledgeable, but are also viewed as the bearers and champions of family traditions. American men rediscover the 'lost frontier of the family' among Filipinas, owing to the Catholic background inherited from the Spaniards which, it is believed, further strengthens the faith of Filipinos in marriage and family ties.

Richard, an 'Internet groom', posted his testimonial on what he values in Weena, his correspondence sweetheart and eventually his spouse:

> I, like many other males, turned to the Filipino culture because of its rich heritage based on the oft-mentioned 'traditional family values'. Many of these 'values' have been heavily eroded in modern Western society; one only has to read of the escalating divorce rates and preparedness to 'walk away' from a marriage over seemingly small or minor problems. But the Filipino culture offers more. Those of us fortunate to court and subsequently wed a Philippine girl/women find a warmth of affection we have never enjoyed and a close-knit family who embrace us with love as soon as we enter the door. Sure, we occasionally have to endure the stares: 'Oh, he's got a "mail-order" bride.' Mail order? Did we simply pluck our wife from a catalogue or Web site? What crap!! We fostered a relationship like any other couple through getting to know one another. Your site offered the

means—we did the rest! We marry with so much love in our hearts because, invariably, we find a 'better' person than we would expect to find in our own country.[2]

Another white male online searcher residing in the Philippines gave rather strict specifications for the Filipina he wanted to meet:

What I'm in search of . . .
I would like to find ONE female friend who either lives at home with her family or works at a decent job and would like to cultivate a friendship with an American who would respect her and develop a closeness that would lead to togetherness.[3]

It is these sets of shared values that draw prospective online spouses to each other. Filipinas who are seriously searching for spouses insist that their electronic love interests materialise in the flesh before they jump into spousehood. It is in part a reincarnation of the old tradition of courtship (*panliligaw*) in which the suitor makes known the sincerity of his intentions by presenting himself personally to her family. The meeting between the suitor and the girl's family is likewise a kind of guarantee that she obtains a-more-than-electronic impression of the man she hopes to marry. And finally, it is a presentation of her prospective spouse to her significant community—her family, her friends, her loved ones—in order to draw from them their approval, their blessing and their support in the event that the union proves to be a failure later on. In short, Filipinas resort to traditional practices even in the modernist pursuit of an online husband, as a way of hedging against a potentially bad wager and reducing the risks that accompany an electronic courtship.

Betty, an administrative assistant, recalls the day when her electronic penfriend arrived in Manila to formalise his proposal of marriage:

He went straight to my family to meet them. He saw me only briefly at the airport and then I took him to the domestic airport for him to catch a flight to the province where my parents stay.

He stayed there for two weeks. I stayed behind in Manila because of my work. He met my brothers and sisters. My oldest brother really approves of him. I told him that was very important to me, because I will not go without the approval of my family.

Upon her fiancé's return to Manila, Betty accepted his proposal. She was convinced in her heart that he was the right man for her. Her entire family participated in her decision to marry a man whom she had met physically only a short while back. While the initiative to maintain an electronic correspondence relationship was fully hers, the final decision to marry was rather a family affair. Elated by the family's approval, she finally allowed herself the freedom to admit to herself that indeed she loved him.

Last, there is the logic of social responsibility, particularly one's responsibility to family and closest kin. Marriage, electronic and otherwise, is not restricted to two individuals; rather, it encompasses entire social networks in which the two marrying individuals are located. With this comes the responsibility among partners to care for and look after the communities they inherited vis-à-vis marriage. To a large extent, electronic marriages provide an *escape* from this formidable responsibility. The decision to marry an electronic partner provides a measure of distance that would otherwise not be possible if there was a regular suitor whose presence became familiar within the bride's family circle. Thus, even while families play an important role in sanctioning the union, their ability to interfere in the daily workings of the marriage is severely restricted once the couple has taken up residence overseas. This negotiation between distance and closeness puts the bride in an advantageous position: she maintains close family connections, yet the physical distance, augmented by her family's lack of familiarity with her white spouse, sets her marriage apart from regular co-ethnic marriages.

Migration and Agency

A final strand in the discussion on marriage and migration is the question of agency, a long-standing debate within sociology, which inquires whether migrant women are victims of structurally-embedded social and economic processes, or whether they are subjects and agents with a capacity for self-direction. Particularly within the context of migrant women who face potential dangers of victimisation and abuse from their potential online (white) spouses in search of the exotic, erotic wife-cum-maid-cum-sexpot, agency is not only an intellectual, but more importantly, a moral question.

Agency, as defined by McNay (2000: 10), 'attests to the capacity for autonomous action in the face of often overwhelming cultural sanctions and structural inequalities'. These capacities, however, occur within a context of constraints. Some of these constraints are the result of limited information, uncertainty, history and political economy, even while actors are shaping and reshaping their own biographical circumstances in response to the constraints they face. The result is a creative response among agents that testifies to wider personal latitude than has previously been assumed by victimisation models. Electronic marriages provide one such instance in which agency is possible and available to bridal migrants.

What ought not to be overlooked, of course, are the backgrounds of these women whom I interviewed. They are not the female migrants of the 1980s who left the country in droves to work as domestic helpers and guest entertainers in Asia and in the Middle East. Whereas the latter wave of migrants emigrated for jobs and family welfare, Internet brides are skilled professionals with bank accounts and cellphones, who enjoy both material and social assets to take with them on their migration routes.

But their agency is not without constraint, as one might be led to believe, though it differs from that of their female counterparts who go into domestic work and similar undesirable job situations. One source of constraint is what Suzuki (2002: 103) terms 'gendered surveillance', particularly 'communal surveillance' in which freely circulating rumour and gossip at home serve to exert power and authority over women's sexuality. For all women—whether professional or unskilled (although Suzuki confined her interviews to Filipina entertainers about to leave for Japan)—their continuing status as single women subjects them to all form and manner of innuendo and speculation, a kind of 'social harassment' that would not occur if they were in socially sanctioned relationships, and more so if they were married. For unmarried professional women communal surveillance is even more exacerbated, not only by their male co-workers who view them as 'fair game', but also by their female peers. Professional unmarried women beyond 25 years of age pose threats to other women. They are perceived as destabilisers of stable marriages, potential mistresses of married man, modern versions of the biblical adulteress, Mary Magdalene. One married man referred to a highly educated unmarried woman as a UFO—an 'unidentified flying object that might land on someone else's [married] rooftop'.

The narrative of Nanette attests to the varied forms and sources of surveillance she had had to endure for years until she finally left for the United States to marry Rob:

> I was supposed to get married several years ago to Steve. Everyone in the office was waiting for the announcement. I even bought my dress for the reception, because it was going to be held in the province and there was no air-conditioning in the reception area, so I had to change from my gown into a short dress. I had it all planned.
>
> Then the marriage fell through [*hindi natuloy*]. I didn't want to talk about it with anyone, of course I was hurt, but also I was very embarrassed. What will I say to my officemates? I already took a leave of absence, and then when I came back from leave, I was still not married. It was really embarrassing [*nakakahiya talaga*].
>
> But of course everyone [in the office] wanted to know. They were asking why this? Why that? What happened to him? Did he leave? What did I do? As if it was my fault that the marriage didn't push through.

Thus, the prospective online brides escape to the Internet as a kind of refuge, and as an opportunity to reconfigure their lives, away from the almost constant scrutiny of their sexuality by both men and women. In this respect, these women navigate within very tight gendered spaces and achieve a measure of agency.

One feature of electronic marriages that promotes agency is the 'choice' of online spouses via the extensive array of marriage partners posted online. The dependence on social networks in the quest for a prospective spouse is much lessened even while the choices are vastly increased. Many online services post qualifications ranging from physical attributes to social and economic backgrounds, including the specifications of an online seeker's requirements. This listing bridges the gap in information, helps focus particularities of the search, and provides comfort in a process that is private and anonymous. Consider for example the following detailed text posted by a white male in search of a Filipina bride:

> I am a high educated man from . . . with a good work who believes in love and loyalty. I am honest, kind, understanding, sincere and easy-going with a good sense of humor—I like to smile

I put the family in the highest priority and I like to have a nice home there the family/we together will have a nice time. But I also like to travel because I am interested in different cultures and like to see different places.

Gender	:	Male
Age	:	57
Race	:	Caucasian
Marital status	:	Divorced
Children	:	0
Religion	:	Christian
Drinking	:	Light/social drinker
Smoking	:	Non-smoker
Food	:	Non-vegetarian
Occupation	:	Education & science
Education	:	Doctoral degree/Ph.D.
Languages	:	English (Fluent), German (Minimal)
Interests	:	Arts/crafts, cars/motorcycles, cooking, football, soccer, rugby, gardening, hiking/camping, ice/snow sports, literature/history, motor racing, movies/cinema, museums/galleries, music—world, nature, politics, sailing/boating, theatre/ballet, travel/sightseeing

Appearance

I am 178 cm, have blond hair and blue eyes and think I look younger than my age. I also am still a child at heart. I like all nice clothes including blue jeans and T-shirts (but not at work). I just now do a lot of things after work. I am both practical and theoretical and I am goal-oriented.

Eye colour	:	Blue
Hair colour	:	Blond
Body type	:	Average
Height	:	5'7"–5'11" (170–180 cm)

Looking for

Gender	:	Female, prefer Filipina since I visit that country often

Age from : 35
Age to : 49
Looking for : Marriage, relationship, romance
(**Source:** http://www.match.com)

Online search for spouses also provides actors with a larger measure of personal control. Either party can initiate electronic contact, and the person at the receiving end is under no contractual obligation to respond or reciprocate. For Filipinas, who are culturally expected to rely on introductions to men via social circles, the (inter)mediation of electronic services removes this dependence and provides them with a sense of autonomy just by enabling them to meet prospective partners on their own.

More autonomy is made possible by the fact that they may either sustain the online conversation or terminate it at any point of their choosing. Filipinas who have been introduced by their friends and colleagues often face additional pressure from their peers to continue the relationship long after it has ceased to provide personal satisfaction. Electronic romances provide efficacy, albeit brutally; termination of the electronic liaison is but one click away.

Thus, while victimisation and abuse do form a significant part of the lived experiences of female migrants, as has been documented substantively in migration literature, the ability of women to engage in 'strategic conduct in constructing their own (multiple) identities and navigating their (and often their families') life paths' (Yeoh et al. 2002: 2) should also not be overlooked. As exemplified by the women migrants whose narratives have been presented here, the electronic route to marriage and migration was one of the avenues they consciously cultivated and utilised in order to forge for themselves alternative life paths and to reframe their relations, and, in this way, invest themselves with a larger measure of personal autonomy.

Additionally, a transnational life course perspective, as suggested by Lee and Piper (2003: 126), is predicated upon 'transcend[ing] political boundaries', which imbue migrants with more agency in that they maintain local social networks to continue contact with families and friends even while they locate and relocate within their migratory life course. The migration experience does not end with marriage or with settlement. Rather, Lee and Piper argue, migration is a perpetual process depending on the life course pattern of migrants. Many Filipinas have

transmigrated the globe; others have returned home, to leave again later.

Marriage migrants have played the citizenship card rather conveniently. They are now at liberty to take up dual residences and of late dual citizenship. In the most optimistic and most generous reading of marriage migrants, they have the best of all worlds indeed.

Postscript

I conclude by returning to Nanette's narrative that occasioned this chapter in the first place. The day Nanette was to leave for the United States, I asked if I could speak to her. Her office desk faced me, now emptied of all her papers, her computer shut down, and the photos of her family dutifully packed away in her suitcase. She had corresponded with Rob for the last five years between writing office memos and preparing training kits. When she finally saw him again two months ago, he went to see her family in the south to formally ask for her hand in marriage. It was the first time she had seen him in five years.

He was heavier now, she said, aged by a life spent alone far too long. He had completed the last messy touches of his divorce and his only son was quite well settled. He was 56 years old, ready for a second chance to commit to someone again. Nanette said yes, for many reasons, she said. Eight hours before her flight, I asked her to state some of them. 'He puts me first,' she said. 'My welfare comes ahead of all the others.'

'He says I don't need to work if I don't want to. I can study if I like.' And then she asks for my opinion on good schools in California.

I asked about love. Did it happen to her? Without batting an eyelash, and with characteristic self-assurance as if to dispel my doubts, and hers too perhaps, she said, 'Yes, oh yes. I knew that I loved him when he made me speak to his mother on the phone. She welcomed me into her life without even meeting me yet.' And then again, I detected the old familiar ring of traditionalism—the pull of family approval, the necessary acceptance into a new world from her would-be in-laws—to carry with her like a talisman before embarking into the relative unknown.

'I have put my nieces and nephews through school. My obligations to my family are finished,' she proudly claimed. 'My whole family

approves of him. They will all take me to the airport tonight.' A last final indication that she was going off to her version of a Promised Land with the blessings from those who mean a great deal to her.

She beamed as she spoke this last bit of self-encouragement. Truly, it was time to claim her life as her own.

Notes

1 In the context of migration via marriage, the term 'diaspora' is used here as the 'doubled relationship or dual loyalty that migrants, exiles, and refugees have towards places—their connections to the space they currently occupy and their continuing involvement with "back home"' (Lavie and Swedenburg 1996: 14).
2 From http://www.filipinaheart.com.
3 From http://www.kazudatephilippines.com.

References

Constable, Nicole. 2003. *Romance on the Global Stage: Virtual Ethnography, Pen Pals and 'Mail Order' Marriages*. California: University of California Press.

David, Randolf S. 2001. 'The Filipino Diaspora: Identity in the Global Village', in *Reflections on Sociology and Philippine Society*, pp. 68–77. Diliman, Quezon City: University of the Philippines Press.

del Rosario, Josefina. 2001. 'Information, ICTs, and Migrant Workers: The Experience of Overseas Contract Workers (OCWs) in Belgium'. Unpublished Master's thesis, University of Manchester.

Du Toit, Brian. 1990. 'People on the Move: Rural–Urban Migration with Special Reference to the Third World: Theoretical and Empirical Perspectives', *Human Organization*, 49: 305–19.

Elliot, Charles Burke. 1917. *The Philippines: To the End of the Military Regime* (2 Vols.). Indianapolis: The Bobbs-Merrill Co.

Lavie, Smadar and Ted Swedenburg. 1996. *Displacement, Diaspora and Geographies of Identity*. Durham: Duke University Press.

Lee, Michelle and Nicola Piper. 2003. 'Reflections on Transnational Life Course and Migratory Patterns of Middle Class Women: Observations from Malaysia', in Nicola Piper (ed.), *Wife or Worker? Asian Marriage and Migration*, pp. 121–36. Lanham: Rowman and Littlefield Publishing Inc.

McNay, Lois. 2000. *Gender and Agency: Reconfiguring the Subject in Feminist and Social Theory*. Cambridge: Polity Press.

Parrenas, Rachel Salazar. 2001. *Servants of Globalization*. Stanford: Stanford University Press.

Racelis, Mary and Judy Celine Ick (eds). 2001. *Bearers of Benevolence: The Thomasites and Public Education in the Philippines*. Manila: Anvil Publishing.

Rafael, Vicente. 2000. *White Love and Other Events in Filipino History*. Durham: Duke University Press.

Suzuki, Nobue. 2002. 'Gendered Surveillance and Sexual Violence in Filipina Pre-migration Experiences to Japan', in Brenda S.A. Yeoh, Peggy Teo and Shirlena Huang (eds), *Gender Politics in the Asia-Pacific Region*, pp. 99–119. New York and London: Routledge.

United Nations. 2002. *International Migration Report*. New York: Department of Economic and Social Affairs, Population Division.

Yeoh, Brenda S.A., Peggy Teo and Shirlena Huang. 2002. 'Women's Agencies and Activism in the Asia-Pacific Region', in Brenda S.A. Yeoh, Peggy Teo and Shirlena Huang (eds), *Gender Politics in the Asia-Pacific Region*, pp. 1–16. New York and London: Routledge.

4

'AMERICA VARAN' MARRIAGES AMONG TAMIL BRAHMANS: PREFERENCES, STRATEGIES AND OUTCOMES

U. Kalpagam

Introduction

This chapter explores the way in which diasporic opportunities are sought after and rendered possible through matrimonial strategies. While studies on diasporic marriages are quite common in Western anthropology today, such studies have been rather few in the Indian context. Uberoi (1998) explores the internationalisation of the middle-class family and the problem of cultural reproduction in transnational locations through a critical reading of two popular Hindi films meant both for NRI and local audiences, which thematise issues of courtship and marriage. In this context, Uberoi observes that, while issues of transnational identity are taken up in Indian films, Indian sociological studies have lagged behind. The study of matrimonial strategies has always been an important component of kinship studies, but kinship studies in India, being largely preoccupied with the older debates on the decline of the joint family[1], have largely ignored the diasporic terrain and, for that matter, changing forms of marriage and transgressive behaviour such as inter-caste marriage. The study of evolving community-specific matrimonial strategies in what are generally understood as 'arranged marriages' is not merely interesting in itself, but indeed essential for understanding how *habitus* constructs gendered identities and how diasporic opportunities redefine social status within cultural groups through the acquisition of both symbolic and economic capital.

Here we explore through ethnographic methods the widely prevalent and much sought-after form of marriage alliance among middle-class Tamil Brahmans[2], known as 'America *varan*'. Among Tamil Brahmans, *varan* refers to a prospective marriage alliance, either for girls or for boys. This Sanskrit word means a boon. Marriage is considered a boon, and the marital state a 'blessed state' among Hindus, and especially among Brahmans, as indeed it is in many other cultures and societies. America *varan* refers to a prospective marriage alliance with Indians residing in both the US and Canada.[3]

Since the early 1960s, when marriage-induced migration to the US started, America *varan* marriages caught the Tamil Brahman imagination, shaping and in turn being shaped by contemporary social aspirations. For instance, the then widely popular Tamil weekly *Ananda Viketan*, read largely by Brahman housewives, serialised for over a year Savi's story, called 'Washingtonil Thirumanam' (Wedding in Washington). This was about a Tamil Brahman wedding conducted in Washington in the most traditional way and incorporating some aspects of the American way of life as well. In a sense, that hugely popular story marked the beginning of a new-found aspiration among middle-class Brahmans to fix alliances for their daughters with boys settled in the US or Canada. This aspiration grew alongside the aspiration to send their boys to the US for higher education and employment.

In the 1980s, this enthusiasm was to some extent restrained by a widespread awareness of the risks involved in such an alliance. Such awareness was generated to a great extent by the popular Tamil writer Sivasankari's story 'Napathielu Nattkal' (Forty Seven Days), later made into a Tamil movie. In this story, a girl who contracts a diasporic marriage is severely ill-treated by her husband, but, using her ingenuity, somehow manages to escape the torture and return to India. Although the story is set in the context of the Indian diaspora in Europe, France in particular, the story's significance in the popular imagination can be gauged from the fact that most of my respondents referred to it in their interviews with me. Today, Tamil magazines like *Kalki*, *Kumudham* and *Ananda Viketan* carry innumerable short stories, including some by expatriate Tamil women writers who live unconventional lives[4], depicting assertive expatriate women in the US who challenge these America *varan* arranged marriages to make choices of their own, even transcending the barriers of race.

Diasporic alliances in the 1960s and 1970s, like alliances with partners in India, were largely settled through personal kin and friendship

networks. As local alliances became increasingly difficult to settle in this way, personal networks were complemented through impersonal networks, especially matrimonial advertisements, though many Brahman families shied away from that style of seeking alliances even in the late 1970s. Those that used the 'advertisement route' were seen as being less traditional and more opportunistic, and, above all, bold and fearless to the extent that they were willing to entertain alliances from families about whom they had no prior knowledge or reference. As inhibitions gave way and as more women came to be employed, even the marriageable girl herself would go to the newspaper office to place the advertisement; some took the initiative to use that channel when their parents felt inhibited to do so. Subsequently, a kind of community networking emerged, using the temple as a nucleus. Many temples in Chennai began to offer horoscope exchange services and a few, like the Mahalingapuram temple, earned quite a reputation for efficient service. Today Internet advertising has added a new dimension to the business of identifying compatible partners.

Among Tamil Brahmans, finding and fixing marriage partners entails first gaining access to the horoscopes of potential spouses, a process of matching horoscopes, and then enquiries, especially on the part of the boy's family, regarding the attainments and status of the girl's family and the likely quantum of dowry. In the case of a diasporic alliance for a girl, such inquiries extend to clearing their suspicions that the boy might be an impostor, be already married in the US or have a 'white girlfriend'. Generally, the boy and the girl themselves meet and come to their decision only at the last stage of the negotiations.

Methodology

In this chapter we explore the strategies of matchmaking in diasporic Brahman marriages, and the outcome of such marriages in terms of the acquisition and deployment of symbolic capital for the reproduction of class *habitus*. Matrimonial strategies, as Pierre Bourdieu (1977: 70) argues, are 'objectively directed towards the conservation or expansion of the material and symbolic capital jointly possessed by a more or less extended group' with a view to reproducing or improving their position in the social structure. This explains why marriage practices are often at variance with the marriage rules.

The sociological literature on marriage and kinship in India has presented the main distinction between North Indian and South Indian marriage in terms of a preference for cross-cousin marriages in the south, whereas all close kin marriages are prohibited in the north. However, with urbanisation and increasing economic differentiation, there has been a shift in Tamil marriage preferences from kin- to class- and status-based alliances[5], suggesting that matrimonial strategies are being deployed in the acquisition of material and symbolic capital. The increased preference for non-kin marriages, along with the emergence of nuclear families in urban areas, has enabled families to reckon their success in terms of the symbolic and cultural capital obtained through marriage alliances, judged in terms of various status symbols.

In the scale of symbolic capital, America *varan* alliances are exceptionally prestigious. For a boy residing in America, the symbolic capital of a particular alliance depends on the kind of family from which the bride is taken and the girl's personal attainments, reckoned largely in terms of beauty. The prestige of an America *varan* itself varies depending on whether the boy possesses a Green Card or an H-1 visa; whether the boy went to the US/Canada for higher studies and then settled there; or whether he went there for employment. In case of emigration for employment, there is a distinction between employment for a short-term job contract (like the numerous software professionals who are on the global move) and a more enduring job contract with prospects of permanent relocation. The America *varan* alliance with Green Card-holding boys ranks as the most prestigious match. On the other hand, the parents of girls who go abroad for higher studies and then find their mates through some kind of arrangement (not necessarily a 'love' match) never boast of having fixed an America *varan* alliance. While obviously happy to see their daughter settled abroad, they view America *varan* as a simple necessity, taking pride instead in their daughter's scholastic abilities.

In this ethnographic inquiry, I have sought to gather data on general perceptions of America *varan* by Brahman families today, its popularity among girls of marriageable age, and the various strategies deployed by families to find and fix such alliances. This entails considering the importance of different kinds of networks, the role and expectations of astrological matchings, and the way in which families seek to gather and present information on attainments and expectations. In today's complex world of diasporic opportunities, including the demand for software professionals, marriage preferences in diasporic marriages appear to be

shaped by considerations of the durability of migration and the nature of the boy's employment as well as by the girl's attainments.

For instance, depending on the nature of their work contracts, some software professionals prefer the girl to have acquired similar professional qualifications, while others definitely prefer the wife to remain unemployed. Those with longer contracts on the higher end of the salary scale prefer their wives to be homemakers, while those on short-term contracts are keen that their wives have similar qualifications. This is despite the fact that such short-term contract workers are generally on H-1 US visas, while their spouses, on H-1B visas, are not permitted to work. So, despite their qualifications, they remain unemployed, sometimes shifting locales in the US within short intervals, leading to isolation and vulnerability. There are two main reasons for the insistence on spouses having compatible qualifications as software professionals. First is the subjective calculation that, in case of permanent relocation, a well-qualified software professional could also enter the labour force some time in the future. Second, after moving around the world on short-term contracts, a time will come when they will eventually settle in India, where a wife qualified in software could easily find a job. As the total period of global moves is not likely to exceed five or so years, most young professionals feel that their wives' qualifications will not become outdated.[6]

I had planned to interview at least 15 families that had recently (within the last three to five years) fixed America *varan* alliances, an equal number of families for their general perceptions of the phenomenon, and as many young, marriageable girls. In the end, given certain constraints, I was able to interview only 11 families, two of whom were from the non-Brahman castes; one person submitted the information I sought by e-mail. In addition, I engaged in conversations with many Brahmans, mostly women.[7] Although a preliminary ethnographic exploration, my interviews yielded many insights on matrimonial preferences and strategies.

America *Varan*: Who are They?

In the past, Green Card grooms were much sought after, as this ensured permanent residence in the US. A striking fact that emerged from

the interviews, quite contrary to my expectations, is that today Green Card boys/girls rarely seek brides/grooms from India, and even have trouble finding them. This is because the time involved for the girl to get the Green Card to join her husband is now very long, almost four to five years, with no guarantee that it will be issued by the US immigration authorities. Thus, most of the America *varan* marriages today are with boys with H-1B or student visas. Even then, most girls do not expect to be able to become US residents and citizens, unlike in the past. Boys with H-1B visas are scrutinised and classified by the girl and her family in terms of their qualifications and the probability of their securing a Green Card for permanent residence. Families are well aware that, while permanent residence would be their first option, many software jobs are being relocated from the US to cities like Bangalore and Pune in the post-9/11 scenario, and that the H-1B visa itself is being restricted. Parents, and now girls as well, are prepared to stay in the US for a relatively short time and then return to India. Some told me that with 'everything now being available in India', it really did not matter that they might have to relocate back to India after a few years, and that it was actually important to do so relatively early in one's career in order to be absorbed into the Indian software market. In other words, unlike the earlier Green Card marriage migrants, the majority of the America *varan* migrants to the US must reckon with the fact of impermanence.

But for parents who would like their daughters to settle permanently in the US, screening the H-1B visa holders in terms of education is important. Many feel that mere software qualifications, like MCA (Master of Computer Applications) or degrees/diplomas from GNIIT, are insufficient; in their perception, the probability of the employer sponsoring such a person for a Green Card was rather low. Those with engineering or MBA degrees from reputed institutions are preferred.

Nonetheless, the IT expansion and the growth of software job opportunities in the US have now brought the 'America dream' to a cross-section of middle-class Brahman households of more modest means than earlier Green Card marriage migrants. This 'America dream' has also spread to the non-Brahman castes among whom technical higher education has caught on. These respondents often remarked that nobody else from their family was in the US, whereas in the case of girls who had married and migrated permanently to the US in the 1970s or 1980s, many family members and relatives were now settled in the US. In some of the latter cases, even the parents of the girl have become US residents and citizens, and have stayed on there.

America *varan* marriages among those on student visas are also common. Boys who have gone to the US for higher studies are seen as brighter and more intelligent, and therefore likely to have better career prospects; sometimes, though not invariably, they are also from the higher economic and social strata of Brahmans. Typically, a boy who goes to the US to study returns to get married even before the completion of his studies, enabling him to take his wife along with him on a student spouse visa. Many are confident of getting work sponsorship that will subsequently secure a Green Card. Those who fail to get a work sponsorship after an MS (Master of Science) or MBA programme of study move on to a doctoral programme to extend their stay in the US in the hope of staying there permanently, though some do not succeed and are ultimately forced to return to India.

With a growing number of Brahman girls themselves going to the US for higher studies, it is now common for parents in India to match the horoscopes and come to a general agreement with the family concerned. Following this, they ask the boy and girl in the US to talk over the phone, and then meet over a weekend at their mutual convenience to come to a decision as to whether to marry. These girls generally prefer to choose among potential Green Card holders or those with student visas, preferring boys with US educational backgrounds similar to their own, and seeking permanent residence. Only when a young woman is sure of work sponsorship leading to the acquisition of a Green Card would she opt for someone with a H-1B visa. Only very rarely does a girl on a student visa come back to India to select a groom for herself; rather, she lets the parents do the screening and introduce her to young men already in the US.

In the 1970s when marriages to Green Card holders were common, Brahman girls from the upper social strata, who had enrolled for their BA degrees in English literature in reputed women's colleges in Chennai, often hoped to find a scientist husband in the US. Even if at the time of marriage the young men were still doing their postdoctoral research, they could eventually expect to find themselves in a scientific research establishment or a university. Such girls already had a good knowledge of Western society and culture gained through reading Western literature and history, and were eager to assimilate to the extent possible with their host society. But in today's globalised diasporic world, the young women getting married to H-1B visa holders are often themselves MCA or engineering graduates, and have little knowledge of Western culture and civilisation except for what is now aired on television. Few of them can claim education in convents or Christian colleges that, at least

until recently, promoted greater exposure to Western culture through literature, the arts and history.

Thus, one respondent, living in Houston and visiting her family in Chennai for the first time after her marriage nearly two years ago, was eager to tell me how she was running her household in Houston and celebrating religious festivals exactly as she would have done in Chennai. When I asked specifically about her interaction as a housewife with people of another race/colour/culture, she said that these interactions were more of a casual nature in the apartment building and stores. Not all girls are necessarily content with such a life, however. One parent respondent who was fixing an alliance for her son, then on a student visa but with high probability of obtaining a Green Card through employer sponsorship, confided her anxiety that young women are becoming more assertive and independent. She was afraid that a young woman, after getting married to her son, might walk out of the marriage on the grounds that she did not like living in the US. 'What if she came back with her suitcase?' was the way she put it. Hence, the parents had decided that they would prefer to select a girl who had already visited the country for a short while—an ultra-precautionary stand, but they ultimately did succeed in finding such a girl. Of course, not every one insists on such a condition. I heard of no recent case of a Brahman US citizen coming to India to select a bride. This could be on account of the time required to acquire US citizenship, by which time the young men would already have found a partner. Or, if they were single, their age or their divorced status may have been a disadvantage in seeking a partner through this kind of arrangement.

The Various Channels and Networks

The channels that each family sources to identify potential brides and grooms are numerous and varied. The first stage in the process involves both putting the horoscope into circulation and collecting as many horoscopes as possible. The use of personal networks of family, extended kin groups and friends, though prevalent, is now of much less importance than was the case earlier. Correspondingly, there is greater dependence on the impersonal sourcing of horoscopes. Most respondents clarified that they never searched only for America *varan*. For

one thing, it would be a little embarrassing to be seen as openly aspiring for material well-being. Second, given the uncertainties of finding such a match, it is deemed best to keep options open. All admitted, however, that they were keenly interested in America *varan* for various reasons. For instance, they might claim that the girl preferred to live abroad, or that the astrologer/s whom they consulted had indicated such an alliance as more promising. All the same, most interviewees considered that such an alliance was quite 'prestigious' and 'status-enhancing' for the girl's family within their social class.

Personal networks have generally been, and continue to be, a productive source when the girl for whom the alliance is sought is strikingly beautiful. The mother of such a girl is generally prodded and encouraged by her relatives or friends to seek a match for her daughter in the US, even if she had earlier decided against doing so, or had been wavering. Otherwise, it appears that personal networks are not a very encouraging source for locating prospective grooms. Nowadays personal networks function to provide information to the girl's family that a possible match may be found in a particular family whom they may then contact. Among Tamil Brahmans, relatives tend to leave the initial selection of a prospective alliance to the parents themselves, though in many instances family tradition and hierarchies of status within the family oblige them to consult 'family elders' before finally settling the alliance.

A Telugu Brahman respondent highlighted the contrast between his community and the Tamil Brahmans by noting that personal networks for finding boys were still the dominant mechanism of matchmaking in their community. This could also be a reflection of the fact that close kin marriages are still strongly preferred among the Telugu Brahmans, whereas this is no longer so among the Tamils. Indeed, in the light of the literature on Dravidian marriage practices, it is a matter of surprise that not a single respondent spoke of the rule of cross-cousin and preferential marriage, nor did they indicate that any such eligible kinsperson was overlooked in favour of a non-kin alliance. Clearly, modernisation and urban cultural values have weakened the relations between affines, which are now more or less symbolic rather than functional. With non-kin marriage alliances now overwhelmingly common among Tamil Brahmans, the modalities through which alliances are made are therefore outside the kin networks.

Sometimes friends are supportive in passing on horoscopes of prospective brides and grooms that they come across, mostly

intermittently rather than on a regular basis. One respondent told me that she and her husband were assisting their neighbour in finding a suitable boy for their daughter by passing on to them the horoscopes that came their way. One day the neighbour's family asked my respondent why they themselves could not accept their daughter as a match for their son, living in the US. Although the respondent was not keen to fix an alliance for their son prior to that of their daughter, they acceded to their neighbour's request, as the boy and the girl had known each other for a long time as neighbours, and the boy himself had consented to the alliance.[8]

As the role of personal networks has diminished, impersonal networks have emerged. Advertisement in the English newspaper, *The Hindu*, is by far the most popular channel for placing an advertisement, though women's magazines like *Mangaia Malar* also carry advertisements. A non-Brahman Gounder respondent noted that members of the Gounder caste bought a monthly magazine that carried matrimonial advertisements. One Brahman respondent who was earlier employed in a women's organisation was critical of the stereotyping in advertisements for brides expressed in key words like 'slim, beautiful, fair, professionally qualified, preferably working or studying in the US', disregarding aspects she felt should take priority in fixing a match and thus leading to trouble should differences arise later. For her, emotional compatibility, not just physical attraction or material well-being, was the important consideration.

Parents of girls also seemed sensitive to gender power asymmetries regarding responses to advertisements. The girls' families are still cautious of placing a newspaper advertisement, and those who did seemed to have done so just once. Many felt that they did not get sufficiently good responses from newspaper advertisements either in terms of numbers or in terms of the quality of prospective grooms, as judged largely in terms of education and employment. Advertisements placed by the boys' families seemed to be more common and have better responses. The shift in the corresponding addresses from post office box numbers provided by the newspaper to e-mail addresses has not always worked well for the girls' families as the families of prospective grooms often do not respond by e-mail or do so very casually. Almost every respondent from the girls' side complained that in most instances the boys' families typically collected as many applicants' horoscopes and photographs as possible, and then short-listed them. Those that are not shortlisted get no response at all or, if contacted by the girls' families, are not always told clearly that they did not make it to the

shortlist. This kind of behaviour was seen to indicate that the boy's side has the upper hand in the negotiations.

While personal networks are not usually helpful in identifying potential grooms, it is still necessary to network with persons residing abroad in order to verify the boy's character. Such verification of the boy's and his family's background and character is fairly easy in the case of local alliances, but when the boy is residing abroad, the risks involved are many. Most families identify a friend or relative in the US/Canada to initiate a telephonic contact with the boy. I heard of a number of cases in which the boy so contacted was unavailable over the phone or refused to return calls several times. In all such instances the girls' families invariably dropped the negotiations. In many cases parents in India are eager for their son residing abroad to get married, but the boy himself shows no interest. Cases were also reported to me of instances when the boy came to India and got married to a girl of his parents' choice, but then never called the girl to join him abroad, and after some years terminated the marriage.

Selection and Rejection

The plight of those on the boys' shortlist is no better. The girls' families often felt that they were given too much hope about the alliance being settled. As a result, they sometimes put their search on hold, perhaps for eight to nine months, but when the boy finally came from the US, he saw half-a-dozen or more on his shortlist and picked the one he liked. Of those girls who were not selected, their parents felt not just rejected but even cheated. One respondent who experienced this quite recently told me that the boy had chosen his bride even before landing in India, having stopped en route in Dubai where he met one of the shortlisted girls and decided to marry her.

While rejection and acceptance are invariably aspects of all matrimonial selection, in the case of 'domestic' alliance, this is done on a case-by-case basis. This seemed less humiliating for the girls' families than rejection based on a brief comparison. One respondent who recently got married to a boy in the US said of America *varan*:

They are so quick in the sense that they go see five girls or more and decide on one and reject the others. [This was not the case for me

however.] It's usually hotshot, see today and get married day after tomorrow.

A boy's family observed that they had received nearly 100 horoscopes in response to just a single advertisement placed in *The Hindu*. However, my respondent expressed surprise that many horoscopes had been sent thoughtlessly, since the family had even received one or two horoscopes from families of other castes, though they had advertised only for a Brahman alliance. The family of a Chettiar girl had even approached them personally to assure them that they had no objection to a Brahman alliance. There were one or two applicants who were much older than her son, which shocked her immensely. Ultimately, the family did not pursue any of the responses to their advertisement. Not only was the rejection rate by the astrologer whom they consulted for 'matching the horoscopes' very high, but they were also dissatisfied regarding the applicants' family backgrounds. My informant claimed that they were only looking for an 'orthodox type' girl, by which they meant a religious background and belief in God, an 'acceptable' relationship between her parents, and correct behaviour of the girl towards elders. Being personally unwilling to embarrass the rejected applicants, she passed on the burden of rejection to her mother who made the excuse of 'horoscopes not matching'.

Most respondents used newspaper advertisement along with other channels. For example, temples now provide horoscope exchange services. Commercial and voluntary matchmaking services also undertake horoscope exchange. Many of my respondents had heard of the well-established service provided at the Ganesh temple in Mahalingapuram in the Kodambakkam area. Once registered there, the temple mails a list of prospective grooms/brides on a quarterly or bimonthly basis, from which an initial selection may be made, after which the temple or the party concerned could be asked for the horoscope.

One of my respondents claimed that she had fortunately found an America *varan* match for her daughter from the horoscopes mailed to her by the Mahalingapuram temple. However, another respondent, who is still seeking such a match, claimed that the temple list contained applicants from a lower socio-economic class of Brahmans, not quite up to their expectations.

While the Mahalingapuram temple service is preferred primarily by the Iyer Brahmans, the Iyengars in Chennai prefer a similar service rendered by the Parthasarathy temple in Triplicane. A recently married Iyengar respondent observed that her mother had registered her

horoscope at the Parthasarathy Swamy temple marriage bureau called
Geethacharyan. She claimed that she had not been totally in favour of an
America *varan* marriage as she wanted to live close to her ailing parents.
But the problem was that the horoscopes of prospective grooms living
in Madras did not match, while the horoscopes that matched were of
young men living elsewhere, mostly outside the state in places like
Mumbai, Delhi or even abroad. One day, her husband's father, who
had also registered his son's horoscope at Geethacharyan, approached
her parents saying there were 'nine *poruthams*' (horoscopes matching
on nine different counts, which is considered a near perfect match).
That is how she ultimately got married to a groom in the US, who is a
software engineer on an H-1B visa.

For this respondent's family, horoscope compatibility was deemed
extremely important, as it generally is in the case of domestic alliances
as well. But another respondent, the mother of a 'non-beautiful'
daughter whose marriage was fixed recently to a boy in Bangalore,
placed a different construction on horoscope matching. She confided
that she would have liked to have fixed an America *varan* alliance for
her daughter. She believed that her family had the requisite social and
economic status, but noted that, in reality, the primary consideration for
an America *varan* alliance is the 'girl's beauty'; if the prospective groom
and his family are pleased with the girl's beauty, they can sometimes
even overlook the question of horoscope compatibility.

Indeed, many parents of the girls were acutely sensitive to the
issue of rejection based on the criterion of personal beauty. Many
were bothered by the emerging practice of asking for the girl's
photograph along with the horoscope right at the initial stage.
The boys' families on the other hand claimed that such an approach
expedited the matchmaking process, especially considering the fact
that the boys concerned generally came on a brief three-week trip
from the US. In fact, even temples or other agencies that use the
Internet to maintain their databases of potential partner-seekers ask for
photographs to be put up. Not everyone approves of this.

Commercial Agents

Not only do temples use computerised databases, but other agencies,
such as the Tamil Nadu Brahmans' Association, have also started

providing horoscope exchange services and maintaining a computerised database.[9] Many of my respondents also used the services of one Jayarama Iyer of Mandaveli, who facilitated the exchange of horoscopes by maintaining files of prospective matches, throwing his house open for fixed hours every day for clients to avail of his free services. Other respondents, however, felt that his database contained relatively few America *varan* cases.[10]

Individuals have also started commercial matchmaking agencies. A respondent claimed to have been cheated by one such agency, to whom he had advanced nearly Rs 8,000. The agent had promised his clients that he would give them a set of horoscopes of prospective boys that suited all their stipulations within three months. Although the client did receive some horoscopes during the period, these were neither pre-screened nor did they come up to expectations, many being simply downloaded from Websites like Tamil Matrimonial.

A respondent of the Gounder caste told me that marriage brokers are very common in their community, charging something like 3–5 per cent of the cash and gold dowry that the boy receives from the girl's family, and a certain amount from the girl's side as well. Such brokers are virtually non-existent among the Brahman community, however.

The Role of Astrologers

When the girl's or the boy's family acquires the horoscope of a desirable match, the next step is to check with the astrologer on the compatibility of the horoscopes. In some families an elder may have acquired the proficiency to read and match horoscopes, but that is relatively rare. By and large, Brahman families consult an astrologer whom they have known for a long time, or one who has been introduced to them by someone considered reliable. Astrologers commonly charge fixed fees, or they may leave the matter to the client's discretion. As the process of matching horoscopes might involve numerous attempts, the family will generally seek the advice of the same astrologer, effecting a change only when they find the rejection rate is unduly high, if they learn that another astrologer gives more specific or accurate predictions than the one whom they have been consulting, or for one who uses alternative

methods like *'nadi joshiam'*.[11] Limitations of time did not allow me to seek interviews with astrologers.

That one of the most forward-looking and modern communities in India, a community that has produced numerous men and women of science, still believes strongly in astrology appears to be a puzzle[12], but faith in horoscope compatibility and astrological advice is a distinguishing aspect of Brahman matchmaking strategies. In fact, many non-Brahman castes that had hitherto selected partners on the basis of mutual liking have also begun to consider the compatibility of horoscopes.[13] A Nadar respondent told me that the Self-Respect Movement of E.V. Ramaswami Naicker in the early decades of the 20th century was very strong in her village and that most of their caste have adopted what are called 'social reform marriages' that do away with Vedic rituals, Brahman priests, horoscopes, etc. Even in such communities, however, changes in matchmaking practices have begun to set in. Nowadays, something like a fete is held in the village area to which all community members on the lookout for partners come to discreetly make choices. One has heard of such get-togethers among NRI communities in the New York–New Jersey area, but it is apparently prevalent in some areas of India as well.

Expectations and Dowry

Once the horoscopes of the girl and boy are matched, the girl's family usually approaches the boy's family to confirm their interest in the alliance. If the boy's family is also interested and finds the horoscopes compatible after consulting with their own astrologer, they indicate their desire to proceed further. Astrologers for both the parties do not necessarily concur. In some cases the boy's family comes to see the girl first to decide on her suitability and whether to send her photograph to the boy abroad; others wait for the boy to come and see the girl. In a few cases I found that the families concerned had already approved the alliance, the girl and the boy saw each other via a web camera, spoke to each other over the phone, exchanged a few e-mails, and then agreed to get married. Sometimes when the boy from the US comes to India to meet a couple of girls before making a choice, he prefers to meet the girl first in some common friend's house, a shopping mall, a restaurant or, more likely, in another wedding, rather than in her own home.

It may come as a surprise to many that not a single Brahman respondent in my sample admitted to having given or received any dowry. Until the 1960s and 1970s it was common for the girls of Brahman families to give a specified sum of money, called *vara dakshana*, to the groom's family at the time of fixing the marriage, for which a small ceremony is held at the groom's house. It appears that this practice of giving a stipulated cash sum is not as widely practised as it used to be. In fact, it would be considered inappropriate and shameful if the boy's family were to ask for *vara dakshana*. In its place, the boys' families now indicate that both the marriage and whatever gifts of jewellery the girl's family gives to her should be appropriate to the social and economic 'status' of the boy's family. There are also expectations of gifts to the boy, like a diamond or gold ring, and good quality suits.

Most of my informants observed that the general expectation in the America *varan* alliances is one of 'decent marriage'. This involves gold jewellery to the extent of 15–20 sovereigns (each sovereign is 8 grams of gold), the silver utensils generally required for ceremonies and rituals, diamond earrings of nearly 1.5 carats of diamond, and the mandatory four Kancheepuram silk saris. Additionally, the wedding should be solemnised in a nice *kalyana mandapam* and should include an evening reception with a music programme and wedding meals served through the entire day-and-a-half of the function for an average of 200 guests each time.

Some respondents mentioned that these expectations for America *varan* alliances are in fact relatively modest compared to domestic alliances, where more household items, like utensils, mixers, cots and steel almirahs, need to be given to the married couple to set up their home and a number of gifts are to be given on various occasions throughout the first year of marriage. Even so, Tamil Brahman families do not in general demand consumer durables like cars and refrigerators, as often happens in other parts of the country.

In recent times newspapers have reported cases of America *varan* marriages in which the girl is abandoned by her husband on the promise that she would be invited to join him later. In the meantime, his parents make excessive demands for additional dowry, putting the girl and her family through considerable mental torture. It is difficult to determine the caste status of these families from newspaper reports. A few of my Brahman respondents did tell me that they were aware of such cases of abandonment and that in some cases the girl concerned had sought a divorce and remarried, but these were all cases that had occurred to 'a

friend of a friend of a friend'. Most of my informants were aware of the risks of America *varan* marriages, but were willing to take them.

The question of who is to bear the airfare for the girl to join her husband in the US is sometimes a ticklish issue for middle-class parents who find the marriage expenses burdensome, but usually the girl herself requests her prospective husband to send the ticket. More worrisome is the question of whether or not a visa will be issued to the spouse at all. When the boy is on a student visa, his family may prefer to have a girl who already has a family member in the US, either a brother or a sister, who can file the necessary papers to get her there, first on a visitor visa and change the status later on. One respondent told me that she was compelled to drop a prospective alliance for her son precisely on the grounds that the girl's father had said that he could not ensure that the girl would get a US visa. Many respondents also indicated that software engineers on H-1B visas have a marked preference for girls with MCA or BE (Bachelor of Engineering) qualifications that would enable them to get employment in the same field, while boys studying for MS degrees in the US, and likely candidates for Green Cards are not so particular about the girl being professionally qualified, often giving her the option to study, work or just be a housewife.

Matches for Girls Who Go Abroad for Higher Studies

As a modernised social group, Tamil Brahmans have always sought to outsmart the rest by playing the education card. This was the first community to overcome inhibitions and send girls abroad for higher education, and is now the first to capture the benefits of the IT opportunities through technical education. While other forward and non-Brahman castes are now catching up with the trend of sending their daughters abroad for higher studies, there is no doubt that the Tamil Brahmans are well ahead of others.

Finding partners for girls studying abroad is also a major parental concern. Radhamami's only daughter Nandini was an exceptionally bright student who had completed her undergraduate engineering degree from BITS, Pilani. After graduation, she worked for a year in Novelle, a Bangalore-based IT company, and a year later proceeded to

the US on an assistantship for a dual MS degree in science, technology and information technology in Portland, Oregon. Radhamami, recently widowed and coping with her new status in a joint family with no income of her own, was initially very frightened and reluctant to send her only daughter to the US, but she was encouraged by friends and relatives to do so. Today she has no regrets.

Nandini was fortunate to have her father's cousin living nearby in Seattle who took the initiative to find a marriage partner, a boy appropriately qualified and working in Intel in Portland itself. Although her uncle knew the boy's uncle and vouchsafed for his character, it was an arranged marriage in which horoscopes were exchanged and matched. The boy's mother and the girl's mother also met with the girl and the boy respectively. Radhamami claims that she gave considerable importance to the boy being religious, celebrating Hindu festivals and keeping up Indian cultural traditions, and she is indeed happy that her son-in-law recites *shloka*s and *sandhyavandanam* or *gayathri japam*.[14] Although she broke down inconsolably many times during the interview recalling the death of her husband at a young age, she is happy that her daughter is both well settled and very supportive. On completion of her programme of study, Nandini got a job in Portland, although she did not yet have her Green Card. She had apparently taken an assurance from her husband before her marriage that he would have no objection to her either being employed or supporting her mother in India financially. With her earnings she also financed her brother's MBA education in India, and more importantly, put Rs 500,000 from her earnings into her own wedding.

Young women like Nandini who are bright and who graduate with engineering degrees from good institutions have used their qualifications as a passport to get out of the rut of Indian middle-class living to what appears to them as a better-off life in the United States. Opting for higher education in the US and jobs there, they use various channels to find partners, often within the framework of what would be considered 'arranged marriage'.

On the other hand, Raghuraman's strategy for getting all his daughters married to boys in the United States indicates the great importance that middle-class Brahman families attribute to a girl's higher education and professional qualifications in conjunction with marriage to an equally educated and qualified man of the same caste and social background. Raghuraman had encouraged all his daughters to go the US for higher education—one for engineering, another for optometry, and the third

for media studies—while he himself opted for voluntary retirement from a bank in order to finance his youngest daughter's education. He also encouraged them to find their partners there. The first two girls found their partners through channels like the Internet, but once they had decided that the match was allright, they passed on the details to their parents in India, who then checked up with the boys' families. The girls were keen to select only boys who, like them, had gone to the US for higher education and had settled there after finding appropriate jobs. Lest there be too many adjustment problems, they did not want to marry boys who were born and educated in the US to immigrant parents, or those who had gone to the US only for jobs through employer or family sponsorship. Once the eldest daughter got married through that process, she helped her younger sister in finding a husband in the same way. Only the last daughter had selected a partner on her own through a love affair with a Brahman boy of a different sub-caste, who had first gone to Australia for higher studies and then joined her in the US. The father told me that he had indicated to his daughters that he would accept a love marriage, but had advised them to fall in love only with Brahman boys, as otherwise there would be adjustment problems. He then went on to narrate the difficulties of inter-caste marriages in his own extended family in India.

Gowri is perhaps an exception to the way the girls who go the US find their husbands. A graduate of the Indian Institute of Technology, Madras, she was the only child of a middle-class Brahman family. Despite her mother's reluctance and fear but thanks to her father's encouragement, Gowri did what every IIT graduate is expected to do, that is, proceed to the US for higher studies. After her studies, she got herself a job and a Green Card through employer sponsorship. Once settled there, she found herself a partner, effectively a 'love match' to a Tamil Brahman boy who was born and educated in the US to immigrant parents and who could hardly speak proper Tamil. She married him in the US with his family members attending the wedding, and then returned to Chennai where her parents organised a wedding reception. Gowri's selection of a first-generation immigrant would be considered a bold and rare step by most Indian girls and their parents wanting to settle their daughters in the US.

In all the cases cited we note how diasporic opportunities are realised by the girls themselves through the channel of higher education, and the ways in which diasporic marriage alliances are fixed, most often within the frame of 'arranged marriage'. Yet these strategies give the girls a much

higher degree of autonomy and freedom of choice in matchmaking than is available in India, where parental involvement is much greater.

Why the America *Varan* Preference?

Explaining their America *varan* preference, most parent respondents said that they felt it would ensure a better future for their daughters. One mother, the principal of a well-known school in Chennai, whose daughter was studying in the US, explicitly pointed to what she thought were immense opportunities for her daughter's intellectual growth in the US and the possibilities for her to lead a more creative life. She recounted in detail her visits to the parental homes of young men under consideration for her daughter. In many cases, she said, even if the boy was well educated and settled in the US, she had been forced to drop negotiations in view of the way his family lived in India, far below their own social status and standards of good living.

Brahman women who migrated through marriage to the US in the 1970s have children studying in leading institutions like Harvard or Princeton, and this serves as a role model for many Brahman families, like the aforementioned intellectually inclined teacher. Typically, such persons endeavour to send their girls for education to the US and arrange for them to get them married to boys who are also studying in the US and are likely to get Green Card sponsorship through employers.

On the other hand, another mother told me that she has advised her daughter, who is on an H-1B spouse visa, not to put up with all sorts of difficulties just to stay on in the US. She was most welcome to return to India where all opportunities for a good life are now equally available. A Brahman father, frustrated by all the efforts that he has so far put into finding an America *varan* alliance for his only daughter, was more frank about his preference for such an alliance. If he married his daughter to a boy living in Chennai, he told me, he would have to worry about the locality and neighbourhood where she would be staying. Earlier, the elite and the rich Brahmans of Chennai lived in independent bungalows and a girl married into such a family would live in her in-laws' bungalow in an extended nuclear if not a joint family. Now, with apartment living becoming more common, young couples living apart from their parental families cannot afford a pricey apartment in a good

residential neighbourhood in the early stages of the boy's career. This bothers the girl's parents who feel that their daughter would be better off in the US. In all these rationalisations, we note how matrimonial strategies are being deployed in the reproduction of class status.

With newer economic opportunities available to this forward-looking community, there is greater differentiation within the caste. Matrimonial strategies are deployed to ensure class mobility, as in the case of lower- and middle-class Brahman families whose children become software specialists and proceed on H-1 visas to the US. Elite Brahman families concerned with the inter-generational reproduction of class status in a globalised world use diasporic opportunities through foreign education for their children, and seek to retain their class status through the strategies of matchmaking.

Even after an alliance is fixed, the girl's family have to assert themselves to keep the boy's family happy. While this may be true in other communities as well, Tamil Brahmans do indeed have an exaggerated attitude to what is called *sammandi mariyadai* (respect for in-laws), a much talked about feature of Tamil Brahman society. A Telugu Brahman respondent told me in this connection that the girl's and the boy's families in her community relate to each other like friends and family members once an alliance is fixed, unlike Tamil Brahmans, among whom the in-laws' family will have to 'sit on the drumstick tree'. (In Tamil folklore only demons sit on the drumstick tree!) One can only imagine how exaggerated this aspect of 'respect for in-laws' would be in the case of prestigious alliances like the America *varan* marriages.

Both mothers and daughters whom I interviewed felt that fixing an America *varan* alliance was socially extremely prestigious: 'It's a big thing,' as one girl put it. Many of the respondent mothers had availed of the opportunity to visit the US at least once, most probably at the time of their daughter's pregnancy and childbirth. For many of them it was not merely the first time they had travelled outside the country, but the first time they had boarded a flight. All the excitement apart, it greatly added to their prestige in their own social circles. There are numerous jokes and caricatures in circulation about how some parents wear their pride. One girl I interviewed reported that her father-in-law had told her that he was a simple man who did not go about wearing a T-shirt just because his son was in the US!

At least one set of respondent parents were thinking of migrating permanently to the US or Canada where both their sons were residing. However, many others felt that this was not feasible and had no intention

of migrating, perhaps because they themselves were relatively young. Many of the Brahman marriage migrants of the 1970s and 1980s have taken their old parents either permanently or for long stays in the US, especially if there are no other siblings in India to take care of them.

Conclusion

Many may wonder as to what makes this account of America *varan* marriages so unique to Tamil Brahmans when presumably all other castes and communities would go through the same processes in order to find a match. While we need to have more information on other caste groups, a number of considerations distinguish the Tamil Brahman community's preference for such marriages. To begin with, the Dravidian movement in Tamil Nadu for much of the last century was a non-Brahman movement that, in targeting Brahmanism for attack, rendered them a socially and politically powerless group within Tamil society. Sidelined from the state's organised sector employment avenues, such as the administrative services and educational employment, on account of the Dravidian movement politics and reservation policies of the 1950s and the 1960s, Tamil Brahmans have shown great agility in grasping opportunities for upward social mobility. Migrating out to other metropolitan cities in India, and to the US and elsewhere from the 1960s, it is not surprising that, with the so-called IT revolution, this group is once again at the forefront. Not only have the boys and girls of this community been quick to acquire the requisite technical qualifications, without much gender bias, but the software industry in Chennai is also apparently dominated by them.

The analysis of America *varan* marriages among Tamil Brahmans indicates the role played by matrimonial strategies in promoting upward social mobility and the enhancement of social status. But what it also indicates is both the awareness and unquestioning acceptance of deep gender asymmetries in matrimonial transactions. Such an unquestioning acceptance arises from prior caste and gender socialisation. Kathleen Gough (1993) has noted that, as wives, Brahman women have a much lower status in the husband's family. Despite modernisation and higher education, Brahman girls do not question the patriarchal family structures. The class and gender *habitus* that is the outcome of these

dispositions facilitates the reproduction of these gender asymmetries, constructing gendered identities that make Brahman women happy subjects of patriarchy in one sphere even as they gain the freedom and opportunity to move into the modern world.

Acknowledgements

I am deeply grateful to Radha Raman, M.S. Rajagopalan and Kedarnath for helping me identify respondents and setting up interviews with them. Special thanks to Patricia Uberoi and Rajni Palriwala for their insightful comments on an earlier draft of the chapter.

Notes

1. See Uberoi (1993) for the classic readings on family, kinship and marriage in India.
2. The sociological literature has underscored the importance of the principle of 'alliance' in Indian marriages, whereby a 'marriage' is construed as a union between two families through the 'giving' of women, rather than just an arrangement between two individuals setting up a new conjugal family together (Uberoi 1998). Also see Dumont (1983).
3. Although the term 'America varan' is reciprocal and could be used for finding either grooms or brides, in practice it refers to finding America-based grooms. Tamil Brahmans rarely find a groom from India for a girl residing in the US. This is because girls who go to America on their own do so mainly for higher studies; it is expected that a marriage alliance for them would be fixed with a boy already residing in America. Unlike Punjabi or Pakistani immigrants, Tamil Brahman immigrants in America rarely seek alliances from India for their America-born-and-educated children, except in the case of a 'love marriage' between an Indian girl or boy who goes for higher education and meets a first-generation immigrant.
4. For instance, Geetha Benett, who has written novels and short stories in Tamil on expatriate life in the US.
5. While Karve (1993) noted that Dravidian marriages are increasingly following the North Indian marriage model, Dumont (1993) observed the commonality between the two in terms of the role of affinity, which, dominant in Dravidian marriages, was not altogether devalued in the north. Gough (1993) observed the preference for matrilateral cross-cousin marriages over patrilateral cross-cousin marriage among the Brahman youth of a Thanjavur village, although she also noted that patrilateral and matrilateral cross-cousin marriages and marriage to the sister's daughter each accounted for only

4 per cent of all Brahman marriages. Trautmann (1981, 1993a, 1993b) quite rightly suggests that we need to explore through rigorous statistical methods the degree to which marriage practices deviate from the rule. According to him, the rule of cross-cousin marriage on the ground is subject to many contingencies, such as, the availability of a cross-cousin, the existence of conflicting rules—for instance, the matching of horoscopes and considerations of family and personal advantage—and so on. Kapadia (1996) brings to attention the fact that cross-cousin marriages among Brahmans were never isogamous, as among non-Brahmans, but were hypergamous, much like those in North India. In the Tamil village that she studied in the late 1980s, she observed a shift from cross-cousin marriage among both Brahmans and non-Brahmans to a marked preference for non-kin marriages, suggesting that class- and status-based alliances within endogamous groups are becoming more important as a result of the spread of urban cultural values.

6 I came across a young MCA graduate who was interviewed for a job in Chennai after graduation. She made the mistake of letting the interviewers know that her parents were on the lookout for an alliance for her. The potential employer was sure that she would be married quickly to a software professional proceeding abroad, and did not offer her the job. As luck would have it, her marriage was not settled for a year, and the next year she had to compete for a job with fresh graduates.

7 One woman, contacted by an intermediary, refused an interview because she was afraid that I might ask awkward and embarrassing questions. According to my intermediary, the woman refused to be interviewed because Raj TV, a Tamil channel, had recently screened a play *Rakkaiya Kattiya Manasu* (A Winged Mind) in which an Indian male researcher from the US comes to conduct a survey and asks explicit questions about sexuality, causing discomfort to the women interviewed.

8 It is usual practice among Tamil Brahmans, and quite generally among all Tamils, that if the age difference between a son and a daughter is not great, then it is the girl's marriage that gets precedence even if she is the younger of the two. My respondent's experience is, therefore, relatively uncommon.

9 The Tamil Nadu Brahmans' Association, which came into prominence following the demolition of the Babri Masjid and the rise of the BJP, has tried to take up the social and economic problems of lower-middle-class Brahman families adversely affected by the policy of lower-caste reservations in employment. The rise of this association indicates the dilution of Dravidian fervour in Tamil Nadu politics in recent years.

10 An attempt to confirm this directly from him met with a strong rebuff as he refused an interview with me, claiming he was only doing social service and did not seek publicity by giving interviews.

11 *Nadi joshiam*, a system of astrology based on inscriptions contained in ancient palm leaf manuscripts that probably originated from Kerala, is claimed to be a more accurate method of astrological prediction.

12 A.K. Ramanujan (1990) deals briefly with this puzzle of the Brahman's belief in astrology.

13 This may be seen as yet another aspect of the Sanskritisation process.

14 *Sandhyavandanam* is the daily mandatory worship of the sun god for Brahman youth and men who have been initiated through the performance of the *upanayanam* ceremony and are consecrated to wear the sacred thread, which, in effect, ushers them into Brahmanhood. *Gayathri japam* is the prayer recited during the performance of the *sandhyavandanam*. It is claimed that the prayer confers mental and spiritual powers of endurance.

References

Bourdieu, Pierre. 1977. *Outline of a Theory of Practice*. Cambridge: Cambridge University Press.

Dumont, Louis. 1983. *Affinity as a Value: Marriage Alliance in South India, with Comparative Essays on Australia*. Chicago: University of Chicago Press.

———. 1993. 'North India in Relation to South India', in Patricia Uberoi (ed.), *Family Kinship and Marriage in India*, pp. 273–86. New Delhi: Oxford University Press.

Gough, E. Kathleen. 1993. 'Brahman Kinship in a Tamil Village', in Patricia Uberoi (ed.), *Family, Kinship and Marriage in India*, pp. 146–75. New Delhi: Oxford University Press.

Kapadia, Karin. 1996. *Siva and her Sisters: Gender, Caste and Class in Rural South India*. New Delhi: Oxford University Press.

Karve, Irawati. 1993. 'The Kinship Map of India', in Patricia Uberoi (ed.), *Family, Kinship and Marriage in India*, pp. 50–73. New Delhi: Oxford University Press.

Ramanujam, A.K. 1990. 'Is There an Indian Way of Thinking? An Informal Essay', in McKim Marriott (ed.), *India through Hindu Categories*, pp. 41–58. New Delhi: Sage Publications.

Trautmann, Thomas R. 1981. *Dravidian Kinship*. Cambridge: Cambridge University Press.

———. 1993a. 'The Study of Dravidian Kinship', in Patricia Uberoi (ed.), *Family, Kinship and Marriage in India*, pp. 74–90. New Delhi: Oxford University Press.

———. 1993b. 'Marriage Rules and Patterns of Marriage in the Dravidian Kinship Region', in Patricia Uberoi (ed.), *Family, Kinship and Marriage in India*, pp. 273–86. New Delhi: Oxford University Press.

Uberoi, Patricia (ed.). 1993. *Family, Kinship and Marriage in India*. New Delhi: Oxford University Press.

———. 1998. 'The Diaspora Comes Home: Disciplining Desire in *DDLJ*', *Contributions to Indian Sociology* (n.s.), 32 (2): 305–36.

BROKERING MARRIAGE

5

COMMERCIALLY ARRANGED MARRIAGE MIGRATION: CASE STUDIES OF CROSS-BORDER MARRIAGES IN TAIWAN

Melody Chia-wen Lu

Introduction

Commercial marriage migration, commonly termed the mail-order brides (MOBs) phenomenon, has received attention over the past few decades from women's movements as well as from immigration policy makers in Europe, North America and Japan. However, scholarly efforts began only about 10 years ago (Del Rosario 1994; Glodava and Onizuka 1994; Robinson 1996). While earlier work points to the link between the MOB phenomenon, sex tourism and sex trafficking (Barry 1995), others associate it with female labour migration, particularly for domestic work (Chang 2002; Wang 2001). There is a strong tendency to conflate female labour migration, trafficking and commercial marriage within the same analytical category and to identify the political economy of gender and the international division of labour in a market-oriented economy as its root causes (Derks 2000; Piper 1999; Wijers and Lin 1997). Other scholars argue that there is a direct link between trade relations, trade dependency, capital flow and commercial marriages (Han 2002; Hsia 2002). Whatever macro factors are identified, it is commonly agreed that the commercialisation of marriage migration is a product of globalisation, that is, the widening of the gap between developed and developing countries, causing social stratification within richer countries and, most importantly, creating gender inequality both locally and globally. It is also commonly agreed that commercially arranged

marriages turn women and marriage into commodities, placing women in vulnerable and exploitative situations.

While acknowledging the global forces at play, this chapter focuses on a much less discussed aspect of commercial marriage migration—the matchmaking and/or marriage brokerage operation. I will argue that: (a) the marriage brokering industry plays a key role in motivating potential brides/grooms to enter into international marriages and give shape to their preferences in mate choice; (b) transnational marriage migration has taken on a very traditional form and involves complex, localised social networks in which women play active roles. By investigating what is 'commercial' about commercially arranged marriages, I also argue that money 'transactions' at the time of a wedding are not the only factor affecting women's status in the receiving societies and families; or, in other words, that commercial marriage brokerage does not necessarily make women traded commodities.

This chapter draws upon empirical studies of marriages between Taiwanese[1] men and women from Southeast Asia and the People's Republic of China (PRC). To avoid any dispute on whether cross-Straits marriages (between Taiwan and the PRC) constitute internal or transnational migration, I use the term 'cross-border marriage' to cover both cases. The term 'cross-border' is also deliberately used to suggest that there are other kinds of borders, that is, gender, racial and class, apart from the national borders that set barriers for these women and differentiate between 'us' and 'others'. Apart from the demographic data provided by various government offices and the small-scale household surveys done by myself, the primary data was collected during the 15-month ethnographic fieldwork for my Ph.D. research in Hukou and Baihe in Taiwan, and Fuqing in the PRC in 2003 and 2004. The main methodology I use is life story interviews and participant observation. As my own Ph.D. research focuses specifically on cross-Straits marriages, I draw heavily for comparative purposes on the research findings of other scholars' work on Southeast Asian brides.[2]

Demographic Characteristics of Brides and Bridegrooms in Cross-border Marriages

As one of the new receiving countries of women's marriage migration from and within Asia, Taiwan has been receiving both ethnic Chinese

Table 5.1 Estimated Number of Cross-border Marriages with Southeast Asian and PRC Nationals in Taiwan: According to Nationality

Year	Vietnam	Indonesia	Philippines	Thailand & Myanmar	Cambodia	PRC	Total Marriages (%)
1994	530	2,247	1,183	870		7,177*	
1995	1,969	2,409	1,757	1,301		7,926*	
1996	4,113	2,950	2,085	1,973		9,716*	
1997	9,060	2,464	2,128	2,211		12,115*	
1998	4,644	2,331	544	1,173		15,014*	16.2
1999	6,790	3,643	603	1,184		21,165*	19.2
2000	12,327	4,381	487	1,259	875	26,474*	25.2
2001	12,340	3,230	377	1,389	567	32,438*	29.5
2002	12,823	2,602	389	1,664	632	29,545**	27.4
Current total***	42,835	10,662	3,830	6,796	2,399	161,260	

Sources: Various sources compiled by the author. The authorities governing PRC nationals and other foreign spouses are different and changing.

* Provided by the Cross-Straits Exchange Foundation, Taiwan.

** Ministry of Interior Affairs, ROC. Other figures represent the number of visas issued to foreign spouses by the Ministry of Foreign Affairs, ROC.

*** The current total (2003) is not the sum of the above columns, but the number of foreign spouses presently residing in Taiwan. (Source: National Police Agency, Ministry of Interior Affairs, ROC, December 2003.) The current number of PRC spouses is provided by the Immigration Office, National Police Agency, Ministry of Interior Affairs, ROC, December 2003.

and non-Chinese women from Southeast Asian countries and the PRC since the mid-1980s. The scale and speedy growth of the phenomenon in Taiwan is striking compared to other receiving countries of marriage migration. In 2002 cross-border marriages constituted 27.4 per cent of all marriages in Taiwan (see Table 5.1), and in some rural areas the proportion is as high as 37.1 per cent.[3] In 2002 one out of every eight children in Taiwan was born in a cross-border family.[4]

The figures in Table 5.1 include both sexes but, with the exception of Thailand, it is predominantly women who marry Taiwanese and reside in Taiwan. Table 5.2 shows the gender-wise percentage of foreign spouses and legal foreign contract migrant workers. Thai men constitute the highest proportion, that is, 2,024 of the total 6,292 foreign male spouses (32.17 per cent), of all foreign male spouses of Taiwanese nationals residing in Taiwan. They also constitute the majority of the foreign male workforce under the guest (contract) worker policy.

Table 5.2 Number of Foreign Spouses and Foreign Migrant Workers by Sex and Nationality

Nationality	Foreign Spouses*		Foreign Migrant Workers**	
	Men (%)	Women (%)	Men (%)	Women (%)
Vietnam	104 (00.2)	42,731 (99.8)	11,079 (17.5)	52,226 (82.5)
Indonesia	236 (02.2)	10,426 (97.8)	6,542 (13.2)	42,911 (86.8)
Thailand	2,024 (33.1)	4,090 (66.9)	84,408 (82.5)	17,919 (17.5)
The Philippines	307 (08.0)	3,523 (92.0)	23,806 (28.5)	59,479 (71.4)
Total (including other nationals)	6,292 (08.4)	68,159 (91.6)	125,855 (42.2)	172,537 (57.8)

Sources: Various sources compiled by the author. Percentages in brackets represent the gender-wise proportions of male and female foreign spouses/migrant workers.
* National Police Agency, Ministry of Interior, ROC, December 2002.
** Bureau of Employment and Vocational Training, Council of Labour Affairs, Executive Yuan, ROC, March 2004. The earlier published data on foreign migrant workers does not indicate gender.

Ethnic Composition and Place of Origin

Most Indonesian brides are ethnic Chinese of the Hakka ethnic group, and come predominantly from Kalimantan (Hsia 2002). Only one-fourth of all Vietnamese brides are ethnic Chinese,[5] the majority come from southern Vietnam, with 54 per cent from Ho Chi Minh City

(Wang 2001). Most mainland Chinese brides are of the Han ethnic group, with just a few exceptions from ethnic minority communities. Their places of origin are rather diverse, the biggest number coming from the coastal province of Fujian, with some from inland provinces such as Sichuan and Hunan.

Not all cross-border marriages in Taiwan are commercially arranged. Many couples meet via business contacts or during travel; in common perception, these would be regarded as 'love marriages'. (In a later section, I will illustrate the difficulties of distinguishing between a love marriage and a commercially arranged marriage.) Nevertheless, it can safely be argued that in Taiwan the majority of cross-border couples are introduced with a view to marriage. A survey[6] shows that 53 per cent of all cross-Straits couples are introduced by friends and relatives; 39 per cent are love marriages; and only 7 per cent have been matched by brokers (Chen 1999). My own survey in Baihe shows that 55 per cent of all Vietnamese brides are matched by marriage brokers, 37 per cent are introduced to their future husbands by relatives and friends, and only 7 per cent meet their husbands on their own. (As I explain in the following section, marriage brokers are quite possibly relatives and friends.)

Motivating Factors in Cross-border Marriage

It is beyond the scope of this chapter to discuss exhaustively the motivations and structural factors that impel men and women into commercially arranged marriage migration. A point to be stressed here is that, similar to Piper's (1999) findings, poverty alone is not the sole factor motivating migration. Rarely does the potential bride marry simply because she or her family is in dire need of cash; the motivation is rather the overall 'betterment' of life.[7] The term 'betterment' implies dissatisfaction with constraints experienced in the home country/region, as well as aspirations in respect of the migratory destination and, for women, is often related to personal and familial experiences. It should be noted that the majority of Southeast Asian and Chinese brides in Taiwan already have experience of internal labour migration to urban areas in the sending countries,[8] and many have earned a middle-level income and are financially independent. Many perceive cross-border marriage migration as an extension of their earlier experience of internal migration. A general feeling of a lack of work opportunities and age-related constraints, combined with the cultural belief that marriage and

economic support from a husband are the ultimate blessing for women, drives these independent women to move into an uncertain and risky world. The choice to marry abroad using the commercial brokerage system is therefore not completely driven by economic motivations.

On the receiving side, before the mid-1990s, Taiwanese men looked for Southeast Asian and mainland Chinese brides simply because it was difficult to marry local women. The areas where mainland and foreign brides are more concentrated[9] have a higher sex ratio[10] and are also less urbanised. The skewed sex ratio is partially the result of son preference,[11] but more a consequence of women's out-migration to urban areas. Men of lower education and higher age find it particularly difficult to marry.[12] Nevertheless, not all areas with a skewed sex ratio embrace cross-border marriages. The areas populated with aborigines have the highest sex ratio in Taiwan,[13] but a lower percentage of cross-border marriages.

However, since the mid-1990s, coinciding with the growth of institutionalised brokering operations, prospective bridegrooms are no longer limited to men who have difficulty finding Taiwanese brides. Some middle-class men have been tempted by the advertisements of brokering agencies, while others are motivated by observing successful cross-border marriages of friends and relatives.

The Links between Domestic Labour, Sex Work and Women's Marriage Migration

What does the geographical and ethnic origin of brides tell us? Contrary to the cases of MOB in Japan, North America and Europe, in Taiwan the marriage market, the domestic labour market and the prostitution market are differentiated. The favourite destinations for sex tourism for Taiwanese men are Thailand, the Philippines and, in recent years, the PRC. However (see Table 5.2), relatively few Thai and Filipina women marry Taiwanese men. The majority of migrant women workers in Taiwan are Filipina, Indonesian and, since 1999, increasing numbers of Vietnamese. While Indonesian migrant workers are predominantly non-ethnic Chinese, Indonesian brides are predominantly ethnic Chinese. It would appear that ethnicity is a key factor in mate choice, and that Taiwanese men prefer ethnic Chinese wives, suggesting that these should be conceived as marriages within the Chinese diaspora rather than

as MOB and cross-cultural marriages.[14] However, ethnic preference cannot explain the growing number of non-ethnic Chinese brides from Vietnam and Cambodia. Empirical data show that most Taiwanese husbands and their families do not have a definite preference in respect to the brides' ethnicity, excepting the Hakka communities, which have a clear preference for Hakka women from Indonesia and the PRC. Moreover, empirical research shows that it is very rare for Taiwanese men to marry foreign women who are already doing domestic work in Taiwan. That is to say, maids and prostitutes seldom become wives, despite ample opportunities for daily contact. When Taiwanese men look for wives, they have recourse to matchmakers and/or marriage brokers.[15]

Why should an unknown 'docile, young and beautiful' Vietnamese woman, and not an equally 'docile, young and beautiful' Indonesian woman working in the neighbourhood, be a potentially good wife? Apart from the international political economy of gender, there is another influential factor driving women into the cross-border marriage market, the migrant labour market and sex work. Shared culture and language is an advantage. However, the choices made available by brokers/matchmakers are often crucial factors in mate choice. It is the role of the mediator—the marriage broker and/or matchmaker—that determines, for instance, why an ethnic Chinese Indonesian woman might decide to marry into a Taiwanese family rather than into a more affluent Hong Kong family.

The Practice of Matchmaking

As mentioned earlier, the majority of cross-border marriages in Taiwan are intermediated; that is, potential brides and bridegrooms are introduced to each other for purposes of marriage. Unlike the MOB phenomenon in the West, where men usually select women from photo/video portfolios provided by the broker agency and engage in letter-writing for some time before they actually meet each other (Constable 2003; see also del Rosario, this volume), Taiwanese men and their families prefer to meet the potential brides in person and make a decision in a very short time. Given the cross-border dimension of matchmaking and the restrictive immigration measures in force in Taiwan[16], Taiwanese men need to travel to meet the women. The travelling, introduction, ensuing arrangements for registration of the marriage and the wedding itself, as well

as the negotiation of bride price and dowry, need to be facilitated. The marriage brokering industry was born to provide these services.

Types of Marriage Brokerage

I have classified the very diverse organisations and operations of the matchmakers/brokers into three categories[17]: (a) institutionalised brokering companies and agencies; (b) individual entrepreneur brokers and/or matchmakers; and (c) Southeast Asian or mainland Chinese brides married to Taiwanese men acting as matchmakers.

The first are brokering agencies with standardised matchmaking operations, charging fixed fees, with business contracts and guarantees for their services[18], and utilising advertisements (in newspapers, on television and the Internet) to attract potential clients. Since there is no law regulating marriage brokerage in Taiwan, these companies often register as tourist agencies or consultancy companies for immigration, or they may not be registered at all. Several researchers point out that many of these brokers have had prior business associations with the women's countries of origin (Chang 2002; Hsia 2002; Tsai 2001). Such agencies maintain a large database of the women's bio-data and visual images from which the male clients can choose, and they usually focus on one particular country or location.

The second type are individual entrepreneur brokers and/or matchmakers. I use the term 'entrepreneur' to indicate that these brokers make a profit from arranging cross-border marriages, and the profits so generated constitute one of their major sources of income. Such brokers usually operate at a particular locality, using their social and kinship networks to attract male customers and to recruit women. Advertisements are less common. Some of them charge fixed fees like the aforementioned agencies, while others charge brokerage fees but allow the brides and bridegrooms to negotiate the bride price and wedding expenses. Individual entrepreneur brokers need to have a good social network in the local community, but do not necessarily have prior business or social connections in the countries of the women's origin. They go straight to a particular locality in Southeast Asia or China and identify counterpart brokers as business partners. Research shows that their counterparts in Vietnam and China are also similar brokers. Since

it is illegal to broker international marriages, they also recruit women through a social network and do not advertise (Chang 2002).

Matchmakers of the third type are Southeast Asian or mainland Chinese brides who matchmake for their relatives and acquaintances in both countries. Obviously, they also operate within their social and kinship networks, both in the sending and the receiving communities. Distinguished from the individual entrepreneur matchmakers, they do not do this work on a regular basis and do not earn a living from the profits of matchmaking, or at least do not appear to do so. In other words, profit making may not be the sole purpose of their matchmaking. These matchmakers are predominantly women.

The first type of agencies are often referred to as 'brokers' (*zhongjie*) by couples in cross-border marriages; the second type are referred to both as 'brokers' (*zhongjie*) and 'matchmakers' (*meiren* in Taiwan or *hongniang* in the PRC), the terms used interchangeably. The third are called 'matchmakers' (*meiren* and *hongniang*). Demarcation between these types is, however, rather thin and flexible. For example, a Southeast Asian bride or mainland Chinese bride may in time become on entrepreneur broker or even operate an institutionalised marriage brokerage agency.[19] In addition, as it often requires the cooperation of counterpart brokers in both the sending and receiving countries, an agency may work with other types of local partners or vice versa.

Changing Operations

The marriage brokering industry started in the mid-1980s and did not boom until the mid-1990s.[20] Before the early 1990s Taiwanese men or their parents[21] who had difficulties in marrying local women looked for wives abroad through their contacts in China and Indonesia, mainly through Taiwanese businessmen or through their own relatives overseas. As I describe later, the matchmaking process is not standardised. There is no time limit[22] and no fixed fees. Wedding arrangements and bride prices are negotiated by both parties, facilitated by matchmakers. The earlier brokers were Taiwanese male employees or owners of Taiwanese companies in the PRC, the Philippines, Indonesia and later Vietnam. Some had already been brokering for migrant workers, particularly female domestic workers from Southeast Asia (predominantly Indonesia and the Philippines).

In the mid-1990s the number of institutionalised operations began to grow rapidly. The common practice is that men go to an agency to look at photos or video portfolios of women, and then target some of them. The agency organises a matchmaking tour (minimally two men in a group). When they arrive at the locality, they check into a hotel and the women are called to the hotel to meet the men. Men often decide upon the targeted women very quickly. They talk briefly to each other and in a few minutes they decide whether to marry. Some operations allow potential couples to spend the next few days touring the city together before they reach a decision. By the end of the trip, if they decide to marry—and in most cases they do—the man visits the bride's natal family and performs a 'proposal ritual' before completing the marriage registration, the wedding ceremony and banquet. This kind of matchmaking takes five days in Southeast Asia and seven days in the PRC.[23] In two months the brides can join their husbands in Taiwan.

A fixed fee is charged covering the travel expenses of both the matchmaking trip and the bride's travel to Taiwan, the bride price, the paperwork and the wedding ceremony as well as the banquet in the bride's natal home; it also includes the services charged by the brokers. In the early 1990s the standardised price was NTD 350,000–450,000 (equivalent to US$ 10,000–13,500). By the late 1990s, due to competition, the price had been lowered to NTD 200,000 (US$ 6,000). At least half of this sum is shared by all the brokers involved. The actual bride price a bride's family receives varies, the average ranging from US$ 1,200 in Fujian in the PRC to US$ 2,000 in Vietnam. There are exceptional cases of bride price as high as US$ 20,000, but it depends on the negotiations between two families rather than charges fixed by the brokers (Wang 2001). On the whole, the profit generated from brokering cross-border marriages is higher than the bride price, and proportionally much higher than matchmaking fees of local marriages, which are estimated to be 4–5 per cent of the bride price or dowry.[24]

Usually, all the expenses of the matchmaking process are borne by the prospective bridegroom. However, in the past two years a trend has been observed wherein both the bride and bridegroom pay brokering fees to their respective matchmakers and share travel and wedding expenses. In such cases the bride will receive a small sum of the bride price from the groom, and the wedding ceremony is traditional. This kind of practice is limited to the PRC, starting from the coastal province of Fujian, and is fast spreading to the inland provinces.

Brokering agencies as described earlier tend to be short-lived. Since the mid-1990s the number of agencies specialising in brokering

marriages for Indonesian and Chinese women have decreased dramatically, or have shifted their business to work for Vietnamese and Cambodian women. This corresponds to the growing number of brides from these two countries (see Table 5.1). In particular, the number of agencies brokering mainland brides has dropped drastically. This shift is attributed by brokers to the following factors[25]: (a) Vietnamese and Cambodian women are cheaper; the bride price paid to the bride's family and the logistic expenses of the matchmaking tour are lower and the brokerage profits are higher; (b) brides, particularly mainland brides, often resort to matchmaking for their relatives and friends, in competition with the brokerage agencies; and (c) it is difficult to provide 'after-sales services' to mainland brides who often hold brokers responsible when their expectations of husbands are disappointed. This seldom happens in the case of women from Southeast Asia.

The brokerage agencies' practice of fixing fees, standardising matchmaking processes, contracts and guarantees, as well as their using language such as 'after-sales services' and 'buying a wife' in their advertisements clearly point towards a commercial operation. The price and the shifting origins of women are determined by market mechanisms; the guiding principle is profit making. The business deal ends the moment the bride arrives in Taiwan for the first time. The decline of such agencies shows that these commercial operations do not necessarily satisfy prospective brides and bridegrooms; marriage is not after all a one-off deal, and no warranty can be provided. Some 'after-sales services', to put it in brokers' words, such as facilitating the bride's adjustment in Taiwan and mediating in conflicts between newly wed couples, are expected, and most of the brokers feel morally responsible to provide these. That is why more and more people turn to other kinds of matchmakers, because the existing social and kin ties hold them responsible for further involvement in the couple's marriage and family life.

Individual brokers adopt similar practices to the matchmaking agencies, such as arranging matchmaking tours, and they charge the same fees. The third type is more complex. While some of these matchmakers may not charge a fee, they may receive gifts in the form of cash from the parents of both parties[26] and enjoy a free air ticket home. In such cases the two families often negotiate the bride price and wedding arrangements, but there are variations if the arrangement involves the cooperation of both latter types of matchmakers. The following case illustrates the complexity of such arrangements.[27]

Lily's Story

Lily is a Hakka ethnic Chinese woman from Kalimantan in Indonesia. Li is a Hakka man in his late 30s from a small town in northern Taiwan, who is currently unemployed. Lily's aunt, who is only four years older than Lily, married one of Li's former business contacts from Taiwan some years ago. Li witnessed their happy marriage and was motivated to marry an Indonesian woman. He requested Lily's aunt to do the matchmaking for him. Lily's aunt thought of Lily, who was then 18 years old, and invited Lily to visit Taiwan with the purpose of matching Li and Lily. During her six-month stay in Taiwan, Lily decided to marry Li. Lily returned to Kalimantan and started processing the documents. It took another eight months to get everything ready, and during this period Li visited Lily and they held the engagement ceremony and wedding banquet. The ceremony and customs are similar to the ones in Taiwan, but only the bride's kin were present in this instance. Although Lily's aunt introduced them, they went to a local (Kalimantan) matchmaker/broker to arrange legal matters and to negotiate the bride price and wedding arrangements. Their local matchmaker, Mr H, is a professional broker in Indonesian-Taiwanese marriages[28] and was recommended by Lily's friends, but she and her family did not know Mr H personally. Mr H asked for an amount according to the 'market price', and Li paid him this. Li did not know how much of the bride price Lily's parents actually received.

Now Li and Lily have been married for three years and have a 2-year-old boy and a baby girl of seven months. In the course of three years, Lily has arranged three Taiwanese-Indonesian marriages. The bridegrooms are Li's friends, but Lily did not know the brides prior to matchmaking. She accompanied the potential bridegrooms to Kalimantan and referred them to Mr H, who took over from there. She did not charge the bridegrooms, but her travel expenses were paid, and she was given a red-pocket (gift envelope) in cash as a thank-you gift after each successful match. In addition, she requested Mr H to share some of the profits with her. She justified this as a means of not allowing these 'money suckers' to take all the profits.

Lily plans to match Li's elder brother with her own younger sister. In a few months, when her baby daughter is old enough to travel, she will accompany her brother-in-law to Kalimantan. She is rather excited about the trip because her mother is eager to meet the newborn granddaughter. Li will also join them since he does not need to work. Once again Lily

plans to ask Mr H to take charge of bride price negotiations. When asked why she will not bypass Mr H but allows him to profit from her family members, Lily answered: 'This is the way to do it. There is no other way. We are not capable of preparing legal documents ourselves,' adding, 'We don't want to be accused of ruining what should be done [*hanqing*]'.[29]

Lily's experience is a typical example of the way many Indonesian brides are matched. For Lily, profit making is not the main purpose of matchmaking. It is a way for her to be able to renew her ties with her natal kin, both by physically visiting her home and by bringing her relatives to Taiwan. Many Indonesian women feel more confident about marrying a Taiwanese because they have female relatives already living in Taiwan. What Lily and her aunt did—matching young women from their native village to men from their new village as a way of consolidating their network in both villages and enhancing their status in the new village—has been common in China for a long time (Jordan 1999), and the main means whereby marriage migration generates migration chains (Davin 2001).

Long-distance and cross-border marriage migration requires complicated legal procedures and travel arrangements that traditional 'women's networks' cannot handle. Mr H plays the multiple roles of solicitor, marriage broker and tour agent, tasks that are sometimes done by a group of people. In Indonesia and Vietnam a person like Mr H, who has an influential local network and connections with local government officials, is indispensable in 'getting things done', for instance, bribing officials to acquire a passport and approval of the marriage, etc. In the PRC it seems easier for prospective couples to apply for legal documents and to complete marriage registration because the information is more transparent, although it also varies from place to place and depends on the level of education of the couples and their social capital.[30] This explains how mainland brides can easily bypass marriage brokers and take up matchmaking tasks themselves.

Having left Kalimantan a few years earlier and having gradually lost ties with younger women there, it is understandable that Lily would have turned to Mr H to introduce more potential brides. However, one wonders why she still needs Mr H to match her own sister and her brother-in-law. Even if Mr H's services are required for legal matters, surely it would make more sense and be more economical for Lily to pay a fixed amount to Mr H to get the legal procedures done, rather than to entrust him with the negotiations and allow him to make a

substantial profit? There are two possible and interrelated explanations for this. One is that the institutionalised and marketised matchmaking operations now commonly practised in Lily's and Li's hometowns have eroded the traditional practices and become the norm for matchmaking in cross-border marriages. There are many matchmakers in these towns, including Lily herself. As Li points out, he has to follow the market norm even in matching his own family members, otherwise he would jeopardise the long-term profit-making opportunities for others and for Lily, and damage his own social reputation. The other explanation is that marketisation has eroded the meaning of matchmaking activities that were traditionally perceived as a voluntary act of goodwill. A division of labour has thus developed among a number of matchmakers such that the aspects of voluntary matchmaking and making profit from it are dealt with separately.

The Role of Matchmakers

Traditionally Chinese matchmakers have two main tasks: (*a*) introducing the interested parties to one another; and (*b*) negotiating the dowry and the bride price, as well as making wedding arrangements. A successful match commonly involves more than one matchmaker—one who is in charge of the introduction and another who does the negotiating (Jordan 1999). As Jordan points out, one can only guess at the motivations of matchmakers, but it has been observed that brokers/matchmakers of all types hesitate to acknowledge profit making as their primary purpose. It is commonly believed that matching a happy marriage is a meritorious act, and that the rewards would ultimately be reflected upon oneself or one's offspring. Although 'thank you money' is to be expected from the parents of both bride and bridegroom, the amount is based on the *hanqing* and is in relation to the bride price and/or dowry. It is not common for matchmakers to demand or even discuss the matchmaking fee, as doing so would contaminate the voluntary nature of their services. This would be more reprehensible if the matchmaker is closely related to the families of prospective couples. In the act of negotiating the dowry and bride price, the matchmaker is expected to mediate without favouring either party, and without considering his/her own profit.

For Lily the task of introduction was easy, but if she were to take up the task of negotiating monetary transactions she might be caught in an

embarrassing situation and be accused of favouring either one party or the other. She would then need another independent matchmaker to mediate. Since it is difficult to arrive at a socially agreed bride price due to the disparity in wealth of the two families in both real and relative terms (between Taiwan and Indonesia), the established marketised operations and prices have become the reference point. As mentioned earlier, the commercial operations require the bridegroom to give the matchmaker a fixed sum that includes all expenses, and it is commonly known that the profit that matchmakers make is larger than the bride price. As Lily and Li do not want to be seen as making a profit from their own family members—and according to traditional perception she cannot actually demand a matchmaking fee—she leaves the task of negotiating to Mr H, an unrelated professional, who plays the role of 'money sucker'. Afterwards, when she asks Mr H for a commission, her voluntary versus profit-making intentions will not be under scrutiny.

In cross-border marriages, restrictive immigration policies and legal complications require the matchmaker to take greater responsibility both before and after the marriage. This includes hosting the bridegroom during the matchmaking trip, facilitating his communication with the bride's family, making sure that the marriage is consummated smoothly[31] and so on. As the legal procedures often take months, the matchmaker also acts as the guardian of the bride in the period when she waits to join her husband, monitoring her to make sure that she does not run away or commit any 'immoral' acts. Earlier a mainland bride was permitted to reside in Taiwan for no more than six months a year during the first two years of marriage.[32] In some cases the bride lived with the matchmaker in the PRC for the first two years of her marriage because it is not customary for a married woman to continue to stay in her natal home.

On their arrival in Taiwan, and in the absence of social and kin support, the brides often seek advice and help from the matchmakers. Matchmakers who have themselves been cross-border brides can best provide cross-cultural experience and knowledge. Often they are proud to be of help as this enhances their status in the family and community. Even if the bride has not had any prior social or kin relations with an individual matchmaker, she will still count on the matchmaker if she has no one else to turn to. Such matchmakers often provide legal, health and cultural information, as well as emotional support to help the bride adjust to the new environment; this may even include providing job references. At times such assistance continues for years, and the bride and matchmaker build up a friendship. Not every matchmaker is

so helpful, since such assistance is provided on a voluntary basis[33] and depends on how resourceful he or she is. Nevertheless, as matchmakers live in the same locality and now share social/kin relations with the couples, it is difficult for them to refuse the bride's demands.

Since the bride lacks social support in her new environment, the matchmaker is also expected to mediate in the couple's conflicts and any conflict with the bridegroom's family members in the initial stages of the marriage. This often happens when the bride's expectations of her husband's material situation are disappointed and she begins to feel deceived, as well as in the case of domestic violence.[34] When prior social or kin ties exist with the husband (but not the wife), the individual matchmaker often tends to defend the interests of the husband rather than the wife. The third category of matchmaker may not be powerful enough to defend the bride, so that the bride is often persuaded to accept the reality of her situation. Nevertheless, there are matchmakers, often female, who are sympathetic to the bride.

Money Transactions in Weddings

Figure 5.1 summarises the relationships, the flow of money transfers and the expected services provided in the preferred matchmaking practice in cross-border marriages, which is based on individual matchmaking operations as well as those arranged by brides married to Taiwanese men.

In traditional Chinese marriage practices[35] there are two flows of money transactions: (a) the bride price and dowry, negotiated by both families with the help of the matchmaker; and (b) a gift of money to matchmakers, to be given at or after the wedding. Both are given in the form of cash without commercial connotations. The practices of bride price and dowry are highly diverse in different parts of China, and among different classes and ethnic groups, and are being transformed in response to changing socio-economic realities (Siu 1993; Whyte 1993). A detailed analysis of these changes—of who controls the bride price and dowry, and how they are used—provides insight into intra-familial relations and family strategies. On the whole, the bride price and dowry symbolise the social status of the two families involved. The exchange strengthens the alliance between the families, although an unbalanced exchange may adversely affect the bride's status in her

Figure 5.1 Actors, Services and Money Flows in Matchmaking Practice

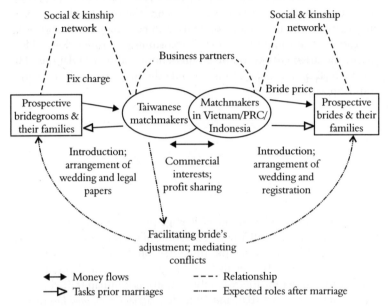

Money flows ---- Relationship
Tasks prior marriages ----- Expected roles after marriage

husband's family. The money for the matchmakers is given voluntarily
by the parents of both parties as a sign of gratitude.

How are we to understand the money transactions of cross-border
marriages in the light of the traditional matchmaking practices as
schematised in Figure 5.1? Chang (2002) and Shen (2003) both argue that
the cross-border matchmaking operation is a kind of commercial activity
disguised as traditional practice. Whether institutionalised or not, the
brokering industry is driven by market mechanisms. I have illustrated
earlier how market rules of standardised operations and fixed prices
have eroded traditional practices. The fixed charges have changed the
traditional meaning of bride price and the gift money to matchmakers;
these are not given voluntarily, leaving no room for negotiation. The
goal of matchmakers is not to identify a suitable match that will lead to
a sustainable marriage, but to complete a match within the limited time
permitted by a standardised tour operation. Otherwise their profits
would suffer. It is the profit-driven motive and the time limit, not the
money transaction *per se*, which makes matchmaking a commercial
activity.

If matchmaking is a business deal, how should we understand the
continuous involvement of matchmakers in the family lives of the

couples? Any business deal has prescribed tasks, corresponding prices, and a time of closure. On the other hand, the matchmaker's never-ending involvement is often voluntary, and bound by moral and social obligations that cannot be analysed according to business logic. Here we see the interplay of economic transactions and social relations. The commercial deal does not, thus, exclude the meaning of gift exchange and reciprocal duty.

Making Sense of Commercially Arranged Marriages

Having described the marriage brokerage practice and its meaning for the actors involved, I will now discuss some of the problems that emerge from the public and academic discourse on commercially arranged marriages, both internationally and locally, in Taiwan. These may be summarised under the following three heads: (a) human trafficking; (b) mail-order brides (MOBs); and (c) trade marriages (maimai hunyin).

Human Trafficking

Broadly defined, human trafficking denotes the transporting of human beings or human parts, by means of threat or coercion, for the purpose of exploitation.[36] Three aspects are emphasised: (a) the use of force, including deception and the manipulation of consent; (b) its exploitative nature and the vulnerability of the victims in circumstances sometimes described as 'slavery'; and (c) its illegality, especially its control by organised crime networks. Although not limited to prostitution, the trafficking of women and young girls into prostitution or other forms of sexual exploitation is the most highly publicised aspect of the agenda against trafficking.

Mail-order Brides (MOBs)

The MOB system is generally defined as a system of introduction provided by commercial institutions for the prime purpose of marriage

with a foreign national. More specifically, it is the term applied to
women entering into international marriages by the use of such a
system (Del Rosario 1994: 2; see also del Rosario, this volume). Three
elements are emphasised in the MOB discourse: (*a*) profit making;
(*b*) institutionalised matchmaking operations; and (*c*) cross-border
situations. What is not reflected in the definition is that the term 'mail-
order bride' suggests the commercial sale of women as commodities,
as is done through advertising catalogues. However, it is unclear
whether the commercial element relates to the actual price of buying
the commodity, or to the fee charged for providing services to enable
clients to meet such women.[37] The latter can be so broad as to include
a dating service and online love club. Additionally, it is not clear from
the definition that the term 'mail-order bride' is usually used with
reference to women from economically less developed countries and
men from richer countries who seek to marry each other. That is, few
people would consider a British woman who is dating a German man
via a commercial friendship club a 'mail-order bride'.

Trade Marriage

Commonly used by both Taiwanese and mainlander Chinese, the
term 'trade marriage' has negative connotations as the buying and/or
selling of wives. It is not necessarily used in a cross-border context,
but the current phenomenon of cross-border marriages in Taiwan is
predominantly thought of as 'trade marriage'. When I was investigating
people's perceptions of this term, I came across several diverse yet
contradictory meanings. No one seems able to give a clear definition of
the term 'trade marriage', but it is clear what is 'not' a trade marriage. I
discuss briefly the terms that compare or contrast with trade marriage.

Blind Marriage and Arranged Marriage

Both terms refer to marriage decisions and mate choices made by
parents without consulting the potential couples, especially the brides.
While blind marriage is considered a feudal, outdated practice and

outlawed in the PRC, arranged marriage is a more neutral term that, in modern times, refers to parental choice with the consent of the couple. Arranged marriages require matchmakers, whose role has been described earlier. Arranged marriages are considered 'traditional', but not necessarily negative, since it is not uncommon to 'first wed, then love' (Jordan 1999).

Love Marriage

In contrast to arranged marriage, love marriage couples enter into marriage of their free will after a period of courtship. The term emphasises the individuals' independent choice and the conjugal bond. The social status of their natal families is not an important factor. Love marriage has been constructed as the ideal form of modern marriage.

In his ethnographic research on matchmaking in both Taiwan and the PRC, Jordan (1999) argues that in real life the line between arranged and love marriage is rather fluid.[38] For instance, potential mates can easily fall in love after one or two brief encounters arranged by semi-professional matchmakers and then enter into a love marriage. Couples who meet on their own have to win the approval of their parents and might still need a matchmaker to negotiate the bride price and wedding arrangements. There is no commercial mechanism in the introduction and negotiation, but gift exchange and certain financial transactions are always features of the wedding.

Marriage of Convenience

This refers to marriage for purposes other than 'love', whatever the definition of the latter. In this case, marriage is a means, a contract, an exchange of terms that both parties benefit from, although not necessarily financially. It is also the individuals' independent choice.

In contrast to love marriage, a marriage of convenience is not morally sanctioned and is considered problematic. The underlying assumption is that the emotional and the instrumental aspects of marriage (such as material considerations) are not compatible.

When I asked cross-border couples and members of the community what the difference was between a trade marriage and a normal marriage, I was told that a trade marriage is a more problematic and unstable form of marriage because: (a) the marriage decision is made in haste without a period of courtship, in contrast to love marriage; (b) the disparity between the husband's and wife's ages, physical appearances, and the social and economic status of their natal families (and of their countries and ethnic communities), as well as cultural differences, make it more difficult to maintain a good married life, although they also acknowledge that such disparity does not necessarily constitute major problems as long as there is love (developed after marriage); and (c) motives are questionable. The brides see marriage as a means of labour migration or securing citizenship, and are therefore not fully devoted to their husbands and their families in Taiwan.

It is interesting to observe that the commercial elements of money transactions and matchmaking operations are *not* identified as major causes of marital problems *per se*. That is, it is not the money aspect, but the lack of courtship and the social and economic gap that make cross-border marriages vulnerable. The actors involved do not perceive the women entering into commercially arranged marriages as traded commodities. Rather, they see the arrangement as an exchange based on consensus and acknowledge that the women themselves exercise some agency in such marital decisions. This is closer to the idea of a marriage of convenience, as there is always hope that emotional bonds will develop after marriage. This kind of exchange leads to an imbalance in power in the domestic sphere, in both conjugal and inter-generational relations, but it does not thereby signify a commodified relationship. Having instrumental motivations does not exclude the possibility of developing emotional and social bonding in due course.

Coming back to the discourses of trafficking and MOB (and putting aside the phenomenon of women entering sex work via bogus marriages), can we construe the phenomenon of commercially arranged marriages as human trafficking? With regard to coercion and deception, it has been observed that the matchmaker, constrained by the

profit motive and a time limit, would seek to persuade the prospective couple, especially the bride, to come to a quick decision, often without providing sufficient information and time for mutual understanding. However, all brides are aware of the risks involved and are prepared to accept the consequences of their decision. The question lies in whether it is at all possible to reach a fully informed decision, given that the brides are likely to have some fantasies and expectations of the receiving society that may often diverge from reality. Not only their lack of social support, but also social stigma might make brides vulnerable and their working conditions exploitative. However, the suggestion that these brides are brought to Taiwan purely for the purpose of exploitation is questionable.

Emphasising the profit-making and institutional aspects of the MOB system, the discourse equates the commercialisation of matchmaking operations with the commodification of women, even as it acknowledges women's agency in utilising this system. However, it also carries certain moral connotations concerning the monetisation of marriage that are implicitly derived from an ideal of conjugal relations based on romantic love between two independent individuals, an ideal that would be contaminated by commercial operations and material considerations. This explains why the MOB discourse construes women's decision to use commercial systems to enter marriage as an indication of the corruption of values brought on by free market forces.

The discourse on trafficking projects women as either powerless victims or as ignorant, uneducated and backward, and their husbands and brokers as vicious exploiters and criminals. The MOB discourse projects images of calculating, morally questionable women. Such popular images further stigmatise the actors involved, especially the brides. This has led to the introduction of policies that hold them responsible for social problems in the receiving countries.

Concluding Remarks

Seeing commercial marriage migration as part of the globalisation process gives the impression that it is something new, and that women are traded as impersonal commodities. However, if we take a closer look at matchmaking/brokerage operations, we see that cross-border marriages involve complex, localised social networks—as all marriages in fact do.

Studies of these networks and processes indicate that women are not faceless commodities, but active agents in making their life choices.

Although the brokering industry is driven by commercial interests, the presence of individual entrepreneurs and brides acting as matchmakers shows that the industry goes beyond mere commercial activities to involve other types of social relations. In the case of cross-border marriages in Taiwan, the actors' own perceptions of money transactions tell us that at the time of the wedding these are not considered to be a major problem contributing to making cross-border marriages unusually vulnerable. The custom of bride price reveals complex cultural meanings attached to women's productive and reproductive labour, and the construction of feminine and gender roles. These features of financial exchange, not the money transaction *per se*, create asymmetry in conjugal power relations, and support and sanction certain mechanisms in the kinship network. In the case of cross-border marriages, the imbalance of power relations is further reinforced by ethnic and class differences and, in the case of cross-Straits marriages, political differences as well. Commercial operations should not be singled out as the only cause of women's vulnerability in cross-border marriages.

While women's marriage migration, labour migration and sex trafficking share the same macro push factors from the sending countries, the actors' aspirations for migration and corresponding strategies are different. A marital decision is a long-term, if not a permanent, life choice. The temporal dimension of economic relations in marriage, and how it is interwoven with emotional and sexual relations, need to be considered in future studies and theoretical speculations on the relationship of gender and migration.

Notes

1 'Taiwanese' refers to all citizens of Taiwan, Republic of China, including all ethnic groups, that is, 'mainlander', Minnin, Hakka and aborigines. Mainlander refers to the people who migrated to Taiwan in 1949 from all parts of mainland China during or after the civil war, as well as the second and third generations born in Taiwan. Minnin, Hakka and most of the mainlanders belong to the Han ethnic group.
2 Acknowledged whenever I use their source.
3 Source: Household Registration Office, Baihe township, Tainan county, Taiwan, 2003.

4 Source: Waiji Yu Dalu Peiou Zhaogu Fudao Cuoshi Zhuan An Baogao (Report on the Measure of Assistance for Foreign and Mainland Spouses), Ministry of Interior Affairs, Taiwan, May 2003.

5 According to the father's ethnicity.

6 Commissioned by Mainland Council Affairs, ROC, 1999, and conducted by Prof. Shao-Hong Chen in 1999.

7 I am inspired to use the term 'betterment' instead of 'long-term economic welfare' after reading Delia Davin's chapter (this volume).

8 According to my fieldwork. Han's (2002) research on mainland brides makes the same observation.

9 That is, the percentage of cross-border marriages against the total number of marriages in a locality.

10 For instance, the average sex ratio in Taiwan is 103.84 males per 100 females, while in Baihe, a rural town in southern Taiwan where I conducted my fieldwork, the sex ratio is 114.09 males to 100 females (Ministry of Interior, Taiwan, 2003).

11 The sex ratio at birth in Taiwan was 110.1 (male babies per 100 female) in 2004 (Source: Department of Statistics, Ministry of Interior, ROC). Similarly, in mainland China, where son preference is also predominant, the sex ratio at birth is as high as 116.9, according to the Fifth National Population Census in 2000. This is much higher than the world average of 103–7 (Source: National Bureau of Statistics, PRC, quoted in China Population Web, http://www.chinapop.gov.cn/nkzh/zgrk/tjgb/t20040326_2836.htm).

12 The overall sex ratio of the unmarried population in Taiwan (excluding divorcees and those widowed) with primary school education or lower is 283 (Ministry of Interior, Taiwan, 2000).

13 Wufong town in Hsinchu county, where the majority of the population is aboriginal, has a sex ratio as high as 134.4 males per 100 females (Ministry of Interior, Taiwan, 2003).

14 Another possible explanation is that Taiwanese men are not a preferred choice for Filipina and Thai women compared to Japanese, American and European men. However, in view of the large number of Filipina domestic migrant workers in Taiwan, the small number of Filipina brides confirms the differentiation between the marriage market and the labour market.

15 Thanks to Rajni Palriwala's comment, it is interesting to note that the same logic does not apply to marriages between Taiwanese women and Thai men working in Taiwan. From my limited observations in my fieldwork sites, they seem to meet and decide to marry when Thai men come to work in Taiwan and later choose to settle there. One possible explanation is that the majority of Thai men work in the construction and manufacturing industries, and the value attached to their work is higher than the value attached to domestic work (see Ding's [2002] work on images of domestic work/ers in Taiwan and China). Thai–Taiwanese marriages, as well as the marriages between Taiwanese women and mainland Chinese men, break the traditional patrilocal pattern in Chinese society and pose a challenge to the study of changing interrelations in the patrilocal system, economic and social status, and gender relations. All such issues require further scholarly attention (see Charsley, this volume).

16 On the whole, it is very difficult for Southeast Asian nationals to obtain a tourist visa for Taiwan, and almost impossible for mainland Chinese. However, there are also a

small number of Southeast Asian women whose relatives (often their own sisters) have earlier married Taiwanese. They are able to obtain visitor visas, but actually come to Taiwan for the purpose of making a match.

17 Other researchers make different categorisations based on brokers' prior professions and initial associations with the women's countries of origin (Hsia 2002; Tsai 2001), and patterns of organisation (Chang 2002: 55–75). Here, I follow Chang's categorisation in the main, but emphasise the elements of the brokers' prior relations with their clients, that is, the potential brides, bridegrooms and their families.

18 Some of the guarantees include the women's virginity and a one-year marriage contract (so that the wife will not run away). This is particularly the case for Vietnamese brides.

19 A Web-based agency specialising in brokering for mainland Chinese women is hosted by a mainland Chinese bride. She claims that she provides better services because she herself has experienced a cross-Straits marriage. See http://home.pchome.com.tw/education/haixia2000/ (information gathered in 2001). Another example is that of a restaurant called 'Vietnam Village of Culture', located in Baihe, Tainan county, which claims to be run by Vietnamese brides themselves, and also offers matchmaking services. See http://www.vnvan.com.tw.

20 It is impossible to estimate the number since the flow is not regulated. The following trends are summarised from my interviews with brokers as well as from the research done by Chang (2002), Hsia (2002), Tsai (2001) and Wang (2001).

21 It is often the mother of the potential bridegroom who takes the initiative and is involved in mate choice.

22 In some cases the bridegroom stays with the wife's natal family for several weeks to complete the paperwork.

23 In the case of Vietnam and Indonesia, the husbands need to visit the women again as it is compulsory for the couples to be interviewed by Taiwanese representatives in Jakarta and Ho Chi Minh City. The actual wedding ceremony and banquet may take place during the second visit. In the case of mainland China, everything is completed in a seven-day tour.

24 Jordan (1999: 339) quotes research done in Taiwan and Tianjin, PRC.

25 Summarised from my interviews with six brokers of various types. Interviews conducted in June and July 2002, and October 2003.

26 It is a Chinese custom that the parents of both bride and bridegroom give a 'red envelope' with cash inside to the matchmakers after successful matchmaking as a sign of their gratitude.

27 I interviewed Lily and Li in May 2003 in Taiwan. The pseudonyms Lily, Li and Mr H are used to protect their privacy.

28 Close to the individual entrepreneur brokers of my categorisation.

29 *Hanqing* is a term used in Taiwanese Mandarin to denote the price of a commodity in the market, but it is also used generally to describe the relative values of people, acts and traits as socially evaluated. It can be translated literally as the 'market value', but here the 'market' should be interpreted as a social evaluation system rather than a commodity value.

30 It is not because the PRC and Taiwan share similar legal systems. On the contrary, the political ambiguity makes any authentication of legal documents more difficult, and the barriers set to cross-Straits marriages are far higher than is the case with other cross-border marriages in Taiwan.

31 In Kalimantan, Indonesia, from where the majority of Indonesian brides come, many matchmaking groups stay in the home of the brokers, as is also done on the second visit after marriage. In some cases the matchmakers also provide sexual education and knowledge of contraception.

32 This regulation was gradually relaxed and was eventually abolished in March 2004.

33 Although they have the incentive to do so, as they can make small profits from the renewal of legal documents for the brides.

34 In some advertisements the brokers specify that the warranty of a 'one-year marriage' is not valid if the husband beats the wife.

35 Similar customs continue to prevail in Taiwan, the PRC and among overseas Chinese communities despite the state's intervention to redefine the marriage regime.

36 For the full definition, see the Protocol to Prevent, Suppress and Punish Trafficking in Persons, Especially Women and Children, supplementing the UN Convention Against Organised Crime.

37 The proposed International Marriage Broker Act in the USA defines 'mail-order bride' broadly as 'providing dating, matrimonial and social referrals, or matching services between United States citizens or legal permanent residents and non-resident aliens by providing information that would permit individuals to contact each other'.

38 He also argues that the word 'love' in Chinese is very different from the troubadour-drenched traditions associated with the word as it is conventionally used in English (Jordan 1999: 330).

References

Barry, Kathleen. 1995. *The Prostitution of Sexuality: The Global Exploitation of Women*. London: New York University Press.

Chang, Shu-Ming. 2002. 'Tai Yue Kuaguo Hunyin Shichang Fenxi: "Yuenan Xinniang" Zhongjie Ye Zhi Yunzuo' (Marketing International Marriages: Cross-Border Marriage Business in Vietnam and Taiwan). Master's thesis, Graduate Institute of South-East Asian Studies, Tamkang University, Taipei.

Chen, Shao-Hong. 1999. *Dalu Peiou Laitai Shenghuo Zhuangkuang Anli Fangshi* (Report on the Lives of Mainland Chinese Spouses in Taiwan). Taipei: Mainland Council Affairs, Taiwan, ROC.

Constable, Nicole. 2003. *Romance on a Global Stage: Pen Pals, Virtual Ethnography, and 'Mail Order' Marriages*. Berkeley and London: University of California Press.

Davin, Delia. 2001. 'Marriage Migration in China'. Paper prepared for the 2001 Forum on 'Rural Labour Mobility in China, Beijing', July.

Del Rosario, Virginia O. 1994. 'Lifting the Smoke Screen: Dynamics of Mail-order Brides: Migration from the Philippines'. Ph.D. dissertation, Institute of Social Studies, The Hague.

Derks, Annuska. 2000. *Combating Trafficking in South-East Asia: A Review of Policy and Programme Responses*. Geneva: International Organisation for Migration.

Ding, Naifei. 2002. 'Kan/Bujian Dieyin: Jiawu Yu Xingongzuo Zhong De Beiqie Shenxin' (Seeing Double, or Domestic and Sex Work in the Shade of the Bondmaid-Concubine), *Taiwan: A Radical Quarterly in Social Studies Research*, 48: 135–68.

Glodava, M. and Richard Onizuka. 1994. *Mail-order Brides: Women for Sale*. Fort Collins: Alaken, Inc.

Han, Jialing. 2002. 'Quanqiuhua Xia Yazhou Nongcun Funu De Qianyi' (Asian Women's Migration under Globalization: Research on Mainland Chinese Brides in Taiwan). Paper presented at the Conference on 'The Rights of Ethnic Minority Women', Taipei, November.

Hsia, Hsiao-Chuan. 2002. *Liou Li Xun An: Ziben Guojihua Xia De 'Waiji Xinniang' Xiansiang* (Internationalisation of Capital and Trade in Asian Women: The Case of 'Foreign Brides' in Taiwan). Taipei: Radical Quarterly in Social Studies Research Series No. 09.

Jordan, David. 1999. 'Chinese Matchmakers of Tianjin and Taoyuan', in Cheng-Kuang Hsu and Lin Mei-Rong (eds), *Anthropological Studies in Taiwan: Empirical Research*, pp. 319–62. Taipei: Institute of Ethnology, Academia Sinica.

Piper, Nicola. 1999. 'Labour Migration, Trafficking and International Marriage: Female Cross-Border Movements into Japan', *Asian Journal of Women's Studies*, 5 (2): 69–99.

Robinson, Kathryn. 1996. 'Of Mail-order Brides and "Boys' Own" Tales: Representations of Asian-Australian Marriage', *Feminist Review*, 52: 53–68.

Shen, Hsing-Ju. 2003. 'Tiantang Zhi Ti? Tai Yue Kuaguo Shangpinhua Hunyin Zhong De Quanli Yu Dikang' (Stairway to Heaven? Power and Resistance within the Commodified Taiwanese–Vietnamese Marriages). Master's thesis, Institute of Sociology, National Tsing Hua University, Hsinchu, Taiwan.

Siu, Helen F. 1993. 'Reconstituting Dowry and Brideprice in South China', in Deborah Davis and Stevan Harrell (eds), *Chinese Families in the Post-Mao Era*, pp. 165–88. Berkeley: University of California Press.

Tsai, Ya-Yu. 2001. 'Tai Yue Kuaguo Hunyin Xianxiang Zhi Chutan' (A Study of Intermarriage between Taiwanese and Vietnamese). Master's thesis, Institute of Political Economy, National Cheng Kung University, Tainan, Taiwan.

Wang, Hong-Zen. 2001. 'Shehui Jieceng Xia De Hunyin Yimin Yu Guonei Laodong Shichang: Yi Yuenan Xinniang Wei Li' (Social Stratification, Vietnamese Partners, Migration and Taiwan Labour Market), *Taiwan: A Radical Quarterly in Social Studies Research*, 41: 99–127.

Whyte, Martin King. 1993. 'Wedding Behavior and Family Strategies in Chengdu', in Deborah Davis and Stevan Harrell (eds), *Chinese Families in the Post-Mao Era*, pp. 189–218. Berkeley: University of California Press.

Wijers, Marjan and Lin Lap-Chew. 1997. *Trafficking in Women, Forced Labour and Slavery-like Practices in Marriage, Domestic Labour and Prostitution*. Utrecht: Foundation Against Trafficking in Women (STV).

6

BANGLADESHI GIRLS SOLD AS WIVES IN NORTH INDIA

Thérèse Blanchet

This chapter derives from a study carried out between 2001 and 2003 of female migration across the Bangladesh–India border. It documents the case histories of 112 Bangladeshi girls/women, representing roughly 10 per cent of the migrants followed up, who had been transported to North India and sold into marriage.[1] Even though the number of girls who left to get married is relatively small compared to those who migrated for work, their stories constitute a significant chapter in the history of gendered migration, which is important to document.

Several of the Bangladeshi girls who were sold/married in 'Lucknow' never returned. They were lost to their families and what happened to them could not be known. Others came back several years later. In some cases, it took 15 years or more before families learned that their daughters were alive. They had been sold to men who could not find wives locally, either because they were too poor, had been married before, were elderly or had 'flawed' reputations. These men belonged to a society where females are reportedly 'missing' and where the sex ratio recorded in successive censuses is remarkably skewed.

Data were collected only gradually. At first, there were mainly rumours and little evidence, but the poignant testimonies of a handful of women who had returned to Bangladesh made it imperative to pursue the research. More returnees were found, and family members who had traced a daughter or a sister in India were interviewed. Recurrent themes in narratives suggested that the purchase of a Bengali wife was

not an unusual practice, and that the demand for brides occupied a good number of go-betweens who made a living out of this trade. Retired village *dalalis*[2] were identified. Too old to fear reprisals, they explained what types of girls were candidates for migration; how they ferried them across India; and how they disposed of them. Finally, equipped with addresses, fieldwork was conducted in Uttar Pradesh to get some insights on the demand side and on the present circumstances of these purchased wives.

Why did Bangladeshi parents allow their daughters to be married so far away? What was the exact role of the go-betweens, *dalals* or traffickers? How did they operate, and what profit did they derive from these transactions? How did the sending and receiving communities compare in terms of economic development, sex ratios, gender relations and marriage patterns? What were the economic, demographic, social and cultural factors that led to the procurement and purchase of foreign wives in rural communities of Uttar Pradesh and beyond? Do such commercial transfers of girls and women deserve the label 'trafficking' in human beings? If so, how can marriage, a core institution that stands for auspiciousness and morality, necessity and duty, be built upon a trafficking event? For the women sold into marriage and for their families who were duped, how could good be constructed upon evil? The study questions notions of agency, consent, trafficking, slavery, 'faked' and 'real' marriages, as well as *desh* (land), *bidesh* (foreign land) and the borders separating them.

Those who left to be married were mostly village girls in their teens, generally poor, whose parents could not afford to pay for their dowries. A few girls had been divorced or were a burden on their families. Migration for marriage peaked between 1983 and 1993, and then decreased, though without stopping altogether. By the early 1990s it had become more acceptable and attractive for village girls to seek work in cities such as Mumbai.[3] Marriage in a distant land was no longer an interesting proposition, especially after it came to be known that these girls did not have a good life. A radical social change was taking place. Daughters could become economic agents on their own. Like sons, nay, better than sons, they could support their natal families. With the prospect of gainful employment, parents' sense of urgency in arranging a daughter's marriage relaxed. A 17-year-old girl was no longer considered an old maid. Other changes occurred in the receiving communities, which reduced the demand for purchased wives from Bengal.

The Market for Women and Girls in North India

The markets where girls and women were sold were described in some detail by returnees and by ex-*dalalis*. Railway stations, especially Howrah in Kolkata, have been critical platforms for trafficking activities. Other locations often mentioned for the marriage market are Haridwar, Nainital, Bareilly and Gonda. Bibi, an ex-*dalali* we met in 2001 in her Jessore village, explained how she operated. She began to transport and traffic in girls after her own 11-year-old daughter went missing. She heard that the girl had been sold in Uttar Pradesh as a wife, and it was while trying to locate her daughter that she travelled and learned the trade. Her daughter was never found. First a victim, Bibi herself became a trafficker, and was well known in her locality as a *dalali*. She explained:

> If you don't want to make much money, you can sell a girl at the border. You have no cost and no risk. Two years ago [in 1999], the price was between 2,000 and 5,000 taka.

> Most *dalal*s are in Howrah station. There is more profit to be made there. These *dalal*s recognise one who is selling a girl and you can recognise them Police can also tell The girl being sold will not notice anything. Five years ago [in 1996], one could get between 10,000 and 20,000 taka for selling a girl in Howrah station.

> Howrah is risky. You can be jailed and fined. On the train also you can be arrested. In Bombay, it is less risky. I knew many *dalal*s in Howrah station. When they were arrested by the police, they paid and got free again.

> You can also take a train and sell a girl in Basti, Faizabad or Bareilly. *Dalal*s stand at the station there and wait for you.

A different route was used for girls recruited from Rangpur. They travelled via Maldah and Katihar, avoiding Howrah. Railway stations such as Basti, Gonda, Barhni and Bareilly in Uttar Pradesh remained important hubs of traffickers' activities and were never policed to the extent that Howrah was.

Returnees provided good information on the way the system worked some 10 to 20 years ago. A particularly detailed story was that heard from Tahomina. At the age of 14, pushed out from her Satkhira home by destitution, she travelled to Howrah station with an older girl from her locality. There, she separated from her friend and was handed over to a Bengali woman who took her to Bareilly by train. Tahomina was looking for work, but was sold as a wife instead. She protested, but was frightened into submission. A Bengali neighbour explained that it would be foolish to run away. 'These people bought you and they will not accept to lose their money. If you try to run away, they could kill you,' she was told. The announcement that she had been purchased carried a power of its own and weakened Tahomina's resistance. After a brief marriage ceremony, the Muslim girl became wife to a Hindu man nearly three times her age and father of three children. Tahomina never settled down and never developed a sense of belonging. She returned to Bangladesh in 1999 with five of her six children.

In the villages we visited in Basti and Gonda in Uttar Pradesh, the idea of a 'purchased wife' (*kharidan awrat*) was found to be remarkably familiar, and village chiefs could identify such women in their community. Those we met were from both Bangladesh and West Bengal. From which side of the border a girl came made little difference to the receiving community. Informants mentioned that girls brought by Bengali *dalals* were taken to homes close to railway stations (in Basti, Barhni and Gonda). Interested 'buyers' were then invited to come and take their pick. One man mentioned that his father had chosen for him a 16-year-old girl, the best looking of the three on offer. He paid Rs 1,000. This was 20 years ago. The man added, 'Some of these Bengali girls were very good-looking, yet they sold for very little money.'

A Bengali doctor who worked in Itwa said that she used to live near the police station and was often called by the police to serve as an interpreter when conflicts erupted. This happened when men fought among themselves over a particularly attractive girl, or when girls went 'crazy', tried to commit suicide, ran away or set fire to the house. The doctor added that a majority of the girls were between 14 and 16 years. This is in line with ages recorded in our sample, where 75 per cent of the girls were between 12 and 18. One can only imagine how such 'markets' were held. There are stories of *dalals* who brought several girls at a time, were accused of trafficking and ran away out of fear, leaving the girls behind without collecting payment. These girls were distributed to local men by the village chief (*pradhan*). In later years the transport of girls for

sale became more risky and the groups became smaller. Few *dalals* now engage in this activity from Bangladesh, as profits have diminished and accusations of trafficking are more likely. New girls are now procured through women already married in Uttar Pradesh who occasionally take up the role of *dalali*.

Marriage Migration and Trafficking: Identifying the Problem

The migration and sale of young girls and women from Bangladesh to India for the purpose of marriage is known to have occurred at least from the 1970s onwards. Informants mentioned that even in the late 1960s girls were recruited from West Bengal:

> In Murshidabad district, boys from Bihar and from Uttar Pradesh came to marry. From 1977 to 78 such boys also visited Bangladesh. At that time, there was a lot of poverty here. Girls from very poor families and those abandoned by their husbands were married like this. A 'guardian' who brought a girl received 1,000 taka, but some took more (60-year-old ex-*dalali* from Godagari, Rajshahi, Bangladesh).

Some girls were taken to Kolkata and Mumbai, where they were groomed for a month or two and offered on the markets of Uttar Pradesh or other parts of North India. Others were recruited from their Bangladesh villages by *dalals* who could be neighbours or relatives, and were taken directly to Uttar Pradesh. A few girls were recruited from the slums of Mumbai where they lived with their families. In the 1990s, it became increasingly common for Indian men to enter Bangladesh and look for a wife with the help of a go-between. If a poor girl of marriageable age could be found and her parents convinced, the marriage was celebrated at the girl's home before migration. The latter method had the advantage of protecting the husband and the matchmaker from accusations of trafficking.

A majority of the marriages in our sample had the assent of parents, who allowed their daughters to be taken away for marriage or else handed them directly to a man who had travelled to marry. *Dalals* and go-betweens who accompanied prospective husbands and helped them find

a wife generally benefited from the 'sale', while parents seldom received money. Not surprisingly, for a long time, until women returned and told their stories, the trafficking aspects of these marriage transactions were not appreciated in the sending communities.

In 1995 the Association for Community Development (ACD), an NGO based in Rajshahi, alerted public opinion to the problem of girls who were married to Indian men and never returned to visit their families. They carried out a study in villages along the Indian border and found that female migration to India for the purpose of marriage had occurred in 180 of the 500 families surveyed. The year of departure was not recorded, but at the time the survey was done, 84 per cent of the migrated girls/women had not returned to visit and many had not been heard of since their departure. Implying that the girls had been procured for prostitution, the report declared that these were cases of trafficking. The ACD launched a campaign to sensitise the community about the risks of such marriages. While the NGO had identified a real problem, their conclusion was perhaps too hasty.

Our data largely confirm that a substantial number of the Bangladeshi girls and women taken to India to be married were actually sold, and many lived difficult and unenviable lives afterwards. However, there is no conclusive proof that they were forced into prostitution. Most of them were locked into marriages and could not keep contact with their natal families. Perhaps some of them had no wish to keep in touch with parents who had so completely failed them. Others were married to men of another religion, making contact with their natal families problematic. Altogether, the existence of an important marriage market is proven beyond doubt. It operated alongside a prostitution market, and girls destined for one would sometimes be diverted to the other.

fluidity

'Real' and 'Faked' Marriages

The association of migration for marriage with trafficking in girls introduces evil within a core institution that Bengali society posits as necessary, sacred and auspicious. That the same act of transfer could be interpreted as both marriage and trafficking in a girl appears contradictory. One way for the ACD to deal with the problem has been to label the marriages contracted by the migrant girls/women as 'faked' ones:

But most of these marriages have no marriage document. So, it proves very clearly that these were all faked marriages in nature and the girls were simply cheated in the name of marriage. After performing the so-called marriage the man crossed the border and sold the girl to another person against money. In many cases, the ownership of these girls changed very frequently. Above all, marriage here serves as a means of migration, but most of the marriages do not comply with the necessary conditions of a marriage and the girls were just smuggled out of the country as a very cheap commodity. (ACD 1995: 10, 11)

Marriages concluded without registration or deeds are common in Bangladesh, and this in itself does not make them fake. The notion of 'faked' marriage begs the question of what a 'real' marriage is. Is a marriage made 'real' by the fact that it is registered? Is it 'real' when parents agree to the union? Can parents delegate their authority and entrust a third party with the responsibility of arranging the marriage of their daughter? Does it make a difference to the 'reality' of a marriage if the girl is a minor, is handed over for a price or marries a man of another caste or religion? Clearly, answers to the above questions depend on the legal, social and religious norms prevailing in a particular context at a particular time. Forms of marriage in the region have been diverse, changing and hierarchically ranked. State law has never effectively regulated marriage universally, and the criteria of a 'true' marriage are debatable. A categorical pronouncement by activist lawyers wishing to promote monogamous long-lasting marriages does not erase other sources of power and legitimacy.

Let us return to the notion of a 'purchased wife'. Anthropologists long ago debated the question as to whether the practice of bride price could be equated with trafficking in women. They concluded that it could not, since it remained inscribed in a system of ritualised exchange between wife-givers and wife-takers. More recently, historian Indrani Chatterjee, revisiting 19th-century Bengal, found that after slavery was officially abolished, the *nizam*s of Murshidabad and other Indian royal houses continued to keep female slaves who were an integral part of their households (Chatterjee 1999). Girls bought at a young age became concubines and a few became wives and even mothers of future *nizam*s. To have been purchased as a slave was no disqualification for later marriage and incorporation into the master's family. Chatterjee recalls a process of 'classicisation of Islam in Bengal', which in the later part of the 19th century led to the redefinition of marriage, *nikah* and

slavery. Poor and itinerant *maulvis* invited poor men to marry freed female slaves and even help themselves to the slaves kept by Hindu masters. Putting female slaves to work as prostitutes for the profit of their holders was proscribed, but marrying them—regardless of the women's volition—was encouraged.[4] In other words, the wedlocking of a woman was seen to restore morality, and the manner in which she was acquired was not at issue.

In rural Bengal, the practice of keeping a *bandi bou* (slave-wife) persisted well into the 20th century. A study carried out in 2003 identified 12 women who been purchased and married under such a regime between 1940 and 1974 (Blanchet 2004). The youngest was 39 years old. She had been sold by her mother against 1 *bigha* of land during the 1974 famine. *Bandi bou* were tied to their master-husband until the latter's death.[5] They and their children were not entitled to inheritance. The children of *bandi bou* were not bastards— their mothers had been married according to the *Shariah* and were legal wives, but they were excluded from the patrikin.

How do *bandi bou* compare with the purchased wives of Uttar Pradesh (*kharidan awrat*)? Let us consider the man who purchased and married Tahomina. Since this marriage broke caste rules, it can be assumed to carry low prestige. However, in the eyes of the receiving community and even in Tahomina's own society, the marriage was not termed 'faked'. Tahomina was excommunicated after she returned to her native village, not because her marriage was a faked one, but because she, a Muslim girl, had been married to a Hindu man.

One of the merits of marriages in Uttar Pradesh, widely recognised in the sending communities, is their lasting character. Husbands were known not to divorce their wives and simultaneous polygamy does not exist.

One cannot say that all these women married in Uttar Pradesh are doing well. One or two have done well; all the others have to work really hard. They go to the field like men but they are not allowed to speak to people outside the family. Their husbands beat them, just like here. One thing is good: polygamy and divorce are very rare (Mother of a woman married in Uttar Pradesh 15 years earlier).

If it could be confirmed that girls were purchased, not for prostitution but to serve as wives in long-lasting monogamous unions, would they still be considered to have been trafficked? Remarkably, in both sending

and receiving communities, the term 'trafficking in women' (*nari pachar*) has not been applied. In Bangladesh marriages contracted by Uttar Pradesh men with Bangladeshi girls were considered 'real' marriages and, as such, were moral and binding even though it was recognised that the wives had a hard life. This was clearly expressed by men at a tea stall in a village of Jessore.

> Eight women from our village left to be married in Punjab and Uttar Pradesh. Two had been abandoned by their husbands and six were unmarried. Their parents could not marry them. They were poor and some of the girls were not good-looking. Those who came back to visit after a few years looked in bad health and exhausted. The husbands we saw were elderly.

> Maybe these women have a hard life, but if they had stayed here they would have become 'spoiled'. So, it is better that they got married in this way.

That some of the girls/women had been sold was known to these men, yet no association was made with 'trafficking in women'. Rather, there was a sense of relief that the poor girls had found shelter, while their natal community was rid of women likely to have become 'spoiled' had they stayed.

In the receiving communities acquiring a wife by purchase was also acceptable. If a man could not find a wife locally, he could purchase one from a distant country. Go-betweens and *dalals* were sometimes accused of cheating, for instance, taking money from a prospective husband in advance and failing to deliver the promised girl. Wife-purchase could provoke disorder (as indicated by the Itwa doctor), but the practice itself was not condemned.[6] It was simply looked upon as a lower form of marriage, marriage with dowry following caste prescriptions being preferred and more honourable.

In the NGO milieu, trafficking in girls has been strongly associated with prostitution, so that the idea that a girl could be trafficked into marriage appeared incongruous for many. Generally, a girl is considered to have been either trafficked or married, the two terms being mutually exclusive. As seen earlier, marriage is seen as a means to restore morality and exonerate the evil of trafficking. Accusations of trafficking were proffered only when it was known that a girl had been sold to a man of another religious group.

The Economic Value of Wives: Comparing Uttar Pradesh and Bengal

The fact that rural women in Uttar Pradesh, unlike Bangladesh, commonly work on their husbands' land or hire themselves out as day labourers no doubt increased their economic value. Purchased wives are usually considerably younger than their husbands and could thus be counted upon to support them in old age. There was sufficient work (at least until the introduction of combined harvesters a few years ago) and a hard-working wife could feed herself and her family.

Purchased wives have been compared to cows, which are highly prized by their owners and which must, therefore, be tied and carefully watched over to minimise the risk of loss. The fear that newly acquired wives might escape has been a real concern, and several witnesses reported that for one year after marriage and until they gave birth, wives were locked in, closely guarded and forbidden to talk to people outside their husband's compound. They were especially barred from speaking to Bangladeshi girls living in the same locality. Later on, if and when they were allowed to visit their families in Bangladesh, most of their children were kept behind to ensure that they returned.

In Basti, we met a Bengali woman called Joya Devi, married for 16 years to a much older man. She explained that her husband possessed only a *bigha* of land when he married her. Thanks to her hard work, he now owns thrice that amount. The woman's hands were rough and lined with crevasses and she looked much older than her age. She supported three children and an elderly husband unable to work. While speaking to Joya Devi, a local man commented on how devoted Bengali wives were. 'They are better than local women,' he said. In 16 years, Joya Devi had not contacted her natal family. Her situation recalls the description of a *bandi bou* provided by a Sylheti informant in a mid-19th-century document. Asked whether the transportation and sale of women constituted a domestic slave trade, the woman had replied:

Whereas a wife continued to have claims upon kin for redress of wrongs and retained visiting rights, and her children had both sets of kin (maternal and paternal), a slave-wife did not. These girls never again in their lives saw their relations. (cited in Chatterjee 1999: 26)

Joya Devi did not consider herself to be a slave-wife, though she had been a purchased wife and the above definition fits her situation rather well. Many hard-working wives like her eventually gained the appreciation of their husbands and could achieve a degree of economic security for themselves and their children. But they possessed nothing of their own. Joya Devi said her son would inherit his father's land.[7]

The distinction between purchased wives and non-purchased wives, as well as the extent of their respective 'alienation' and 'non-belongingness' (to use Chatterjee's criterion of slavery), are certainly matters of degree. For the women whose stories we recorded, the success of integration has been variable. In some cases, 20 years did not suffice to develop a sense of belonging. Others stayed and were eventually absorbed into their husbands' families.

Marriage Across the Frontier: Views on *Bidesh*

For most Bengali girls marriage entails migration.[8] Marriages were, and still are, largely virilocal. But in the cases reviewed here the cultural and the geographic distances travelled by these wives-to-be were exceptionally large, creating a deep rift between wife-givers and wife-takers. We have seen that married daughters' visits to their father's homes on *nayor* could not take place in a normal way. Husbands forbade or delayed these visits to the extent that contacts between a wife and her natal family were often severed and the wife-givers eliminated from the social landscape altogether. The cost of purchasing the wife was often recalled to justify the cancellation of wife-takers' obligations towards wife-givers. It did not matter that the money was not paid to the girl's parents themselves, but to a go-between. Here, the asymmetry between wife-takers and wife-givers is carried to the point of negating kinship and ritual exchange altogether.

The exploitation of Bangladeshi girls sold as wives in Uttar Pradesh or elsewhere was facilitated by their uprooting to a foreign land (*bidesh*). *Bidesh* is a relative term. In the context of the events studied here, it defines a place where the language, food habits, hygiene, climate, crop patterns, gender division of work and many other customs were unfamiliar. Hindi or Bhojpuri was spoken, wheat and *dal* replaced a diet of rice and fish,

bathing every day was frowned upon[9], winters were cold and summers extremely hot, and wives were made to work outdoors on the land like Santal women. The initial confinement and isolation suffered in their husband's home and the low respect in which they were held made *bidesh* a particularly inhospitable place. The contrast with women who migrated for work in cities such as Mumbai is considerable (Blanchet 2002). The latter experienced the modernity of a cosmopolitan city, which offered them income and a much appreciated independence and autonomy. In their case, *bidesh* is described very positively.

In defining *bidesh*, the demarcation between Bangladesh and India is not what matters. Even though the border has become increasingly difficult to cross (without documents), West Bengal is not understood as 'foreign land'. The same families straddle the border, journeys are frequently made, and marriages across the border are contracted regularly. A Bangladeshi girl marrying an Indian man does not necessarily imply a journey to *bidesh*. *Bidesh* starts further west, beyond Katihar in Bihar.

Relatives who have visited sisters or daughters in Uttar Pradesh have been shocked by the lack of consideration and the poor reception they received there. This is how a mother described the visit she made in 2001 to her two daughters married to two brothers in Basti 18 years earlier.

Last year, we gave the *dalal* who took our daughters 700 taka and, with my 21-year-old daughter, I went. What I saw was appalling. My daughters were married to men who had been married before and had children from a previous wife. They had to work the land like Santal women. They were not given any consideration. My daughters could not spend any time with us. They are like slaves.

We were not allowed to go out and meet with other girls from our area who have been married there. We were kept in one room like prisoners. Food was brought to us, but our daughters were kept away from us. We could not speak to them freely. In the end, we were told by their husbands: 'Your daughters were sold to us for 40,000 taka. You need not come and visit them any more. This damages our reputation.' My son-in-law gave money to a man who took us back to the border.

People here know my daughters were married. After 18 years, I learned they have been sold. Now I know. They are like the cows one

gets to plough the field. They get fed because they work and give birth
to children. They could not talk to their own mother. They could not
offer her a plate of food. If I had married my daughters to beggars
here, they would have been better off.

In another case, a father visited his daughter in Gonda seven years
after she had left and once more two years later. On the first trip, he
found out she had been married to a Sikh. This is how the mother
describes the two visits.

My husband took a lot of trouble to find Lukki. When he did find her,
he was not allowed to see or to talk to her. He stayed with Rahima
for five days [a woman originating from the same Bangladesh village
and married to a Muslim man].
 One day, Lukki's husband threatened my husband with a gun.
Rahima's husband intervened. In the end, he was allowed to see
Lukki from a distance, but he could not talk to her.
 Two years later, my husband returned. This time he was allowed
to stay in our daughter's compound, but in a separate house. He was
given raw food, which he cooked himself. He could talk to Lukki,
but he could not touch her or go near her. He felt humiliated and
sad and after five days, he returned. As he was leaving, Lukki sent
a photo of herself and her husband for me. This is all I have of
her. My husband died three years ago and I cannot visit her. Our
daughter has been lost to us.

In 15 years of marriage, the daughter did not meet her mother. The photo
she sent has been framed and hangs on the wall of her mother's house.
It shows a 'happy' couple. The bride wears *shindur* on her forehead,
and a tattoo has been imprinted on her arm with her husband's name.
The mother commented: 'This is how they mark them. Rodhuli [the
neighbour who took her to India] sold my daughter.'
 In other words, *bidesh* is understood as a location where marriage
is differently constructed and where 'our' rules do not apply. In both
the cases cited above, the girls' parents did not initially know that
their daughters had been sold. When they learned in addition that
their daughters had been married to men of a different religion, the
reckoning was painful. For them, the religious merit expected from
kanyadan was transformed into guilt and shame, not to mention the

humiliation of having been fooled by the *dalal*. These are the cases where parents talked of their daughters having been trafficked.

Inter-religious Marriages and their Consequences

Among the daughters who never kept in touch with their families, how many were sold to men of another religion? Such occurrences are preferably concealed, but there are indications that such mismatches are not at all unusual. Women who are married into a different religious group describe how they were made to hide their identity, infringe food taboos (for example, raising pigs, cooking and eating pork were taboos for a Muslim girl) and follow unfamiliar rites, a situation that further exacerbated their sense of alienation and non-belonging. In contexts of exaggerated communal antagonism, as recently witnessed, their situation could become untenable.

Some parents suspected that their daughters were married to men of another religion but they could not get confirmation of this. A mother who accompanied her two daughters to Basti described the marriage event:

> Seven girls from this village left together. There were three *dalals*, two men and one woman. I was the only guardian. Other parents had insisted that I go to represent them. It took three days and two nights to reach there. The *dalals* paid for my ticket. We got off at Basti station.

> The *dalals* left me alone in one place and went elsewhere with the seven girls. I could not say anything. The following day, my two daughters were married to two brothers. All girls were married in the neighbourhood. I could hear the sound of the wedding, but I could not go.

> I had seen Hindu weddings before. I recognised the drums, the *shehnai*, and the *ulu-ulu*. It was like that. Was it a Hindu or a Muslim wedding, I could not tell.

After the marriage, I asked to see my daughters again, but I was not allowed. I pleaded with the *dalals*. Allow me at least to see from a distance what my daughters' husbands look like, but they refused. I just cried.

This mother has never been able to clear her doubts and her married daughters have remained silent on the issue. We questioned two ex-*dalalis* regarding this matter. Their statements are revealing. The first said:

When you took a girl there, the community leaders [*morols*] arranged the marriage. The one who brought the girl was only the guardian. Local people were the matchmakers. If we did not agree to their choice, there were problems. Who the girl married depended on the power of the leaders.

The second explained:

Matching *jati* and religion was not possible for us. We did not understand which religion these men practised. Besides, they were not particular about the religion of the girls they took. They were satisfied just with getting a girl.

Finally, one *dalali* who is still active was very specific:

All the girls I took to Bareilly and Haridwar were married to Hindu men who had been married before. Demand for girls was especially high among Hindus as it was more difficult for them to find a second wife locally.

These testimonies are consistent with the information obtained in Uttar Pradesh. Men sometimes fought among themselves to get the most attractive girl, and the most powerful prevailed. That no question is asked about the religion or the caste of the girl to be wedded in a society where caste remains an important marker of status and identity is telling.

In Uttar Pradesh, people were aware about the mismatch in marriages with purchased wives. Upper-caste men claimed that the practice did not exist among 'us'; it was found only among 'them', that is, the Scheduled Castes. Similarly, Shia Muslims said it occurred only among Sunni Muslims. *Dalals* were blamed. It was said that they were only interested in the highest bidder and did not care to match *jati*. Jokes

were made about purchased girls who, within a few hours, were pressed to learn the basics of a religion they had not belonged to. Our fieldwork in Uttar Pradesh was too short to fully enter into the complex issue of caste and religious identities. The little we saw, however, suggested that caste thinking (among both Hindus and Muslims) is pervasive and Bengali girls acquired by purchase had to contend with the problematic identity their mode of entry entailed for themselves and for their children. The low rank of the *kharidan awrat* was passed on to their children, restricting their marriage prospects. In Basti and in Gonda, men who had purchased a wife were found to marry their children within similarly constituted families, creating a kind of sub-caste, and we met children of purchased wives who wished to migrate to Mumbai or Delhi to escape the handicap of their birth status.

If incorporation has its problems, to leave a religiously mismatched marriage is even more complicated. How can a Muslim woman return to her natal community with 'Hindu' children? This is what Tahomina did. She and her children were received as sinners. Though they had sinned through no fault of their own, atonement and purification were imposed on them before they were offered any food. Tahomina described the public ceremony (the performance of *tauba*) that she and her five children, aged between 2 and 11, had to go through. She remembered the event as a traumatic and humiliating affair, leaving its mark especially on the children:

> We stood in the midst of a crowd, the children clinging to me. They did as they decided
>
> For six months, the children were terrified and did not want to go out of the house. My brother and others were hoping that they would rapidly learn Bangla and practice Islam, but it was not so easy; it took a long time for them to lose their fear.
>
> Still today, no one eats from our hand in the village. I work on the road with CARE. When I am away, the children are regularly insulted. We converted to Islam. Still people sneer at us and call us 'Hindu'.
>
> We are rootless. I am worried about my children. When I took the decision to leave with them, I did not foresee the problems we would face. The children were free and happy over there. Now, they never smile. It is as though some life substance has been sucked out of them. I feel guilty.

We see the difficulty—nay, the impossibility—for a woman to reintegrate into her natal community in a dignified manner once it gets known that she has been wedded to a man of a different religion, even though she had no choice in the matter. Other women married in a similar way may well have preferred to sever contact with their natal families.

Marriage, Consent and Trafficking

What did the migrant purchased girls have to say about these marriages? Were they willing candidates for wifehood in a foreign land? Were they even asked for their opinion at any stage of the transfer?

It must be emphasised that marriage for these daughters and their parents was not a matter of choice. The pressure on guardians to marry off daughters before a certain age was considerable and, although there are differences in the marriage systems of Hindus and Muslims, this obligation is woven into a shared Bengali cultural fabric.[10] Many girls left for Uttar Pradesh obediently as their parents entrusted them to a neighbour or an 'auntie' with the instruction to arrange a marriage should a suitable husband be found. Others took the initiative and convinced their parents to let them go to Uttar Pradesh to be married. A mother whose two daughters did so describes the pressure they felt then. This was in 1983:

> We could not marry our eldest daughter who had reached the age of marriage [she was 17 years old]. We could not pay for dowry. Her sister was one year younger. We kept them inside the house, but people still criticized us. 'Your daughters are like banana trees. They are growing out of the roof. They are like elephants [too big to be living at their parents]. How can you keep them inside the house? At their age, I had two children already.' My daughters felt shame. They did not want to hear these insults anymore. So they left to be married in Lucknow.

In 2002 this mother said she will not send her youngest daughter to Uttar Pradesh even though she is still unwed at the age of 21:

> The pressure to marry a daughter is not as strong as it used to be. People don't insult us anymore. This unmarried daughter is not

confined to the house as her sisters were. She is a BRAC member; she raises ducks and has some income.

Today, two types of daughters continue to migrate for marriage in Uttar Pradesh. The first are poor Hindu girls. Dowry demands for them are even higher than for Muslims, and the matching of caste in a dwindling Hindu community creates additional problems. In 1999, Nironjon, the father of eight children, married his 15-year-old daughter to a man from Uttar Pradesh who came looking for a wife:

> We agreed to the marriage. They left the day after the wedding. We did not offer anything except food. They came prepared with the sari and everything. Tulie cried at first, but she seemed happy afterwards.
>
> Two years ago, Tulie came on a visit with her husband. She had lost weight and looked very depressed. She had to serve a large family of in-laws. Her mother-in-law and her husband made her life very difficult. They beat her. She worked like a slave. She was not given time to eat or to rest. As she left she said: 'Instead of marrying me, why did you not drown me in a river?' She cried the whole time. I felt sad, but what could I do?
>
> I cannot poison my daughters. If I send them away to survive, what is the problem? You don't know how tormenting it is to keep an unmarried daughter in the house. Our community sent many girls to the west and we still do.

He is now considering marrying another daughter in Uttar Pradesh. Though he did not actually 'sell' Tulie, he did not have to pay dowry and thus saved himself from running into debt. In Basti, we noted that wives acquired by husbands from Bangladesh continued to be categorised as *kharidan awrat*, even when no money was given to the girl's parents. It sufficed that the husband spent money to procure a Bengali wife.

The other women recently married in Uttar Pradesh were older and they had 'agreed' to sell themselves to flee from intolerable situations. One woman had a heroin-addicted husband who was so desperate for the substance that he offered her to other men. She left him and went to live with her mother, but her husband pursued her there. The mother suggested a marriage in Uttar Pradesh, but this second marriage gave

her daughter no peace either. Her daughter had escaped the frying pan to jump into the fire. In another case, a 14-year-old girl became the family's main breadwinner as her father was sick and her elder brother was a heroin addict. She earned an income by carrying smuggled goods across the border, a job which exposed her to all kinds of risks and abuse. At home, the heroin-addicted brother regularly seized her earnings and could be violent. With no peace at home and no peace at work, at the age of 18, she accepted a marriage in Uttar Pradesh. Women who 'agreed' to sell themselves, surrendering their freedom and entering into servitude to pay for a debt or simply to survive, were common in times of famine not so long ago.

To sum up, some of the migrant girls were prepared for marriage; others were caught by surprise. Some left enthusiastically; others reluctantly. Whether they consented to the marriage or not made little difference to the outcome. Most of them sooner or later realised that they had been cheated and were trapped. Husbands were much older or much poorer than announced; they often had children from a previous marriage; the workload was excessive; the lack of trust and isolation were intolerable. Cheating and lying by matchmakers or prospective husbands to convince parents to agree are common in 'normal' marriages as well. But the distance involved in the migrant marriages made it easier to elaborate a fiction that could not be checked beforehand. And once married, the girls were trapped: by the marriage, by the distance from their natal family and by the announcement that they had been purchased. Nazma did not protest when, aged 14, she was taken to Nainital by a village 'auntie' and her marriage was arranged. After all, her parents had instructed the auntie to do so if a good party could be found. The shock came four years later when she asked her husband for permission to visit her parents. He replied that she had been purchased for 20,000 taka and that she had no such right. The sale could not be verified, but the husband's claim prevailed. Being denied the right to visit one's natal family came to symbolise the plight of purchased wives.

Could the girls not have challenged the conduct of such 'sale' as immoral, illegal and unacceptable? The power of ideological constructs sustaining market and marriage systems here must not be underestimated. The actors involved in the trafficking scenario shared a culture in which the right to appropriate a purchased girl is recognised. As for marriage, it guarantees a husband and his family the right to wedlock a wife and exert monopoly rights over her. These wives

possessed no wealth of their own, not even the jewellery that came with a dowry, and they had completely lost the support of their natal families. Given their educational levels and the isolation in which they were held, most of them stayed on.[11] A *dalali* we met in 2003 in Jessore announced that two Muslim girls whom she had sold 20 years earlier to two Hindu men in Haridwar had returned. They were middle-aged women and they claimed money from her as they knew she had sold them. These women had voluntarily come forward when the police searched for illegal Bangladeshis living in the area, and it is through the police that they returned to Bangladesh, leaving their numerous children behind.

For people with very little choice, protest and lack of consent cannot be regarded as criteria for the offence of trafficking. Here, parents were trapped. They could not pay dowry, and without dowry, prospects for marriage were extremely poor. The obligation to arrange a marriage, even if it is a bad one, was felt by both parents and children. Many daughters agreed that if a marriage in Uttar Pradesh was the only kind their parents could afford, they would accept the situation. Some girls left laughing, others left crying, but most were quiet and resigned; they 'understood' what was expected of them. In this sense, the criterion of 'consent' or 'protest' is inadequate to measure the extent to which exploitation and pain may be suffered by an individual.

The Role of *Dalal*s and *Dalali*s

Parents' inability to pay dowry comes at the top of the list of reasons alleged for agreeing to a marriage in Uttar Pradesh or further west (see Tables 6.1 and 6.2). Explicitly stated in 31 per cent of the cases, the inability to pay dowry can be read into other answers as well. We know that a high dowry could redeem poor looks, damaged reputations, advanced age or other negative points on the marriage market. Similarly, acceding to dowry demands could avert the dissolution of a marriage. Asked the reasons why a girl had migrated, nearly one quarter of the respondents mentioned enticement by the *dalals* (Table 6.1), who acted as the main motivators in half of the migration cases (Table 6.2). Proposing a service, some go-betweens took money from wife-givers so as not to provoke suspicions regarding their ulterior motives.

Table 6.1 Reasons for Marriage and Migration to North India

Reasons	No. of Women	Per cent
Parents unable to pay dowry	35	31.2
Enticed by dalal	26	23.2
Parents wanted the money (Jaipur)	12	10.7
Previous marriage failed due to poverty	8	7.1
Marriage only	9	8.0
Girl getting old for marriage	6	5.4
Girl not attractive	4	3.6
Father took no responsibility for daughter; used daughter's sale proceeds for his own marriage	3	2.7
No job opportunity in Bangladesh	3	2.7
Violence in the family	3	2.7
Other reasons	3	2.7
Total	**112**	**100.0**

Table 6.2 Main Motivators/Decision Makers for Migration

Motivators and Decision Makers	No. of Women	Per cent
Dalal motivated both parents	34	30.4
Parents alone	16	14.3
Parents and the migrant jointly	10	8.9
Migrant alone	11	9.8
Dalal motivated the migrant	9	8.0
Dalal motivated the mother	9	8.0
Father took decision with migrant's consent	5	4.5
Sister and brother-in-law	5	4.5
Father forced mother to take the decision	4	3.6
Dalal motivated the father	4	3.6
Mother took decision with migrant's consent	2	1.8
Husband and migrant motivated by dalal	1	0.9
Brother took decision with the migrant's consent	1	0.9
Father-in-law took decision with the migrant's consent	1	0.9
Total	**112**	**100.0**

In rural areas, dalals and their recruits often lived in close proximity, and the families continued to do so after the 'sale'. Even if parents knew that a relative or a neighbour had sold their daughter, they might avoid using the word dalal (at least upfront) as this is taken as a declaration of enmity. Close family members were unlikely to be termed dalals. In some cases, having discovered the trafficking activity of a particular 'uncle' or 'auntie' who had been trusted in the past, parents did not hesitate to call him/her dalal. Tarnishing a reputation was the only punishment that the wronged parents could exert.

Mumbai *dalals* used more sophisticated techniques and participated in a market where profits were higher. A woman from Jessore, Sabiha, gave a good description of the *dalali* who sold her 13-year-old daughter. Sabiha migrated to Mumbai in 1985 with her husband and their five children. She first worked as a maidservant, but the pay did not suffice. A Kolkata *mashi* (auntie) introduced her to prostitution and employed her two daughters aged 11 and 13 as maidservants. Within two years, Sabiha was persuaded to place the two girls in a brothel and her youngest daughter replaced them in the *mashi*'s house. Sabiha saw the *mashi* as her mentor. Through her, her family was pulled out of destitution. But one day she realised that she had been made a party to the selling of her own daughters. The event that opened her eyes was the sale of her third daughter, at the age of 13, to an elderly man in Haridwar:

This Kolkata *mashi*, I know her business now. She keeps girls at her house as maidservants for some time, prepares them mentally, then fixes work for them. She recruits destitute people from Bangladesh who are grateful for her help and kindness. Then, it is easy to get them to accept anything.

Look what she did with my youngest daughter. One day she said to me: 'I will marry Sonia to a man in Uttar Pradesh, a widower. She will be happy. The man is a bit old, but that should be no problem.' I agreed. I did not know she would do this to me. She sold my daughter for 50,000 rupees. When I asked for my daughter's address, she gave me all kinds of excuses. Finally, she scribbled an address on a piece of paper and said: 'You go and find your daughter, but I cannot help you.'

I had a lot of problems getting there. I finally traced my Sonia. She had been there for two years and I found her pregnant. She refused to talk to me. The husband told me that he had bought her for 50,000 rupees.

I could not tell this to anyone, least of all my husband. If he knew, he would kill me. I just said to him that I had arranged Sonia's marriage. Here people know she is 'happily' married, but I know otherwise.

Sabiha had agreed to a marriage, not to a sale. There is something irrevocable about being sold as a wife. The trap is for life, whereas prostitution could be a temporary affair. Sabiha felt guilty, but she also

knew she had been manipulated and exploited by her mentor. Another woman explained how in 1986 her two daughters were enticed from the slum where they lived in Mumbai:

> There are women there whose work is to look for girls ready for marriage and send them to Uttar Pradesh. They act like matchmakers, but their purpose is to make money. Agents inform them about newly arrived people.
>
> We had not been there four months before the matchmaker spotted my daughters. The woman behaved so nicely with us. We trusted her and allowed our daughters to go out with her. She was about 40 years old, from Faridpur. Her name was Shona Bibi. She came with gifts for the younger children and she showed us such kindness.
>
> She spoke like this: '*Arre*! My country people are dying of starvation and here there is so much to eat. Boys offer money to marry girls, and in my country girls remain unmarried because dowry cannot be paid. You are my country people. I will see what I can do for you.'
>
> She found new employers for me and I earned more. I felt very grateful to her. In my absence, she visited my daughters and motivated them. In the end, my daughters themselves proposed to go with 'auntie' who would arrange their marriage in Uttar Pradesh. I was overwhelmed with problems and I agreed to let my daughters go. This was seven or eight months after we arrived. I thought: Shona Bibi is Bangladeshi. I can find her if need be. The girls themselves were happy to leave. They could not stand their miserable life any more. We went out to work, but they were left in the *basti* all day. I thought my 12-year-old daughter was too little to be married, but my husband convinced me to let her go.
>
> In 1986, I entrusted the two girls to Shona Bibi, taking God as a witness. They left happily, but their father and I were crying. This woman came to see me 20 days later. She said the two girls had been married in Bareilly and, should I want to visit them some day, she would go with me. She left no address.
>
> People around us started talking. Some said: 'Don't you see, your daughters were sold.' Others said: 'You were burdened with four daughters and you are poor. It is better like this.'
> We never saw the matchmaker again.

Zamiron received from the matchmaker a total of 10,000 taka. It was given in small amounts as a kind gesture to a needy family. She did not link these 'gifts' with the departure of her daughters for Uttar Pradesh. It is only 15 years later when she found her daughters and heard they had been sold that she realised this money had been an advance payment for their sale.

Offering parents a share in the benefit of their daughter's sale is a very efficient way whereby *dalals* shame and silence them. One poor widow, mother of five daughters, allowed one of her daughters to be taken to Uttar Pradesh. She never saw her again. She confessed with great sorrow: 'The *dalal* secretly gave me 1,500 taka. I "ate" those takas. That means I can never say anything against him.'

Dalalis who, entrusted by the parents, took girls from their village communities, did not admit to dealing with both the marriage and the prostitution markets. But we have evidence that some did so. As seen above, these village women and men were of humble origin and, in carrying out their business, they exploited the trust they could easily gain from families of a similar background. They spoke the same language as their recruits. In the trafficking of girls Bengalis exploited Bengalis, females exploited females, neighbours and relatives exploited their own people. *Dalalis* sheltered behind the appearance of simple village women, often past their prime and of a respectable age. If religious merit as well as money could be gained by selling a girl into marriage, why should they not do so? they reasoned. But the driving *motivation* of their trade was certainly not religious.

Conclusion

The migration and sale of Bengali girls from Bangladesh (and West Bengal) to North India for the purpose of marriage peaked 15 to 20 years ago. It decreased thereafter, but never completely stopped. Go-betweens/traffickers traded in girls between a country that supposedly had a surplus, and another with a shortage of them. Dowry demands crippled poor Bengali parents who could not arrange marriages for their adolescent daughters. At the same time, obsession with purity required that girls be married early. These factors, rather than demography,

created a 'surplus' of girls available for marriage to men in a foreign country (*bidesh*). Girls were collected from densely populated areas along the Indian border in Jessore, Satkhira, Khulna and Rajshahi. They were also recruited from Mumbai slums and from Indian railway stations where poor Bangladeshi migrants transited. Parents who could not ensure their daughters' security agreed to let them go to be married in Uttar Pradesh. Most wife-givers were not aware of the sale, and did not benefit from it.

Go-betweens (*dalals/dalalis*) were often women of humble origin, and their profits could be modest. The 'sales' they effected were nonetheless highly consequential for the girls they disposed of. Purchased girls were integrated into a rural economy where their labour and their reproductive power were exploited to the utmost. The demand for purchased wives came from areas where girls have been 'missing'. Since the technology enabling the selective abortion of female foetuses was not in use at the time, it may be assumed that female neglect, hard work and lack of health care accounted for the skewed sex ratio.

Purchased girls were often married to older men who had been married before. Marrying a young girl procured for these men a source of dependable labour and insurance for their old age. Several Muslim girls were married to Hindu men, a situation that exacerbated their sense of unjust appropriation and made return to their natal communities impossible. For poor men, the purchase of a Bengali wife was cheaper than marrying local girls:

Twenty-three years ago, it was expensive for men to marry over there. They had to offer gold and silver to the bride and the *den mohor* [in Islamic law, the money pledged by a man to the woman he marries] money had to be paid to the guardians. It was much cheaper to marry a girl from Bangladesh (A Bengali wife married in UP for 23 years).

In the last few years combined harvesters have reduced the demand for agricultural labour in the receiving communities, while out-migration to the city has drained villages of their youth, altering lifestyles and marriage patterns. One informant explained:

Now, *dalals* do not bring girls from Bangladesh as before because boys migrate to the city and marry over there. The demand for Bangladeshi girls is not as it was before. In our village in case of emergency you will not find 10 men. Girls who were married in my

time all stayed behind in the village. Now, half of the young wives live in the village, the rest in cities.

Boys there live abroad—Delhi, Bombay, Agra, the Middle East and elsewhere. Some come only every three years. Why should a girl leave her country to marry such men?

While demand decreased in Uttar Pradesh, 'surplus' girls available for marriage abroad also decreased in Bangladesh. Parents became increasingly reluctant to send daughters for marriage to the distant west. Returnees spoke of the harsh lives and the low status of these wives, and there was concern for the girls who never came back. Migration for work to cities such as Mumbai and benefiting from remittances became more attractive propositions.

Today, girls from the same villages migrate to Mumbai and the Middle East to work in the entertainment industry, earning more than their brothers and redefining gender roles within the family. They migrate as individuals, breaking away from *purdah* and living temporarily without familial supervision. This type of migration promises to usher in profound changes within sending communities, the full measure of which is still to be assessed.

The marriages concluded by foreign men with Bangladeshi girls who later disappeared and were never seen again have been termed 'fake' by activist lawyers in Bangladesh. It was suspected that these marriages were mere instruments to recruit girls for prostitution. But the existence of a marriage market to acquire wives is well documented. Purchased girls lived monogamously in long-lasting marriages, gave birth to several children and were most effectively wedlocked. They were denied the right to visit their natal families on the grounds that they had been paid for. Affinal relationships were not recognised, and ritual exchanges between wife-givers and wife-takers did not take place. Like slaves, the purchased girls were denied antecedents by those who acquired them, their natal families obliterated from the social landscape. The geographical and the cultural distance travelled facilitated this unilateral transfer by 'guardians' who were not the girls' parents, and the purchased girls were effectively appropriated and silenced. The fiction elaborated by wife-takers could go unchallenged so long as purchased daughters did not reconnect with their natal families.

The girls who left to be married were driven away, and were not meant to return. Remittances were not expected of them. They did not enrich their natal families or their country of origin. Their migration

without return may have pained their parents, but it hardly left a ripple on the collective memory. Hopefully, this research study can restore them a place, if only in migration studies.

Notes

1 Thirty cases were documented from communities in Jessore and Satkhira, and 67 were recorded from villages in Rangpur. Some of the informants in Jessore and Satkhira had migrated with their families to Mumbai, and it is from that city that their adolescent daughters were taken away from them. Fifteen cases were collected from a community of Bangladeshi migrants living in Jaipur, Rajasthan.

2 *Dalal/dalali* refers to a male/female broker, agent or go-between. The word often has a negative connotation. *Dalals* play an important role in cross-border migration. They are useful, for they get things done, but at the same time they are suspected of using devious means, telling lies and cheating. The term is ambiguous in that it can describe technical skills in a neutral way, but can also be used as an insult, for example, when it refers to transporters of human beings in cross-border trafficking.

3 For communities living in Western Bangladesh, along the Indian border, Kolkata and Mumbai are better known cities than Dhaka.

4 The burning down of brothels under government patronage in the latter part of the 20th century and 'rehabilitation' of the inmates through marriage shows that attitudes shaped in the late 19th century survived for a long time.

5 While both Hindus and Muslims kept *bandi*, only the latter could marry them, as Islam permits polygamy. The number of Muslim men marrying *bandi* is likely to have increased following government pressure to end slavery. The colonial government could hardly object to a second or third wife married according to the *Shariah*. The survival of *bandi bou* much after the abolition of slavery, and its subsequent demise when the practice came to be seen as shameful, unjust and unIslamic, provides an excellent example of the juxtaposition and contradictions between the different laws governing marriage.

6 Recent events in Uttar Pradesh have led to greater caution in exposing the practice. The topic is now censored. Many in the area admitted that such a system of wife procurement could lead to some excesses, but the phrase 'trafficking in women' was carefully avoided.

7 This constitues a major difference with the children of *bandi bou*, who were barred from inheritance.

8 This is especially so for Hindu women. Muslim women can marry their father's brother's sons, in which case they do not migrate.

9 'If you bathe every day, your sari will tear quickly and this will be inauspicious for our family,' said a mother-in-law to her Bengali daughter-in-law. In Bengal the daily bath is regarded as a necessary social and religious performance, especially after a wife has had sexual intercourse. Skipping it could bring illness, inauspiciousness and other ills. Such divergent rules and beliefs defined *bidesh*, marking the body and the most intimate gestures.

10 In the true spirit of *kanyadan*, parents have a religious duty to marry their daughters before or soon after puberty, and they are not meant to derive any material benefit from doing so. The gift of a virgin daughter in marriage is believed to bring blessings upon the parents, and the transfer of a bride from wife-givers to wife-takers is, ideally, total and final. See Bennett *(1983)*.

11 The same faithfulness has been found among *bandi bou*. Most of them remained with their master-husband until the latter died, even though they were treated as servile inferiors.

References

Association for Community Development (ACD). 1995. 'International Migration of Women: A Study on Causes and Consequences'. Mimeo, Rajshahi, ACD.

Bennett, Lynn. 1983. *Dangerous Wives and Sacred Sisters*. New York: Columbia University Press.

Blanchet, T. 2002. 'Beyond Boundaries: A Critical Look at Women, Labour Migration and the Trafficking Within'. Mimeo, study presented to USAID, Dhaka.

———. 2004. 'Slavery Revisited: *Bandi Bou* in the Rural Homes of Bengal'. Mimeo, study prepared for Save the Children, Sweden and Denmark, Dhaka.

Chatterjee, I. 1999. *Gender, Slavery and Law in Colonial India*. New Delhi: Oxford University Press.

7

Unorthodox Sisters: Gender Relations and Generational Change among Malayali Migrants in Italy

Ester Gallo

Introduction

This chapter deals with the migration of Christians from the South Indian state of Kerala to Italy[1], focusing on the experiences of migrants and on their discourses on marriage and dowry. In exploring the relation between women's active engagement with transnational migration and transformations in the meanings and practices of marriage, the chapter analyses the way in which this important lifecycle event intertwines with experiences of geographical and social mobility, how migration contributes to the redefinition of family, and the way in which gender ideologies and generational relations and values are questioned and reformulated by women as migrants and earning subjects. First, I will briefly reconstruct the history of Malayali migration in Italy to highlight the heterogeneity of women's experiences and the different roles played by marriage and dowry in their lives. Second, I will show how ideologies and practices surrounding marriage and dowry, far from being confined to one country, are subjects of negotiation between different contexts and heterogeneous household expectations. I argue that the relation between women's transnational migration and changes in household relations and practices should be understood as a dialectical process, and that the analysis of transnational marriages through the perspective of lifecycle transformations and generational change is a prerequisite for

understanding how multiple meanings of modernity inform processes of change in contemporary Malayali marriage.

The importance of past and present changes in South Indian marriages within the wider context of modern social transformations has been widely documented (Billig 1992; Caplan 1984; Fuller 1976; Kapadia 1996; Visvanathan 1993), but little attention has been paid to the way in which these changes are informed by and contribute to shaping migrants' experiences in different places (for some exceptions, see Kurien 2002; Osella and Osella 2000a). The transnational perspective on migration has encouraged us to explore the ways in which people build social fields across borders, linking together different locations (Glick Shiller et al. 1992; Rogers 1986), and underlines the importance of understanding the dynamic processes of constant networking that characterise contemporary migration (Riccio 2001: 585). More specifically, recent studies on the relation between migration and the formation of transnational families have shown how the adoption of a wider perspective on household life-cycle rituals can contribute not only to a deeper understanding of the complex and changing meanings of rites of passage, but can also represent an important key to interpreting relations between places, cultures and gender (Gardner and Grillo 2002; Mand 2002). In this chapter I will draw on the theoretical framework developed from these studies in order to analyse the dynamic interplay between women's active engagement with transnational migration and processes of transformation in the meanings and the practices of marriage.

In order to understand how gender and generational relations inform and are reformulated in the context of migrant marriage, it is important to take into account the active role played by women in the recent Malayali migration to Italy.[2] The history of Malayali migration in Italy is distinguished by the pioneer role played by women during the past four decades in developing a transnational network of relations which supports and stimulates an increasing flow of people from Kerala, particularly after the 1960s.[3] This recent tendency in Malayali international migration, while historically and socially rooted in heterogeneous experiences of geographical mobility[4], nevertheless reflects deep changes in contemporary migration patterns towards what has been recently called, with reference to Southern European countries, the 'feminisation of migration' (Anthias and Lazaridis 2000: 15).

If we look at Malayali migration to Italy, it emerges that the process of feminisation of migration has meant not only the increasing

presence of young women in the migration flow, but also the growing importance of these women in shaping patterns of social and geographical mobility through the development of contacts, jobs and life experience opportunities for other women and men. The narratives and experiences of these women encourage us to explore not only the influence of global forces in shaping their lives as migrants, but also their personal agency in aspiring to social and geographical mobility. As Anthias and Lazardis (2000) point out, women's involvement in contemporary migration to Southern Europe is characterised by their presence in the lowest sectors of the labour market and thus serves the needs of global capital for flexible and underpaid workers. But this image should not obscure the transformative impact of women's transnational roles as migrants and earning subjects. I will show here how the meanings and effects of these experiences are always subject to negotiations between different contexts and heterogeneous expectations, making migration a complex, ambiguous and often conflictual experience.

Migration is important not only on account of possible economic advantages but also, as Mary Beth Mills' (2001) insightful analysis of women's migration and modernity shows, for its potential for personal transformation. That is, migration entails 'projects of transformation' through which new identities are forged and existing orders either challenged or in some way changed (Gardner and Osella 2003: xxii).[5] If we consider the way in which these projects are actively carried out at the household level in Kerala, we see that women are more often than not the first members of the family to take the decision to migrate to Italy. Typically, such households have not directly benefited from previous forms of migration (for instance, during the colonial period, soon after independence, or during the 1970s' mass migration phase to the Gulf), and come from the lower middle class of Christian society. As with female migrants from Sri Lanka to the Middle East, Malayali women's experiences in Italy as earning subjects give them considerable power, since they are transformed from being dependant to having others dependant on them (Thangarajah 2003: 155; see also Gamburd 2000). This fact emerges at both the conjugal as well as the inter-generational level. Younger migrants—often unmarried—only rarely bring their parents or other elder members of the household to Italy. Contemporary Malayali migration to Italy is partly stimulated by elders' material and symbolic investment in younger members of the family, who are seen as more suited to taking up uncertain and temporary jobs abroad and better able to adjust to new lifestyles.[6]

Migrant women's new roles within the household also promote the reinterpretation of conjugal roles and affinal relations. One of the striking features of Malayali women's migration to Italy is that only a minority follow their husbands. Moreover, the percentage of women who left their spouses behind in Kerala is higher than that of their male counterparts.[7] The meanings and ambiguities of women's active involvement in migration should be understood in the wider context of modernisation in Kerala, where women's engagement within the household as active domestic subjects was an integral part of a public project aiming at the consolidation of the conjugal family.[8] In this respect, Devika's (forthcoming) analysis shows how, within this process, the affirmation of active gendered subjectivities may ultimately, and paradoxically, contribute to the consolidation of a patriarchal order in contemporary Kerala. In the first decades of the 20th century, employment for women of the new elite was projected and justified as an extension—and thus as a continuity—of their domestic agency (ibid.). In this light, lower-class Malayali women's migration may be interpreted as an alternative strategy aimed at developing active domestic subjectivities within the household.[9] We should, therefore, be cautious in identifying women's active role in migration as a process necessarily antagonistic to the establishment of patriarchal hierarchies and ideologies.

Nevertheless, it is important to remark that the achievement of an active role *within* the household is only one aspect of women's expectations of migration. This is paralleled by their personal project of transformation *outside* the household as independent women, a development that is often the cause of conflicts within the family.

Second, women's transnational activities have led in the past decade to the development and the vitalisation of a transnational kin network between related households that is, in both symbolic and practical terms, wider than the conjugal family.[10] This kin-sustaining network expresses solidarity as well as moral and economic dependence between women of different ages and generations. I will try to show how these overlapping dimensions of lived kinship—conjugality and extended women-centred kin relations—are potentially a cause of tension between and within families in Italy and Kerala.

The reconfiguration of generational relations and values produced by the migration of young Malayalis—alongside the partial erosion of generational hierarchies entailed in the affirmation of the conjugal family—goes along with the consolidation of inter-generational relations

between migrant women in the migrant destination. Young migrants are often stimulated by the example of sisters, cousins or aunts who first came to Italy as individuals, and who are considered as successful and attractive models for women aspiring to migrate.

The adoption of a generational perspective represents an important key to understanding the complexity of people's experiences of migration and of their engagement with modernity and processes of social mobility (De Haan 2003). In adopting a life-cycle perspective on migration, I am particularly interested in showing how different values and meanings attached to generational relations are reformulated in the context of transnational locations, and how this informs migrants' desires and choices in respect of marriage.[11]

Malayali Migration to Italy: A Brief Account

Compared with more widespread and historically rooted forms of international migration from Kerala, the Malayali presence in Italy has a relatively recent history, dating back to the end of the 1960s. Moreover, it has increased substantially only over the past 15 years.[12] In the province of Rome the community is estimated to be around 3,800 persons, of whom women account for around 63 per cent.[13] Historically, Malayali migration to Italy may be divided into two linked phases.

First Cohort: 1960s to the Late 1980s

The pioneering role played by women in 'opening the way' to Italy for other Malayalis is historically rooted in a peculiar relation between the Vatican State and the local churches in Kerala. Between the end of the 1960s and the beginning of the 1970s, a considerable number of Syrian Christian women arrived in Rome with the intention of becoming nuns. Their decision was encouraged by Italian members of the Vatican who were sent to Kerala to 'recruit' local girls with the support of village parishes. In women's narratives, their past as pioneering migrants and the decision to embrace a radically different life, perhaps far from their

real expectations, is typically presented as the only means available to them to cultivate a different existence. Their narratives allude to subtle or open family conflicts, emphasise women's inability to adjust to family hierarchies and the lack of opportunities for them in the natal village.[14] As one of the women I spoke with in Rome said:

> What would have I done in Kerala? Get married and stay at home. . . and who would have paid for my marriage? We were five daughters . . . and my family was so poor! I think I was only ready to go because I have never been able to adjust to the life there.

This comment illustrates the tensions and the ambiguities surrounding women's expectations of marriage. As they recall it, the decision to leave Kerala was not motivated only by their household's inability to assure them a future marriage and a 'good' dowry. Marriage was also conceived as limiting their wider choices and aspirations. Indeed, my informants were sometimes quite critical of familial and social hierarchies. Mary, who came to Italy in 1967 and is today living in Rome, shared similar sentiments with other pioneer migrants:

> I did not like the way in which my father was treating us, and the people who were working our small land . . . you could not say a word, especially women! I think I am happy I have chosen a husband by myself!

In this sense, many of them initially regarded the religious life opened up to them not only as a way to relieve their families of the burden of their marriages, but also as a means to detach themselves from local hierarchies.

Subsequently, however, due to the difficult and alien living conditions in the Italian religious institutions, a number of women abandoned the convent during the middle of the 1970s and the following decade, and looked for jobs or educational openings in the city. The years that followed are often described as the most difficult period experienced by migrants. The feelings of being exploited in the religious institutions on the one hand, and abandoned by their families after their scandalous decision to leave the convent on the other, contributed to the women's sense of rupture with their original country, and shaped the individuality of their experience. It was often because of conflicts with their families in India that migrants decided never to 'go back'. Instead, working for

some years in Rome and building up an alternative way of life seemed to be the most realistic way to overcome their feelings of being excluded from both societies. In this period women's professional involvement in activities in the national or private health structures was partly facilitated by the shortage of skilled nurses in this sector until the beginning of the 1990s. This encouraged Malayali women to undergo professional training in Italy in order to ensure relatively secure and well-paid jobs. These jobs in turn allowed them to establish a wide network of relations with Italian colleagues and patients, and to find important contacts to sponsor other women to come to Italy.

In pioneer women's narratives the image of Italy is often ambivalent. On the one hand, their stories emphasise the isolation and sacrifice that they had to face during their first years in Rome, when there were few other Malayalis to support them. On the other, Italy was the place where they could find the social and economic recognition and independence that they felt was denied to them in their country of origin. This ambivalence contributed to shaping the way they represented themselves as 'self-made' women and influenced their relations with the 'newcomers', who are seen as facing fewer difficulties in coming to Italy in terms of emotional suffering and insecurity owing to the moral and economic support they receive from older women migrants. The women who first migrated to Italy played an important role in developing transnational networks between Kerala and Italy. In both contexts, they personally undertook the paperwork to help their relatives obtain regular sojourn/work permits, financially supporting their travel expenses and providing for their accommodation during their first months in Rome. In both Italy and Kerala high prestige attaches to Malayali women who are able to help a considerable number of relatives reach Italy. In describing these women as 'powerful' and 'influential', many Malayalis (women and men) refer to the range of kindred they were able to 'reproduce' in the new context.

Second Cohort: End of 1980s to the Present Day

The importance of the solidarity and interdependence between women of different ages and generations emerged with renewed

emphasis during the 1990s, when the restrictions imposed by the
Italian migration laws led to the Family Reunion Visa and Job Purpose
Sponsorship becoming virtually the only legal ways for non-EU
citizens to reach Italy[15], thus restricting migration flows in accordance
with EU directions.[16] Malayali women who came in that decade also
had to face the increasing lack of professional jobs in the health sector,
as these openings were restricted mainly to EU citizens or to non-
EU members who were able to regularise their positions during the
enactment of the Martelli Law.[17] These changes led to a considerable
restriction of job opportunities for the majority of Malayali women
in Italy, who are today concentrated mainly in the domestic sector.[18]
Nevertheless, the past decade has seen a considerable increase in the
Malayali presence in Rome, mainly assisted by the legal sponsorship of
the kin network in Italy.

In this phase, migration reflected the solidarity between related
households in Kerala and resulted in the formation of extended kindred-
based networks in the new context (see Figure 7.1). Though narratives
of first-generation migrant women refer to a 'rupture' with their
original country and a sense of belonging in Italy, their role as sponsors
for further migrants from Kerala has led them to be involved in recent
years in a deep and continuing relationship with the sending society.

The employment possibilities offered in Italy play an important
role in shaping household strategies in Kerala, for instance, in deciding
which family member is more 'eligible' to migrate. Malayali women
in Italy often encourage their female—rather than male—relatives to
migrate, knowing that it would be easier for a woman to find a full-
time job as a housemaid in Italy and to live permanently with an Italian
family. Nevertheless, it would be reductive to see the development
of a women-centred transnational network as merely the outcome of
the migrants' instrumental adjustment to the Italian labour market
requirements and constraints. Rather, through their kinship work[19],
Malayali women assure continuity to the migration process, thereby
enabling other women to achieve active roles within the family. This
continuity also fulfils women's desire to feel emotionally closer to their
native society. At the same time, through further sponsorship, migrant
women also contest family hierarchies and social pressures, supporting
other women's desires for personal independence. Thus, in privileging
the sponsorship of younger kinswomen—in being more sensitive
to their aspirations of mobility—pioneer migrants reiterate a critical

Figure 7.1 Development of a Malayali Migrant Kindred between 1967 and 2004 through Subsequent Sponsorships

1: Merci. A: 1982. M: 1989.; 2: Paul. A: 1989.; 3: Mary. A: 1993.; 4: Joy. A: 1995.; 5: James. A: 1986.; 6: Benny. A: 1990. M: 1996.;
7: Manju . A: 1996.; 8: Matihri. A: 1987.; 9: Cherli. A: 1987. M: 1993.; 10: Jose. A: 1993.; 11: Thomas. A: 1996. 12: Tommy. A: 1990.;
13: Lisi. A: 1992.;14: Kein. A: 1999.; 15: Shilbi. A: 2002.; 16: Elsi. A: 1988. M: 1993.; 17: Santosh. A: 1993.;18: Jose. A. 1993. M: 1996.; 19: Lia. A:
1996.; 20: Anis. A: 1995.; 21: Thomas. A: 1991. M: 1994.; 22: Alfonsa. A: 1995.; 23: Marina. A: 1992.; 24: Silvi. A: 1997.;
25: Alfonsa. A: 1993.; 26: Heater. A: 1998.; 27: Sophi. A: 2000.; 28: Maymol. A: 1995. M: 1999.; 29: Merine. A: 1997.; 30: Lucy. A: 2000.; 31:
Benny. A: 2001.;32: Elamma.A: 2001.;33: Mary. A:1997.;34: Shilli. A:1997. M: 2002.;35. Shamol. A: 2000.;36: Thomas. A: 2003.;37: Mary. A:
2004.;38: Mariamma. A: 1999.;39: Mary. A: 2001.; 40: Leela. A: 1996. M: 2002.; 41: George. A: 2004.; 42: Merine.

Main focus of sponsorships. Mary is the first woman of
her family and in her kindred to have migrated in Italy in 1967.

■ Living in Italy A.: Date of the arrival in Italy
□ Living in Kerala M.: Date of the marriage

(within figure) Sandro 1980 | Mary. A. 1967 | 1952

consciousness about their experiences as migrants and about the limited
social and economic opportunities for women in their native society.

Pioneer Women and Love Marriages

When Manju met her future husband in Rome, she was 32 years old
and she had been working in Italy for nearly 10 years without going back
to her village. When she told her parents that she was going to marry a
Latin Catholic man, who was also two years her junior, the latter were
quite disappointed[20], though they also expressed their happiness with
her long-delayed decision to return home for her wedding. In speaking
about her marriage, Manju often emphasised her willingness to defend
her personal decision because, as she used to say, her experiences in life
had made her mature enough to choose the right person. The marriage
was finally celebrated in Kerala in a private manner, with both families
taking part in the ceremonies. In the decade that followed her marriage,
Manju has helped her two younger sisters and many other related
women come to Italy and has also started to send money to her natal
family, which was spent in building a new brick house.

Among the women who came first, love marriages seem surprisingly
widespread. In many cases they involve Italian or other non-Malayali
men.[21] Sheila married an Italian doctor in 1983. After 12 years abroad,
her newly acquired status as a married woman encouraged her to
contemplate her first journey back to Kerala with more self-confidence
and emotional security, and she hoped that this important change
in her life would contribute to dissipating the gossip and criticism
surrounding her. Her family's acquiescence to her marriage was partly
related to the difficulties she would have had in marrying someone
back in Kerala. Her experiences were too 'unorthodox':

> Who would have married me after all this time away? I was too old
> for my country and you never know what people in India say about
> you when you are far away for a long time. . . . They invent stories.

Moreover, love marriages with Europeans are considered prestigious
as important sources of contacts abroad that can be capitalised on for
social and geographical mobility for other members of the household.

A love marriage with a non-Malayali may also put a family in a 'neutral' and less embarrassing position, since the personal choice of the young couple need not be judged through 'local' considerations of status and class/caste position.

Despite their feelings of being excluded from what is perceived as a more orthodox, arranged marriage back in their home country, women's love marriages are never conceptualised by them as a 'second choice' taken to compensate the lack of marriage opportunities in Kerala after many years spent alone in a different country. Rather, their marriage choices testify to their ambivalent experiences of constraint, independence and acquired power in relation to both contexts.

For many women, like Manju and Sheila, their marriages represented the first opportunity for them to return to their country after many years of separation, and to tie up what was until then perceived as a broken thread. Although unorthodox, their marriages gained them renewed respect in the eyes of their families and native society, and publicly legitimised their achievements as earning migrants. Their return visits as newly married women were often occasions on which years of tension and conflicts with their families in Kerala were partially erased. In many cases, following this initial return visit, their journeys back to their village start becoming more frequent, opening the possibility of sponsoring further migrants and representing a turning point in the development of a transnational kinship network. With the status and social acceptance that marriage entailed for these women, families in Kerala expressed their renewed trust in and expectations of their daughters' and their son-in-laws' capacity to ensure better opportunities in Italy for younger members of the family.

If we compare the marriage experiences of the pioneer women with those of their younger relatives, some differences emerge in terms of the role played by the event of marriage in their lives and expectations. As already stated, for many pioneer women the difficulties of getting married represented, initially, one of their reasons for leaving Kerala and embracing a radically different way of life; their subsequent marriage choices were partly informed by this. Though love marriages continue to be relatively frequent among younger migrants, the prospect of going 'back to Kerala' for their marriages has now come to play a different role in women's life stories. Moreover, personal as well as family expectations surrounding marriage seem to have changed considerably in recent times.

Marriage: Between Desire and Family Expectations

Different and stronger expectations of migrants characterise the recent migration to Italy. The experience of Thomas and his family is particularly revealing in that regard. Thomas, who lives in Kerala and is over 70, has his elder daughter and one of his nephews in Italy. The elder daughter, Shamol, has been working in Italy since 1967 as a professional nurse, and subsequently helped her sister's daughter, Shilly, among other relatives, find a job in Rome as a housemaid. Speaking about his expectations of the new migrant members of the household, Thomas told me one day:

> When Shamol left in 1967, our situation was not good, I could not have found her a husband. . . . I did not know exactly what was going to happen to her in Italy, but I thought that she might have better opportunities there than here. Now it is different. . . . See Shilly, my granddaughter, she arrived in Italy and she easily found a job, thanks to Shamol. We know the place now. . . . Now my daughter's [Shilly's mother] house is almost finished and next year Shilly will have a very big marriage.

The development of an extended kin network between Italy and Kerala has contributed to increasing family trust and expectations regarding the migrants' capacity to constantly contribute to the household economy and to fulfil the family's desire for upward mobility. Arranging a good marriage, widening the field of spouse selection possibilities and giving a 'good' dowry are understood in Kerala more as a way of showing off newly-acquired status and modernity than as a 'traditional' practice. In other words, marriage payments often represent a relatively 'traditional' framework through which families can express 'modern' achievements in terms of educational, social and geographical mobility, and access to consumer goods (Osella and Osella 2000a). As Thomas reminds us, the possibility of choosing a good husband for one's daughters or granddaughters, and of arranging a 'big' marriage represents a major turning point in a man's life.

During the first years of migration, preceding their marriage, young girls are expected to send remittances to their parents, who use the money to build up long-desired lifestyles for all members of

the household. Migrants' marriages often represent an important step within a longer process of socio-economic improvement and status renewal, which is conceived in Kerala as a basic condition for entering the marriage market. Having a newly built brick house is one of the main visible markers of the success of one's daughter's migration, as well as of her family's readiness to marry her into a good family. Household achievements such as college education can also represent symbolic capital that can be used to realise aspirations for prestigious alliances. In many cases the women's remittances are used by their families to fund the younger children's higher education and their ambitions, thus facilitating the latter's entry into the privileged group of skilled migrants. For many families this opens up the possibility of asking for bigger dowries for their sons or of marrying their younger daughters to engineers working abroad. The capitalisation of women's remittances in the forging of favourable marriage alliances for the younger members of the family may promote, at the household level, the shift from previous forms of unskilled migration to more valuable and desired patterns of professional migration to prestigious destinations like America.

The importance that the migration of young and unmarried women has for their natal households underlines the way in which women's migration intertwines with both the household development cycle and with ideologies regarding affinal relations. First, the process of status renewal achieved through migration can partly explain the household's concern to delay their migrant daughter's marriage. After marriage a woman is expected to be a member of her husband's family and to contribute to the new household economy; if her marriage takes place too soon, her family fears that they will have less claim over their daughter's remittances. Second, migration can contribute greatly to the redefinition of affinal relations since a woman's earning power and her relative independence, gained during the first years of migration, potentially enable her to contest the expectations of her husband's family and to use part of her earnings for her own family in India.

Yet marriage cannot be delayed too long. As we have seen, full recognition and legitimisation of women's success as migrants is inseparable from their renewed status as married women and from the possibility of establishing valuable alliances. I would suggest that women's migration to Italy should be partly understood in terms of a continual tension between women's temporary unmarried status, their family expectations of social mobility and the ideological representations in Kerala of women's migration. The decision of a family to send their

daughter away is often taken in a context where the project of improving
the family's socio-economic conditions is in conflict with the aim of
preserving the girl's and the family's honour (see also Gamburd 2000).
Women's mobility creates tensions and involves changes in the way in
which gender roles and social values are understood and conceptualised
(Mills 2001: 4, 18–19). As Manju clearly told me one day, 'Women are
not so free to be far away as men are.' This becomes particularly evident
in a context like Kerala, where migration has been mainly undertaken by
men and, more importantly, where male migrant earning power and the
role of these men in providing big dowries for their sisters contribute to
shaping and strengthening their masculine identity (Osella and Osella
2000b). Migrant women who provide for their own dowries perform a
duty that is customarily regarded in Kerala as the duty of the family, a
fact that partly explains the pervasive criticism of men who 'send' their
daughters abroad to earn money.

It is within this context that we may understand the renewed
importance given by families to the possibility of arranging a good
marriage for a daughter who is working abroad; the wedding
arrangements represent a field where parents can accomplish at
least part of their duties. The prospect of becoming a *marumakkal* or
daughter-in-law after many years spent abroad will give the woman
and her family the opportunity to dissolve some of the ambiguities
surrounding her role as an unmarried migrant and earning subject.
Through ritual performances, participants are able to operationalise
an ideal, and perhaps a normally unattainable, concept of family and
family relations—what a 'good family' should do and how 'ideal
family relations' should be—which are often challenged by processes
such as migration and transnationalism (Gardner and Grillo 2002:
186). In this sense, marriage choices and arrangements represent a
field in which older members of the household try, materially and
symbolically, to *reappropriate* their roles and duties. However, looking at
the marriage experiences of migrant women, it is clear that this process
of reappropriation can often be the subject of negotiation and conflicts
between different contexts and generations.

Kuriachel, a 31-year-old man who has been working in Italy since
1993, met Merine during a Sunday mass celebration in the Syrian
Christian parish in Rome. His aunt, who was working in Rome at the
time, had suggested that he meet Merine as she was a kind, hard-working
and good-looking girl. Merine comes from a backward area of Kerala
and did not have a college education. When they decided to marry in
1997, both their families in Kerala were quite disappointed. Merine's

family feared that it was too early for her to marry as they had just started to build a new house in their village. Kuriachel's parents wanted an educated girl from a better family. But comparing his experience with that of other Malayalis who had accepted their parents' choice, Kuriachel asserted that marrying a girl who has never been out of Kerala could have been a 'risky' decision:

> Women here are more trained in jobs and they have a forward. . . different mentality. If I marry a Malayali who has never been out of her place, I will have trouble in making her understand how life is here. . . language problems, the food is different. You never know what will be the reaction.

Finally, their parents agreed to the marriage. Interestingly, both Kuriachel's aunt and Merine's relatives in Rome played an important role in persuading Merine's parents to agree to the marriage:

> They know that I am working hard here. . . . They knew me very well even before Merine came here and they see that I was sending home money regularly and I was taking care of my family there. . . . When a new person arrives here you never know if he will be able to adjust or what will be his behaviour. They can change, they can be violent because their wife does something they do not like. . . I know some cases like that. But in our case it was different! Here you have to change a lot See. . . men in Kerala. . . they are so lazy, so lazy! They study a lot and then they do not find anything to do. . . they do not know what a hard job is, like we do! And they go around wasting their time and waiting for their marriage, that's what they do!

In some cases tensions between migrants and their parents in Kerala may arise if marriage arrangements are made in Kerala whereas the woman or her relatives in Italy have already found a potential bridegroom in Rome. Families in Kerala often speak of the embarrassment involved in pulling out of arrangements already made with other families. They feel they could have found a better bridegroom in Kerala, in terms of education and social background, since the higher status of the husband's family could have been exchanged for the prospect of the bridegroom going to Italy. In other words, to 'marry back' a daughter is valued because it provides the opportunity for better alliances and gives continuity to the migration process. At the same time, the criteria that

families in Kerala may use to judge a good alliance may not necessarily be approved by their relatives in Italy, who might think that a snobbish and over-ambitious boy who has never been out of Kerala would not be able to adjust to the new context.

The marriage aspirations of young men and women are based on considerations that may be quite different from those of their families in Kerala. While the latter often seem more concerned with status priorities and strategies of social mobility to be enacted in the local context, Malayalis who have years of experience abroad seek to find a spouse with whom they share a common perspective and experiences. This is part of an implicit project to strengthen the conjugal bond. Thus, Malayalis who have never migrated are often described by the younger generation of migrants as 'backward' and 'traditional', not necessarily in terms of their economic and social status in India, but more often in relation to the resistance they might have in accepting their spouse's changed lifestyle and difficult situations in the new context. Both men and women were conscious of the fact that the potential success of their marriage could be undermined by marriage to a Malayali who lacked familiarity with other places and lifestyles. Such worries were particularly voiced by women, who are concerned that a Malayali man from Kerala might not adjust to the new context or be unwilling to accept a new pattern of family life and degrading job experiences. Shilbi, a 28-year-old woman who has been in Italy for the past six years, used to tell me about Malayali men who follow their wives to Italy:

> They have to understand that they cannot have the same life here as they have in Kerala. Here I am always busy with my job and I only have Sundays off I cannot cook and do all the work I am supposed to do, and they have to manage by themselves. One of my friends had a lot of trouble because her husband, once he came here, did not want to work as a domestic help and he did not like her to go out for that kind of job I think her family did not tell him that this was the kind of job you find here.

Marriage can be an important occasion on which migrants express and claim their personal transformation (Mills 2001: 149). Women's full-time work in Italy often conflicts with the tasks they are supposed to perform within the household. Most of the women I spoke to in Rome expected their husbands to take up housework and childcare while they were working. Women's claim to more equal conjugal

roles is frequently supported in the new context by their wider circle of kin. This 'extension' of everyday lived kinship is partly reflected in the residential patterns in the city, where women of different ages and generations, single or married, live together with or close to other relatives (see Figure 7.2). The establishment of conjugal life for the newly married couple has to strike a balance between women's desire for conjugal intimacy and independence, and their reliance on this supportive kin network. Migrant women, thus, tend to be reluctant to separate from their kin to set up a new conjugal home after the arrival of their husband.

In other words, the redefinition of gender ideologies through migration plays a crucial role in the construction of women's identity, which is partly expressed through their contestation of their parents' marriage choices. The 'dowry question' is another field where women's claim to different lifestyles and modern achievements has to be reconciled with the natal households' expectations of upward social mobility.

The Ambivalence of Dowry

In Kerala, Syrian Christians are often indicted as the community with the highest rate of giving dowry, and their marriage practices are often identified as one of the main causes of the dowry escalation problem in contemporary Kerala (Billig 1992). Marriage prospects and dowry are often mentioned by migrant women and their families as factors motivating the decision to migrate. Women's wedding arrangements and expenses are conceived in Kerala as the 'last economic effort' a family has to make on her behalf, and the dowry given at that time is understood as their share in the family estate. This can put migrant women in the position of themselves having to generate their family share. Women are allowed a certain discretionary use of their personal income (cf. Mills 1997), and marriage and dowry expenses represent one of the few legitimate ways to use and capitalise on their earnings. Conspicuous personal consumption in Italy or Kerala—for instance, on Western clothes and other items that are not directly required for a woman's marriage—are often subject to scathing criticism in both contexts. The older relatives of young women working in Italy, who continue to supervise the young women's activities in the new context, are much concerned to orient

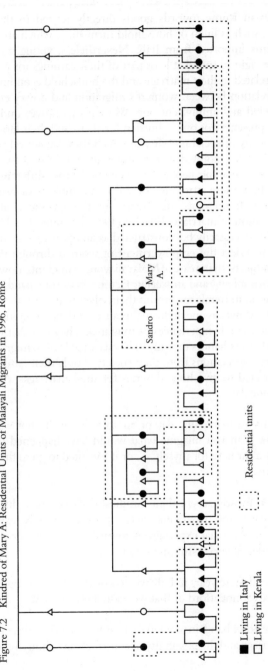

Figure 7.2 Kindred of Mary A: Residential Units of Malayali Migrants in 1996, Rome

Residential units

Living in Italy
Living in Kerala

Sandro Mary A.

purchases in Rome towards goods directly related to the migrant's marriage, such as linen or household furnishing, which are among the main items imported from Italy. Nevertheless, young women often claim the right to spend at least part of their earnings for purposes not directly related to their marriage and the household economy.

The relation between women's migration and dowry emerges as a multifaceted and ambivalent one. Women's narratives underline how dowry represents not only a burden for them and their families, but is also a strategy of social mobility to which they can actively contribute. Salih (1999) has pointed to the important role played by hegemonic structures in shaping people's movements across different countries, and also how these structures may become subjects of resistance and negotiation in migrants' discourses. In the specific context of the transformation of marriage, Bhachu (1985) has underlined how dowry should not necessarily be constructed as an oppressive institution, but may often reflect the empowerment of women through their role as earning subjects. In the case of Malayali women migrants, dowry emerges as both a *constraining* and an *enabling* factor. On the one hand, after giving up education in Kerala to commit themselves to precarious jobs abroad, women see dowry as one of the main causes of their emotional sufferings and degrading job experiences as migrants. They feel that they would have had better chances to study in Kerala, or at least to migrate with less oppressive expectations from their society, if only their families had not been expected to give huge dowries for their marriages. As Mayamol told me one day:

> We have to marry one day or another, if you do not want to have trouble. Can you imagine what would have happened if I decided to buy a car here for myself . . . or if I wanted to go to the university in Rome?

Women mostly accept their families' decisions regarding marriage arrangements and payments, even if they privately express deep criticism, since social expectations towards dowry are incorporated in the very idea of successful migration:

> If after all these years in Italy we do not give dowry, people will think that we cannot afford or that we wasted our money.

On the other hand, in women's narratives it is often the perspective of their marriage and the possibility of contributing to household expenses

that encourage the women to migrate in the first place) Mariamma, who left Kerala in 1987 when she was 20 years old and who got married in 1994, was very keen to underline her positive involvement as a migrant in the arrangements for her marriage:

> I think it was good for me . . . you see when I came to Italy I was very young and I thought it was too early for me to marry and at that time my parents could not have afforded to marry me in the best way . . . so I thought that it was a good time for me to come here where my auntie was living and to experience [a] new life. When you are married then it becomes more difficult to leave . . . because you do not know [whether] the new family will like you to be away I think it was good . . . when I was here I thought that it would have been good for me to go back and to marry when I was ready and had saved good money. When my parents told me that they had found a good family for my marriage I went back and we all went to purchase gold for my sisters and me . . . it was exciting! And my husband's family was really good . . . they did not ask for money or whatever . . . but I was happy to give something anyway because they were good.

The opportunities offered abroad are conceived both in terms of active engagement with new life experiences and the making of 'good marriages'. In taking the decision to migrate, women question their family's capacity to provide adequately for household members. Migration allows them to delay marriage and to postpone their uncertain encounter with the new family's expectations and requirements of them. Migrant women not only contribute to their family budgets, but also experience a certain degree of independence that they would rarely have achieved in their home villages (Mills 2001). In other words, earning money for their families to enable them to arrange good marriages for younger members is represented as a matter of pride and self-respect for modern women. As Manju, one of the young girls I met in Rome, pointed out:

> Now if you simply stay at home people will think you are not able to do things . . . then nobody will want to marry you Now my family have already had some proposals. We have to marry . . . we have to give something[22] . . . and I knew in this way I could help my family Here I work hard and everything is more difficult and painful . . . here there are no good things for us[23] . . . but I feel I am doing something, having experiences At least I can say that I did not fear to see some other world

> Here I feel active . . . I feel as if I am always growing This
> makes me feel better if I think of my family They can say
> I helped them a lot.

Migration, thus, represents for them not only the quickest way to
accumulate cash but also a means to gain respect from their families,
to be 'more active' and self-sufficient, and to take up responsibilities
and achieve goals that are associated with the prospect of becoming a
marumakkal or daughter-in-law.

I would also suggest that women's active commitment to activities
that are taken up partly to raise money for their marriage and dowry is
an integral part of their project of self-transformation as modern and
self-sufficient women. On the other hand, after years of migration, their
new status and modernity also finds expression in their reluctance to
accept passively some of the practices and ideologies surrounding dowry.
Women capitalise on their experiences of migration in order to negotiate
the marriage transactions between families and their roles in the future
husband's family. Women's earnings abroad can be particularly attractive
for other families who often conceive of dowry as a potential fund to
sponsor the higher education of its members or to further migration.
This is one of the contexts in which women seek to affirm their ideas
and expectations of conjugal life and affinal relations and, in a way, their
modernity. In criticising the obligation to give a big dowry, young migrant
women contend that the most important 'gift' they are able to give to
their future husband is to sponsor his migration to Italy. As I was told by
a newly married woman who was recently joined by her husband:

> I said to my family that with my earnings I could have sponsored my
> husband's travel to Italy and find a job and live happily together . . .
> and I've also helped his brother to come So why should I have
> to waste all my earnings to give a big dowry? Is not this a big thing I
> am doing for his family . . . is this not a big dowry?

Interestingly, young men looked at the prospect of migration as a
more attractive and stimulating possibility than accepting their parents'
ambitions for a bigger dowry.

Women often narrate how their marriages took place after years of
work abroad, during which time their remittances were used to build
a new house for their family. The request of their husband's family
for similar help in house building through a big dowry tends to be
less acceptable to them than the prospect of assisting their husband

to migrate and contributing jointly with him to their new family life.
Instead of giving their earnings directly to their husbands' families—and
thus losing control over their dowry—young migrant women prefer to
offer their future husband the active possibility of migrating to Italy in
compensation for the reduced amount of the dowry given at the time of
the marriage. Dowry is thus transformed by women into a *virtual fund*
that is used to give continuity to the migration process.

While women are keen to use their earnings to purchase gold and
personal items for their marriage, they seem much more reluctant to
accept that their earnings could be used towards the cash component of
their dowry, effectively to 'pay' to get them married:

> After so many years here . . . how could I have accepted to be taken
> and sold out back in the marriage market? This is because people are
> ignorant For my marriage I was wearing a lot of gold, and with
> the last four months' salary I bought a television and a fridge for my
> husband's family . . . [which] they did not have. I was accustomed
> to having one here in Italy and my family also had one . . . so I was
> happy to give those things to them and I can also use it when I am
> going back to Kerala But it is really bad to ask for money.

In their narratives the obligation to give money as dowry is seen by
the women as a degrading and backward practice, and they are much
keener to invest in items that can help reproduce their consumption
choices and lifestyles in Italy.

Similarly, the conjugal couple also gains leverage with regard to
marriage choices, matchmaking and dowry negotiations in relation to
their households in Kerala. Vincent and Beena met in Italy and decided
to marry back in Kerala. Both of them refused dowry at the time of
their marriage, to the great disappointment of both their families. As
Vincent said to me one day:

> Every time we go to Kerala we spend so much money! You have to
> be ready to go . . . and a lot of us decide to postpone the journey if we
> do not have enough money for the gifts, for the debts and for family
> needs. Both Beena and me had built huge houses for our parents
> but my family was expecting a huge dowry for me nevertheless
> They were disappointed when we both decided not to give one
> But now we want to think of our life here, and we have a lot [of]
> expenses here in Italy. People in Kerala do not realise that we also
> have to survive here!

Beena often expressed her regret over the conflicts that had arisen in her family in Kerala and had never been completely overcome. Their decision was also motivated by their intention to take a 20-year bank loan to buy a small flat in a Rome suburb, committing the couple's earnings and delaying indefinitely their decision to return to Kerala. Withdrawal from some aspects of dowry-giving is frequent among couples who have met in Rome and who, while they may decide to marry back in Kerala, intend to return to Italy and take up their jobs and life there as a newly married couple.

The Transnational Dimension
of Intergenerational Relations

The analysis presented in the previous sections indicates that marriage and dowry arrangements, far from being localised, are often the subject of wide-ranging material and symbolic negotiations. Transnational marriages can be an important site for different projects of social mobility and status renewal, which may challenge not only gender ideologies, but also intergenerational values and duties.

Malayali migrant marriages seem to reflect two overlapping dimensions of intergenerational relations, linking related households transnationally. On the one hand, the transnational dimension of generational relations is dependent on the stage in both the personal as well as the household life-cycle. As already noted, marriage (including processes of matchmaking, dowry payments and the consolidation of the husband–wife bond) can be the subject of negotiations, if not conflicts, between young migrants and older members of their families in Kerala. As migrants and earning subjects, women are in a position to put into question their elder relatives' authority.

On the other hand, the transformation of the meanings and the practices surrounding marriage is deeply informed by the peculiar linkages between women of different ages and generations in Italy, and by the increasing influence that pioneer women have gained in their native society. Their roles as pioneer women in promoting further migration and the close contacts they maintain with the sending society have widened their influence among their relatives' households in Kerala in a way that would probably have been more difficult had

they not achieved this position. As Gardner (1995: 121) points out, it is important to think about households not only as bounded, physical entities, but also as a set of relationships and transactions, and to see how duties between people and places are continually renegotiated. Pioneer women are able to locate themselves within an extended network of related households whose members are displaced into different contexts, and this increases their power in both locations. Their influence is not only related to their easier access to material resources (for instance, money and job opportunities), but also to their deeper knowledge of bureaucratic issues and general living conditions in both places. The prestige gained through the enactment of *kinship work* may represent an important source that women utilise in the context of their relatives' marriage.

In transnational marriage arrangements pioneer women can play a mediating role between different marriage projects and expectations, giving young women the moral support needed to legitimise their marriage aspirations and decisions vis-à-vis their families in India. Young women in turn see in the marriage choices and lifestyles of their elder relatives in Italy an example of mature, independent and modern women, deserving emulation.

That pioneer women promote themselves as self-made women is a 'contagious' ideal for younger migrants, provoking their uneasiness with their families' expectations towards marriage. 'When I went back for my marriage after five years here . . . I felt as if my life was running back,' one young woman told me. In the context of marriage, the women who first came to Italy are often critical of the great emphasis given to dowry and marriage expenses in Kerala. They often identify 'the problem of dowry' as one of the main reasons for their difficult experiences as pioneer migrants. Mary spoke about her relatives' excessive concern with dowry in this way:

> Sometimes I think [this] is amazing! See, I left Kerala to avoid dowry and marriage problems . . . and now Malayali women are coming to Italy to give bigger dowry when they go back to marry in India!

Mary was much dismayed that a modern and independent young woman had been obliged to accept what she considered a 'backward practice'. Along with her Italian husband and her niece Leela, who was going to meet her future husband's family, Mary had come to the Kerala village where I was staying, invited by Leela's parents to take

part in the marriage discussions. For Leela's parents, inviting Mary to this crucial meeting was considered a manifestation of their moral and economic debt to her. For Mary, who often told me to consider Leela as one of her daughters since they had been so close in Rome, meeting Leela's husband was part of her duties and rights as mentor, for she felt responsible for the girl's future. When she came back from the boy's village, Mary and her family were quite satisfied with the meeting and with the good behaviour of the boy's family. Mary told the groom's family that she would help Leela fund her husband's migration—providing him with a ticket and helping her niece with the paperwork to obtain his visa—and to find a job for him in Rome. She also informed them that this should be considered as part of the dowry and that there was, therefore, no need to ask for a huge amount of money.

Yet solidarity and complicity are not the only factors that shape relationships between migrant women of different ages and generations; hierarchical forms of moral and economic dependence also play a pivotal role. Women's use of their earnings has often to be filtered through the approval of the older women, who may also expect to be repaid, at least partially, for all the expenses involved in sponsoring their sisters and nieces. Though this is not always expected by the elder women, it is considered a young migrant woman's duty nevertheless to use part of her earnings to repay her relative's financial support. Young migrants often have to mediate between their parents in India and their 'guardians' in Rome. In some cases conflicts may arise if the girl's family agree in Kerala to give a bigger dowry when the young girl still owes money to her relatives in Rome. These conflicts can also disturb a younger woman's position within the hierarchical network of relations in households dispersed across different locations.

Conclusions

The aim of this chapter was to analyse how women actively engage in processes of geographical and social mobility, and how the projects of transformation which this engagement entails are utilised to reinterpret gender ideologies and generational relations on the occasion of their marriage.

The re-elaboration of women's roles within their households and the wider society as pioneer migrants and earning subjects should be

conceived as the historical outcome of different and cross-cutting processes that reflect both global, national/institutional and also personal agencies. The adoption of a historical perspective on Malayali migration to Italy allows us to understand not only how women's experiences have changed in the past decade, but also highlights how their transnational lives are the outcome of their unique, ambivalent and often painful experiences of isolation, constraint and transformation in relation to both contexts. Marriage represents a turning point in their lives as migrants, and in the development of a transnational network between Italy and Kerala, which women actively contribute to building. Marriage produces ambivalence and tensions at the household and personal levels. For migrant women it represents a form of rehabilitation within a legitimised conjugal domesticity, but also an important context in which they claim more equal gender relations in their family and the wider society. Conjugality also represents an important basis for building up a wider kin network, and for the redefinition and extension of household relations. I have shown how these processes, which reflect the solidarity and interdependence between women of different ages and generations, can influence and transform marriage and affinal relations.

The comparison between the lives and the marriage experiences of pioneer women and those of their younger relatives seems to me particularly useful to underline the multi-level relations between marriage and dowry, and women's transnational activities. This relation, I would suggest, emerges as a dialectical process of reciprocal influence. On the one hand, as Salih (2002) and Gardner (2002) have pointed out, migration and transnational movements can be influenced by the roles women are increasingly expected to perform in the domestic sphere. Women's duties towards their families and their expectations of conjugal life inform the ways in which they build up transnational networks of relations through remittances, frequent journeys or sponsoring new migration. On the other hand, I have underlined how women's activities as earning subjects and 'dowry providers' contribute importantly to the reformulation of their roles and tasks within the family, and to the transformation of marriage ideologies and practices.

This process of transformation should also be understood within a context where Malayali men often need to depend on their wives for geographical and social mobility. Yet the way in which the husband–wife bond is reinterpreted through women's migration and transnational lives is more than a simple inversion of the conventional dependence of the wife on her husband. On the one hand, it is true that women's migration

puts into question the male role as an independent earning subject and the main household breadwinner. Nevertheless, women also aspire to involve men actively in migration, to share their experiences with them, and thus to consolidate their conjugal lives. Women see the chance to use their earnings to help their husbands to come to Italy—and to build up the conjugal bond in a new context—not only as part of their renewed duties as married women, but, more fundamentally, as an important way through which they can actively display their power and independence as modern women. In this sense, the way in which women negotiate and transform the meanings and the practices surrounding dowry is part of a larger project of transformation of affinal relations, which works to strengthen the husband–wife bond in relation to older relatives in India. The possibility of sponsoring their husbands' migration through their earnings and of living together in a new context is thus an integral part of women's ideas and projects of modernity. The strengthening of the conjugal bond as a central dimension of the negotiations between different contexts and generations is also very noticeable among Malayali couples who meet in Italy and decide to have their wedding celebrations in their home country, but who clearly intend to return to Italy soon after the marriage.

Yet the way in which the relation between migration and the dowry system is transformed by women's transnational lives is ambivalent, and never unidirectional. The completion of this life-cycle event, far from being confined to one country, is subject to negotiations across different locations. Marriage ideologies and practices may force migrants to face the conflicting and ambiguous decision of embracing personal and familial expectations in terms of prestigious alliances and bigger dowries on the one hand, and of affirming their renewed status as modern women through the consolidation of the husband–wife bond abroad on the other.

The analysis of transnational marriages through the perspective of life-cycle transformations and generational change allows us to look beyond the idea of arranged marriage 'back' in the migrants' native society as instancing the persistence of 'traditional' values among migrant communities. As Salih (2002) points out, interpretations and performances of 'modernity' and 'tradition' are not context-bound processes, but embrace both local and global perspectives. This is particularly evident in the way in which migrant women have to mediate between constraining and enabling processes of household transformation at the time of their marriages. Migrant experiences and

expectations of marriage and conjugal life are continually informed by different projects of modernity, reflecting the influence of ongoing historical processes of affirmation/legitimation of the 'modern' family, as well as the heterogeneous expectations of the migrants and their households. This is clearly reflected in the ambiguities and the tensions surrounding migrant marriages, and in the way in which migrants negotiate and transform the meanings of this event in their lives.

Acknowledgements

The research on which this chapter is based was carried out in Rome, Italy, from October 1996 to May 1997 during a two-year research project connected with my graduation thesis, and in Kerala (India) for a period of 11 months between 2000 and 2002, connected with my Ph.D. in the University of Siena. I wish to thank Pier Giorgio Solinas (University of Siena) and Simonetta Grilli (University of Bologna) for their stimulating comments and criticisms during my research in Rome. This article is also the fruit of a six-month Marie Curie Fellowship at the Sussex Centre for Migration Research (SCMR, University of Sussex, Brighton, UK). I wish to thank Ralph Grillo, who acted as my mentor during my stay at Sussex, for his advice and criticism, and Geert De Neve (University of Sussex) for his comments on earlier drafts of this chapter. J. Devika, Praveena Kodoth and Mary Searle-Chatterjee made useful suggestions and criticisms during a seminar at the Kerala Council for Historical Research, Thiruvananthapuram. I am particularly grateful to Patricia Uberoi and Rajni Palriwala for their support and comments, which helped me to clarify my ideas and to develop wider theoretical interests. All the errors, of course, are mine.

Notes

1　According to my data, the Malayali community in Rome is mainly composed of Syrian Christians, though the Latin Catholic presence has also increased in the past decade. In this chapter, I will mainly refer to the Syrian Christian community, though some of the considerations reported may apply also to Latin Catholics. During my fieldwork in Rome I interviewed 146 individuals, 79 women and 67 men. Part of the

data presented here are based on the information collected during these interviews. Though I was not initially interested in collecting data in a systematic way, I decided nonetheless to organise a database with some basic information during the interviews since at the time of my fieldwork in Rome there was little information available on Indian migration to Italy. Apart from that, I spent most of my time in Rome living with families, recording their stories and taking part in their ceremonies and functions. During my fieldwork in Kerala I had initially contacted families who had relatives in Rome, and then established a wider network, which covered different neighbouring villages near the main city of Kochi, Ernakulam district (central Kerala).

2 In the context of South Asian migration, women are often described as passive subjects, whether they remain in their country of origin while their husbands are working abroad or follow the latter to the host country. Recent literature on gender and migration has shown, however, that women are deeply involved in processes of social change in both types of migration (Chant 1992; Gardner 2002; Gulati 1993; Kurien 2002). Gardner (2002) points out how women have constantly been engaged in transnational migration, playing a key role in maintaining social connections between places and enabling successful migration strategies. This observation underlines women's active engagement in processes of geographical and social mobility, even when they do not directly migrate, and contravenes the 'victimised' image of women as subjects who are 'left behind'.

3 Italy has experienced mass emigration in different periods of its post-Unitarian history. In the past 50 years this tendency has overlapped with and been partly substituted by increasing immigration flows. Compared to the wider and heterogeneous history of the Malayali diaspora, the presence of this community in Italy is relatively 'young' and numerically limited. Nevertheless, its study may be useful to compare longer-established patterns of Malayali migration with recent trends of migration to Southern European countries.

4 For a detailed analysis of the changes in women's roles in the context of international migration from Kerala during the colonial period and soon after Independence, see Kurien (2002). In relation to the recent trends in Malayali migration, Zachariah et al. (2000) note how Malayali migration in the past decade has witnessed the increasing presence of women.

5 In this sense, I look at 'modernity' here as a *discourse* connected with people's projects of migration and *expectations* of social mobility as well as with their negotiation of personal, familial and community identity (De Neve 2003; Ferguson 1999; Mills 2001; Gardner and Osella 2003; Osella and Osella 2000a).

6 In migrant narratives this fact is often presented as a consequence of their unwillingness to live in Italy for more than a few years. They do not wish to involve their parents or other older members of their households in what is considered, at least in their ideal projects, as a temporary experience. Moreover, the legal restrictions adopted by the Italian government during the 1990s and the limited possibilities offered by the Italian labour market in terms of job and career prospects contribute significantly to shaping migrants' uneasiness with the prospect of living in Italy for good.

7 See Gallo (1998) for more detailed tables and data.

8 Devika (forthcoming); see also Devika (2002). On the patrilineal and nuclear family as a symbol of modernity in 20th-century Kerala, see Fuller (1976) and Osella and Osella (2000a).

9 This historical tendency coexists today with the affirmation of a renewed model of the bourgeois housewife among the newly-established or aspiring middle class

(Osella and Osella 2000a). In the context of transnational migration, Kurien (2002) notes how women's involvement in unskilled or skilled migration abroad during the colonial period was often reversed in the following generation by the withdrawal of women from extra-domestic occupations.

10 For a detailed analysis of transnational kinship relations and matrilineal and patrilineal values among migrants, see Gallo (1998). Here, I wish to stress that migration, though partly inscribed within a project of affirmation of the conjugal family, may also produce patterns of kinship relations and values that overlap, interact with and sometimes put into question the 'ideal' of a nuclear family set-up and the hierarchies underlining it.

11 The problematic relation between different generations within the context of migrant marriage arrangements has received wide attention in the anthropological and socio-logical literature concerning South Asian communities in the UK. See, for instance, Ballard (1978), Bhopal (1999), Bradby (1999), Shaw (1988) and Werbner (1986).

12 Though the majority of the village households I visited in Kerala were Gulf oriented, Italy seems, nevertheless, increasingly popular as a possible migrant destination.

13 Unofficial data from the Indian Embassy and the Vatican Migrant Centre in Rome. The only official data available refers to the whole Indian population in that area, which is estimated to be around 5,378 people. The Indian presence in Italy is nearly 30,000 and represents 2.2 per cent of the total migrant population of the country (*Caritas Dossier Statistico Immigrazione* 2000).

14 Despite the high level of social development—in terms of literacy, birth rate, provision of social services, etc.—Kerala is a state with low GDP, limited per capita income and a high rate of unemployment. [On the so-called 'Kerala model of development' see, among others, Franke and Chasin (1992); and Jeffrey (1993).] For a more critical analysis of the limits of the land reform and the unequal redistribution of economic wealth and of social services among the Malayali population, see Herring (1980), Mohandas (1994), Radhakrishnan (1989) and Sivanandan (1979). Some attention has been paid to the inverse relation between the high rate of literacy among Malayali women and the paucity of women in public life and the limited socio-economic opportunities for them. In terms of gender relations and segregation, contemporary Kerala is depicted in these studies as a conservative society. See, for instance, Mathew (1995), Osella and Osella (2000a) and Ramachandran (1995).

15 If we exclude, for example, US or Australian citizens.

16 The promulgation of the Martelli Law in 1990 (Law N. 39-28/2) made a visa compulsory for those coming from 'high emigration risk areas'. It also introduced a minimum income level for those residing in Italian territory. National EU citizens were given priority in the right to work. The Turco-Napolitano Law in 1998 (Law N. 140) introduced the role of 'sponsor/tutorship' as one of the conditions for obtaining a temporary visa in Italy. The sponsor in Italy has to take up all the legal and bureaucratic responsibilities involved and has to prove capable of providing for all the newcomer's expenses until the latter finds a regular job (within a one-year period).

17 According to the Circolare, n. 900.6/IAG52/4806, pot. N.04424, 25.07.1996 of the Health Ministry Department, all non-EU workers in the health sector who had not regularised their position during the Legge Martelli would not have a right to work in that sector.

18 According to my data, 62 per cent of women and 27 per cent of men are working in the domestic sector, while there are 25 per cent and 13 per cent in the professional health services.

19 I take this expression from Gardner (2002: 16). The expression 'kinship work'—originally introduced by Di Leonardo—is adopted by Alicia (2000: 305) in her account of Puerto Rican women's active engagement in transnational activities and of their role in assuring and preserving the household's contacts and kinship relations across locations. In Gardner's analysis this expression is used to underline how Bangladeshi women's active role in migration and in maintaining links between places have allowed the enactment of successful migration strategies.
20 In Kerala, Syrian Christians consider themselves superior in status and in caste to Latin Catholics.
21 Among the 28 pioneer women with whom I had close contacts in Rome, eight had married Italian men, two had married men from Eastern Europe, one married a man from the Philippines and seven met their Malayali husbands in Italy. In the latter case some marriages (three) involved Syrian Christians and Latin Catholics. According to my data, marriages between Italian women and Malayali men are much rarer.
22 She was referring to dowry, since my question was partly related to it.
23 Manju means that there are no good jobs available for them in Rome.

References

Alicia, M. 2000. 'A Chambered Nautilus: The Contradictory Nature of Puerto Rican Women's Role in the Social Construction of a Transnational Community', in K. Willis and B. Yeoh (eds), *Gender and Migration*. Cheltenhan: Edward Elgar.

Anthias, F. and G. Lazaridis. 2000. 'Introduction', in F. Anthias and G. Lazaridis (eds), *Gender and Migration in Southern Europe: Women on the Move*, pp. 1–12. Oxford: Berg.

Ballard, R. 1978. 'Arranged Marriages in the British Context', *New Community*, 6: 181–96.

Bhachu, P. 1985. *Twice Migrants: East African Sikh Settlers in Britain*. London: Tavistock Publications.

Bhopal, K. 1999. 'South Asian Women and Arranged Marriages in East London', in R. Barat, H. Bradley and S. Fenton (eds), *Ethnicity, Gender and Social Change*, pp. 117–34. London: Macmillan.

Billig, M.S. 1992. 'The Marriage Squeeze and the Rise of Groomprice in Urban Kerala State', *Journal of Comparative Family Studies*, 23 (1): 198–215.

Bradby, H. 1999. 'Negotiating Marriage: Young Punjabi Women's Assessment of their Individual and Family Interests', in R. Barat, H. Bradley and S. Fenton (eds), *Ethnicity, Gender and Social Change*, pp. 152–66. London: Macmillan.

Caplan, L. 1984. 'Bridegroom Price in Urban India: Class, Caste and "Dowry Evil" among Christians in Madras', *Journal of the Royal Anthropological Institute* (n.s.), 19 (2): 216–31.

Caritas Dossier Statistico Immigrazione. 2000. Rome: Anterem Edizioni.

Chant, S. 1992. 'Introduction', in S. Chant (ed.), *Gender and Migration in Developing Countries*, pp. 1–36. London: Belhaven Press.

De Haan, A. 2003. 'Calcutta's Labour Migrants: Encounters with Modernity', in K. Gardner and F. Osella (eds), *Migration, Modernity and Social Transformation in South Asia* (special issue of *Contributions to Indian Sociology*), 37 (1&2): 189–216.

De Neve, G. 2003. 'Expectations and Rewards of Modernity: Commitment and Mobility among the Rural Migrants in Tirupur, Tamil Nadu', in K. Gardner and F. Osella (eds),

Migration, Modernity and Social Transformation in South Asia (special issue of *Contributions to Indian Sociology*), 37 (1&2): 251–80.

Devika, J. 2002. *Family Planning as 'Liberation': The Ambiguities of 'Emancipation' from Biology in Keralam* (working paper 335). Thiruvananthapuram: CDS.

———. Forthcoming. *En-Gendering Individuals: The Language of Reform in Early Modern Kerala.* Hyderabad: Orient Longman.

Ferguson, J. 1999. *Expectations of Modernity: Myths and Meanings of Urban Life on the Zambian Copperbelt.* Berkeley: University of California Press.

Fuller, C.J. 1976. *The Nayars Today.* Cambridge: Cambridge University Press.

Gallo, E. 1998. *Reti Migratorie e Strategie di Radicamento nell'Immigrazione Indiana a Roma.* Tesi di Laurea: Università di Siena.

Gamburd, R.M. 2000. *The Kitchen Spoon's Handle: Transnationalism and Sri Lanka's Migrant Housemaids.* Ithaca and London: Cornell University Press.

Gardner, K. 1995. *Global Migrants, Local Lives: Travel and Transformation in Rural Bangladesh.* Oxford: Clarendon Press.

———. 2002. *Age, Narratives and Migration: The Life Course and Life Histories of Bengali Elders in London.* Oxford: Berg.

Gardner, K. and F. Osella. 2003. 'Migration, Modernity and Social Transformation in South Asia: An Overview', in K. Gardner and F. Osella (eds), *Migration, Modernity and Social Transformation in South Asia* (special issue of *Contributions to Indian Sociology*), 37 (1&2): v–xxviii.

Gardner, K. and R. Grillo. 2002. 'Transnational Households and Rituals: An Overview', in K. Gardner and R. Grillo (eds), *Transnational Households and Rituals* (special issue of *Global Networks*), 2 (3): 179–88.

Glick Shiller N., L. Basch and C. Szanton-Blanc. 1992. 'Transnationalism: A New Analytic Framework for Understanding Migration', in N. Glick Shiller, L. Basch and C. Szanton-Blanc (eds), *Towards a Transnational Perspective on Migration. Race, Class, Ethnicity and Nationalism Reconsidered*, pp. 1–24. New York: New York Academy of Sciences.

Gulati, L. 1993. *In the Absence of Their Men: The Impact of Male Migration on Women.* New Delhi: Sage Publications.

Herring, J. 1980. 'Abolition of Landlordism in Kerala: A Redistribution of Privilege', *Economic and Political Weekly*, 15 (26): 59–89.

Kapadia, K. 1996. 'Marrying Money: Changing Preference and Practice in Tamil Marriage', *Contributions to Indian Sociology* (n.s.), 27 (1): 25–51.

Kurien, P. 2002. *Kaleidoscopic Ethnicity: International Migration and the Reconstruction of Community Identities in India.* New Brunswick: Rutgers University Press.

Mand, K. 2002. 'Place, Gender and Power in Transnational Sikh Marriages', in K. Gardner and R.D. Grillo (eds), *Transnational Households and Rituals* (special issue of *Global Networks*), 2 (3): 233–48.

Mathew, G. 1995. 'The Paradox of Kerala Women's Social Development and Social Leadership', *India International Centre Quarterly*, Summer–Monsoon: 203–14.

Mills, M.B. 1997. 'Contesting the Margins of Modernity: Women, Migration and Consumption in Thailand', *American Ethnologist*, 24 (1): 37–61.

———. 2001. *Thai Women in the Global Labor Force: Consuming Desires, Contested Selves.* New Brunswick: Rutgers University Press.

Mohandas, M. 1994. 'Poverty in Kerala', in B.A. Prakash (ed.), *Kerala's Economy: Performance, Problems, Prospects.* New Delhi: Sage Publications.

Osella, F. and C. Osella. 2000a. *Social Mobility in Kerala: Modernity and Identity in Conflict.* London: Pluto Press.

Osella, F. and C. Osella. 2000b. 'Migration, Money and Masculinity in Kerala', *Journal of the Royal Anthropological Institute*, 6 (1): 117–33.

Radhakrishnan, P. 1989. *Peasant Struggles, Land Reforms and Social Change: Malabar 1836– 1982*. New Delhi: Sage Publications.

Ramachandran, T.K. 1995. 'Notes on the Making of Feminine Identity in Contemporary Kerala Society', *Social Scientist*, 23: 109–23.

Riccio, B. 2001. 'From "Ethnic Group" to "Transnational Community"? Senegalese Migrants' Ambivalent Experiences and Multiple Trajectories', *Journal of Ethnic and Migration Studies*, 27 (4): 583–99.

Rogers, R. 1986. 'The Transnational Nexus of Migration', *Annals of the American Academy of Political and Social Science*, 485: 34–50.

Salih, R. 1999. 'Transnational Lives, Plurinational Subjects: Identity, Migration and Difference among Moroccan Women in Italy'. Ph.D. thesis, University of Sussex (CDE).

———. 2002. 'Reformulating Tradition and Modernity: Moroccan Migrant Women and the Transnational Division of Ritual Space', in K. Gardner and R.D. Grillo (eds), *Transnational Households and Rituals* (special issue of *Global Networks*), 2 (3): 219–31.

Shaw, A. 1988. *A Pakistani Community in Britain*. Oxford: Blackwell.

Sivanandan, P. 1979. 'Caste, Class and Economic Opportunity in Kerala', *Economic and Political Weekly*, Special Annual Issue: 475–80.

Thangarajah, C.Y. 2003. 'Veiled Constructions: Conflict, Migration and Modernity in Eastern Sri Lanka', in F. Osella and K. Gardner (eds), *Migration, Modernity and Social Transformation in South Asia* (special issue of *Contributions to Indian Sociology*), 37 (1&2): 141–62.

Visvanathan S. 1993. *The Christians of Kerala: History, Belief and Ritual among the Yakoba*. New Delhi: Oxford University Press.

Werbner, P. 1986. 'The Virgin and the Clown: Ritual Elaboration in Pakistani Migrants' Weddings', *Man* (n.s.), 21 (2): 227–50.

Zachariah, K.C, E.T. Mathew and R. Irudaya Rajan. 2000. *Dynamics of Migration in Kerala: Dimensions, Differentials and Consequences*. Thiruvananthapuram: Centre for Development Studies.

Section IV
MARRIAGE TRANSACTIONS AND TRANSNATIONAL CONTEXTS

8

MARRIAGE, MONEY AND GENDER: A CASE STUDY OF THE MIGRANT INDIAN COMMUNITY IN CANADA

Ranjana Sheel

The complex interplay of money, marriage and gender has significant impacts upon women's status in society. It highlights the important issues of women's power and autonomy, as well as the constructions of culture, tradition and patriarchy. These connections come into sharp relief in the context of migration, being particularly evident in the custom of dowry that occupies a central place in many Indian marriages. Dowry is a crucial index of the status of women in contemporary Indian society. Its expansion in many parts of India and the spate of cases of bride burning, suicide and harassment reveals its distinctive present-day form. Dowry in India today is extortionate. It is characterised by an element of compulsion in that the bridegroom's family exerts pressures, implicitly or explicitly, on the bride's family to fulfil their demands and expectations. The development of an Indian diaspora in alien lands and in critically different socio-economic settings has not eliminated dowry from the marriage system. Media reports, government surveys and academic studies (see for example, Bhachu 1985; Walton-Roberts 2001) indicate not only the prevalence of dowry but also its changing forms in the process of migration from India to the adopted country. This is witnessed in the Indian diasporic settlement in Canada too.

The complexity of the phenomenon of dowry is apparent from its diverse meanings. It is not a static custom, but a product of historically changing, socio-political, cultural and economic processes. Certainly, dowry cannot be seen as a fast disappearing remnant of a traditional society. Rather, it is an expanding, if not strengthening, modern Indian

custom. It is much more than merely a transfer of money and materials at the time of marriage, defined by some anthropologists as 'pre-mortem inheritance'.[1] In the traditional North Indian marriage system, dowry connoted the gifts accompanying the gift of the maiden (*kanyadan*), and as such was regarded as an act of high spiritual merit, enhancing the status and family honour of the giver (Tambiah 1973; Van der Veen 1972; Vatuk 1975). This reinforced the principle of non-reciprocity within the framework of a hypergamous marriage system[2], and fulfilled the father's 'this-worldly' and material obligations towards the bride—his daughter. Shifts in the nature and the consequent spread of dowry can be linked with the reinvention of tradition and the process of Brahmanisation, begun during the colonial period (Sheel 1999), whereby dowry marriages came to be equated with social and ritual superiority.

Despite anti-dowry legislation in independent India, a conspicuous increase in dowry has been witnessed. Dowry in the larger sense refers to many things, including the cost of the wedding celebrations and rituals, gifts to the groom and the bride by relatives and friends, goods carried by the bride to her conjugal home at the time of marriage as well as on subsequent occasions, and the property or cash demands made by the groom's family (Menski 1998). 'Modern' dowry marriage is manifested not only in the voluntary or involuntary transfer of goods and cash from the bride-givers to the bride-takers, but also in the growing phenomena of ostentatious marriage ceremonies and elaborate rituals. While display at the time of marriage serves to affirm the social status of both the bride's and the groom's families, it also potentially escalates dowry demands, with the burden for 'the show' usually falling on the bride's family. The current euphemism is 'we want nothing, just a *good* marriage', implying arrangements to be made and paid for by the bride's side—a lavish reception, a grand wedding procession replete with bright lights, decorated cars and fireworks, along with the gifts and presentations to the bride, the groom and his family. The bride's side is seldom known to express an expectation of a 'good' marriage or reception from the groom's side.

Despite the outcry against opulence and show at weddings, with the entrenchment of elaborate rituals and huge marriage expenses, Indian marriages in Canada are becoming increasingly expensive events and, for many families, an unavoidable burden. As with every other life-cycle event among migrant communities[3], marriage remains a defining moment used to reinforce relationships with the homeland. Many immigrants agree to an arranged marriage, with the wedding taking place

in India. However, the growth in the number of immigrants and the development of dense social networks have shifted preferences towards finding a spouse from within the immigrant community itself. Yet the traditional framework of spouse selection and marriage celebrations is reiterated.

The delineation of certain distinctive aspects of the immigrants' lives, paralleling their simultaneous integration into the culture of the 'other', needs to be examined in the specific Canadian context of multiculturalism, transnationalism, state ideology and ethnic identity.[4] This affects the total migration process, and the notions of culture, gender and identity that are constantly being reconstructed. What is it that makes a culture work 'traditionally' in a changed context, even as it undergoes a process of restructuring in the wake of new socio-economic and cultural forces? Why do Indian communities abroad selectively choose certain customs and practices from among their plural native traditions? How do these interface with the traditions of their place of settlement? To what extent do state policies reinforce or otherwise impact upon the patriarchal aspects of the immigrants' marriage practices?

This chapter addresses these questions by focusing on the changing nature of marriage forms and dowry practices among the migrant population of Indian origin in the Vancouver area of British Columbia, Canada, in the context of the issues outlined above. The Indian community in Vancouver is highly differentiated. It includes Sikhs and non-Sikhs, and twice and thrice migrants.[5] To a great extent, internal social rankings influence the retention of values, beliefs and the accompanying rituals. A cross-section of the immigrant population of Indian origin in Vancouver is covered. Part-time workers, professionals, businesspersons, students, bus operators and women in the voluntary sector were interviewed personally. My interactions with the Indian community during my three-and-a-half-month stay in Vancouver have contributed to some of the hypotheses. Since the area has a large Sikh community, their views may unintentionally dominate the study.

Indian Migrants in Canada

The earliest immigrants in Vancouver were male Jat Sikhs. Mainly from the Doaba region in the Punjab, they had arrived in the Vancouver area

about a century ago and settled there to form the nucleus of the Indian community (Johnston 1984), working mostly as lumber and logging workers.[6] Canada's nation-building processes whereby Europeans were designated the 'preferred races'[7] opened up to Indians/Asians only intermittently. A head tax of $200 for landing, anti-Oriental riots (1907), the continuous passage requirement (1908) and the Komagata Maru episode (1914) are examples of a policy of denial and exclusion of non-European migrants.[8] Between 1920 and 1945, only 675 Indian immigrants could enter Canada (Singh 2002). The discouragement of permanent settlement also took the form of women being deterred from entering the country (Doman 1984). Even so, by 1909 the Sikh *gurudwara*[9] in Vancouver's West 2nd Avenue was erected and the Khalsa Diwan Society was formed to look after the religious concerns of the Sikh community.

In April of the same year, the first local Sikh wedding ceremony was held when Bhai Gayan Singh (ex-Munsha Singh) married Bibi Labb Kor (ex-Annie Wright). This was the first Sikh–white Canadian marriage (ibid.). Indian women came in intermittently and in small numbers; between 1921 and 1923 only 11 women and nine children were admitted. They were diffident about displaying their ethnic identities through their different styles of dressing, tending to wear Western clothes to avoid being conspicuous (Raj 1980). In 1947 franchise was granted to the community after an intense struggle for elementary political and property rights. In the post-Second World War era the number of Asian immigrants entering Canada increased. According to the Canadian census statistics for 1991 and 2001, the predominant, visible minority group in British Columbia in 1991 was Chinese (192,300 or 5.9 per cent of the provincial population), followed by South Asians (118,200 or 3.6 per cent) and Filipinos (31,100 or 1.0 per cent). In 2001 this pattern was still evident, with the Chinese forming 9.4 per cent of the provincial population, followed by South Asians (5.4 per cent) and Filipinos (1.7 per cent).

In the late 1960s, the liberalisation of immigration laws ostensibly removed race, religion, national origin and cultural suitability biases from the immigration criteria. A point system categorisation based on qualifications like occupational skills, education, work experience and a sponsored category were introduced.[10] The Immigration Act (1976–77) further reclassified the categories for entry into the skilled class and the family class[11], the latter enabling the migration of women, old people and children. Women then started to migrate to Canada in large numbers. While the family class category has provided scope for increased mobility to all Asians, Indians constitute the largest number of such immigrants

to Canada. In 1996–98 nearly 20 per cent of this category came from India, twice as many as those from China, followed by 7 per cent from the Philippines and 4 per cent from Hong Kong. About 80 per cent of the family class, Indian migrants were from Punjab (CIC 1998). Besides the large number of Sikhs and non-Sikhs from India, the Indian diaspora in Vancouver also consists of the 'twice migrant'—such as Indians from Fiji, East Africa and the UK. They were later joined by a large group of professionals in fields such as IT, engineering and higher education. Most were 'chain migrants', who came to Canada through various linkages (Buchignani et al. 1985).

Migration, Marriage and Identity

The changing profile of the migrants, as well as the historical, socio-political and lived material realities of their lives, inflected social relations and issues of ethnic identity. Each generation of immigrants brought in different cultural traditions with respect to marriage arrangements. For example, the relatively rich Indian migrants from the UK and Africa were said to have promoted consumerist tendencies, characterised, for instance, by opulence and elaborate detail in their marriage ceremonies.[12] On the other hand, the increased sense of ethnic identity among different groups within the Indian community prompted them not only to seek spouses from within the socially approved pool of eligible brides and grooms, but also necessitated the fulfilment of the demands and expectations of traditional marriage ceremonies and the attendant custom of dowry—whether voluntarily or involuntarily.

To a large extent, these compulsions have not only perpetuated patriarchal cultural norms and practices, but have also made women socially and physically vulnerable in their relatively isolated and new surroundings. Many women-centred networks have been established to provide a support structure to such women (see Abraham, this volume). These networks also deal with issues of dowry demands, domestic violence and female foeticide, among others. Mobility across nations may not diminish the patriarchal norms intrinsic to marriage practices, but may result only in their relocation and reconfiguration.

The Canadian policy of multiculturalism, prompted by the significant growth in the numbers and diversity of immigrants, and the

resulting race and ethnic dynamics, ostensibly sought to enable the continuation of the diverse cultural practices brought by immigrants.[13] Migrants tend to respond in two broad ways. First, for a section of the Indian migrant population, the ideology of multiculturalism encouraged a heightened ethnic identity and confidence and pride in the display of rituals and ceremonies symbolising their cultural heritage. This was more noticeable among those who had attained a measure of socio-economic success.[14] For others, on the other hand, the process of state-sponsored multiculturalism has not mitigated their socio-economic insecurities[15]; for them, ethnically segregated neighbourhoods provide security and solidarity. State immigration policies have exacerbated this process of ethnic distancing from the so-called mainstream or dominant white community. The interrelationship of these two responses with the sociocultural organisation of the immigrant community is reflected in the complex interplay of marriage, money and gender. This is apparent when we view the different scenarios of marriage in the Indian diaspora. Four broad scenarios are presented here.

Scenario One: The Display of Ethnic Affluence

This relates to those of high socio-economic status, including some twice and thrice migrants. The preferences in spouse selection of this class are determined less by caste (religion is still a consideration)[16] and more by compatibility based on socio-economic status. While some families still prefer to bring brides from India, there is an increasing trend of selecting brides or grooms from among the migrant Indian communities in Canada, the US, the UK and Africa. The ideal is an equal status family, a good educational background and, in the case of a prospective bride, 'a girl brought up with Indian values'. Usually, demands for dowry are not expressed.

An example of a marriage between a Sikh girl and a Kayasth boy is illustrative. Both were second-generation migrants from professional families. The marriage was held after much opposition on the part of the bride's family because of the religious differences. The wedding ceremony was solemnised in the Hindu tradition and held in a public park overlooking a lake. Several hundred people had been invited. Lavish

food was served for breakfast as well as for lunch. The wedding day was preceded by a week of ceremonies attended by family and friends. Many family members were flown in from India for the occasion. Many weddings had taken place in the community centre near the park, but only a few marriages took place in the open like this one. The wedding was talked about for its opulence, including gifts on several occasions for all those invited, its observance of rituals (each guest was provided with a written explanation of all marriage rituals in English), and a 'near aggressive' display of success and confidence in life—in the choice of an open public area, which naturally attracted many interested onlookers. Also remarkable was the choice of white Canadian boys and girls to stand behind the tables serving the food and clearing the dishes. Many women from needy Punjabi families had helped stock up on prepared food for the numerous ceremonies held earlier at home, but they were not visible in the publicly held ceremony.

The wedding mandap[17] was elaborate, with red and gold cloth draped over white pillars. The priest (from the local temple in the area) who was officiating at the function, sat in the mandap with the groom. After the milni[18] and dwar puja[19] were over, it was time for the bride to join the ceremonies. An announcement was made: 'Ladies and gentleman, please finish your snacks or bring them to your seats. The bride is about to enter the pandal.'[20] On the beat of a Hindi film song rendered by a male relative, five young girls in a geometrical formation entered, followed by the bride. The wedding ceremony was translated into English at every step.[21] The priest and other male members of the family, notably the father and brother of the bride, were part of the ceremonies that took place at the mandap. The mother sat at a distance. In the evening a reception was arranged by the groom's family in a hotel. The short speech made by the new bride on the occasion was, 'I am coming to your house and family. Please forgive me if I make mistakes.'

The passive role—indeed, near absence—of women in directing the rituals on this most important occasion was a noticeable dimension of the wedding ceremony, in contrast to weddings in India. There, local family, clan, village or regional traditions, perpetuated by elderly women, and also men, are intertwined with the prescribed ritual conducted by the priest or officiant. Despite the emphasis on traditional culture, the typical marriage songs by women at the time of the marriage ceremony were missing in the Canadian context.[22] Disconnected from local traditions, Hindu marriages in the diaspora literally follow the directions of the pandits, who may not be from the region to which marrying families

belong. More often than not, a standard ritual, said to be in keeping with Hindu *sanatan dharma* (literally, the eternal faith, referring to the Vedic religion to which Hindu tradition is linked), is used. However, in the Canadian case the bride's mother did not sit at the *mandap* alongside her husband, the usual *sanatan dharma* practice.[23] The printed explanation of the 'Vedic Hindu Marriage Ceremony' circulated among the guests by the local temple priest referred several times only to the father of the bride in connection with the rituals.

Such ostentatious weddings have become the norm among successful Indo-Canadians.[24] Affluence appears to be easily combined with traditionalism and rituals.[25] Some respondents had made a trip to India especially to find an 'Indian' daughter-in-law who respected Indian family values. Although they did not make any demands for cash or kind from the bride's parents, they expected 'good treatment' befitting their status and an elaborate marriage ceremony. Their high expectations were evident in their comments that, in spite of not asking for dowry, the girl's side had not taken adequate care of them: 'I think that we spent much more than they did!' Another informant mentioned that the families of both his daughters-in-law did not spend much at the wedding, but 'we were more interested in getting girls with Indian values and traditions'. The sons had approved Indo-Canadian girls after being introduced by the parents to several eligible girls across Canada. On his part, the father had organised the wedding reception in an expensive hotel in the city, for his sons as well as for his daughter. In fact, he had not differentiated between the sons' and the daughter's wedding in spending lavishly on them. The daughter had married a 'white Canadian'[26] and the groom's mother has been 'overwhelmed' by the gifts of jewellery and clothes that were showered upon all the groom's family members by the daughter's parents! 'We told her that it was our Indian tradition,' he recalled.[27]

A recent trend is the display of a deep interest in 'traditional' weddings among the second generation from affluent migrant families. A woman informant who enjoys immense prestige in the city remarked, 'My sons wanted a typical "Indian" wedding even though we tried to persuade them to avoid the unnecessary expenditure. They wanted all the rituals, a grand wedding procession, including a limousine, and extended celebrations. My own marriage was a simple ceremony at the *gurudwara*, for we could not afford anything else.'[28] She correctly assessed that the impact of such ostentation lay mainly in its demonstration effect, setting a dangerous and unhealthy trend in society.

Scenario Two: The Growing Burden of a Daughter's Marriage

This relates to migrants resident in the ethnically concentrated area of Surrey[29] in Vancouver. Societal expectations and conformity fostered by close family and social ties determine marriage arrangements. One of my informants was a Jat Sikh woman who had come to Canada as a bride about 30 years earlier. After working for several years in a garment factory, she had opened her own laundry store where she and her daughter worked. Her daughter, 20 years old, was studying part-time and hoped to go to college soon. At work, both mother and daughter constantly listened to Radio India, which broadcasts programmes in the Punjabi language.[30] The woman's husband had no job. She drove to work every morning from Surrey, also known as 'Mini Punjab', and worked till late at night, after which she attended to her household responsibilities. She had visited India only thrice in the three decades that she had lived in Canada and the daughter had never done so. Even so, the latter felt it imperative to observe Indian traditions of marriage, behavioural norms and cultural practices she had learnt in the environment she had been brought up in.[31] She would marry a Jat Sikh, just as her sister had done. The mother added that it was better for girls to marry boys from the immigrant population. A groom from India brought in severe adjustment problems. On the other hand, a bride from India could adjust with a little help.[32]

It was estimated that marriage expenses would amount to at least $100,000, which would include a down payment for an apartment, a good reception, gold ornaments and household effects. This was the 'normal' expectation; the rich spent more and presented a marriage style that others longed for. Like other respondents of her age, she added that marriages had become increasingly burdensome over the years. Earlier, ceremonies organised by the bride's side were performed in a *gurudwara*, after which a simple lunch was provided. (Meat and drinks are not permitted inside the *gurudwara*.) The groom's side bore the expenses of the evening reception, while the bride's family was responsible for her clothes and jewellery, which were not as expensive as what girls 'carried' these days. Now, elaborate dowries, detailed rituals and competitive grandeur and display have increased the burden on the bride's family.[33] Films and the media were influencing the younger generations in this direction.

Others from a similar socio-economic background also spoke of the financial drain now entailed in a daughter's wedding. 'Whether you get a groom from Punjab or here, it is the same story!' Lavish and ostentatious display is considered so much a part of the Indian wedding scene that Canadian immigration officials in New Delhi are known to reject applications for an immigration visa for a spouse on the grounds that the applicant has not been able to demonstrate the grandiose marriage ceremony that they considered to be the local norm.[34] In 1997, 17 per cent of visa applications were refused because the concerned official considered the marriage as invalid or fraudulent. Thus, immigration officials determined a yardstick for a valid marriage on the basis of a generalised reading of Punjabi matrimonial rituals (Walton-Roberts 2001: 311–14).

Scenario Three: Marriage, Dowry and Migration Strategies

This scenario emerged from the experiences of the steady stream of part-time—male and female—Indian migrant employees in a food store chain and 24-hour shops. The young women employees, many of whom had come to the country after marriage, were afraid to talk of or to reveal any aspect of their marriage or the other arrangements that had brought them from Punjab. Several attempts were made to establish rapport with them, but after their initial friendliness, they became withdrawn and wary. The male staff was more ready to talk.

One revealed that his aunt had sponsored him and he was trying to make ends meet by doing three shifts a day, often past midnight. He spent sleepless nights worrying over this. Even though he was facing financial hardships, he could never return to India as a 'failure'. Instead, he was keen to bring his parents and sister to Vancouver. He said that socialising with people belonging to better-off families added to his misery, as it was important to wear branded clothes and have a good car. He was sure that he would not marry an Indo-Canadian girl for 'they were too fast, too advanced'. He preferred someone from India. A nurse would be the right choice, he felt, as that profession, much in demand and high on the list of approved skills for immigration purposes, would help to make life easier for him!

This informant is not alone in his struggle. Securing employment is wrought with difficulties for those entering Canada in the family class category as well as for the 'independent' entrants. Factors such as economic recession, lack of 'Canadian experience', non-recognition of educational degrees and racial/ethnic discrimination play havoc with the adjustment process. It is estimated that the unemployment rate for South Asian Canadians is 20 per cent, and for recent immigrants the rate goes up to 30 per cent (Spigelman Martin Research Associates 1999). Many are forced to take up part-time work and jobs unrelated to their qualifications or preferences. The ensuing uncertainties lead some to seek a spouse with a 'preferred skill' for easy immigration and quick relief. For them, this is a 'traditional' and socially acceptable means to make ends meet.

Another example is that of a taxi-driver who, though a trained accountant, was unable to find a suitable job. He agreed to an arranged marriage with a girl from rural Punjab and came back and bought a taxi, which became a viable business. He recalled that he had told his father-in-law, 'All I need is a good wedding reception, and whatever else you would have spent, give it in cash so that I can invest it properly and keep your daughter happy.' The girl's parents, for whom an NRI (non-resident Indian) son-in-law meant heightened status and a good future for their daughter, willingly consented to such demands and provided an elaborate wedding, since the groom's side did not demand more than what they had anticipated spending. Perhaps this was also viewed as a long-term investment, as the daughter could subsequently sponsor her natal family for immigration to Canada.

In this scenario, dowry emerges transformed. Dowry marriage as part of a status enhancement strategy for the two families connected through the woman is not novel. The daughter is wedded to a migrant, along with the presentation of dowry, bringing status to her and to her natal family, and economic benefit to her marital family. However, what is new is that marriage and dowry are a strategy for the horizontal and economic mobility of the bride's natal family (see Uberoi 1998). The bride serves as a willing conduit to provide her family with an opportunity to better their life chances. It has been reported that 70 per cent of the female students in a particular college of Jullundur district marry NRIs from Canada. A road in Surrey district in Vancouver is jokingly referred to by the name of the road on which this college is located in the Punjab! The college is said to impart liberal arts courses 'without the corrupting influence of the west', thus catering to the 'idealised imaginary' of the

Indian, as opposed to that of the Western woman (Walton-Roberts 2001: 306).

There have been many reports of NRI marriages ending in harassment and even death for women. Harjinder Nijjar, whose father raised $10,000 for dowry through the sale of land and bank loans, was found in a garbage dump after being strangulated by her husband. Her case is still vivid in people's memory (*Kinesis* 1993). In Punjab there has recently been a demand for the promulgation of strict legislation to check fraud perpetrated by deceitful travel agents and devious 'foreign bridegrooms'. According to an estimate, at least

10,000 women in Punjab, 1,500 in Haryana and 50 in Chandigarh had reported being victims of 'devious foreign bridegrooms' who had either withdrawn sponsorship, sought huge amounts for travel procedures or other purposes, subjected their wives to the most barbaric violence on reaching abroad, serving divorce decrees through fraudulent methods or having deserted the bride within two or three months after the marriage.

Cases of elderly grooms or married men who married girls on the promise of taking them abroad have also been noted (Pandher 2003; see Abraham, this volume).

Scenario Four: Acculturation and Marriage

This reflects a recent trend indicated in the first two scenarios. Some of those engaged in family businesses and enterprises were now reconsidering the idea of bringing a bride from Punjab or 'back home'. Economic expediency is a reason. As one of the respondents explained:

Now there are many families with our socio-economic background here in Canada, even the UK or the USA, from which to choose a bride. A girl brought up here would be more useful as we would not have to spend time in teaching her the language or how to drive a car or train her in business. Already adjusted in the life here, her early integration would help her to start participating in this business right away.

However, they too were not ready to accept girls who had not been brought up in the 'Indian tradition'. Many see the 'Canadian' notions of family, children and marriage as a threat to their own precious 'Indian' values. The presence of extended kin support system helps strengthen the hold of traditional beliefs and practices. The outcomes no doubt vary, but early socialisation is believed to impact upon the gendered acculturation process.

Transnational Marriage Migration

The four scenarios reveal the complex and changing nature of marriage practices and dowry in transnational locations. The socially normative desire of parents to find suitable matches for their children takes many different courses. International 'marriage migration' is one such avenue, despite reported cases of deception and mistreatment. Usually brief winter visits of eligible NRI men force quick decisions on families for whom the settlement of a daughter's marriage is a socio-religious priority. For those who prefer to choose marriage partners for their sons from among families settled in Canada, the UK or the USA, the ideal is an equal-status family and good educational and other accomplishments of the girl. Equally important and common to all was the demand for 'a girl brought up with "Indian" values'. Daughters are seen as symbols of cultural identity and must thus bear the additional 'burden' of preserving the culture. It was reported that in ethnic social gatherings as well as in their everyday behaviour, daughters are subjected to intense scrutiny by others of their community.

The process of acculturation may gradually diminish premigration norms of a given immigrant community. However, the process is neither inevitable nor without contradictions. Several factors impinge upon this. The resistance to assimilation may take the shape of residentially segregated community living, with people from a particular region living in the same neighbourhood—some out of choice, but most due to necessity and the vicissitudes of the migration process. This fosters and perpetuates a sense of identity through dense social linkages involving marriage, regional language usage[35], selection of a common school for children's education and ethnic institutional services, as well as a sharing of cultural-religious practices and norms.

Informants presenting the second, third and fourth scenarios said that there was little need for interaction with white Canadians as they had a large number of family members living close by. The sense of security arising out of dense networking amongst themselves, linked to the cultural and economic uncertainties inherent in the migration process, makes it unlikely that such ethnic residential segregation would be a transitory stage.

Ethnic segregation in this environment is maintained through marriage practices, and interracial/ethnic marriage is not encouraged. Even though the pool from which grooms and brides are chosen has in some cases modified caste or regional considerations, the emphasis is on at least being Indian in origin. Researchers have explored the incidence of endogamous and exogamous marriages as an indicator of the acculturation and assimilation of immigrant populations. Statistics reveal that among the visible minorities, South Asians revealed the least propensity for mixed unions. In its latest social trend report of 8 June 2004, Statistics Canada analysed 1991 and 2001 census data to demonstrate that 87 per cent of South Asians preferred marriage unions within their own visible minority group (Milan and Hamm 2004). Historical circumstances related to both racialised practices as well as cultural preferences and organisation may account for this trend.

The ideal of Indianness underlines ethnicity. Informants emphasised being 'Indian' by culture, while holding Canadian citizenship. Even those who had only occasionally visited India sought to preserve 'Indian tradition' by emphasising cultural and religious practices, and the observation of rituals that they considered Indian. The high divorce rates and sexual norms among white Canadians, particularly women, as well as their apparent disrespect for older people and for familial relationships were cited as the most obvious threats that necessitate control over social interaction. A 15-year-old son of an informant said that he had to keep an eye on his sister at school and prevent her from talking to boys, because his mother had explained that this was the Indian tradition.

A respondent remarked, 'Why should we not observe our rituals the way we want to? Why should you expect anything different? The host society is as much a patriarchal site as any other.' Indeed, the immigration process that has fostered the broad two-fold response of heightened and even aggressive cultural identity as well as of insecurity offers scope for both the transformation and the reinforcement of traditional cultural behaviour. The impact on marriage as it becomes a part of the

'transnational diasporic circuit' is inevitable, as marriage has become an important focus of community and ethnicity. The pre-migration gendered norms are also resilient as a result of the gender, race and class biases in Canadian immigration policies. Most women have migrated to Canada under the family class category after being sponsored by a husband/relative (87 per cent of the migrants in the year 2000, mostly in the category of spouse and fiancé [CIC Delhi; for details, see Walton-Roberts 2001]), and this dependent status may well reinforce patriarchal control over her. A case of default leaves her vulnerable on two grounds: her own insecure immigrant status, as well as the end of her family's chances to immigrate through her sponsorship. In the interests of her natal family and of herself, she may be placed in a position in which she dares not subvert any norm or expectation of her.[36] The young married women who would not reveal anything about their life in Canada[37] or the young man who hoped to better his chances through the importation of a nurse as wife are examples of the uncertainties that sponsorship and immigration entail.

My observations do not suggest any fixed or essentialised set of processes. Nor do they discount notions of female agency. Scholarly attention has only recently been directed at the interlinkages of gender with marriage and migration. More transnational studies of diasporic sites and communities need to be conducted in order to sharpen insights into the differentiated responses and changing dynamics. This study has worked outward from its central focus on money, marriage and gender to develop a general interpretation of the linkages between the vicissitudes of the immigration process, the construction of notions of culture and identity, and marriage practices and gender relations.

Acknowledgements

I acknowledge with thanks the award of a fellowship in Women and Development by the Shastri Indo-Canadian Institute, which made it possible for me to conduct fieldwork in Vancouver in July–November 2002 as a Fellow at the University of British Columbia, Canada. I am also thankful to Mandakranta Bose, Sunera Thobani and Sneja Gunew at the Institute of Asian Studies and the Centre for Women's Studies and Gender Relations, University of British Columbia, for useful

comments and suggestions on the study. I am grateful to Patricia
Uberoi and Rajni Palriwala for their comments.

Notes

1 Dowry has been defined as the money, goods or estate that a woman brings to her
 husband at marriage as 'pre-mortem inheritance' (Tambiah 1973: 64). This provides
 a wider analytic perspective to comprehend the historical roots of dowry. 'Modern
 dowry' in the North Indian context, however, includes much more, even though the
 articulated basis of gift-giving to the daughter may remain the same.
2 Hypergamy refers to the practice whereby brides marry into families of higher status
 than their own. See Pocock (1954) for an explanation in the Indian context.
3 I have interchangeably used the terms Indian migrant, immigrant, Indo-Canadian or
 Indian community for people of Indian origin. Changing identifiers such as Hindu,
 East Indians, South Asians, visible minority, etc., for people of Indian origin in Canada
 have been employed by the Canadian state, historically linked with successive state
 policies.
4 Given the scope of the paper, theoretical discussions of these highly complex
 phenomena have been only briefly dealt with.
5 These are immigrants who have moved to Canada from a second or third country
 after an earlier outmigration from their native country, for example, Fiji-Indians or
 Ugandan-British-Indians.
6 For detailed discussions on the history of Indian immigration and related events, see,
 for example, Buchignani et al. (1985); Doman (1984); Engineer (1973); Johnston
 (1984); Raj (1980).
7 Scholars have ably demonstrated the racialised nature of the Canadian immigration
 policy. See, for example, Bannerji (1996); Bolaria and Li (1985); Das Gupta (1995);
 Thobani (2000a). The preferred immigrants were from Northern and Western
 Europe. Later, Eastern Europeans were also accepted and, by the first few decades of
 the 20th century, the 'preferred race' status included all white immigrants (Thobani
 2000a: 285). The 'liberalisation' of immigration policy in the 1960s and the 1970s was
 due to Canada's need for skilled personnel for economic development, even though it
 is only the humane aspects of promoting family unification and removing racial bias
 which were emphasised (Helweg 1986).
8 Many stringent laws were passed to discourage non-whites from entering British
 Columbia. Indians, for example, had to possess at least $200 in person, and had to
 come via direct passage from India. In 1914, in defiance of these rules, the *Komagata
 Maru*, a Japanese steam liner, was chartered by some Indians, and carrying about 375
 persons, departed from Hong Kong, stopped in Japan, and finally arrived in Vancouver.
 It was, however, not allowed to berth for over two months. Thereafter, only a few
 were allowed to stay and the rest were returned to India. Similarly, a $50 head tax that
 was levied on every Chinese immigrant was raised to $500 in 1904. In 1907 serious
 racial riots broke out in Vancouver and many Chinese immigrants were forced to
 move to other parts of Canada.

9 A Sikh place of public worship, where a copy of the *Guru Granth Sahib*, the Sikh holy book, is kept.

10 By the late 1940s, there were fewer than 2,000 Sikhs in Canada, residing mainly in the Vancouver area. In 1951, 150 immigrants per year and spouses and children under 21 years were admitted. This was increased gradually to over 2,000 per year. In 1961, there were 6,774 people of Indian origin in Canada with 4,526 residing in British Columbia. Of these, 95 per cent were Sikhs. Most of the immigrants were engaged in railway construction and lumbering, in farmwork, in logging operations and in small businesses (Singh 2002).

11 In the skilled or the independent class category, points were allocated for education, skills, language, etc. The needs of the Canadian economy dictated the preferred skills. This also translated into entry primarily for male applicants. The family class was based on the family relationship to the sponsor. Sponsorship or financial responsibility was tenable for 10 years, during which time the sponsored immigrant could not avail of any state-run job training or language training programmes or any social assistance. In the main, women, elderly family members and children entered through this category. These categorical divisions have been termed as the independent or 'masculinised' and the dependent category respectively (Das Gupta 1995; Thobani 2000a). The Act also allowed discretion on the part of the immigration officers for allocation of points and processing of applications.

12 Many informants linked the coming of these twice and thrice migrants with the beginning of opulence in marriage celebrations among Indian migrants in Vancouver. This was described as a corrupting influence for others. A useful study by Bhachu (1985) explores the reasons for lavish wedding ceremonies and dowry among the Ramgarhia Sikhs who migrated to the UK from East Africa and some who had moved to Vancouver.

13 Unlike the metaphor of the melting pot used in the USA to denote an assimilative policy for its diverse settlers, Canada developed a policy of preserving the diversity of ethnic identities under the rubric of multiculturalism. The official policy of multiculturalism was formulated in October 1971 and was institutionalised by an Act in July 1988. Scholars have, however, noted the limited scope of this policy. It has been observed that the policy's priorities remained limited to the recognition and legitimation of East Indian ceremonies or other ethnic events and not to genuine 'power sharing'. See Bannerji (1996, 2000); Lewycky (1992); Li (1999).

14 There are people among the successful Indian immigrant population, however, who prefer to be less 'ethnically' conspicuous and practice their preferred rituals and ceremonies in private. Also, for this class, residential proximity to other Indians is not a priority.

15 According to an informant, multiculturalism exists, but on paper. One has only to come to the east side of Vancouver city to hear name-calling or references to the gutter-like living pattern of South Asians. Stereotypical images and intolerance of the 'visible minorities' are still prevalent among white Canadians.

16 It was reported that, besides Ismailis, Indo-Canadian Sikhs are in general more particular about region, caste and religious criteria in spouse selection than other North Indians in Canada. For purposes of spouse selection, the latter make distinctions between those belonging to Amritsar, to Doaba or to other regions of Punjab. Many cases of parents not agreeing to interethnic or interracial marriage were cited.

17 The canopy under which the marriage rituals are performed.

18 The formal welcome of the groom's marriage procession by the bride's family members on the former's arrival at the wedding venue.

19 The ritual welcome of the bridegroom at the entrance to the marriage venue.

20 A decorated temporary enclosure set up for wedding celebrations.

21 While adaptations such as a bridal procession to the *mandap* and speeches by guests, family members and the couple at the reception are common, the actual wedding ritual is followed carefully. One of the relatives remarked that in the near future Indians (in India) may have to consult immigrants regarding the authentic ritual order and other details!

22 Marriage songs are female forms of expression and part of wedding celebrations in India (Chowdhry 1994).

23 The mother's absence from the *mandap* cannot be taken as the universal practice among Hindus in Canada. It may have been a result of the bride being from a Sikh family.

24 Some informants said that ostentation and display were more prevalent among the *nouveau riche* and amounted to wastage. Cases of simple marriage ceremonies were reported where the bride had been given only one or two sarees (since she usually wore Western dresses), or where even the jewellery had been borrowed for the occasion. However, only a tiny minority appeared to profess simple marriages and disapproved of ostentation.

25 Uberoi (2001) describes the approval and appreciation by cinema audiences of the opulence and elaborate rituals in 'traditional' weddings, as depicted in the Bollywood blockbuster *Hum Aapke Hain Koun*. This film has inspired many 'event' weddings, both in India and among Indian emigrants.

26 This was emphasised as a matter of pride for the family.

27 The notion of unidirectionality between the bride-givers and bride-takers in North Indian marriages, tied to notions of the gift of the maiden, hypergamy, spiritual merit and social honour to the bride-giver, is entrenched among Indian immigrants and leaves little room for expectations of reciprocity in gift-giving.

28 Many NRI weddings these days take place in palaces and hotels in India. Elephants, horses and a palanquin for the bride are part of the 'traditional' fare.

29 Surrey holds more than 40 per cent of the Indian immigrant population in the Vancouver area.

30 Radio India is one of the popular radio stations and provides an active forum for discussions on traditions, and for airing concerns and anxieties over gender and generational relations.

31 Most of their relatives had, over the years, migrated to Vancouver from Jullundur (Punjab), and the girls had grown up around people sharing similar beliefs and customs.

32 See Charsley, this volume, for a discussion of this problem in the context of Pakistani migrants to the UK.

33 It was stated that even when no demand is made openly, the details of the groom's family members are provided so that appropriate gifts are given. Ceremonies and rituals provide a good cover for 'gifts'.

34 It is interesting to note that the British courts applied similar static norms during the colonial period to decide property and inheritance-related cases. See Sheel (1999).

35 Buchignani et al. (1985: 194–95) discuss the revival of native language learning in the context of culture maintenance.

36 Feminists have demonstrated that the commonly assumed cultural differences and
 problems of adjustment that are seen to explain immigrant women's problems do
 not take into account the 'systemic features' of Canadian society that perpetuate
 women's vulnerabilities. Immigration law in Canada is one such feature. Changes
 have been proposed in the length of the sponsorship and application process. At the
 same time, more priority is being given to the 'temporary worker' category (see, for
 example, Ng 1992; Thobani 2000b).

37 Even after women enter paid work, which most do soon after their arrival, their
 'dependent' sponsored status remains. This leaves them vulnerable to violence and
 insecurities, and makes them hesitant to reveal or talk about their situation (see
 Abraham, this volume).

References

Bannerji, Himani (ed.). 1993. *Returning the Gaze: Essays on Racism, Feminism and Politics.*
 Toronto: Sister Vision Press (Black Women & Women of Color Press).
———. 1996. 'On the Dark Side of the Nation: Politics of Multiculturalism and the State
 of "Canada"', *Journal of Canadian Studies*, 31: 103–28.
———. 2000. *The Dark Side of the Nation: Essays on Multiculturalism, Nationalism and Gender.*
 Toronto: Canadian Scholars Press, Inc.
Bhachu, Parminder. 1985. *Twice-Migrants: East African Sikh Settlers in Britain.* London:
 Tavistock Publications.
Bolaria, P. and P. Li. 1985. *Racial Oppression in Canada.* Toronto: Garamond Press.
Buchignani, N. and Doreen M. Indra with Ram Srivastava. 1985. *Continuous Journey: A
 Social History of South Asians in Canada.* Toronto: McClelland and Stewart in association
 with the Multiculturalism Directorate, Department of Secretary of State and the
 Canadian Government Publishing Centre.
Chowdhry, Prem. 1994. *The Veiled Women: Shifting Gender Equations in Rural Haryana,
 1880–1990.* New Delhi: Oxford University Press.
Citizenship and Immigration Canada (CIC). 1998. 'Facts and Figures 1998', available
 online at http://www.cic.gc.ca/english/pdf/pub/facts1998.pdf.
Das Gupta, Tanya. 1995. 'Families of Native Peoples, Immigrants and People of Color',
 in N. Mandell and E. Duffy (eds), *Canadian Families: Diversity, Conflict and Change*,
 pp. 141–74. Toronto: Harcourt Brace.
Doman, Mahinder. 1984. 'A Note on Asian Indian Women in British Columbia, 1900–
 1935', in Barbara K. Latham and Roberta J. Pazdro (eds), *Not Just Pin Money*. Victoria:
 Camosun College, available online at http://www.camosun.bc.ca/~latham/pin_
 money/doman.htm.
Engineer, H.M. 1973. 'Arrival of the East Indians (Sikhs) in Canada (B.C.)', in *An
 Introduction to East Indian Culture*, pp. 1–3. Vancouver: Centre for Continuing Education,
 University of British Columbia.
Helweg, Arthur W. 1986. 'India's Immigrant Professionals in Toronto, Canada: The Study
 of a Social Network (1)', in S. Chandrashekhar (ed.), *From India to Canada: A Brief
 History of Immigration, Problems of Discrimination, Admission and Assimilation*, pp. 67–79.
 California: Population Review.

Johnston, Hugh. 1984. *The East Indian in Canada*. Ottawa: Canada's Ethnic Group Series, Canadian Historical Association.

Kinesis. 1993. 'India Mahila Association Report', Vancouver, March.

Lewycky, Laverne M. 1992. 'Multiculturalism in the 1990s and into the 21st Century: Beyond Ideology and Utopia', in Vic Satzevich (ed.), *Deconstructing a Nation: Immigration, Multiculturalism and Racism in 90s Canada*, pp. 354–99. Halifax: Fernwood Press.

Li Peter S. (ed.). 1999. *Race and Ethnic Relations in Canada*. Toronto: Oxford University Press.

Menski, Werner (ed.). 1998. *South Asians and the Dowry Problem*. Stoke-on-Trent: Trentham Books Limited.

Milan, Anne and Brian Hamm. 2004. 'Mixed Unions', *Statistics Canada: Canadian Social Trends*. Ottawa: CanStats. Available online at http://www.statcan.ca/english/studies/11-008/feature/11-008-XIE20040016882.pdf.

Ng, Roxana. 1992. 'Managing Female Immigration: A Case of Institutional Sexism and Racism', *Canadian Woman Studies*, 12 (3): 20–23.

Pandher, Sarabjit. 2003. 'Check on "Devious Foreign Grooms" Sought', *Hindu*, 17 March.

Pocock, David F. 1954. 'The Hypergamy of the Patidars', in K.M. Kapadia (ed.), *Professor Ghurye Felicitation Volume*, pp. 195–204. Bombay: Popular Book Depot.

Raj, Samuel. 1980. 'Some Aspects of East Indian Struggle in Canada, 1905–1947', in K. Victor Ujimoto and Gordon Kirabayashi (eds), *Visible Minorities and Multiculturalism*, pp. 63–80. Toronto: Butterworth.

Sheel, Ranjana. 1999. *The Political Economy of Dowry*. New Delhi: Manohar.

Singh, Kuldeep. 2002. 'Sikh Diaspora in Canada'. Lecture at Oakland University, Michigan, USA, 7 March. Available online at http://www.sikhreview.org/pending/pending1.htm.

Spigelman Martin Research Associates. 1999. *Community Overview: Surrey*. Vancouver: Spigelman Martin Research Associates.

Tambiah, Stanley J. 1973. 'Dowry, Bridewealth and Women's Property Rights', in Jack Goody and S.J. Tambiah (eds), *Bridewealth and Dowry*, pp. 61–98. Cambridge: Cambridge University Press.

Thobani, Sunera. 2000a. 'Nationalising Canadians: Bordering Immigrant Women in the Late Twentieth Century', *Canadian Journal of Women and the Law*, 12 (3): 279–312.

———. 2000b. 'Closing the Doors to Immigrant Women: The Restructuring of Canadian Immigration Policy', *Atlantis*, 24 (2): 16–26.

Uberoi, Patricia. 1998. 'The Diaspora Comes Home: Disciplining Desire in *DDLJ*', *Contributions to Indian Sociology*, 32 (2): 305–36.

———. 2001. 'Imagining the Family: An Ethnography of Viewing *Hum Aapke Hain Koun...!*', in Rachel Dwyer and Chris Pinney (eds), *Pleasure and the Nation: The History, Politics and Consumption of Public Culture in India*, pp. 308–51. New Delhi: Oxford University Press.

Van der Veen, K. 1972. *I Give Thee My Daughter: A Study of Marriage and Hierarchy among the Anavil Brahmans of South Gujarat*. Assen: Van Gorcum.

Vatuk, S. 1975. 'Gifts and Affines in North India', *Contributions to Indian Sociology* (n.s.), 9 (2): 155–96.

Walton-Roberts, M. 2001. 'Embodied Global Flows, Immigrant Capital and Trading Networks between Punjab, India and British Columbia'. Ph.D. dissertation, Department of Geography, University of British Columbia, Vancouver.

9

GENDER, DOWRY AND THE MIGRATION SYSTEM OF INDIAN INFORMATION TECHNOLOGY PROFESSIONALS

Xiang Biao

The spectacular growth of the information technology (IT) industry and the hyper-mobility of IT professionals are among the most significant social developments in India since its economic liberalisation in the beginning of the 1990s. In 2002, 64,980 Indians were granted H-1B visas, the special work permit of the United States for highly skilled temporary migrants, far exceeding the second and third largest groups (China with 18,841 and Canada with 11,760) (US Citizenship and Immigration Services 2003: 153). Even more strikingly, 73 per cent of the Indian H-1B visa holders were computer professionals and 63 per cent of all the computer-related H-1B visas were taken by Indians (ibid.: 95). Across the Atlantic, Indians constituted 78 per cent of all foreign IT professionals entering the UK in 2002 (Clarke and Salt 2003: 572). Unsurprisingly, the mobility of IT professionals is a highly gendered phenomenon. Although the percentage of female migrant Indian IT professionals is unknown, women made up only 24 per cent of all the temporary workers and trainees who entered the USA in 2002 (US Citizenship and Immigration Services 2003: 148). During my 22 months of fieldwork in Australia and India, I came across only eight females out of 102 Indian IT professionals interviewed.[1]

Gender-sensitive readers may immediately ask: why are women underrepresented in this group? And what of the experiences of the women left behind by the male migrant IT professionals? While this chapter will address these questions, it departs from the common tendency in the literature on migration and gender to focus solely on

women's experiences, and instead places the discussion in a broader context. It regards gender as a central organising principle of social life and sees migration as a critical force that reconfigures social relations. In this perspective, by bringing migration and gender together, the chapter aims to examine how, in the case of the migration of IT professionals, migration affects local society by altering some principal frameworks of people's everyday life. It not only demonstrates that the migration of IT professionals is gendered, but also that the migration process as a whole is gendered in its construction. That is, gender relations are central in producing the migration system itself. Indians take a lion's share in the global IT labour market because they provide specially cheap and flexible labour, and the gender relations prevalent in India have been critical in producing this labour force and in supporting it in the volatile global economy. In turn, the emergence of a group of mobile IT professionals contributes to the increase of dowry in some parts of India and this helps mobilise resources to produce a larger IT labour force.

This chapter moves away from the simplistic view that sees gender as a matter of men versus women, or a simple comparison of women and men. It points out, for example, that the participation of women in the IT sector does not necessarily mean the empowerment of women, while at the same time it cannot simply be said that men always benefit from dowry or the male-dominated IT industry. Rather, both women and men can be victims of biased gender relations. At the same time, gender always intertwines with other social dimensions, which means that the empowerment of one group of women may take place at the cost of others. It is with this consideration that I regard marriage and dowry—institutions defining gender relations, rather than simply 'women's matters'—to constitute an important angle for understanding gender issues.

In this chapter, I will first review the current literature on migration, IT and gender, and point out its limitations. I then describe the migration system of Indian IT professionals and suggest that it is not merely a matter of migration in the conventional sense—such as the much-studied India–Gulf movement—but should be seen as part of the global processes of economic change. Accordingly, central to this article is the question of how the new dynamisms of the global economy, rather than geographic mobility per se, intersect with gender relations. The section following this explores women's direct experiences of mobility and reveals that, though very few women participate in the migration system as independent IT

professionals, they are essential to sustaining the system, particularly its flexibility. The chapter then moves to its central concern and details how the globalised and volatile IT industry has affected marriage and dowry practices in local society and how, in turn, the institution of dowry functions as a means of mobilising resources to support the production of the IT labour force.

This chapter is based on my fieldwork in Sydney (January 2000 to June 2001), Andhra Pradesh (from June to September 2001, mainly in the capital city, Hyderabad) and New Delhi (September to October 2001). Australia has special advantages as a research site for this project as it has attracted sizable numbers of Indian IT professionals. Yet, unlike in the United States, Australia often functions as a stepping-stone from where Indian IT professionals move on to other countries such as the United States or the United Kingdom. Australia is therefore a 'semi-periphery' country in the international migration strategy of Indian IT workers, and this position enables me to better observe the worker's global mobility. I identified Andhra Pradesh (AP) as my research site because the state has produced a disproportionately large number of IT professionals, claiming to be the home of 23 per cent of all Indian IT professionals worldwide (AP Finance and Planning Department 1999).

In terms of methodology, in-depth interviews and participant observation were the main investigation methods. I had open-ended interviews with 180 IT professionals and relevant institutes and lived with about 20 Indian IT workers in Sydney and Hyderabad. Besides first-hand data, I accumulated considerable information through documentary study, particularly by collecting media reports. In order to maintain the privacy and confidentiality of individual interviewees, I have used pseudonyms throughout the chapter.

Migration, Gender and IT

Unlike in other fields where gender sensitivity is primarily concerned with the invisibility of women, a gender perspective was developed in migration studies as a result of the increasing number of women moving as independent migrants. The earliest literature on gender and migration almost exclusively focuses on independent female migrant workers (Fawcett et al. 1984; Morokvasic 1983, 1985; Youssef et al. 1979), and

the conspicuous 'feminisation' of migration in Asia brought migrant women into the limelight (see Battistella and Paganoni 1996). Female migrants constitute 60 to 80 per cent of the migrants legally deployed overseas from Sri Lanka, Indonesia and the Philippines. A large amount of research has been devoted to documenting female migrants' experiences, with domestic workers constituting probably the best studied case (Chin 1998; Constable 1997; Heyzer et al. 1994; Parrenas 2001; Truong 1996; Yeoh et al. 1999). Other groups that have attracted considerable academic attention include, to name a few, contract workers (Gibson et al. 2001), returned female migrants (Asis 2001), sex workers and so-called 'entertainers' (Brennan 2001; Dinan 2002; Emerton and Petersen 2003; Seol et al. 2003; Srobanek et al. 1997), and recently, female tourists, particularly those engaged in so-called 'romance tourism' (Taylor 2001; Toyota, forthcoming). The fact that a gender perspective in migration studies was partly a response to the feminisation of migration may explain partially why research on migration and gender often appears to be a study of female migrants.

Another major theme in the literature on migration and gender focuses on the women left behind. It has been observed that, despite the feminisation of migration, being left behind is still predominantly studied as a female experience. This is because, while men of all age groups are free to migrate, migrant women are mainly young and unmarried, such that fewer husbands are left behind as compared to wives (Jolly et al. 2003). The absence of men seems to have mixed impacts on women. It has led to a breaking down of gendered divisions of labour and the increasing authority of women in decision making (for example, Boserup 1970; for a review, see Pessar and Mahler 2001), but it has also had negative effects. One particularly interesting aspect is that migration sometimes brings about changes in social and cultural practices in the name of a reassertion of 'tradition' and identity. For example, male migrants from Bangladesh to the Middle East have, at times, adopted more orthodox Muslim customs, which resulted in an increase in the seclusion of women in their families (Gardner 1995). The increased purchasing power in Pakistani Punjab as a result of emigration has led to inflated dowries, the withdrawal of daughters from agriculture and an increasing seclusion of women (Donnan and Werbner 1991). These findings enable an interesting comparison with my field observations, as described later.

While most literature on migration and gender focuses on women's experiences of migration, the current discussion of IT and gender

concerns exactly the opposite phenomenon—namely, the lack of women's participation. The question of how to improve women's presence underlines both academic and policy research in India and worldwide (Gayathri and Anthony 2002; Vijayabaskar et al. 2001). Raghuram's (2004) work, one of the very few studies of migrant female IT workers, explains why women are underrepresented in IT by looking at the impacts of mobility. She explores the extent to which the IT industry is structured towards career flexibility and job mobility, and the implications this has for Indian women who seek work in this sector. The requirement of flexibility, and particularly the geographical mobility expected of IT professionals, are identified as major problems faced by women in IT careers.

Existing research on IT and gender, though very different from the literature on migration and gender in other regards, shares with the latter the fundamental approach that emphasises the differences between men and women. For example, researches have stressed the differences between women and men in network formation (Bastida 2001; Davis and Winters 2001), choice of means of migration (Eelens 1995 on Sri Lanka; Sobieszczyk 2000 on Thailand)[2], decision making (Jong and Gordon 2000 on Thailand; Yang and Guo 1999 on China) and remitting behaviour (Tacoli 1999). The questions 'how and why women experience changing social and economic pressures differently from men' (Moore 1988: 95) has dominated most studies. Similarly, in policy discussions, being 'gender sensitive' often means treating men and women differently or separating women and men. A most notable example is the ban on the migration of women under a certain age to certain countries, a policy which has been adopted by most South Asian countries and a number of Southeast Asian countries.

While literature along this line has provided rich material on women's experiences and views on migration, which have otherwise been neglected, it fails to shed sufficient light on the migration systems themselves. In explaining the male–female differences, the literature often points to the overall gender ideology beyond the migration system, and leaves the intersection between migration and gender out of focus. Instead of merely differentiating women from men, this chapter stresses how gender relations, particularly in marriage and the family, actually underline the migration system and processes. The focus on the migration system also enables me to link the situations in the sending and receiving societies, and to explore gender relations pertaining to both those directly involved in the migration process and those not drawn in.

For this purpose, a brief overview of the migration system of Indian IT professionals as part of the global economy is required.

'Body Shopping': A Special Migration System of Indian IT Professionals

In a sense, the Indian IT industry is more a result than a cause of the mobility of a large number of its IT professionals. It is based on the exports of IT services, which made up more than 70 per cent of the total revenue of the IT industry at the end of the 1990s (NASSCOM India 2000). These exports are essentially of labour, mainly IT professionals sent overseas to carry out services. According to one estimate, the Indian IT industry would need to send about 200,000 professionals to the United States alone over the years 2000 to 2005 to sustain its 40–50 per cent growth rate (Ramesh 1999).

There are many reasons for the predominant position of Indians in the global IT labour market, which include their proficiency in English, a relatively advanced higher education system as a result of the Nehruvian development agenda[3], and the connections with IT companies in the West established by earlier migrant professionals. However, a more fundamental reason is that Indians form a cheap and flexible labour force. In the United States, H-1B IT workers are reported to be paid 25 per cent less than the average and are not paid any compensation for overwork (see Bacon 2000). Far more important than the acceptance of low pay is the acceptance of being laid off from time to time. Given the extremely volatile global market in this sector, a highly flexible labour force that can be disposed of at any time is essential for the industry. It was once predicted that in 2001 there would be a labour shortage of 850,000 in the IT sector in the United States (Information Technology Association of America, cited in Steen 2001). However, according to media reports, more than 350,000 high-technology jobs were lost in the first eight months of the year (Dunn 2001) and lay-offs amounted to 600,000 by November (Shiver 2001). While more than 20 countries sent their government or industry delegations to India to recruit IT workers during 1998–2000 (according to the media reports that I have monitored)[4], 50,000 Indian IT professionals in the United States

were reported to be jobless in May 2001 (*The Times*, 2001). How do the Indian IT workers manage this?

Indian IT professionals' flexible labour mobility is managed by a special scheme known as 'body shopping'. Body shopping is the practice whereby a firm ('body shop') recruits IT workers and then farms them out to clients for a particular project, though the firm itself is not involved in the project. A body shop can be based either in India or overseas, but most of them are set up and run by Indians and mainly recruit Indians. Unlike the conventional recruitment agents who *introduce* employees to employers, body shops *manage* workers for employers. Workers managed by body shops do not form formal employment relationships with the employers and thus can be laid off at any time.

The key characteristic of body shops is their 'benching' practice. This means sponsoring a worker to move to a new country without any job opportunity in existence, though the body shop claims otherwise when applying for the sponsorship. Therefore, the workers have to wait 'on the bench' after they arrive. During the bench period, workers are not paid or are given only a nominal 'bench salary'. At the same time, body shops rely on bigger agents to find jobs for the workers. As a result, IT workers are constantly on and off jobs, and often have to move from one firm to another and from one place to another.

Body shops in different countries are associated with each other. They send workers from one place to another when required. By doing so, a flexible labour management system on a global scale is achieved. There were a total of 35 to 60 Indian body shops in Sydney by late 2000, and they managed 1,500 to 2,000 contract workers. In the United States in 2000, it was estimated that there were hundreds of agents specialising in deploying temporary Indian IT workers in northern California and perhaps over a thousand across the country (Lubman 2000).

Women in Body Shopping

It is important to distinguish body shopping from another type of mobility of IT professionals, namely, that where employees of large software service companies are sent overseas to deliver services. Compared to those managed by body shops, the second type of workers at least have stable basic salaries. While Raghuram (2004) has demonstrated

why the second type of mobility is difficult for women, body shopping is thought to be even more typically a non-women business. Women would have particular difficulties in coping with being on the bench. For example, it is common for four or five unemployed men to share one bedroom to save money, and it is simply socially unacceptable for an Indian woman to join them. Unstable jobs may also mean high life risks. In one extreme case, a female Indian worker who went to Australia alone through a body shop—the only case that I was aware of throughout my fieldwork—was raped by one of her fellow Indian IT workers and was harassed for over one year afterwards. Although this was known to a few Indian colleagues, no one supported her. Furthermore, my informants held that it is simply foolish for a young woman to move alone like this, and therefore the event was more a lesson to young women than a crime to be condemned. In order to escape from further trauma, all the woman could do was to move to New Zealand through another body shop.

Indians graduating overseas constitute an important source of body shop recruits, since it is much easier to go through the visa process for a worker with a degree from the destination countries. In Sydney, 10 to 20 per cent of all Indian IT students were estimated to be women.[5] Few of them, however, seem to be willing to join body shopping, unlike many of their male counterparts. A common practice for the female students was to return to India after graduation, marry an Indian in the United States, and then move on as a dependent. In other words, migrating as wives is still preferred to moving as independent professionals.

Although very few women participate in the body shopping scheme directly, wives often play a critical role in setting up body shops. In Sydney all the businesses that I investigated, except for one, are run by men. This does not mean that women are irrelevant to the business. The wives of the majority of those running these businesses work in the public sector and this is a matter of choice rather than coincidence. Krishna, a middle-aged IT professional, had been trying to set up a body shop and other types of IT enterprises. His wife quit her job in a private company and took up a job, despite a lower salary, in the local taxation department when Krishna was planning to set up a business. A secure job in the family was seen as essential. Chaya is an owner of a body shop and his wife works for the New South Wales state government. Chaya said, 'The family needs some money coming in on a regular basis. Otherwise it would be too scary for us.' Another body shop owner pointed to the fact that working in the public sector means having a more structured everyday schedule. While he has to work whenever the business requires, his wife can look after the family.

These wives' contribution is significant because the setting up of new body shops is essential for sustaining the body shopping system as a whole. There are two basic reasons for this. First, IT workers see body shopping as a transitional stage in their careers through which they can become employees of large software companies or entrepreneurs; at the same time, body shop owners are also eager to move up to become proper software company proprietors. Therefore, new body shops are constantly needed to channel new workers into the global market. Second, setting up new body shops is the typical route taken by IT professionals to turn themselves into entrepreneurs, and this vision for the future helps workers put up with the hardship of body shops.

Most body shops try to develop small software projects for clients as part of their strategy to upgrade themselves into software companies in the future. However, given the financial capacity of body shops, it is difficult for them to employ anyone formally. Instead, they often outsource the work to fellow Indian professionals in the community. IT wives, particularly those on H-4 visas who, as dependents of H-1B visa holders, are not allowed to work, are often involved in this ethnic network-based subcontracting, working from home. Existing literature has highlighted women's often invisible contributions to immigrants' businesses, particularly through their unpaid labour (see Baxter and Raw 1988) or through wages earned from the mainstream economy, for example, as factory workers (see Bhachu 1988; Werbner 1988). It seems that, in the immigrant IT business, wives assume very similar roles, though the niche is rather different from that studied in the earlier literature.

Despite the importance of the work done by wives, a working wife is not always culturally desirable. This is reflected in many young Indian IT professionals' migration and family strategies: young, single IT workers often work in Australia for one to two years, return to India to be married, and then move to the United States with their wives. The H-1B visa holders are allowed to bring their spouses to the United States on H-4 visas at any time, while it takes an equivalent visa holder in Australia (457 visa) a minimum of six months. The H-4 visa holders in the United States are not allowed to work, but 457 visa holders' spouses in Australia are. This, however, does not make Australia more attractive. One informant in Sydney compared himself with his brother-in-law in the United States. 'Both my wife and I have to work here. When we come home, I am tired, my wife is tired. In the US, my brother-in-law alone makes more money than the two of us. My sister doesn't *need* to

work. She can look after the family and kids.' He decided to go to the United States where his wife could stay at home.

The wives contribute to the construction and sustaining of the flexibility of the IT labour system, but they also suffer due to it. It has been documented in other migration cases that the pressures the husbands face in the destination countries often contribute to domestic violence against women. For example, Hitchcox (1996) reports that Vietnamese men in detention centres in Hong Kong committed violence against their wives and fellow female migrants because of a sense of powerlessness and inability to fulfil the perceived male role. The situation seems even worse in the IT sector due to the highly uncertain employment situation, where a high education level does not seem to reduce the incidence of minor domestic stresses. Maitri, a San Francisco-based South Asian women's organisation, received over 1,500 calls from H-4 women reporting domestic violence over the year 2000–2001 (Srivastava 2001). H-4 visa holders are deported immediately once they are divorced by spouses. This dependency renders Indian housewives in the United States vulnerable.[6] Some newly married wives of IT workers in Andhra Pradesh are blamed by their in-laws if their husbands lose their jobs in the United States. It is a common belief that the bride is to blame if anything bad happens to her husband or in-laws after marriage.

In sum, women's low participation in body shopping does not mean that they are unrelated to or not important to the system. They are making vital contributions to sustaining the new, extremely volatile global capitalist economy at the micro level, and are paying high prices for that.

Caste, Dowry and IT

The body shopping system is based not only on the willingness of individual IT professionals to accept a low pay and to be 'flexible' in their jobs, but also on resources transferred from the local society of the workers' home country. For instance, Indians can accept uncertain jobs and low salaries because the cost of producing the IT labour force is low in monetary terms. In turn, this is because of the unequal gender relations which makes mothers' and wives' reproductive labour 'free'. For

example, servants, mostly women, are common in India. India has the largest child labour population in the world, and Andhra Pradesh (AP) has the largest in India.[7] All the middle- and small-sized IT companies that I visited in AP hire tea boys to serve tea, buy lunch and mop the floor. It is, therefore, hard to assess whether an 'untouchable' woman cleaner, a young tea boy, a high-caste H-1B man or a white venture capitalist contributes the most to Silicon Valley's glory. Whereas the previous section has described women's experiences with body shopping, I now explore how particular gender relations in India, associated specifically with the institution of dowry, intertwine with the body shopping system.

In order to fully appreciate the relationship between the migration system of IT professionals, gender and dowry, it should be noted that IT professionals' mobility is not only gender specific, but is also shaped by caste relations. The majority of IT professionals from AP are from the Kamma and Reddy castes, the two dominant castes, with a smaller group from the Rajus. Both Kammas and Reddys were cultivating castes and still have close links with rural society. In their rise to a dominant position in the last century, education played a critical role. In the 1920s, Kammas and Reddys were the leading force of the anti-Brahman movement in AP. To break the Brahman monopoly over education, they set up Western-style institutes of their own. Higher education was given more importance after independence, when the perceived link of higher education with both the Brahmans and the British ceased and, at the same time, a large organised sector emerged that required an educated workforce. That the two castes have invested heavily in education and the emergence of IT professionals is, in a sense, a continuation of this.

Kammas and Reddys also offer the highest dowry in AP. This, however, should not be seen as contradictory to their high educational achievements. The institution of modern dowry has been linked to modern education from the very beginning. According to Srinivas (1983), dowry is a new institution in southern India. My interviews also suggested that the custom of dowry in AP has a history of less than 100 years and, in many cases, as little as 30 years. Previously, bride price was the norm for most castes in the south, except in parts of Kerala (ibid.). Srinivas (ibid.: 13) convincingly argued that 'modern dowry is entirely the product of the forces let loose by British rule such as monetisation, education and the introduction of the "organised sector"'. The organised sector, particularly the civil services, was superior yet alien to the unorganised sector, where the overwhelming majority of India's population has been engaged. Modern (English) education,

a prerequisite for entering the organised sector, was expensive, and opportunities to enter the organised sector scarce. In a sense, dowry can be seen as the price paid by wealthy families with daughters to purchase those highly profitable men in whom there has been heavy investment.[8] In the beginning of the 20th century, when Western education was just introduced to India, a man with a bachelor's degree in law in Calcutta University was already demanding a dowry of Rs 10,000 or £700 (Risley 1907, cited in Srinivas 1983: 14). Based on historical material from the Punjab, Oldenburg (2003) demonstrated that, to a large extent, modern dowry in North India owes its roots to the exclusion of women from property rights over land and the 'masculinisation' of the economy, which made men far more economically valuable than women—both results of British colonial rule.

While modernisation and Westernisation were responsible for the establishment of modern dowry, globalisation escalates the practice. An IT groom of the Kamma or Reddy caste, working in a big company, is expected to demand a dowry of Rs 800,000 to Rs 2 million in Hyderabad, more than double that of a non-IT engineer. If the boy is US-based, the figure could go up to US$ 120,000 (Rs 5.5 million). IT stocks were also a popular component of dowry in AP during 1998–2000. A family with a son who was a successful IT professional often attracted the attention or jealousy of the neighbours; first because of the dowry that such families could offer for their daughters, and second on account of the dowries they could demand for their sons.

The association between an IT occupation and high dowries seems to be obvious for the locals: IT men are rich and prestigious, and therefore popular in the marriage market. However, a closer examination reveals that the connections are more complex. Dowry as an institution, particularly when it involves such a large amount of wealth, is closely connected with other institutional arrangements such as education, and bears far-reaching social consequences. The following section aims to disentangle the linkages between the practice of dowry and the IT industry.

The Transnational Marriage Market, Dowry and Status

It is a surprise to many that IT professionals demand high dowries because they expect that highly educated professionals with a Western

exposure would break with this kind of 'tradition'. My fieldwork, however, suggests that education and migration have *not* made people more liberal in the Western cultural sense. Indeed, IT professionals are particularly proud that they can maintain 'Indian culture' and at the same time succeed in the global IT market.[9] This echoes the findings that migrants are sometimes more fanatical than others about what they see as tradition.[10] Among the IT professionals, arranged intra-*jati* marriage remains the norm and a cross-caste love marriage brings suspicion on the entire family and may jeopardise the marriage prospects of siblings. Quite a few of my informants in Sydney volunteered the dowry rates when discussing with me the marriage proposals that they received from home; they saw these rates as a key criterion in processing the bids.

Furthermore, migration tends to escalate rather than undermine the institution of dowry. Migration enlarges the scope of search for a match and makes economic calculations more central to marriage negotiations. Among migrant IT professionals, a marriage match is sought through newspapers, the Internet and marriage bureaus with sophisticated communication facilities. Once the marriage market is disembedded from other social relationships, decisions regarding a match come to rest almost exclusively on economic calculation (though caste and horoscope are still the bottom line criteria); this also contributes to the increase in dowry rates.

The mobility of IT professionals also escalates dowry rates because both dowry and being a mobile IT professional are loaded with tremendous cultural value, related to the notion of *kutumba gowravam* (family prestige [in Telugu]). The anxiety to ensure or, more often, to promote the *kutumba gowravam* impels young male IT workers to attach importance to dowries at their own marriages and also to contribute their incomes to their sisters' dowries. Usually, an IT worker sends money back unconditionally in the first year or so. Subsequently, the remitter may give instructions or require explanations from the family as to how the money was used. Securing good grooms for sisters is a top priority. A common tendency in AP is to marry off the daughters before bringing in daughters-in-law. There are two reasons for this. First, claims of social status and demands of dowry for sons are based on how much dowry a family has offered in a daughter's marriage. Second, marrying away all the daughters means being free from future burdens. This enables the families of potential brides to calculate the groom's family's property accurately and then to offer a 'fair' dowry. Therefore, a family is quite willing to exhaust its capacities to perform

grand marriages for its daughters, and then wait for the sons' dowries to come. As a result, it is common for an IT professional's sister to be married to an IT professional.

The fact that dowry is seen as a key symbol of family prestige and status also explains why women with IT degrees do not necessarily pay less dowry, despite their own potential for high earnings. In AP, female IT professionals are predominantly from the Kamma caste. As mentioned before, this caste also offers and expects the highest dowry in AP, including for IT professional brides. More intriguingly, Kammas are well known for their relatively equitable gender ideology: my informants in Hyderabad told me that female Kammas have full rights of inheritance as daughters. Further, they are said to own the dowry that they bring to their husband's household to the extent that they can take the dowry back in case of divorce and make claims for financial returns if the husband had invested the dowry in any business. Therefore, the high participation in IT of Kamma women is more a reflection of their status within the caste rather than a new means to empower them. At the same time, the high dowry rate associated with them should certainly not be seen as an indicator of their suffering and, as I will show later, it is the lower-caste men and women, who have nothing to do with IT, who in fact suffer the most from this.

Dowry as a Means of Resource Transfer

A fundamental reason for the reinforcement of the institution of dowry through the IT boom is its channelling of local resources to produce an IT labour force for the global market. In the local society high dowry is seen as a direct reward to the groom's parents for their investment in his education. Due to the high costs of private education in IT and medicine, the association between education and dowry is particularly stressed in marriage negotiations for doctors and IT professionals. It is common for the groom's father to list the costs of his son's education in detail to the bride's kin and demand dowry accordingly. Some informants suggested that in 'good families' the groom's parents demand dowry as a conjugal fund for the young couple. However, in most cases the dowry is presented to the parents and the parents decide how the money should be distributed.

There have been some interesting changes in the composition of dowry recently. According to my informants, dowry in northern India consists mainly of gold, cash, furniture and utensils, which is also the case for many low-class families in AP. However, expensive articles and immovable properties have become an increasingly popular component of dowry for the wealthy. In one case a US-based IT groom from the weaving caste received Rs 1.5 million in dowry, including a three-bedroom apartment in Hyderabad worth Rs 500,000, a car worth the same amount, and cash and jewellery. Since the young couple had moved to the United States, the groom's parents were using the apartment and the car. This is an ideal reconciliation between dowry as a conjugal fund and dowry as returns on the investment in the next generation: the boy's parents enjoyed the dowry, but without making it their own or consuming it, unlike the case with cash or gold.

Dowry is also used to sponsor IT study and/or emigration. In small towns and villages a 'forward business' or 'futures market' pattern of dowry payment, which has been common for physicians, has now spread to IT professionals. A girl's father may offer to pay the college fees or the costs of going abroad for a boy on the condition that the boy later marry his daughter. The engagement may be used as the occasion to publicise the deal in the community. In some cases, a civil marriage is registered before the groom leaves for overseas, financially assisted by the bride's family. The girl starts applying for a dependent visa (which usually takes six months for Australia), during which time the boy is supposed to find a job and settle down. The groom then returns for the religious wedding and takes his wife back with him. Study and/or emigration have become for some men the new excuse to demand additional dowry after marriage.[11] One man complained to me that he would have gone to the United States a long time ago had his in-laws been more generous.

However, dowry does not always ensure favourable outcomes for men. Narendra, a young Telugu IT worker, went to Sydney through a body shop in early 2001, with the would-be in-laws paying for his ticket. He could not find a job for five months. His future in-laws urged his family to finalise the marriage and his family pushed him. He could not tell them the truth, nor could he go ahead with the marriage without a job and the money to buy gifts from Australia. This was a fairly common predicament that young IT workers faced during the dramatic IT market downturn. Vijay Naidu, a civil engineer from Chittoor, south-east AP, received a dowry worth

Rs 710,000 when he married in 1998. His father-in-law and elder brother-in-law urged him to shift to IT and go overseas. Vijay quit his job to take IT courses full-time. His wife brought in Rs 50,000 from her brothers to support him, but he still could not go abroad after two years. He told me that he was suffering from 'chronic mental torture': 'Every time I visit them, all the aunts, uncles, brothers-in-law ask: why are you still here? When will you go? I have to lie; my wife has to lie.' He was glad for the slowdown in the USA, which gave him a legitimate reason for being home.

The institution of dowry is associated with the ideology of hypergamy, which also encompasses a hierarchy of locations. Men are far more likely to migrate to the city or the West than women, and men's parents normally prefer rural/Indian brides. A girl from a rich village family marrying an educated boy in the city or an India-based girl marrying a boy abroad are the most common patterns. On the bride's part, this is upward mobility and a high dowry is thought worthwhile. In these cases dowry serves as a direct means to transfer surplus value from the unorganised sector to the organised, from the rural to the urban, and from the local to the global.

In sum, the institution of dowry and the asymmetrical gender relations associated with it have not only made the production of male IT professionals for the global market financially feasible and culturally meaningful, but have also pressurised IT professionals to participate in body shopping so as to emigrate. The dowries paid to India-based body shops directly subsidise the latter and the supply of IT labour in the international market.

Competition in Dowry

Although the number of mobile IT professionals is very limited and most of them are from the high castes, the effects of rising dowry among them go far beyond this group. Over the last few years, lower-caste and middle-class, and in some cases Scheduled Caste and Scheduled Tribe, families experienced the most rapid increase in dowry, far more than the upper castes and classes. This seems to support the perception that it is 'cheap' families who turn dowry into an evil because they make continuous demands. However, the demands of 'cheap' families are

linked to the voluntary offerings of 'good' families, links which can be specified in three ways.

First, Srinivas (1983) has identified the emulation of higher castes by lower castes as the main mechanism by which dowry became a common practice in an earlier period. Second, the competition between castes of similar ranking increases dowry rates. There has been a strong anti-Kamma sentiment in AP since the 1980s, particularly among the Kapus and Reddys. Sravan Kana Reddy, a college IT lecturer, remarked:

> If I have Rs 100, I will buy one bottle of grade A wine, not four bottles of grade B. What will the Kammas do? If there are guests around, they will buy grade B. When they drink alone, they buy grade A. They don't want to share! They give high dowry, so what? All the dowry is in the wife's name. Even her husband cannot touch one paisa! . . . We are poor. But we try all we can to perform good marriages, give good dowries. The dowry is shared by everyone [of the husband's family].

This statement, of course, also supports the view that Kamma women have a greater control over their dowries.

Third, far more important than the emulation and competition between castes is the competition within a caste. Co-caste neighbours form an important reference group in villages and small towns. K.R.R. Chowdary, a middle-aged man well connected with local politicians and working as public relations manager for a medium-sized IT firm in Hyderabad, called it 'group psychology':

> If a family has no IT people, they will fight. Because the 'side house fellows' have everything, you don't! The wife will fight with the husband. The parents will fight with the sons. Force them to do IT.

Dowry is the focus of competition within a caste. Local AP society is generally very secretive with regard to money matters, but the amount of dowry paid or received is quickly made common knowledge.

An appalling case of the spiralling effect of dowry emerged during my fieldwork. There have been a few professionals, including IT workers, from among the Lambada tribe. Despite the poverty of most of the tribe, a dowry of Rs 40,000 to 50,000 is common, and it can sometimes go up to Rs 100,000. Lambada women form a large percentage of sex workers in AP. They earn money to marry themselves off. Some men take the

dowry, marry them, and subsequently abandon them with their children on the grounds that they were prostitutes. The man may move on to marry another woman with another dowry.

While the rich offer dowry in the 'futures market' pattern, the poor pay dowry in instalments. The girl's father pleads that the man take his daughter with part of the dowry, and promises to pay the rest after the marriage. Failure to pay the instalment is a main cause of dowry torture and death. Five hundred dowry deaths were registered in AP in 1998 (AP Directorate of Economics and Statistics 1999: Table 24.4). A quick browse through local newspapers suggests that dowry-related torture is literally a daily issue. This has become such a concern that some activists have proposed setting up a permanent court specifically for dowry cases (*Deccan Chronicle* 1999). Thus, while those directly involved in IT suffered from the stress brought about by economic uncertainty, the lower castes and classes, also drawn into the competition in dowry, seemed to face a more certain fate: things are unlikely to become better.

Conclusion

Most of the literature on gender and migration has focused on how women experience migration differently from men, taking the migration system that shapes their experiences as given. This chapter examines how a migration system is constructed and sustained through certain gender relations. Specifically, the chapter shows how married women's work ensures household financial security to make the body shopping scheme sustainable in a highly volatile market. It draws out how the institution of dowry accords special cultural value to being an IT professional and channels material resources for producing the IT labour force. The intersection of the migration system and gender is thus part of the interaction between the global economy and local social change. The chapter also questions the approach that focuses on male–female differences on the grounds that both 'men' and 'women' are highly heterogeneous categories, and gender relations always intertwine with other institutional relations such as class and caste.

IT has been the key showcase for the advocates of a liberalised India in a globalised world. This chapter points to some of its dark aspects and to the dangers of neglecting the negative implications. An approach

which ignores the latter is unsustainable, as demonstrated by the Indian electorate in the 2004 general elections. Clearly, a more balanced development agenda is called for. This is all the more crucial now, even as it is more difficult to achieve, for, in this period of globalisation, social stratification is increasingly taking place on a transnational scale.

Notes

1 Indeed, the migration of Indian IT professionals has been on such a large scale and so male-dominated that I was told that in San Francisco some local female IT workers complained about sex discrimination by their Indian colleagues, particularly because of their late age at marriage.

2 For example, migration through specialised agents or personal networks.

3 Immediately after India's independence, Nehru put tertiary education high on India's development agenda and devoted considerable resources to it. The number of universities in India increased from 37 in 1950 to 129 in 1975, and engineering colleges increased from 58 to 179 over the same period (Krishna and Khadria 1997: 351, Table 2). In the year 1970 alone, India granted about 120,000 degrees in science and engineering (ibid.: 352, Table 3). Modelled on the MIT in the US, seven elite Indian Institutes of Technology (IITs) were set up in different cities from 1950. IIT graduates became a major source for skilled migrants at later stages.

4 The main media sources that I have been monitoring for this research include *The Times of India*, *Computer Today* (an India-based magazine) and *Sydney Morning Herald*. The mailing lists that are run by the Centre for Immigration Studies (CISNEWS) and by Professor Norm Metloff ('age discrimination/H-1B e-newsletter') also provide comprehensive leads to relevant media reports. The Website of the IndUS Entrepreneurs (TIE; http://www.tie.org) hosts digests of news reports related to the Indian IT industry and IT professionals.

5 According to interviews with students, student recruitment agencies and university staff responsible for international recruitment.

6 See Abraham, this volume, for further discussions on the issue of domestic violence among Indian migrants in relation to visa regulations.

7 One quarter of the children aged between 5 and 14 in AP fall within the global definition of child labour (UNICEF 2001, cited in Dasu Kesava Rao 2001). The International Labour Organisation estimated the population of child labour in AP to be 1.66 million (*Deccan Chronicle* 2001).

8 Srinivas saw the institution of dowry as part of the process of 'secularisation' rather than 'Sanskritisation'. He noted:

> Another evidence of increased secularisation is the enormous importance assumed by the institution of dowry in the last few decades. Dowry is paid not only among Mysore and other South Indian Brahmins, but also among a number of high-caste groups all over India. The huge sums demanded as dowry prompted the

Indian Parliament, in 1961, to pass the Dowry Prohibition Act (Act 28 of 1961). (1967: 126)

9 The fact that new IT migrants tend to be more 'traditional' may be attributed to their pre-migration background. Rajagopal (2000) explores the association between the Vishwa Hindu Parishad (VHP, the World Hindu Council) and the Hindu Swayamsevak Sangh (HSS, Hindu Volunteers' Corps) movements in the United States on one hand and the increase of Indian migrant IT professionals on the other. He pointed out that IT professionals were mainly from small and middle-sized towns and tend to be more religious compared to the earlier migrants who were from elite, metropolitan families.

10 For example, in Pakistan Punjab, where husbands migrated to the Gulf states in the 1970s and 1980s, the observance of *purdah* has increased, probably as a marker of higher social status. Forms of *purdah* never before seen in Pakistan, including Saudi and Iranian style veils, are now visible in the urban areas (see Balchin 1996).

11 The husband's demands for dowry could go on throughout the marriage. The husband could raise the demand any time, particularly when the wife visits her natal family on occasions such as *rakshabandhan* (brother–sister festival in early August, when the brother–sister relationship is ritually affirmed) or *grihapravesh* (Hindu house-entering ceremony, which is mainly performed by sisters when the brother moves to a new house).

References

AP Directorate of Economics and Statistics. 1999. 'Incidence of Major Cognisable Crimes (IPC) under Different Heads, Districtwise, 1998', in *Statistical Abstract of Andhra Pradesh, 1999*. Hyderabad: AP Directorate of Economics and Statistics.

AP Finance and Planning Department. 1999. *Information Technology Policy of the Government of Andhra Pradesh*. Hyderabad: AP Finance and Planning Department.

Asis, M.M.B. 2001. 'The Return Migration of Filipino Women Migrants: Home, but Not for Good?', in Christina Wille and Basia Passl (eds), *Female Labour Migration in South-East Asia: Change and Continuity*, pp. 23–93. Bangkok: Asian Research Centre for Migration.

Bacon, D. 2000. 'Contract Labor Program by Any Name Hurts all Workers', *Asian Week*, 4–10 August.

Balchin, C. 1996. *Women, Law and Society: An Action Manual for NGOs* (Women Living Under Muslim Laws, Women and Law, Pakistan Country Project). Lahore: Shirkat Gah.

Bastida, E. 2001. 'Kinship Ties of Mexican Migrant Women on the United States/Mexico Border', *Journal of Comparative Family Studies*, 32 (4): 549–70.

Battistella, G. and A. Paganoni (eds). 1996. *Asian Women in Migration*. Quezon City: Scalabrini Migration Centre.

Baxter, S. and G. Raw. 1988. 'Fast Food, Fettered Work: Chinese Women in the Ethnic Catering Industry', in S. Westwood and P. Bhachu (eds), *Enterprising Women: Ethnicity, Economy, and Gender Relations*, pp. 58–75. London: Routledge.

Bhachu, P. 1988. 'Apni Marzi Kardhi: Home and Work—Sikh Women in Britain', in S. Westwood and P. Bhachu (eds), *Enterprising Women: Ethnicity, Economy, and Gender Relations*, pp. 76–102. London: Routledge.

Boserup, E. 1970. *Women's Role in Economic Development*. London: Allen and Unwin.

Brennan, D. 2001. 'Tourism in Transnational Places: Dominican Sex Workers and German Sex Tourists Imagine One Another', *Identities*, 7 (4): 621–63.

Chin, C.B. 1998. *In Service and Servitude: Foreign Female Domestic Workers and the Malaysian 'Modernity' Project*. New York: Columbia University Press.

Clarke, J. and J. Salt. 2003. 'Work Permits and Foreign Labour in the UK: A Statistical Review', *Labour Market Trends*, 111 (11): 563–74.

Constable, N. 1997. *Maid to Order in Hong Kong: Stories of Filipina Workers*. Ithaca: Cornell University Press.

Dasu Kesava Rao. 2001. 'UNICEF Sees Many Grey Areas in AP's Social Development', *Newtimes*, 1 August: 4.

Davis, S. and P. Winters. 2001. 'Gender, Networks and Mexico–US Migration', *Journal of Development Studies*, 38 (2): 1–26.

Deccan Chronicle. 1999. 'Women March against Dowry', 9 December: 5.

———. 2001. 'Little Victims', 27 August: 27.

Dinan, K. 2002. 'Trafficking in Women from Thailand to Japan: The Role of Organised Crime and Governmental Response', *Harvard Asia Quarterly*, 6 (3): 4–13.

Donnan, H. and P. Werbner (eds). 1991. *Economy and Culture in Pakistan: Migrants and Cities in a Muslim Society*. London: Macmillan.

Dunn, L. 2001. 'Landscape Shifts for Laid-off Foreigners', *CBS Marketwatch*, 31 August, http://www.marketwatch.com/, accessed on 27 May 2005.

Eelens, F. 1995. 'Migration of Sri Lanka Women to Western Asia', in *International Migration Policies and the Status of Female Migrants* (Proceedings of the Expert Group Meeting on International Migration Policies and the Status of Female Migrants, San Miniato, Italy, 28–31 March 1990). New York: United Nations.

Emerton, R. and C. Petersen. 2003. 'Migrant Nightclub/Escort Workers in Hong Kong: An Analysis of Possible Human Rights Violations'. Occasional Paper 8, Hong Kong University Centre for Comparative and Public Law, Hong Kong.

Fawcett, J.T., S. Khoo and P.C. Smith. 1984. *Women in the Cities of Asia: Migration and Urban Adaptation*. Boulder: Westview Press.

Gardner, K. 1995. *Global Migrants, Local Lives: Travel and Transformation in Rural Bangladesh*. Oxford: Clarendon Press.

Gayathri, V. and P. Anthony. 2002. 'Ricocheting Gender Equations: Women and ICT Careers'. Paper presented at the International Seminar on ICTs and Indian Development: Processes, Prognoses and Policies, Delhi, 9–11 December.

Gibson, K., L. Law and D. McKay. 2001. 'Beyond Heroes and Victims: Filipina Contract Migrants, Economic Activism and Class Transformations', *International Feminist Journal of Politics*, 3 (3): 365–86.

Heyzer, N., G.L. Nieholt and N. Weerakoon (eds). 1994. *The Trade in Domestic Workers: Causes, Mechanisms and Consequences of International Migration*. Kuala Lumpur, London and New Jersey: Asian and Pacific Development Centre and Zed Books.

Hitchcox, L. 1996. 'Vietnamese Refugees in Hong Kong: Behaviour and Control', in G. Bujis (ed.), *Migrant Women: Crossing Boundaries and Changing Identities*, pp. 145–60. Oxford and Washington DC: Berg.

Jolly, S., E. Bell and L. Narayanaswamy. 2003. 'Gender and Migration in Asia: Overview and Annotated Bibliography'. Report presented at the Regional Conference on Migration, Development and Pro-Poor Policy Choices in Asia, jointly organised by the Refugee and Migratory Movements Research Unit, Bangladesh, and the Department for International Development, UK, Dhaka, 22–24 June.

Jong, D. and F. Gordon. 2000. 'Expectations, Gender and Norms in Migration Decision Making', *Population Studies*, 54 (3): 307–19.

Krishna, V.V. and B. Khadria. 1997. 'Phasing Scientific Migration in the Context of Brain Gain and Brain Drain in India', *Science, Technology & Society*, 2 (2): 348–85.

Lubman, S. 2000. 'Labor Contractor of all Stripes Abound in Bay Area and the Nation', *Mercury News*, 19 November.

Moore, H. 1988. *Anthropology and Feminism*. Cambridge: Polity Press.

Morokvasic, M. 1983. 'Women in Migration: Beyond the Reductionist Outlook', in A. Phizacklea (ed.), *One Way Ticket: Migration and Female Labour*, pp. 13–31. London: Routledge and Kegan Paul.

———. 1985. 'Birds of Passage are also Women', *International Migration Review*, 18 (4): 886–907.

National Association of Software and Service Companies (NASSCOM), India. 2000. 'IT Software & Services Industry in India Grows by 53% in 1999–2000', http://www.nasscom.org/template/itinindia.htm, accessed in September 2002.

Oldenburg, V.T. 2003. *Dowry Murder: The Imperial Origins of a Cultural Crime*. New Delhi: Oxford University Press.

Parrenas, R. 2001. *Servants of Globalization: Women, Migration and Domestic Work*. Stanford: Stanford University Press.

Pessar, P.R. and S.J. Mahler. 2001. 'Gender and Transnational Migration'. Paper presented at the conference on Transnational Migration: Comparative Perspectives. Princeton University, 30 June–1 July.

Raghuram, P. 2004. 'Migration, Gender and the IT Sector: Intersecting Debates', *Women's Studies International Forum*, 27 (2): 163–76.

Rajagopal, A. 2000. 'Hindu Nationalism in the US: Changing Configurations of Political Practice', *Ethnic and Racial Studies*, 23 (3): 467–96.

Ramesh, J. 1999. '"Yankee Go Home, but Take Me with You": Yet Another Perspective on Indo-American Relations', *Economic and Political Weekly*, 34 (50): 3532–44.

Risley, H.H. 1907. 'Letter to the Editor', *The Times* (London), 27 September.

Seol, D.H. et al. 2003. *The Current Situation of Migrant Women Employed in the Sex and Entertainment Sector of Korea*. Seoul: Ministry of Gender Equality, Government of Korea.

Shiver, J. 2001. 'US Tech Firms Abusing Visa Program, Critics Say', *Los Angeles Times*, 21 November.

Sobieszczyk, T. 2000. 'Pathways Abroad: Gender and International Migration Recruitment Choices in Northern Thailand', *Asian and Pacific Migration Journal*, 9 (4): 391–428.

Srinivas, M.N. 1967. *Social Change in Modern India*. Berkeley: University of California Press.

———. 1983. *Some Reflections on Dowry*. New Delhi: Oxford University Press, for The Centre for Women's Development Studies.

Srivastava, R. 2001. 'H4 Visa Leaves Many Indian Women Dependent on Abusive Husbands', *Times of India*, 22 July: 9.

Srobanek, S., N. Boonpakdee and C. Jantateero. 1997. *The Traffic in Women: Human Realities of the International Sex Trade*. London: Zed Books.

Steen, M. 2001. 'Demand for IT Workers is Down 44 Per Cent', *San Jose Mercury News*, 2 April.

Tacoli, C. 1999. 'International Migration and the Restructuring of Gender Asymmetrics: Continuity and Change among Filipino Labour Migrants in Rome', *International Migration Review*, 33 (3): 658–82.

Taylor, J.S. 2001. 'Dollars are a Girl's Best Friend? Female Tourists' Sexual Behaviour in the Caribbean', *Sociology*, 35 (3): 749–64.

The Times (UK). 2001. 'Americans Pull the Plug on Indian Computer Whizkids', 15 May.

Toyota, M. (forthcoming). 'Consuming Images: Japanese Female Tourists in Bali', in K. Meethan, A. Anderson and S. Miles (eds), *Narratives of Places and Self: Consumption and Representation in Tourism*. Wallingford: CAB International.

Truong Thanh-Dan. 1996. 'Gender, International Migration and Social Reproduction: Implications for Theory, Policy, Research and Networking', *Asian and Pacific Migration Journal*, 5 (1): 27–42.

US Citizenship and Immigration Services. 2003. *Yearbook of Immigration Statistics 2002*. Washington DC: US Citizenship and Immigration Services.

Vijayabaskar, M., Sandra Rothboech and V. Gayathri. 2001. 'Labour in the New Economy: Case of the Indian Software Industry', *Indian Journal of Labour Economics*, 44 (1): 39–54.

Werbner, P. 1988. 'Taking and Giving: Working Women and Female Bonds in a Pakistani Immigrant Neighbourhood', in S. Westwood and P. Bhachu (eds), *Enterprising Women: Ethnicity, Economy, and Gender Relations*, pp. 177–202. London: Routledge.

Yang, X.S. and F. Guo. 1999. 'Gender Differences in Determinants of Temporary Labour Migration in China: A Multilevel Analysis', *International Migration Review*, 33 (4): 929–53.

Yeoh, B., S. Huang and J. Gonzales. 1999. 'Migrant Female Domestic Helpers: Debating the Economic, Social and Political Impacts in Singapore', *International Migration Review*, 33 (1): 114–36.

Youssef, N.H., M. Buvinic and A. Kudat. 1979. *Women in Migration: A Third World Focus*. Washington DC: International Centre for Research on Women.

SECTION V
THE STRAINS OF MARRIAGE MIGRATION

10

VULNERABLE BRIDES AND TRANSNATIONAL GHAR DAMADS: GENDER, RISK AND 'ADJUSTMENT' AMONG PAKISTANI MARRIAGE MIGRANTS TO BRITAIN

Katharine Charsley

According to the 2001 Census, Britain is now home to 747,285 people who describe their ethnic group as 'Pakistani'. A large proportion of these are the British-born children and grandchildren of labour migrants from Pakistan, who responded to the need for industrial workers to rebuild the British economy in the years following Second World War. After the immigration reforms of 1962 restricted the right of Commonwealth citizens to move to Britain, family reunification became the primary means for continued immigration from Pakistan, encouraging men to bring their wives and children to join them in Britain. As the years passed and children were born and brought up in Britain, it was suggested that families 'may tend to select a spouse [for their British-born children] from among kin in Britain rather than in Pakistan, on the basis of economic interests, equality of status and the compatibility of spouses' and that, for the same reasons, immigrant Pakistanis might increasingly marry non-relatives in Britain (Shaw 1988: 107). Contrary to this expectation, rates of transnational marriage have increased and the majority of British Pakistanis now probably marry transnationally, with over 10,000 Pakistani nationals granted entry clearance to join their spouses in the UK in the year 2000.[1]

Until recent changes in British immigration regulations,[2] the majority of these migrant spouses were women, conforming to Pakistani traditions of virilocal residence. Since 1997, however, both the

numbers of Pakistani husbands applying and the proportion being accepted for entry into Britain have increased. In recent years there have been almost equal numbers of male and female spousal migrants.[3] This new phenomenon of large-scale male marriage migration has implications for our understanding of the gendered nature of Pakistani marriage migration. It highlights both indigenous models of the relationship between gender, marriage and migration, and the potential for new permutations of these constituent parts to throw up novel challenges. Based on 18 months of fieldwork in the Pakistani Punjab and with largely Punjabi Pakistanis in the English city of Bristol, this article explores the highly gendered character of risks to migrant spouses in transnational marriages.

Potential difficulties facing South Asian brides have been documented both within the subcontinent (for example, Jeffery and Jeffery 1996) and in the UK (see Fenton and Sadiq 1993). Both my informants and the literature stress the risks faced by women in marriage. Brides conventionally move to their husbands' homes—for Punjabis 'womanhood implies travel' (Bradby 2000)—and so are thought vulnerable to mistreatment. Transnational marriage dramatically increases the distance between a woman's natal and marital homes, heightening the dangers that stem from this distance. Little attention, however, has been paid to the experiences of the increasing number of Pakistani male marriage migrants, some of whom find adjusting to life in Britain difficult.[4] In part, this reflects a paucity of studies of South Asian masculinities in general. As Chopra et al. (2004: 2–3) note:

> In comparison to the multiplicities of femininity in South Asian studies, men emerge in a lesser and often two-dimensional range. Commonly they are householders; sometimes priests or renouncers; workers—be they landlord-farmers or landless labourers; patrons or clients—and almost always everywhere 'patriarchs'. Too often men become mere ciphers . . . brothers-in-law who exchange women in order to maintain relationships whose affective or gendered content is rarely written about.

 Gender is, as has long been noted, a relational concept. Masculinity and femininity 'have meaning in relation to each other, as a social demarcation and a cultural opposition' (Connell 1995: 44). Not only are ideas of feminine or masculine at least partly defined with reference to the other, but men play important roles in women's lives, and vice versa. A gendered approach to marriage migration must, therefore, include

both men and women. After outlining reasons for the popularity of transnational marriage among my informants in Britain and gendered models of marriage and migration, the chapter will examine the dangers facing some migrant brides in Britain before turning to explore masculine experiences of marriage migration. For some immigrant men, social and economic processes of migration combine with features of Pakistani kinship and masculinity to produce frustrations, which can lead to tensions within the marriage and, indeed, the wider family. Although they have not themselves migrated, British Pakistani women with transnational marriages are shown to be multiply influenced by migration, as both wives and daughters, or sometimes granddaughters, of migrants.

Close Kin Marriage and the Diaspora

The majority of these transnational marriages are between kin, often first or second cousins. A recent survey of Pakistanis in the English city of Oxford found that 59 per cent of marriages were between first cousins and 87 per cent within the *barādarī/zāt*.[5] These figures are substantially higher than those reported either for Pakistan or for the parental generation in Britain. Moreover, 71 per cent of the marriages surveyed were to spouses from Pakistan, while 90 per cent of the first cousin marriages were transnational in this way (Shaw 2001: 323–27). These data suggest a marked increase over time in the numbers of consanguineous and, in particular, first cousin marriage amongst British Pakistanis (see Shaw 2000). Significantly, however, this increase has only been in transnational marriages—less than half of the marriages to spouses in the UK were to relatives. It seems then that transnational close kin marriage has become particularly prevalent among diasporic Pakistanis in Britain.

This observation lends support to Donnan's (1988) argument that marriage rules or preferences alone are not a sufficient explanation for marital choices, which also entail purposive strategies (Bourdieu 1977). While requests from close kin may be hard to ignore, decisions are made by weighing the social implications of neglecting these expectations against other priorities, including strengthening kin ties, making new connections or having a wealthy or beautiful spouse (Donnan

1988: 119–97). With the addition of considerations stemming from international migration, this strategic perspective has been a pervasive one in the study of British Pakistani marriages. For Alison Shaw (2001), socio-economic interests in Britain are balanced against opportunities for financial connections in Pakistan, the public demonstration of *barādarī* solidarity, obligations to kin and the opportunity to facilitate a relative's migration to Britain. Roger Ballard (1987: 27) writes that parents who reject these obligations 'are likely to be charged with having become so anglicised that they have forgotten their most fundamental duties towards their kin'.

One of the stock answers an ethnographer receives in Pakistan when enquiring about the reasons for close kin marriages is that they are arranged so as to prevent fragmentation of family assets, and the opportunity of migration can be viewed as one such asset. However, for parents in Britain, often separated from siblings by their own migration decades earlier, the ability of kin marriage to strengthen bonds between relatives may present itself as an opportunity as much as an obligation. As I have argued at greater length elsewhere, strategic considerations alone are not sufficient to explain the popularity of transnational close kin marriages among British Pakistanis (Charsley 2003).

In addition to a heartfelt desire to maintain bonds with close relatives in Pakistan, an important set of considerations stem from parents' concern to ensure their children's future happiness. Arranging a marriage is an emotionally risky business, and the wedding of a daughter is considered particularly difficult. Marriage to a close relative is held to reduce the risks marriage poses to women in a number of ways. Parents hope that mutual kin will provide reliable referees in assessing the character and background of a potential match. Characteristics are also thought to run in families, so marriage to a close relative should increase the similarities and therefore compatibility between the couple (Fischer and Lyon 2000).[6] Moreover, if there are problems in a marriage, a network of shared kin is thought to act to prevent marital breakdown, both by supporting the couple and by exerting pressure against divorce.[7]

The perceived security and trust inherent in close kin marriage are particularly valued in the context of transnational marriage, where the incentive of migration may lead to worries that the Pakistani 'side' are entering into the arrangement simply for economic gain, and where distance may help conceal problems until after the marriage (issues considered in greater detail later).[8] Moreover, Pakistanis in Bristol are often wary of matches with other British Pakistanis for fear that they will

have been contaminated by what they view as the amoral climate of the West. A spouse from Pakistan may be thought to be more religious or more traditional in ways that will benefit the marriage and prevent the loss of such traits in the next generation through two similarly 'modern' or religiously lax British-raised parents. This situation, in which either a husband or wife brought up in Pakistan may be viewed as a primary repository of religious or cultural identity in the diasporic context, provides an interesting contrast to the more usual accounts of women as bearers of community (Jeffery and Basu 1998). For many British Pakistani men there is a conceptual opposition between the archetypal British Pakistani girl who wants to go out all the time, may be loud and argumentative, 'does fashion' and might have indulged in immoral activities, and a quiet, cooperative, sheltered, religious Pakistani girl who will make a good mother. Equally, however, women may speak of local Pakistani men's shortcomings in religious commitment, moral standards or work ethic—'not marriage material' as one woman put it—and may hope to find a better prospect in Pakistan. Some contest the authenticity of subcontinental versions of Islam (see the couple debating women's role in marriage later), or argue that transnational couples will have too many cultural dissimilarities for a successful marriage. However, it seems that for most, these concerns are outweighed by the perceived benefits of such marriages. In this, transnationalism and close kin marriage may be mutually reinforcing. The hazards involved in transnational marriage, and the danger that British-raised young people may have developed unacceptable behaviour, intensify the need for security, leading many to cling to what is perceived to be the security provided by close kin marriage.

Risks for Migrant Brides

Issues of trust and risk also feature in intranational arrangements. Jeffery and Jeffery (1996: 98–99), writing of North India, for example, report a case in which the young woman who arrived as the bride was not the same as the one who had been originally 'viewed'. Even the reliability of mutual kin as referees may be undermined by their fears of being held responsible for problems arising from revealing defects. Transnational marriage introduces an additional distance and, therefore, additional

risk. Even between close kin, for example, the distance between the two countries may increase the chances of concealing premarital relationships or other undesirable behaviour or traits potentially damaging to reputation and marriage prospects. When marriages span continents, the ability of families even to visit potential matches is curtailed. This section will examine instances where the families of young women from Pakistan were misled about the character, and in one case the physical health, of husbands based in Britain. Some of these deceptions may be carried out in hope—parents may believe the marriage will be successful and redeem their son's defects—but the failure of this optimism to be realised can leave migrant wives in very difficult situations.

Pakistani families are intensely concerned about the fate of daughters after marriage. Their fears can be increased when the daughter is marrying overseas into an environment that, although perceived to offer a 'better life' in material terms, most believe to be morally decadent and corrupt. Not only are American films increasingly available through the proliferation of new media, but Western pornographic sites are often visited by the predominantly male clients of the Internet cafés that have sprung up in every town.[9] Also prevalent in Pakistan is the pervasive rhetoric found across the Muslim world in which 'the West' is held to be opposite in every way to decent Islamic values. So when Nabila's mother's sister's son in Bristol proposed marriage, she and her mother were very worried about the prospect of her coming to live in that *mahaul* (environment). It is not that they do not trust the 'British-born', she said, but they know they are independent—'they don't want to stay in'. Not having seen the young man since he was in Pakistan 10 years before, her mother worried that he might have a girlfriend in the 'free environment' she had seen in films.

Nabila is now evidently very happy with her husband, but a few women do indeed arrive in Britain to find that their new husbands have other relationships or even pre-existing families. When I first met Tasneem, for example, she invited me to the sparsely furnished terraced home where she lived with her toddler son, while her husband lived with his white English partner and their children. She told me that all she did was cry. Several years later, she claims to have hope that her husband might still return to her. She insists that he liked her when they married, pointing to the existence of her son as evidence that he had been pleased with the match. In any case, her local kin—her husband's family—are against the idea of a divorce.

My suspicion is that some of these cases are concealed forms of males forced into marriage, when a young man's behaviour, such as having a girlfriend or using drugs, is worrying his parents. They are married to a Pakistani woman in the hope that this will bring them back on the desired path. The corrective power of marriage to someone from a less 'corrupt' society is certainly given as a normal justification for forcing young women to marry (see Samad and Eade 2002). Anecdotal information supports the suggestion of similar motivations for male and female forced marriages (ibid.: 56). I was told of one family who got their son married in Pakistan in an unsuccessful attempt to put an end to his drug-taking lifestyle. Another man said his brother was forced to marry a cousin in Pakistan, but left home as soon as his wife came to the UK. The option to resist such compulsion by refusing to consummate the union is probably more readily available to men than to women (Das 1973: 34), but it may be that many women decide that the easiest path is to go along with the wedding and the immigration application, in the knowledge that, unlike most women in forced marriages, they may be able to carry on with their chosen lifestyle after their spouse has come to Britain.

Other men who turn out to be very different from the image portrayed of them may have been very much in favour of the marriage. Hafza, for example, told me how her cousin (patrilineal cousin's son) from England had visited Pakistan. He had liked her and told his family that he wanted to marry her. After arriving in Britain, however, she found him very different from her previous impression. He and his friends drank heavily, moving on to using drugs in the house while she sat frightened upstairs. He abused her verbally and physically, and said that if she told anyone she would be sent back to her parents in Pakistan. She hoped that things would improve once they had children, but the beatings became worse after her son was born. Unaware of her legal rights, she withdrew several statements to the police for fear that she would be deported and lose her children. In perhaps the most extreme case of concealment I came across, one family from Pakistan did not find out until the day after their daughter's wedding that the man settled in England whom she had married was physically handicapped, unable to work and requiring constant attention. This marriage was *bahar se* (outside the kin group), however, and it is unlikely that such a severe problem could have been hidden from family members.[10]

These examples, of course, represent a minority of marriages, but such women are in an extremely difficult position. Some migrant wives

with marital problems had not told their parents of their situation despite distress and loneliness, often compounded by the lack of language skill and local support networks. Women may wish to protect their parents from worry (Jeffery 2001) and Hafza did not tell anyone about the abuse she was suffering for several years for fear of being sent back to her parents in Pakistan, a blow to their honour. In cases of marital breakdown, suspicion of blame often falls on the woman, and remarriage is generally harder for women than for men (ibid.). Moreover, as the nature of close kin is held to be similar, the failure of a woman's marriage may cast doubts on the character of other siblings, potentially damaging any unmarried sisters' chances of securing a good match. Hafza eventually did tell her parents about what she had been through, and in time they agreed to a divorce, but she is resigned to a life alone with her children in Britain. Even if remarriage was possible, she said, she would not want to take the risk again. Life for divorced women may, however, at least be easier in financial terms in Britain than in Pakistan, thanks to the provision of state benefits.

The crucial role of marriage in shaping women's lives is reflected in the value placed on women's ability to 'adjust' to maximise the chances of their marriage's success. In her study of Indian working women, Promilla Kapur (1970: 21) defines 'marital adjustment' as 'that state of accommodation in marital relationships . . . characterised by a tendency in spouses to resolve or solve conflicts and by an overall feeling of happiness and satisfaction with marriage and with one another'. My informants in Pakistan use 'adjustment' in the former, processual sense of adjusting, rather than to mean the state of contented matrimony. Moreover, the concept is highly gendered as women, conventionally the ones to enter a new situation after marriage and with more to lose through marital breakdown, are expected to be the most adaptable: 'to adjust, tolerate, and sacrifice her personal interests for the happiness of the family' (Kapur 1970: 293; see also Singh and Uberoi 1994). Hence, Pakistani girls are prepared from a young age for marriage. In Bristol I heard a girl of 10 corrected by an older sister when play-acting the role of teacher—she wouldn't be Miss 'maiden name', she would have whatever her husband's name might be. Girls are taught not to get too attached to pre-marriage ways of life, because once they arrive in their husband's home they will have to adjust and adopt their in-laws' patterns. As one engaged 19-year-old woman in Bristol put it, girls are told, 'When you go to a household, you adjust totally with what they do, with their ways of living, with their friends, how they talk to their friends, their relatives.

You just go along with what they do—no ifs, no buts, no questions. You just adjust without making any fuss.'

Migrant Husbands: Uncharted Risks

I didn't even cry on my wedding day. Everybody said, 'Why didn't you cry?' I said I was going to come back to England. He should be crying—*he*'s leaving *his* house (Asma, a British Pakistani woman married to a Pakistani cousin [mother's sister's son]).

For Pakistani migrant brides the risks of marriage are charted by a strong cultural model linking womanhood, marriage, migration and risk. Parents of girls are described as *majbūr* (helpless, oppressed, in need) in the matter of arranging their marriage, with the knowledge that if it goes wrong, their daughter is likely to come off badly. Transnational marriage, for the most part, simply acts to amplify some risks by increasing the distance that is understood to make brides vulnerable. For men on the other hand, marriage does not traditionally entail migration, as a bride normally goes to live in her husband's household. Hence, although marriage is an important life event that may help confirm a man's adult status, it is not generally held to be such a central, life-changing event for them. In almost half of contemporary transnational marriages between Pakistan and Britain, however, it is the husband who migrates to join the wife, an experience whose challenges are not charted by the dominant models of masculinity.

Tahir's marriage to his cousin Asma in Bristol was arranged by his parents when he was 20. Their initial meetings dispelled his fears that a girl brought up in Britain could have had previous relationships or be too independent.[11] Nevertheless, he has found adjusting to life in Bristol difficult. The following excerpts from an interview with Tahir will illustrate several of the challenges that can face migrant husbands. Here, he describes his arrival and desire to return to Pakistan:

When I came off the plane [I thought]: 'All right. New place All right, nice place, motorway's nice' [Then after a] couple of days, a week—getting more and more annoyed. Because I'd left everything—friends, family A lot of different things

I had to adjust on in life over here. I tried to get control, but it took some time before I could. Because I used to get those day nightmares: 'Where am I? What? Can I go home? Let's go!'. . . . In the first year I [kept thinking] . . . 'Isn't there any way out? Isn't there any way to go back?' That . . . has cooled down a bit. I think [that's because of] different factors like my children, my wife—we've grown quite close together So I think it's all right—a little bit all right. But I would love to go, we'd all like to live with our parents all together. My father he said, 'All right—I'll grow your children up for you.' I said, 'That's very nice.' Different things we cherish, we can cherish all together [with the family], we do miss over here. I would like those things to be all together, but sometimes I have . . . grown sort of immune to it now. I try to keep those [thoughts] back now and see the new world.

Migration and Downward Mobility

Tahir had almost finished his medical training before he left Pakistan. At first he hoped to find work in this field in Britain, but eventually joined a general employment agency:

They were terrible jobs. I had to work in the rain holding things . . . manual jobs. So for the time being it was all right—shook out the rust out of me Later on I managed to get another job. It was same type of job, manual job, but a little better I worked there for four months. It was a refrigerator—I had to work inside it! But then I found [his current processing job] It's nice and comfortable, just sitting around. Just have to spend the time It's all the same, so it just becomes like a robot or something. So keep on doing it, keep on talking In the beginning it was very hard, because I had never thought in my life that I would have done anything like this. Maybe I didn't know what it was like over here, but over there you know most of the students they are leeches on their family, basically. They don't work much. They do some tuition or something sometimes, but work like this—no. So it was quite an extraordinary experience, but later on I realised I had to do it. Got a family to manage. Maybe later on in life when good times come

I would say if I'd come over for holiday over here it would have been wonderful, but coming into the circle of a new life, it's difficult to adjust to it I think I'm getting used to it now, but life over here is quite stressful. Like jobs, to run about [paying] the bills—mentally you're crowded all the time [thinking]: 'Got to do this, that.' Maybe the job that I'm doing, maybe that's why I have to give more hours. Sometimes, most of the months, I'm working seven days a week. Maybe it's that I can't really find time for myself to think, sit down Because if I just work plain [without overtime] I can just manage, maybe hardly manage the life I'm living with my wife over here. Sometimes I do send money over—every three, four months maybe 100, 200 pounds. That isn't that much, but to manage all that we are affording at the moment, I have to work that much. Because it isn't a very, very well paid job.

Many Pakistani men working in Britain are able to afford to send money to relatives in Pakistan. These remittances and the smart new houses built in Pakistan with money from overseas reinforce the image of the wealthy West many Pakistanis gain through the media. British Pakistanis on visits 'back home' also often spend lavishly on gift-giving and items to bring back. This may only be possible thanks to years of hard saving, and bulk-buying clothes in Pakistan may cut costs in the long run, but such conspicuous consumption also serves to bolster the impression of Britain as a place where financial gains may be made.[12] Migration to the UK does offer most Pakistani men the opportunity to earn far more than they could in Pakistan, but often under conditions that come as a shock to newly-arrived husbands like Tahir.

Given the costs of migration, pioneer migrants to Britain were normally of middling socio-economic status (Ballard 1987) and remittances from previous migrants in the family have often helped further boost the economic standing of those left in Pakistan. In Britain, on the other hand, although many own their own homes, Pakistanis tend to live in small properties in deprived inner city areas (Modood et al. 1997: 343). Ghalib, married into Britain in 1976, voiced these disappointments:

When I came here I had dreams . . . big myth that is in the Third World . . . about Europe and England—they think that everything is rosy, the grass is greener on the other side, people live luxuriously. Because they watch the films, the TV and they see all these big houses,

cars . . . when you come here and reality hits you, it's all shattered, it's all different.

Migration also commonly involves downward mobility. Qualifications and work experience may not be recognised, high fees for foreign students deter further training, and lack of local knowledge may be compounded by poor English and discrimination to limit employment prospects. Although there has been some improvement in recent years, the Pakistani population in Britain suffers from high levels of unemployment, and concentration of employment in semi-skilled, manual work rather than professional or managerial positions (Modood et al. 1997). Families are thus unlikely to be able to offer access to better opportunities to new arrivals, who often have no choice but to take jobs well below their status in Pakistan, let alone their expectations for their new life. Well-qualified men like Tahir, or those who held good jobs at home, often find themselves doing repetitive manual labour or looking to what has been called the 'culture of hope' (ibid.: 348) provided by self-employment, often as taxi-drivers. Moreover, immigration regulations requiring demonstrable sources of income to support spousal migrants mean that most women importing husbands from Pakistan are in employment and may, at least initially, hold better paid or higher status jobs than the husband can immediately hope to obtain.[13]

In an effort to increase their earnings, many commit to long and antisocial working hours, which can leave such men with little spare time to make new social networks to replace the friends and family lost through migration. Social opportunities are further limited as others in similar positions are also working long hours. Moreover, many social spaces in Britain where they might make new non-Pakistani acquaintances, such as the local pub, are not considered respectable venues due to the serving of alcohol. Hence, as one young man put it, the experience can be of 'starting from scratch again'.

The Transnational *Ghar Damad*

Marriage brings new kinship relationships and statuses. For a virilocally resident bride, the nature of her relationships with her in-laws is of fundamental importance to the quality of her married life, as evinced by the common stereotypes of the overbearing mother-in-law, jealous

sister-in-law and vulnerable new bride. However, the literature on South Asia also documents the existence of uxorilocally resident grooms or *ghar jamai* (house son-in-law). Among Muslims in Gujarat (Lambatt 1976: 54–55) they occur largely in relatively wealthy families without sons to farm their land. In Hindu Bengal a *ghar jamai* allows parents without sons to have their married daughters live with them, providing someone to inherit their property and care for them in old age (Lamb 2002: 58). University students in Pakistan told me that this type of husband may also be obtained by a wealthy father unwilling to be parted from a cherished (and by implication, spoilt) daughter, with financial gain as the incentive. In Bangladesh, Gardner (1995: 167) reports, such men are normally landless and lacking an established household to which they could take their wife. However, such an arrangement can also be the result of migration, as fathers working overseas leave a son-in-law to look after their womenfolk. My informants more commonly use the equivalent term *ghar damad* rather than *ghar jamai*. With its implications of being dependent on and under the control of the in-laws (in a similar fashion to the stereotypical daughter-in-law), this is generally considered an undesirable position for men (Jeffery and Jeffery 1996).

Most grooms migrating from Pakistan to Bristol live for at least an initial period in their wife's family home. Two women informants did say that the opportunity to stay with their parents influenced their choosing a husband from Pakistan, but this situation is generally a by-product of the economic consequences of marriage with migration. Unmarried Pakistani women in Bristol rarely live apart from the family and a husband newly arrived from Pakistan is unlikely, for the reasons outlined above, to be able to afford a place of their own. In an unusual case, one woman in Bristol had saved for and bought a house before her husband's arrival and some families do purchase properties for their children. However, the financial circumstances of families are often depleted following an expensive marriage and travel costs, so many couples spend at least some time living with the wife's parents. The concept of the *ghar damad* may thus be helpful in understanding elements of many Pakistani men's experience of marriage migration to Bristol.

A husband's migration disrupts the conventional configuration of kinship after marriage, producing both the unusual absence of some relations and the unusual presence, or at least proximity, of others. The groom is in the abnormal position of being the lone incomer, facing a new family's habits and way of life, whilst his wife starts married life with

her parents and siblings close at hand. Those couples who do set up house independently often live very close to the wife's family home, leaving the men in a structurally similar position to the *ghar damad*.[14] Hence, one husband living near his in-laws complained to his wife, 'You've got all your family and I have no one.' Like the close-knit working-class English families described by Bott in the 1950s, marriage for such women appears to be 'superimposed on the previous relationships', with the wife maintaining frequent interaction with her mother and other natal kin (1957: 218, 132–58). The crucial difference, however, is the husband's lack of corresponding local networks. If the incoming husband has married a relative, he will have local networks of kin, but although they may be close in genealogical terms, he is unlikely to share the types of attachments that his wife has built up over the years of co-residence, frequent visiting and familiarity.[15]

A wife's strong bonds within the household or neighbourhood in which the husband is a newcomer can disrupt conventional power relationships, creating greater support for the woman if conflict arises. In South India, kin marriage has been credited with providing a ready source of refuge and support for married women, as the equality between the families of the bride and groom allows the bride to turn to her natal family, who may then involve themselves in the dispute (Kapadia 1995: 54). For Pakistanis, however, the ideology of separation and inequality between bride-givers and receivers coexists with close kin marriage.[16] In order to resolve this tension, some of my informants voiced the opinion that daughters should be married at a little distance to prevent the bride's parents becoming embroiled in her relationship with her husband and in-laws (cf. Jeffery and Jeffery 1996: 216–17)—a solution which is not practicable, however, when the husband is migrating to join his wife in Britain. Equally, part of becoming a wife is being a daughter-in-law, but here this position of subordination and training is absent. This situation can alter the dynamics of power between husband and wife.

In North India and Pakistan a man without brothers may be con-sidered 'alone' and so vulnerable to victimisation (ibid.: 208). A transnational *ghar damad* can be in a similarly weak position, unable to defend himself from criticism. Some informants blamed interference by the wife's family and criticism of the husband for causing problems in this type of marriage. Azra, for example, said that her parents complained about her recently-arrived husband's dependency on the family for help with filling out forms and finding work, but that

she was careful to take his side. She contrasted this to another couple she knew where the husband felt so criticised that he wanted to leave his wife and return home.

At the core here is also the more usual expectation that brides will 'adjust' to their husband's and in-laws' ways and support their interests. Like Azra, Tahir's wife Asma has been supportive of her husband, 'She always used to listen to me, stay close to me, whatever the adjustments were. There are differences in families—the way of thinking, everything, but she always stuck over to my side, more like she had grown up in my family!'

However, some argue that the preparation of daughters for marriage tends to be neglected in Britain. One couple discussing their experiences suggested that the issue stemmed from differing interpretations of Islam. The Britain-raised wife rejected her husband's accusation that Islamic teachings were being ignored by saying that she had read widely on Islamic views on marriage. Although the Quran and other religious literature instructs wives to respect their husbands, she thought that 'he [husband] puts that slightly higher than where I would put the level, if you know what I mean.' Her parents, she said, had not taught her simply to adopt her husband's and in-laws' ways, 'because we never expected that to happen. We expected to lead an equal life.'[17]

Shaw (2000) suggests that the expectations about domestic relations of authority among young women raised in Britain may be very different from those of their Pakistani husbands. Their views, she suggests, may be framed by the model set by wives of pioneer migrants, who were also outside their mother-in-law's household, and experienced greater levels of autonomy. This is one aspect of what my informants often call the 'culture clash' between transnational spouses, a conflict that interacts with the powerlessness of the *ghar damad* position. A typical story commonly told to illustrate the problem is of a young man who arrives in Britian. He sees his wife talking to an unrelated man, perhaps a former classmate, who may call her by her first name and seem to be overly familiar. Not understanding that this is normal behaviour in Britain, the husband suspects his wife of having an extra-marital relationship, leading to arguments and perhaps the break-up of the marriage.

One young woman engaged to a cousin in Pakistan told me about the instructions given to her fiancé by his mother before his departure for a visit to England, explicitly comparing it to the preparation for marriage given to daughters.[18] Other men were warned by friends

or relatives in Britain that they would have to work much harder in Bristol than in Pakistan. Nonetheless, it is clear that most men do not expect to 'adjust' like the traditional new bride in pursuit of marital and household harmony.

Tahir spoke of the frustrations he had encountered in adjusting to his wife's family, which eased somewhat when the couple moved to a separate house nearby:

> It's been the opposite way round—usually girls make adjustments.... Some things I can't change like certain habits of mine. I've changed most of them—I don't smoke inside, I smoke always outside now.... I think it's more comfortable [since we have moved out of the extended family home]. We have our own privacy. Secondly, the lifestyle we want to develop for our own selves, we can. That's most important to me—I can grow my children the way I want to. Teach them the things I want. Otherwise if I lived in joint family, somebody comes around [and says to his child]: 'What are you doing?'—gives my child a slap [and shouts]: 'Go over there!' It's not right.

Nevertheless, he is keen to return to Pakistan to raise his children:

> Before they are 10 years old, I would like them to go back. Even if I'm here or I'm over there, I would like them to be brought up over there Everybody has their own characteristics but, like Asma's family, for example, it's very nice, they're nice to their parents and everybody. But if... my parents had children like Asma's family, there were a lot of things that they couldn't have tolerated. Like if we talk rude[ly] to our parents, even in early ages, maybe in later life we can still get beaten! ... And second thing is religion. [That's the] most important thing. Over here they do religion, but to learn something, and to see something, is two different things. Like, it can be in your mind, but if you don't see, if religion isn't around you, you'll certainly say, 'What is this? This is something bookish, or something related to books.'

Tahir evidently worries about the impact of the local cultural environment and his wife's family on his sons—indeed, he is scathing about the behaviour of young men raised in Britain. Marriage and childbearing centrally concern cultural reproduction and, in addition to the wider issues of religion and discipline that worry Tahir about British Pakistani culture, he is also eager to pass on his own particular family 'culture'. In

the context of virilocal residence, this type of micro-cultural reproduction is in effect patrilineal and men are habituated to the idea that their natal family's ways will shape their children's upbringing. It is women, trained in their husbands' family's habits from the time that they come as new brides, who take the major role in childcare rather than the men. With male marriage migration, this feminine training is absent. Transnational *ghar damads*, therefore, risk the end of this micro-cultural lineage, raising sons (and daughters) who may carry on the family name, but behave as foreigners.

Marriage, Masculinity and Migration

It has been suggested that the positions of South Asian men vary less than those of women across their life course (Mines and Lamb 2002), but models of manhood also change with age and the assumption of new roles in relation to others. A son should respect his parents and provide for them when they are older. As a husband and father, a man should both provide for his family and be able to exert a certain level of control over his wife (or wives) and children.[19] As the material presented earlier suggests, the position of *ghar damad* may undermine this control. Moreover, although migration to the economic opportunities of Britain is often undertaken partly in order to fulfil the masculine ideal of provider, it seems that, in a cruel irony, marriage migration can undermine a man's ability to fulfil several aspects of these masculine roles.

Rather than contributing to a household budget that sustains both his parents and his wife and children, after migration he has a 'double responsibility'—to provide for his dependants in Britain and to send money to his family in Pakistan (see Gallo, this volume). Although his in-laws were supportive, Ghalib remembered the strain that helping his elderly father finance the marriage of his five siblings had put on his marriage. In some poorer households, tensions can arise over these competing demands on the family resources. Having accepted a proposal from a financially stable family in the hope that funds would not be drained by the need to support her husband's relatives, Azra says her husband has only spoken once of his desire to remit money to his family in Pakistan, not daring to anger her by raising the issue again.

As this husband's timidity suggests, male marriage migration can create new intra-household relations of power. Crucially, living in the father-in-law's home can undermine a man's authority over his wife and children. Yasmin, for example, was largely able to deny her husband sexual access to her after he had been violent, by staying up late with her sisters or turning to her father for support. In this, the young man's ability to be a 'proper' husband and exercise control over his wife was denied when it came into conflict with the more senior, household male's role as a father to protect his daughter. Such 'hegemonic masculinities' 'define successful ways of "being a man"' and so, consequently, 'define other masculine styles as inadequate or inferior'. The *ghar damad* represents one of the other 'subordinate variants' (Cornwall and Lindisfarne 1994: 3) of Pakistani and North Indian masculinity and, as such, may be perceived as emasculating or infantilising men aspiring to a hegemonic masculine role.

After the mother of the visiting fiancé gave the young man the kind of instruction usually given to young women to prepare them for life in their marital home, he complained: 'I felt like a 2-year-old when she was telling me all these things!' In these cases, it is the man who is the incomer and who, therefore, might be expected to make adjustments to fit in with his new environment. However, as Singh and Uberoi (1994: 115) point out, asymmetrical models of 'adjustment' in which wives are expected to carry the burden of self-sacrifice and compromise are not merely a practical response to virilocal residence, but also function as 'an affirmation of male dominance in the family, as in society'. Small wonder, then, that 'adjustment' does not come easily to many of these men.

Marital Outcomes

It is not, however, my intention to suggest that all or even the majority of incoming Pakistani husbands are unhappy class casualties and frustrated *ghar damads*. As Cornwall and Lindisfarne (1994: 5) make clear, 'Hegemonic forms [of masculinity] are never totally comprehensive, nor do they ever completely control subordinates. That is, there is always some space for subordinate versions of masculinity—as alternative gendered identities which validate self-worth and encourage resistance.' It is possible for the *ghar damad* to find subtle ways of redefining his

position. Ghalib, for example, remembered the instruction his father had given him before he left Pakistan to respect and obey his parents-in-law as his parents. Accordingly, he said, if his father-in-law told him that day was night:

> I say, 'Yes, it is night', even [though] I knew it is daytime At that time, I agree, but then quietly, politely, I say to him, 'What do you think if we just go outside and see if it's day or night?' Then he say, 'Yeah, yeah'. So that's why I think we had a relationship between ourselves very successful. I'm never, never outspoken in front of them. That's the key for success I think.[20]

Instead of railing against the new structures of authority in which he found himself, Ghalib portrays himself as a good son by obeying his father's instructions. His deference can then be understood as fulfilling kinship obligations. However, at another level, this is an account of a clever young man tactfully gaining the upper hand in his relationship with his father-in-law, allowing him to emerge from a potentially weak position with his masculine authority unscathed.[21]

For new immigrants with good relationships with their in-laws, the home environment can be welcoming and supportive. Nevertheless, some aspects of this model of the unhappy *ghar damad* husband remain useful in understanding even the positive experiences. Hamid, for example, is content in his new life, partly because of a lack of the features of the model presented here. His local networks are better than is the case for most of the other husbands mentioned here, as he had already developed friendships with male cousins of a similar age in Bristol during their visits to Pakistan. A relative has provided him with a relatively interesting job; he has been able to remit money; and, as his wife's father had died and her only adult brother lives elsewhere, he did not come into conflict with established structures of male authority in the household.

For others, these difficulties may just be a phase. The process of migration, as Werbner (1990) has pointed out, extends well beyond the physical relocation. In one case I came across in Bristol, friction between husband and wife re-emerged years later over the husband's desire to marry his daughter to one of his relatives in Pakistan. Yet, for many, the causes of tension may decrease over the years as they establish their own household, develop more social networks and improve their career status and financial security. Tahir plans to take his family back

to Pakistan, but men in this position may find that their relocation plans come to resemble the 'myth of return' of the pioneer Pakistani migrants to Britain. Over time their lives have become entwined with others in their new country through their children, homes, businesses and relationships (Anwar 1979). Eighteen, twenty or more years later, a new generation of fathers may arrange their children's marriages with relatives in Pakistan to renew bonds with the homeland to which they have only returned as visitors.

In some cases, however, marriages between British Pakistani women and migrant husbands from Pakistan have ended in conflict and divorce. In Yasmin's short-lived and abusive marriage, it was when her husband expressed his frustrations about her family that the real arguments started. He complained, 'Your sister's a bad mother. Your mother's cooking's not that nice. Your dad's so forcive [sic] and he doesn't understand and he doesn't listen. Your brothers have got attitude problems. Your mother hasn't taught you much about marriage and being a wife.'

These accusations speak to many of the issues addressed above: local cultural differences, issues of parenting, expectations of how a wife should behave and 'adjust', and the *ghar damad*'s weak position in the household structures of power. Interestingly, Yasmin's husband's culinary complaint was echoed by another migrant husband. Sonam's husband disliked both his wife's and his mother-in-law's cooking. A man bringing a wife into his family home will eat the same food before and after marriage, as his wife will be trained in her new household's style of cooking. When Sonam's mother-in-law visited from Pakistan, Sonam realised that she had been using far less chilli and green coriander in her cooking than her husband was used to. This apparently trivial matter can thus be seen as symptomatic, both of expectations of continuity in 'family culture' across their life course and of the broader adjustments a migrant husband has to make to the family culture of his wife's household, and indeed to his new social and cultural setting.

Both these marriages ended in divorce. After he had been violent, Yasmin's husband was sent back to Pakistan before the end of the one-year probationary period needed for a spouse to gain the permanent right to remain in Britain.[22] In what is probably a more typical story, Sonam's marriage lasted long enough for her husband's immigration status to become secure. Sonam said that small arguments, like the issue of food, gradually escalated to violence on his part and his taking a second wife in Pakistan. Though not an excuse for his actions, it is interesting to note that this husband was also under several of the other forms of

pressure described earlier. He had given up an 'executive job' with a foreign firm in Pakistan, only to find himself doing long night shifts of repetitive low-status work where he also felt he suffered from racial discrimination. His wife, although highly religious, is also assertive, and as he had married outside the family, he had a complete lack of kinship networks for support in Bristol.

Conclusion: Regendering the Risks of Transnational Marriage

Stories of migrant husbands who are argumentative or even violent, or who abandon their marriages once their immigration status is secure, perhaps bringing another wife from Pakistan, create anxiety for British Pakistani women and their parents. Issues of risk and trust are central to Pakistani transnational close kin marriage and this fear adds a new variation to the repertoire of risks facing British Pakistani women and their parents. I do not want to suggest that such premeditated cruelty does not sometimes occur, and such behaviour undoubtedly causes great suffering. However, focusing only on the hazardous consequences of migration for women masks the fuller picture. The account presented here of the pressures and frustrations faced by many male marriage migrants may aid in understanding the more extreme actions of some imported Pakistani husbands, helping transform them from two-dimensional ciphers (Chopra et al. 2004: 2–3) to people with comprehensible emotional lives. Much recent research has explored male violence against women as a resource in the construction of masculinity by men in subordinate positions (Gadd 2002; Messerschmidt 2000; Totten 2003) and, certainly by understanding some of the problems for immigrant husbands, their wives and families, it is possible that solutions might be imagined to prevent the worst cases of conflict. Nevertheless, these cases of marital breakdown represent a minority of transnational marriages. All husbands' and wives' expectations and experiences are, however, influenced by gendered models of marriage and migration. As Connell (1995: 114) notes, 'An active process of grappling with a situation, and constructing ways of living in it, is central to the making of gender.' Whilst a bride's relationship to marriage is at least partially constructed in terms of risk, husbands are also grappling with the gendered challenges of their

new positions as transnational *ghar damad*. The recognition of these less charted risks presents an opportunity for greater insights into the dynamics of such transnational marriages.

Acknowledgements

This paper draws substantially on my Ph.D. thesis (University of Edinburgh, 2003). Some parts also draw on an article to be published in the *Journal of the Royal Anthropological Institute* (Charsley, forthcoming). I would like to thank Patricia Jeffery, Janet Carsten, Anthony Good, Alison Shaw, Patricia Uberoi and Rajni Palriwala for valuable assistance and comments on earlier drafts, and the organisers and participants of the international conference on Women and Migration in Asia (Delhi, December 2003), the South Asian Anthropologists' Group (London, September 2003) and the Pakistan Workshop (Lake District, May 2003) for their feedback and encouragement. The research and writing of this chapter were made possible by doctoral and postdoctoral funding from the ESRC (PTA-026-27-0274), and a Radcliffe-Brown/ Sutasoma award from the Royal Anthropological Institute.

Notes

1 Home Office figures after these dates are not available, due to the disruption of consular services in Pakistan after the attacks on the World Trade Centre and the war in Afghanistan.

2 This refers to the 1997 abolition of the Primary Purpose Rule (PPR) requiring spouses to prove that their main reason for entering into the marriage was not to gain entry to Britian. Some commentators viewed the PPR as a discriminatory law targeting South Asian migrants (Menski 1999).

3 In 2000, 4,720 husbands and fiancés, and 5,560 wives and fiancées in Pakistan were granted UK entry clearance (Home Office 2001).

4 The topic of gender and migration is the subject of a growing literature, with a number of volumes dealing with migrant women (Anthias and Lazaridis 2000; Buijs 1993; Gamburd 2000). In Pakistan, researchers have studied the impact of male migration on the gendered experience of non-migrant women (Naveed-I-Rahat 1990; Rauf 1982; see also Gardner 1995 on Bangladesh). The interactions of migration and masculinity have, however, been somewhat neglected, although Gamburd (2000) discusses husbands left behind by migrant Sri Lankan housemaids.

5 *Barādarī* is often translated as kin group, and *zāt* as caste, but in practice these terms may be used interchangeably. See Alavi (1972) for a description of the 'sliding semantic scale' inherent in the concept of *barādarī*. *Barādarī* has also been translated as 'patrilineage', but given repeated close kin marriages, many members of a *barādarī* may be related to both one's mother and one's father (Das 1973: 28, 39). Neither my informants nor those in the Oxford survey demonstrate a preference for patrilineal marriage (Shaw 2001).

6 Fischer and Lyon (2000) suggest that Pakistani understandings of similarity between kin help account for the statistical preference they found in Lahore for marriage between the children of same-sex siblings. Brothers 'are more like each other than they are like their sisters, and vice versa'. Similarity travels down the generations, so same-sex siblings' children are likely to be the most alike from available first cousins (ibid.: 305). Also, see Das (1973) on the depiction of disastrous marriages between non-kin in Pakistani fiction.

7 These hopes are not always fulfilled, however, and close kin marriage also generates its own risks in the potential to create conflict within the kin group (Charsley 2003).

8 Rayner (1992) suggests that people deal with risk not as the standard calculation of 'probability *x* consequences', but are concerned with 'fairness', rooted in considerations of 'trust', 'liability' and 'consent'. Kin links provide the basis for all three—trust based on moral obligations and similarity between kin, group sanctions to hold a transgressing spouse to account, and networks along which marriages can be negotiated.

9 At the launch of the Pak Watan (Pak Homeland) Website in Islamabad, a Pakistani official proclaimed the government's intention to ensure that Pakistan would rapidly develop more comprehensive Internet access than India. If we can't beat them at cricket, he joked, we'll beat them at IT!

10 However, it is sometimes seen as a duty for family to provide spouses for disabled or otherwise unmarriageable children and the benefits of migration may be weighed against the disability.

11 The traditional prohibition on engaged couples meeting is not adhered to in all families. In any case, curious couples may find ways of communicating surreptitiously through intermediaries, letters, telephone calls or e-mail.

12 Giving the impression of being a well-off and generous family also does no harm if a good match is being sought for a son or daughter of marriageable age.

13 Some South Asian commentators have suggested that a wife's higher status or wages can be problematic for a successful marriage (Kapur 1970; Singh and Uberoi 1994: 112).

14 This arrangement facilitates frequent visiting and even shared cooking, eroding the distinction between extended family households and couples who live separately. Nevertheless, becoming 'separate' in this way can help ease some husbands' discomfort.

15 See Charsley (2003) on proximity and the production of 'close' kin.

16 See Charsley (2003) on the negotiation of these two aspects in wedding practices.

17 See Akram (2000) for an interesting discussion of the variety of interpretations of Islam in the context of immigration.

18 The opportunity to visit Britain prior to the marriage is rare.

19 See Charsley (2003) for a review of the literature on *izzat* (honour) and control.

20 Interestingly, this formulation is sometimes given as advice to women as to how wives can influence their husbands (P. Jeffery, personal communication).
21 Such examples recall Chopra et al.'s (2004: 14) acute observation that men can appear as 'especially fragile persons who insist on especially powerful personae'.
22 This period has since been extended to two years.

References

Akram, S.M. 2000. 'Orientalism Revisited in Asylum and Refugee Claims', *International Journal of Refugee Law*, 12 (1): 7–40.
Alavi, H. 1972. 'Kinship in West Punjabi Villages', *Contributions to Indian Sociology*, 14 (6): 1–27.
Anthias, F. and G. Lazaridis (eds). 2000. *Gender and Migration in Southern Europe: Women on the Move*. Oxford: Berg.
Anwar, M. 1979. *The Myth of Return: Pakistanis in Britain*. London: Heineman.
Ballard, R. 1987. 'The Political Economy of Migration: Pakistan, Britain, and the Middle East', in J. Eades (ed.), *Migrants, Workers, and the Social Order*, pp. 19–41. London: Tavistock.
Bott, E. 1957. *Family and Social Network*. London: Tavistock.
Bourdieu, P. 1977. *Outline of a Theory of Practice*. Cambridge: Cambridge University Press.
Bradby, H. 2000. 'Locality, Loyalty and Identity: Experiences of Travel and Marriage among Young Punjabi Women in Glasgow', in S. Clift and S. Carter (eds), *Tourism and Sex: Culture, Commerce and Coercion*, pp. 236–49. London: Pinter.
Buijs, G. (ed.) 1993. *Migrant Women: Crossing Boundaries and Identities*. Oxford: Berg.
Charsley, K. 2003. 'Rishtas: Transnational Pakistani Marriages'. Ph.D. dissertation, University of Edinburgh.
———. Forthcoming. 'Unhappy Husbands: Masculinity and Migration in Transnational Pakistani Marriages', *Journal of the Royal Anthropological Institute*, 11: 85–105.
Chopra, R., F. Osella and C. Osella (eds). 2004. *South Asian Masculinities: Contexts of Change, Sites of Continuity*. New Delhi: Kali for Women.
Connell, R.W. 1995. *Masculinities*. Oxford: Blackwell.
Cornwall, A. and N. Lindisfarne (eds). 1994. *Dislocating Masculinity: Comparative Ethnographies*. London: Routledge.
Das, V. 1973. 'The Structure of Marriage Preferences: An Account from Pakistani Fiction', *Man*, 8 (1): 30–45.
Donnan, H. 1988. *Marriage Among Muslims: Preference and Choice in Northern Pakistan*. Delhi: Hindustan Publishing Corporation.
Fenton, S. and A. Sadiq. 1993. *Sorrow in my Heart . . . Sixteen Asian Women Speak about Depression*. London: Centre for Racial Equality.
Fischer, M. and W. Lyon. 2000. 'Marriage Strategies in Lahore: Projections of a Model Marriage on Social Practice', in M. Böck and A. Rao (eds), *Culture, Creation and Procreation: Concepts of Kinship in South Asian Practice*, pp. 297–322. Oxford: Berghahn Books.
Gadd, D. 2002. 'Masculinities and Violence against Female Partners', *Social and Legal Studies*, 11 (1): 61–80.

Gamburd, M.R. 2000. *The Kitchen Spoon's Handle: Transnationalism and Sri Lanka's Migrant Housemaids*. Ithaca: Cornell University Press.

Gardner, K. 1995. *Global Migrants, Local Lives*. Oxford: Clarendon Press.

Home Office. 2001. *Control of Immigration: Statistics United Kingdom 2000*. London: The Stationery Office.

Jeffery, P. 2001. 'A Uniform Customary Code? Marital Breakdown and Women's Economic Entitlements in Rural Bijnor', *Contributions to Indian Sociology*, 35 (1): 1–32.

Jeffery, P. and A. Basu (eds). 1998. *Appropriating Gender: Women's Activism and Politicised Religion in South Asia*. London: Routledge.

Jeffery, P. and R. Jeffery. 1996. *Don't Marry Me to a Plowman!* Oxford: Westview.

Kapadia, K. 1995. *Siva and her Sisters*. Boulder: Westview.

Kapur, P. 1970. *Marriage and the Working Woman in India*. Delhi: Vikas Publications.

Lamb, S. 2002. 'Love and Ageing in Bengali Families', in D. Mines and S. Lamb (eds), *Everyday Life in South Asia*, pp. 56–68. Bloomington: Indiana University Press.

Lambatt, I.A. 1976. 'Marriage among the Sunni Surati Vohras of South Gujerat', in I. Ahmad (ed.), *Family, Kinship and Marriage among Muslims in India*, pp. 49–82. Delhi: Manohar.

Menski, W. 1999. 'South Asian Women in Britain, Family Integrity and the Primary Purpose Rule', in R. Barot, H. Bradley and S. Fenton (eds), *Ethnicity, Gender and Social Change*, pp. 81–98. London: Macmillan.

Messerschmidt, J.W. 2000. 'Becoming "Real Men": Adolescent Masculinity Challenges and Sexual Violence', *Men and Masculinities*, 2 (3): 286–307.

Mines, D. and S. Lamb (eds). 2002. *Everyday Life in South Asia*. Bloomington: Indiana University Press.

Modood, T., R. Berthoud, P. Lakey, P. Nazroo, P. Smith, S. Virdee and S. Beishon. 1997. *Ethnic Minorities in Britain: Diversity and Disadvantage*. London: Policy Studies Institute.

Naveed-I-Rahat. 1990. *Male Outmigration and Matri-weighted Households: A Case Study of a Punjabi Village in Pakistan*. Delhi: Hindustan Publishing Corporation.

Rayner, S. 1992. 'Cultural Theory and Risk Analysis', in S. Krimsley and D. Golding (eds), *Social Theories of Risk*, pp. 83–114. Westport: Praeger.

Rauf, M.A. 1982. 'Labour Emigration and the Changing Trend of Family Life in a Pakistani Village', in S. Pastner and L. Flan (eds), *Anthropology in Pakistan*. Cornell: Cornell University, South Asia Occasional Papers and Theses.

Samad, Y. and J. Eade. 2002. *Community Perceptions of Forced Marriage*. London: Community Liaison Unit, Foreign and Commonwealth Office.

Shaw, A. 1988. *A Pakistani Community in Britain*. Oxford: Basil Blackwell.

———. 2000. 'Conflicting Models of Risk: Clinical Genetics and British Pakistanis', in P. Caplan (ed.), *Risk Revisited*, pp. 85–107. London: Pluto Press.

———. 2001. 'Kinship, Cultural Preference and Immigration: Consanguineous Marriage among British Pakistanis', *Journal of the Royal Anthropological Institute* (n.s.), 7: 315–34.

Singh, A.T. and P. Uberoi. 1994. 'Learning to "Adjust": Conjugal Relations in Indian Popular Fiction', *Indian Journal of Gender Studies*, 1 (1): 93–120.

Totten, M. 2003. 'Girlfriend Abuse as a Form of Masculinity Construction among Violent, Marginalised Youth', *Men and Masculinities*, 6 (1): 70–92.

Werbner, P. 1990. *The Migration Process: Capital, Gifts and Offerings among British Pakistanis*. Oxford: Berg.

11

MARRIAGE AND MIGRATION THROUGH THE LIFE COURSE: EXPERIENCES OF WIDOWHOOD, SEPARATION AND DIVORCE AMONGST TRANSNATIONAL SIKH WOMEN

Kanwal Mand

The idea that 'sacrifice' is intrinsic to being married and that women have to be flexible and accommodating towards a husband and his family was pronounced in my conversations with women who were not happy with their marital situation. Manjeet, whose marriage had been arranged in Punjab to a Sikh migrant in Tanzania, claimed that she 'accepted many things that have been bad' for fear that her husband could easily have asked her to leave. Manjeet had not actually been told to leave, but she tolerated her husband's behaviour to the extent that even after several years of marriage she 'accepted' her husband's woman and their children.[2] Referring to this aspect of her husband's activities, Manjeet focused on her inability to conceive as a reason for 'understanding [her] husband's relationship with the other woman'. At other times Manjeet would highlight her plight as a woman of her generation. Quite often Manjeet would state that, like me, she had been interested in studying, but 'in her day' women had 'no choice' but to do what their parents wanted. As to confronting her husband about his other 'family', Manjeet commented: 'At any time he could tell me to leave and then where would I go?' In the context of transnational marriage practices, the question of 'where would I go?' is highly pertinent. Like many others, Manjeet had left natal kin back in Punjab and had no right of residence in Tanzania except as wife to a migrant man (Mand 2004).

Other women, too, often described marriage as involving the putting aside of one's *cha* (desires), whether in reference to natal kin or lifestyle choices, to ensure the welfare of the husband and his family. While there seems nothing amiss with caring for children and the family, Sikh women's narratives need to be understood in the light of the ideological expectations of the married state, as this is transformed over a woman's life course. Manjeet's narrative implicitly identifies marriage as a pivotal moment for South Asian women, and one that entails a transformation in identity, residence and status. This change in status is reflected in rituals that celebrate the transference of a woman from her father's house to that of her husband.

Understandably, there has been a strong focus in the literature on women in South Asia on the centrality and universality of marriage, but much less attention has been paid to situations where a woman is not in a marriage, either by choice or because of circumstances, such as separation or the death of a husband. The perspective of widowed and separated women has so far remained marginal to accounts of South Asian marriage. Nonetheless, as Chen (2000: 354) argues, 'because of its marginality, widowhood offers a "mirror" on caste, kinship, and marriage . . . [and] serves to illuminate the situation of women generally'. Institutions like marriage, caste and kinship 'regulate the property, fertility, and labour of women (and widows)', being sites where widows' rights are either upheld or undermined (ibid.: 175–76).

In the migratory context, Sikh marriages have been investigated in terms of processes of change and continuity in marital arrangements and rituals, and in the negotiations between generations (Ballard 1990, 1994; Ballard and Ballard 1977; Gell 1994; Jhutti 1998; Mand 2002, 2004). A significant focus of these writings has been on the transformations wrought by the migration process in the 'traditional' ideals of marriage, and on the way rules alter in relation to migration history, caste identity and class position. Bhachu (1985), for instance, has discussed 'twice-migrant' Sikh women's engagement in the labour market in Britain and consequent changes in conjugal relations, and women's active role in the production of dowries (Bhachu 1985, 1988, 1991; see also Jhutti 1998).

Other research has stressed the changing power relations within households arising from migration and marriage, and the impact of such changes on specific norms. For example, the norm of patrilocal residence is said to be altering as a result of transnational Bangladeshi and Pakistani

marriages that entail the movement of men from the subcontinent to live with their wives and wives' families in Britain (see Charsley, this volume). Furthermore, as Gavron (1997) notes, Bangladeshi migrant women are likely to play a greater role in selecting their own spouses and to find a groom of a better calibre if they return to Bangladesh to search for a spouse (also, Shaw 2000). This work notwithstanding, there has been little focus on the experiences of South Asian men and women in different life course stages.[3] One exception has been Gardner's (2002) study of elderly men and women from the Bangladeshi community in London, exploring the ways in which migration intersects with the life course and, to some extent, the experience of widows.

Although Sikhs in Britain do divorce on grounds of adultery, educational differences and disparities in terms of expectations regarding gender roles between spouses (Jhutti 1998), I found divorce to be relatively rare in my case studies. In part, I would suggest that this is because the transnational spaces inhabited by Sikh women influence notions of what is acceptable within marriages. For example, adultery is an acceptable ground for divorce in Britain, but this was not my observation in Tanzania, where Sikh men have affairs with African women without an end to their marriage (Nagar 1995). Such differences are also linked to immigration policies, whereby Sikh women's residence in Tanzania is generally based on their status as wives. However, while widowhood and divorce mark a break in the marital cycle, separation is a relatively unexplored area. Separation draws attention to the centrality of marriage for a woman's identity, as well as to the complex negotiations women must undertake to overcome the continuing stigma associated with living outside the 'norm' of marital life.

In this chapter I look at the relationship between marriage and transnational migration from the angle of widowhood and separation, drawing on Martha Chen's perspective that both married and widowed women's lives are 'embedded in—and conditioned by—the same social institutions; and [that] duties and practices expected of widows are an ultimate expression of what is expected of [married] women as well' (Chen 2000: 8). I utilise the life course as a framework through which to explore the contrast between idealised scenarios and the realities of South Asian women's experiences of the migration process and different marriage statuses. Given the dominant ideals surrounding Sikh marriage, I ask: How do migrant women negotiate their status and how does this relate to their stage in the life course, geographic location and kin networks?

Classic ethnographies have drawn attention to the tradition of arranged marriages in North India whereby the onus for match-making is less on the individuals to be married and more on the family. Besides 'traditional' criteria as caste, *got* (exogamous clan or sub-caste group), region and the social standing of the family, the arrangement of marriages in the subcontinent and beyond also takes into account the potential suitability of spouses in terms of physique, geographic location and education (Jhutti 1998; Parry 1979). Patrivirilocal post-marital residence (in the husband's father's household) is the norm (Hershman 1981; Parry 1979; Raheja and Gold 1994). Young girls are socialised to the ideal of being a caring and dutiful wife, and are reprimanded for actions seen to contravene this role.

The dominant ideology in North India presents women as 'guests' in their natal households. However, despite ritual enactments signalling a woman's severance from her natal household, Sikh women's ties to their natal households are not entirely ruptured; women are, rather, in-between households. Nonetheless, a woman's status does alter in reference to her conjugal and natal households through the different stages in her life course (Hershman 1981; Raheja and Gold 1994). Key episodes are the birth of children, particularly sons, and their subsequent marriages, resulting in incoming daughters-in-law. Vatuk describes three phases of a woman's life course following marriage and the birth of children, highlighting age as a significant feature of social relations (cf. Lamb 2000). These are 'middle age', 'early old age' and 'old old age', with correspondingly different activities and intra-household relationships (Vatuk 1995: 296–98). However, the meanings attributed to being of a particular age are also culturally embedded (Gardner 2002) such that the biological aspects and social referents of age do not necessarily coincide. For example, South Asian women are more likely to become widows at a younger biological age than their counterparts in the West. Furthermore, in South Asia women's experiences are mediated by the biological stage (in terms of pre- or post-menopause), and by culturally embedded concerns with women's 'uncontrolled' sexuality, as well as by the number and sex of their children (Chen 2000).

The exemplary situation is for a woman to be supported by adult sons in her 'old age', and the mother–son bond is said to be cultivated as part of a 'life long "survival strategy" in a patrilineal-patrilocal kinship system' (Vatuk 1995: 298). Observers also note that the necessity for sons in their old age pertains to more than the mere requirements of care

and material provision. As Lamb (2000: 77) writes of the asymmetrical relations between mothers and sons in rural Bengal: 'A mother sacrifices everything for her son, but ultimately there is a failure in reciprocity.' In addition, Lamb points to the symbolic and ideological status attached to being cared for by sons and that being abandoned by a son also means a woman is 'stripped' of her identity as mother (ibid.). The increase in a woman's status and power in relation to younger women (that is, daughters-in-law) in extended households underscores Kandiyoti's (1997) notion of the 'patriarchal bargain'. However, for a widow, the 'death of a husband often presents the ultimate test of a woman's bargaining power' and her position within the household (Chen 2000: 10).

Although women can inherit property following a husband's death, social norms dictate that women transfer their rights to sons, who ultimately take charge of managing resources. This extra-legal transfer of property by women to their sons, a symbolic gesture whereby women 'exchange' material resources in order to be cared for (Vlasoff 1990), discourages remarriage since the inheritance of sons from remarried mothers is potentially problematic. Conversely, it is rare for women to inherit property from their natal kin since, in the dominant ideology, a woman's position is one of shifting connections made and remade over the life course (cf. Lamb 2000).

Unlikely to inherit directly from either their husbands or their natal kin, women are expected to turn to sons for support, and it is rare in South Asia for women to live with their children's in-laws or alone. Living with a married daughter is the least satisfactory arrangement and a matter of shame. Widowed mothers are said to have no 'place' or 'power' in their married daughters' homes (Lamb 2000; Vatuk 1990), though in reality, as Chen observes, many daughters support widowed women who either live with them or with single women in female-headed households (Chen 2000). Widowhood contravenes the ideal, and a woman who outlives her husband is regarded as dangerous, inauspicious and a potential economic burden, occupying 'a transitional state between two ideal auspicious states: when she was a married woman and when she will be reunited with her husband upon her death' (ibid.: 29). A widow is expected to become an ascetic who perpetually mourns the death of her husband, 'never incorporated into society', and 'trapped in a lonely, isolated condition, living in the world but representing death' (ibid.: 30, 131).

Losing a Husband

For many of the women with whom I worked, marriage was not necessarily a pleasant experience all of the time. However, life without a husband was perceived to be a life without joy or meaning. As Maninder said, speaking of her deceased husband in the company of other widowed women:

> Those were times of peace. When he was not drinking. When he was not drunk. The days he was drunk he was bad. Everybody knew that, but a husband provides a woman with peace. Without a husband a woman has no peace, her life is nothing.

Similarly, despite migrating to the UK from Tanzania, via Punjab, Raminder highlighted the lack of 'mobility' that arises from widowhood.

> I was different, I felt I could do anything, go anywhere because Ajay was around. Now I fear, I can't feel settled. Life is just to pass away now.

Losing a husband is a traumatic event. In spite of the varied experiences of marriage as harsh or joyful, women grieve the loss of their husbands as a loss of self. Raminder, a middle-aged Sikh woman whose husband had died in India where he had gone for medical treatment four years earlier, was visiting her daughter, her only child, and her family in Britain. Raminder had been married for over 30 years and had lived mostly with her husband in Tanzania. Following news of his death, Raminder went to India along with her daughter. The latter returned shortly to England and, after a brief period in Punjab, Raminder returned to Tanzania and then migrated to Britain. Here, she speaks about *ketha zindagi bathalgi* (how life has changed) following her husband's death:

> I can't feel settled here [Tanzania], because this is where I lived with my husband and now there is no reason to be here as there is no one left here. After he died, his relatives took me back to their village and I stayed there for some months . . . but they did not speak to me and there was no one there for me. I returned to Tanzania and now I have come again. My daughter, she told me to come to England and so I

had to go to the city and talk to the immigration *wallah* [person] and I was extremely confused. I was lost in the building and they all spoke in English and asked me all the time why I had been in England before and why did I want to go again. These people did not understand me and they brought in a woman who spoke Punjabi. I tried to explain to her that my husband had died and that I had no one but my daughter who lives in England. I was very confused. As a woman I had never had to do these kinds of things . . . they kept asking me why.

I went to England and stayed with my daughter on the six-month visa that they had given me. After 16 months, when my visa had expired, they gave me another—a settlement visa—and I got the right [to live in England]. Every day of those 16 months they would write to me or call me or tell me to go and see them, and they kept asking me why I wanted to settle in England. I know that in our [country] we do not stay with our daughters, but I have no choice There is no one and I had no other children and my husband's family don't care about me. I feel awful being reliant on my daughter and I wish that I could eat from my own money. This is why I have come back [to Tanzania][4] With the 3,000 pounds I could pay my daughter back for the tickets; she paid for my ticket here and everything else. They [her daughter and son-in-law] have a small house and her mother-in-law is always talking about me living with her. With the money I could buy my own house and eat my own food and not be dependent. I always tell my daughter that other women at the [Sikh] temple [in England] have their own houses and some of them work and I could do that. My daughter says there is no need and maybe I could do that when my granddaughters are older. My granddaughters are my life now. Without my husband I feel that life is not worth living, but I have the hope of my granddaughters and the little one is so sweet and always sticks to my side. The older one goes to school, and the little one and I have our own routine. I miss them . . . on the phone the little one asked, 'Grandma, when are you coming back?'

Life has changed and taken me to places that I did not think I would go alone.

I wish I had known more English. My granddaughter speaks English at home and I am learning from her and from the TV. If I knew more English then I will be able to work and this is all

I wish for my granddaughters. I wish that my granddaughters study and forget the whole thing about marriage . . . in any case a simple marriage is good. We keep inventing and elaborating our traditions and it is all show. Over there [England], the *gora lok* [white people] they save and spend money for the wedding and the family also helps in the wedding costs. My neighbour bought the wedding dress for her daughter from working and she is divorced. England is the best place for widows and women as they are able to move about more, control things and do things easily for themselves. The other women at the temple, they have lost their husbands, but some of them live alone and they are happy They have a pension and the government also looks after them.

The death of a spouse in South Asia, we are told, is differently constructed and holds different challenges for men and for women, and these experiences differ further according to caste membership, class position and access to economic resources. Additionally, women's social identities and status are intimately related to their roles as daughters and mothers, as married or widowed women, and these are powerful determinants of their relations with the wider society. Furthermore, women living without husbands are also dependent on kin, who act as their material, emotional and physical support (Chen 2000; Lamb 2000). Unsurprisingly, like many of her counterparts in the subcontinent, Raminder experienced indifference on the part of her husband's family following his death in Punjab. Such experiences are compounded for migrant widowed women owing to the dispersal of kin, as in Raminder's case, where her natal kin are located in Punjab, her married life was spent in Tanzania, and her offspring have migrated to the West (Mand 2004). The migrant woman's search for home thus entails her movement back and forth in three national contexts.

The gender norms of Raminder's generation meant that she had received no formal education and had never been involved in paid labour.[5] With rigid distinctions between the public and private spheres, particularly in Tanzania where it is usually the men who deal with *bhar the kam* (outside work), widowhood resulted in Raminder having to break with convention and deal with agencies such as immigration officers and with various bureaucratic procedures. These new ventures should be understood in the context of the politicisation of migration generally, as well as in reference to the specificity of the British context where migrant marriages and the migration of family members are targeted

through various laws and policies (Mand 2004; Sachdeva 1993), for instance, the requirement to learn English, which is directed (amongst others) at South Asian women.

Geographical location has an impact on women's experiences of being widowed. Thus, according to Raminder, the British context is preferable for widowed Sikh women because of the social and material support afforded by the government, whereas in India, for example, the state provides a pension only on condition that the women are of a particular age, have no adult sons and earn less then a minimal income (Chen 2000: 359–60). In Raminder's case we see the complexities of being a widow within a transnational sphere. She and her husband did not live together in India; but in Tanzania, where they lived together, she holds no residential rights. Had Raminder lived in Britain with her husband, she would have been entitled to a widow's pension, particularly if she had rights of residency and/or if her husband had been engaged in paid work in the UK.

Raminder's experiences thus draw attention to the ways in which gender intersects with the life course, resulting in her moving to Britain to become a carer for her grandchildren. Writing about women in India, Vatuk describes middle age (Raminder's life stage) as being one of relative comfort and a time when women experience greater social and geographical mobility, but this idealised scenario does not necessarily hold either in the subcontinent or in the migratory location, especially if there are no surviving sons.[6] It is Raminder's only child, a married daughter, who provided her with a home and the material resources with which, on her return to Tanzania, she used to perform death anniversary prayers for her husband.[7] Significantly, Raminder's experience draws attention to the dependence of migrant widowed women's rights of residency not just on social norms and custom, but also on the immigration and integration policies of the host countries.

The point at which women and men are in their life course, as Gardner's account of Bengali elders in Tower Hamlets reveals, plays a role in their understandings of places. For example, elderly men and women idealise a return to Bangladesh because of its association with spirituality, but remain in Tower Hamlets owing to their age-related health needs, which are served better in Britain than in Bangladesh. Similarly, for women like Raminder, cultural norms construe her living with her married daughter as deviant. But, though she seeks to be more independent, her welfare is best catered to through kin networks and state support in Britain.

Leaving a Husband

There are significant differences between being widowed and being separated. First, there are no accompanying rituals or visual markers of separation from a spouse, whether for men or women. Although it is common for South Asian men to remarry following widowhood, being separated means that remarriage is not an option for either sex. This situation is not uniform in all national contexts; in Britain if a couple is separated and has not been living with one another for more than five years, one or the other party may file for divorce. At the same time, there can be different degrees of separation, whether through choice or constraint. Couples in and outside South Asia do not necessarily live together in the same locality following marriage. Various factors, including household migration strategies, can mean that the spouses live apart, as is the case with marriages between Sikh men living in East Africa and women living in the Punjab (Mand 2004). A further difference between being widowed or divorced on the one hand, and that of being separated on the other, is the greater stigmatisation of divorce and widowhood.

Rita came to the UK at the age of 18 with her parents, who arranged her marriage to a Sikh man who had been known to the family in East Africa. Following Rita's marriage, her parents returned to Tanzania from where they annually visited her, staying with their married, younger son. Rita's visits to Tanzania were relatively rare, though she usually sent her children to their grandparents over the long summer vacations. This, Rita suggested, was useful because it enabled the children to experience life with their cousins in Tanzania where they 'have more room to play' and 'see wildlife in the game parks'. In England she perceived a lack of facilities and time for the children as both she and her husband work outside the home.[8]

Rita's working life had begun shortly after her migration to the UK, when she joined the civil service. Following her marriage, on her husband's advice, she changed careers to work on a freelance basis. In addition to contributing to the household budget, Rita stated the importance of having her independence in the form of earning a wage:

I've always paid my own way I have never asked Tony for money. Even when I was not working I managed on the child benefit I

go where I want, I went to Africa and paid for mine and the children's tickets, and I bought my own car.

During my fieldwork in Tanzania, Rita was visiting her parents there and was the subject of rumours at the temple about how unhappy she looked, apparently due to a 'problem' with her *admi* (husband). It was during follow-up interviews in the UK that Rita, reflecting on her visit to Tanzania, spoke about a possible separation from her husband and the impossibility of her return to her natal kin in Tanzania. Rita's reason for staying on in Britain focused on her children's educational needs which, while served by the international school in Tanzania in the first instance, would alter as they grew older: 'There are no decent universities in Africa,' according to Rita. Such considerations had been crucial in Rita's decision not to remain in Tanzania. She explained the different factors that went into her decision.

Rita: My parents are very old fashioned. My mum has had a very hard time with my dad, but she believes that you should stick to one person and she says that things will get better. Although times are different for me, my mother's advice is important and I should listen to her. With a divorce, there is always baggage and my mother says that when you have children it is difficult for another marriage. Another man is never able to accept your children as the father does and you have relations with the father in the future, for access and responsibility They [parents] cannot understand—after living their lives with the same ideas, [then] to expect them to change is very difficult.

Kanwal: Did you and your husband know each other before you married?

Rita: Love had developed between me and my husband, although ours was a strict arranged marriage. You see, my parents are old-fashioned and we were not allowed to meet each other alone beforehand. Although I could support myself and the children, I don't think my parents would be able to handle any kind of divorce At the time of marriage, vows are made and marriage is for life The love had grown, but now there are differences. It is when one person does everything, all the giving and the other person does not take on anything Men are selfish

Divorce relates not just to the failure of the couple, but for a woman it is that she is not able to keep her house or hold on to her husband. I admire the women able to work on, knowing that it is not working for them and then to be able to take steps to separate. They are very brave women.

In assessing her experience of marriage, Rita points to the way in which [relations between spouses intertwine with wider social relationships. The breakdown of conjugal relations thus impacts upon wider networks, requiring further 'work' on the part of women as they seek both to reintegrate within their own natal networks and to maintain relations with their husbands and extended kin.]As Simpson (1998: 2) writes of divorce in contemporary Britain:

> Divorce is not simply about endings and fragmentation of once seemingly wholesome chunks of social organisation but it also generates vital continuities Evidence of continuity is to be seen in commitments to ongoing parenting arrangements, the transfer of resources, the re-negotiation of roles and the reordering of patterns of kinship.

Rita's return to Tanzania was under the guise of a visit to her parents with the children; it meant she could leave Britain and her husband and begin to explore the options in her marital situation. The physical separation may also have been a strategy that masked the emotional separation she was experiencing, without publicly acknowledging the tensions in her marriage. As Gardner and Osella (2003: 18) highlight, [movement to other places can be a way in which to avoid 'not only the state but also social relations'.] Nonetheless, in Tanzania, and to some extent also in Britain (notably through the course of our interview), Rita was considering her options even as she continued to live with her husband. In common with other women experiencing marital 'problems', Rita's comments underscore [the presence of children as a reason for staying with a husband: it is assumed to be unlikely that a man will accept another man's children.] Furthermore, with Rita's significant kin networks living outside Britain, divorce could impact her rights of access to the children, given that her husband's family were both more numerous and 'settled' in Britain. Implicit within this is Rita's acknowledgement that her children's needs come first, that divorce carries a stigma for women as well as for children, and

that this stigma can translate into material deprivation if children lose their inheritance.[9]

Rita's narrative also discloses tensions in cultural ideals in the migratory context. For instance, although she had a Sikh wedding, she refers to the 'vows' that are associated with marriage based on the notion of individual, romantic love common in Britain. At the same time, in spite of earning an income and the availability of state support in Britain, Rita's 'choices' are ultimately made in reference to traditional cultural evaluations of marriage, separation and divorce (cf. Kabeer 2000).

Let us now turn to Balbir who is married, but lives apart from her husband from whom she separated over 17 years ago when all three of her children were under the age of 10. Prior to her marriage, Balbir had migrated with her family from Tanzania, residing with them at the home they had purchased in a London borough. On leaving her husband, Balbir turned to her natal kin until the local council housed her and the children, first in bed-and-breakfast accommodation and, eventually, in a council-owned house in the same borough. During interviews Balbir recounted the ways in which she had been 'kept like an animal'. Her husband was physically and mentally abusive, and leaving him had become a necessity 'for her and for the children'. In spite of the length of the separation and with no financial support from her estranged husband, Balbir has taken no formal steps to obtain a divorce through the British judicial system, insisting that there was no need for a formal divorce. In any case, she has been the recipient of state benefits in her role as a lone parent for three children.

In opting for separation rather than divorce (and possible remarriage), Balbir has gained power and an honourable position, enabling her reintegration within her natal household. The decision not to divorce immediately or prosecute her husband was taken against the backdrop of the politicisation of South Asian marriage and migration to Britain. During the 1970s and 1980s marriages involving the subsequent migration of spouses (usually of women) were subject to interrogation under policies like the Primary Purpose Rule, which sought to ascertain whether marriages were genuine or contracted purely for purposes of entry into the UK. When Balbir first came to Britain she held British overseas citizenship that did not give her automatic rights of residence in the UK; according to the rules, she needed to have been married for two years to obtain permanent residency rights. However, in spite of her marital difficulties, Balbir remained married far beyond the minimum two-year period, confirming that community norms remained a significant reference point for Balbir in her negotiation of identity.

At the weddings of her nephew and niece Balbir's ambiguous position of being with/without a husband gave her a certain power. During her nephew's wedding in the Punjab, Balbir visited her estranged husband's ancestral village along with her sister and her brother. Balbir's account of this encounter highlighted the acceptance and warmth of her husband's kin in the Punjab, and also their relative 'backwardness' and poverty in relation to her migratory location. Her natal family and their acquaintances (from Tanzania and Britain), as well as her estranged husband, attended the niece's wedding reception held in Britain. During this reception Balbir asked the video-maker to film her taking a tray of food from the wedding feast to her estranged husband. Amidst much laughter from onlookers, Balbir proceeded to feed her estranged husband with her hand, lowering her eyes before the camera and mockingly evoking the stereotypical image of a young bride. In this way, through her tongue-in-cheek action, Balbir signalled her resistance to the dominant discourses surrounding kin and gender relations (Raheja and Gold 1994).

Conclusion

In the course of this chapter I have drawn upon the experiences of marriage and migration from the perspective of migrant women who are widows, or who seek to separate or are already separated from their husbands. The chapter discusses the ways in which the migration process intersects with stages in women's life course to bring to the fore the dynamic nature of these women's relationships with other household members.

A key to understanding women's experiences of marriage, divorce and separation is the geographic location of their kin networks. For migrant women accessing kin support is mediated not only by cultural norms (as is the case for non-migrant women), but also, importantly, by immigration policies and laws. Being a migrant widow also means that new activities may need to be taken up, resulting in changes in what women do in the public sphere. In Raminder's case we note that living with and being materially supported by a daughter is not an ideal arrangement in South Asia or amongst her peers in the UK, though in fact, like other widowed mothers, Raminder is engaged in an exchange of

support for labour—'invisible' labour—as a carer for her grandchildren. The state fails to acknowledge the central and necessary role played by women like Raminder as carers when both parents are involved in paid labour outside the home. At the same time Raminder does not have the right to claim social welfare until she becomes a citizen, and is classed as a 'dependent' so long as she lives with her daughter. Raminder stayed in Tanzania as the wife of a Tanzanian citizen, while her stay in Britain is based on her identity as a 'dependent' mother. Nevertheless, residence in Britain is preferred by Sikh widowed women like Raminder on account of the social and material support offered by the government.

The experiences of Balbir and Rita challenge the rigid dichotomy between being married or not married. By separating rather than suffering the stigma of a formal divorce, Balbir is able to maintain the moral and social standing of being 'wife' to the man with whom her marriage had been arranged. Balbir could capitalise on the ambiguity of status in being separated but not divorced on account of the location of her kin network nearby and her access to material resources in Britain. By contrast, it was the disjuncture in the location of these resources that made it difficult for Rita to leave her husband.

In combination with cultural and familial norms and networks, the welfare system in Britain plays a significant role in enlarging the options available to women when they seek separation or divorce from their husbands, while the possibility of engaging in paid labour in Britain also enables Sikh women to consider the option of separation and divorce. In the process, as in the cases of Raminder, Balbir and Rita, we can see a shift in women's identities as their marital situations alter from the role of wife to that of mothers. This is why it is important from a gender perspective to analyse marriage and migration across life course stages, as well as in relation to both social norms and state policies.

Acknowledgements

This chapter is based on my D.Phil. research, which looked into the role of women in the establishment of Sikh households in Britain, Tanzania and Punjab in India. Women's activities and networks are shown to be central in the establishment and maintenance of transnational households. Using participant observation and oral histories across three geographical sites, the thesis illustrates the centrality of place and gender in understanding transnational lives.

Notes

1 I would like to thank the women for sharing with me stories that were often painful.
2 The marriage had taken place in spite of her husband's family knowing of the situation.
3 There are numerous writings on divorce, for example, among Gujaratis (Prinja 1999), Sikhs (Jhutti 1998) and Bangladeshis (Gavron 1997), and on differences between Hindus and Muslims (Becher and Husain 2003).
4 To collect money a fellow Sikh businessman owed her husband.
5 In my dissertation (Mand 2004), I look into women's migration for purposes of education and, in addition, to marriage migration.
6 One elderly woman in my sample was supported by social services in Britain, although her sons actually lived in the neighbourhood.
7 This took place during my fieldwork, four years after his death.
8 Sending children abroad also gives women a break.
9 The stigma associated with divorce is, however, changing amongst second-generation South Asian women in Britain. Mediating factors are their socio-economic position and the presence of supportive kin networks.

References

Ballard, R. 1990. 'Migration and Kinship: The Differential Effect of Marriage Rules on the Processes of Punjabi Migration to Britain', in C. Clarke, C. Peach and S. Vertovec (eds), *South Asians Overseas: Migration and Ethnicity*, pp. 219–49. Cambridge: Cambridge University Press.

———. 1994. 'Differentiation and Disjunction among the Sikhs', in R. Ballard (ed.), *Desh Pardesh: The South Asian Presence in Britain*, pp. 88–116. London: Hurst.

Ballard, R. and C. Ballard. 1977. 'The Sikhs: The Development of South Asian Settlements in Britain', in J.L. Watson (ed.), *Between Two Cultures*, pp. 21–56. Oxford: Basil Blackwell.

Bhachu, P. 1985. *Twice Migrants: East African Sikh Settlers in Britain*. London: Tavistock.

———. 1988. '*Apni Marzi Kardhi*: Home and Work: Sikh Women in Britain', in S. Westwood, and P. Bhachu (eds), *Enterprising Women: Ethnicity, Economy and Gender Relations*, pp. 76–102. London and New York: Routledge.

———. 1991. 'Culture, Ethnicity and Class among Punjabi Women in 1990s Britain', *New Community*, 17 (3): 401–12.

Becher, H. and F. Husain. 2003. *Supporting Minority Ethnic Families: South Asian Hindus and Muslims in Britain—Developments in Family Support*. London: National Family and Parenting Institute.

Chen, M.A. 2000. *Perpetual Mourning: Widowhood in Rural India*. New Delhi: Oxford University Press.

Gardner, K. 2002. *Age, Narrative, Migration: The Life Course and Life Histories of Bengali Elders in London*. Oxford: Berg.

Gardner, K. and F. Osella. 2003. 'Migration, Modernity and Social Transformation in South Asia: An Overview', *Contributions to Indian Sociology*, 37 (1&2): v–xxviii.

Gavron, K. 1997. 'Migrants to Citizens: Changing Orientations among Bangladeshis of Tower Hamlets'. Ph.D. dissertation, London School of Economics.

Gell, S. 1994. 'Legality and Ethnicity', *Critique of Anthropology*, 14 (4): 335–92.

Hershman, P. 1981. *Punjabi Kinship and Marriage.* Delhi: Hindustan Publishing Corporation.

Jhutti, J. 1998. 'A Study of Changes in Marriage Practices among the Sikhs of Britain'. Ph.D. dissertation, Wolfson College, Oxford.

Kabeer, N. 2000. *The Power to Choose: Bangladeshi Women and Labour Market Decisions in London and Dhaka.* London and New York: Verso.

Kandiyoti, D. 1997. 'Bargaining with Patriarchy', in N. Visvanathan (ed.), *The Women, Gender and Development Reader*, pp. 86–92. London: Zed Press.

Lamb, S. 2000. *White Saris and Sweet Mangoes: Aging, Gender and Body in North India.* Los Angeles and London: University of California Press.

Mand, K. 2002. 'Place, Gender, Power in Transnational Sikh Marriages', *Global Networks: A Journal of Transnational Affairs*, 2 (3): 233–48.

———. 2004. 'Gendered Places, Transnational Lives: Sikh Women in Tanzania, Britain and Indian Punjab'. Ph.D. dissertation, University of Sussex.

Nagar, R. 1995. 'Making and Breaking Boundaries: Identity Politics among South Asians in Post Colonial Dar es Salaam'. Ph.D. dissertation, University of Minnesota.

Parry, J. 1979. *Caste and Kinship in Kangra.* London: Routledge and Kegan Paul.

Prinja, S. 1999. 'With a View to Marriage: Hindu Gujaratis in London'. Ph.D. dissertation; London School of Economics.

Raheja, G. and A. Gold. 1994. *Listen to the Heron's Words: Reimagining Gender and Kinship in North India.* Berkeley: University of California Press.

Sachdeva, S. 1993. *The Primary Purpose Rule in British Immigration Law*, GEMS, No. 1. London: Trentham Books and the School of Oriental and Asian Studies.

Shaw, A. 2000. *Kinship and Continuity: Pakistani Families in Britain.* Amsterdam: Harwood Academic Press.

Simpson, B. 1998. *An Ethnographic Approach to Divorce and Separation.* London: Berg.

Vatuk, S. 1990. 'To be a Burden on Others: Dependency Anxiety amongst the Elderly in India', in O. Lynch (ed.), *Divine Passions: The Social Construction of Emotion in India*, pp. 64–88. Berkeley: University of California Press.

———. 1995. 'The Indian Woman in Later Life: Some Social and Cultural Considerations', in M. Das Gupta and L.C. Chen (eds), *Women's Health in India: Risk and Vulnerability*, pp. 289–306. Mumbai: Oxford University Press.

Vlasoff, C. 1990. 'The Value of Sons in an Indian Village: How Widows See It', *Population Studies*, 44: 5–20.

12

Domestic Violence and the Indian Diaspora in the United States

Margaret Abraham

It is only in the last two decades that the issue of domestic violence in the Indian immigrant community in the United States has received attention.[1] It is also in the last two decades that the Indian population in the United States has increased significantly. Today, the Indian diaspora in the United States is quite large and diverse in terms of education, occupation, income, region of origin, religion, etc. One of the most important factors affecting the size, growth, composition, and distribution of the Asian Indian population[2] in the United States is immigration (Barringer et al. 1993). Between 1990 and 2000 the Asian Indian population more than doubled to 815,447.[3] In the 2000 census the Asian Indian population was counted at 1,678,765, this being the largest increase for the Asian Indian community. Asian Indians account for 0.6 per cent of the United States' population (total US population is 281,421,906) and for 16.4 per cent of the Asian American community, being the third largest after the Chinese and Filipino communities. In the 1990 census Asian Indians were the 12th highest of the foreign born, but in the 2000 census they jumped to fourth place. The New York metropolitan area has over 400,000 Asian Indians, with the New York in-state population accounting for 251,724. This growing population is represented not just in population figures, but in the more visible forms of greater numbers of Indian (and Pakistani and Bangladeshi) stores, restaurants, Websites, events, cultural performances, ethnic newspapers, cultural and social organisations and, more recently, political lobbying.

Migration clearly accounts for a large percentage of the increase in the Asian Indian population, and the profile of the current Asian Indian

population is largely an outcome of immigration policies and practices. For most immigrants, including Asian Indians, gender, class and ethnic relations get reshaped as women and men adapt to life in a foreign country. In her study of Asian American women and men, Yen Lee Espiritu (1997: 8) points out that through the immigration and settlement process, 'patriarchal relations undergo continual renegotiating as women and men build their lives in a new country'. Hence, immigration policies and practices that have shaped the current profile of the Indian diaspora also factor into immigrant women's experiences of domestic violence.

Although some Indians migrated to the United States to work on the railroads and in agriculture at the turn of the 20th century, it was primarily the 1965 Immigration Act that set the stage for the growth of an Indian diaspora in the United States. The 1965 Immigration Act resulted in a shift from the previous racial and ethnic foci of the immigration law to a greater emphasis on the notion of family unity on the one hand, and meeting the growing and shifting demands of the United States economy on the other. It stipulated occupational preferences to address the labour demands of the American economy. This had a major impact on Indians, many of whom immigrated under the high preference, third category of occupations, namely, that of professionals and scientists.

A Model Minority, Immigration and Domestic Violence

Prior to the mid-1970s, the Indian diaspora was composed primarily of highly qualified individuals, culturally bound to their homeland and families in India, but seeking the opportunities for professional growth and economic success that they felt were lacking then in India (Khandelwal 2003). As members of a small community with a history of colonisation in their own native country, these Indian immigrants carried their own notions of racial and ethnic boundaries, and many bought into the distorted stereotypes of African Americans set by the dominant white society. Investing in the image of a 'successful, hard-working, family-oriented' community in an attempt at upward group mobility, these Indian immigrants of the 1960s and 1970s effectively used avoidance and identity disassociation strategies towards other minorities they perceived as unsuccessful. As a result, the profile of

the Indian community up to the 1990s was that of a 'model minority' (Abraham 2000), that is, a minority group whose members adhere to the valued principle of economic success in the public sphere, while retaining strong cultural values such as family harmony and solidarity in the private sphere.

In 1986 the Immigration Marriage Fraud Amendments (IMFA) were passed, questioning the legitimacy of immigrant marriages and requiring proof that an alien was 'bona fide' through evidence that the marriage had lasted at least two years. The Immigration and Naturalisation Service would only provide a 'conditional' resident status until the completion of two years of marriage. While there were some very limited waivers for abused immigrant women, in general these were extremely hard to attain, making it hard for Indian women to leave an abusive marriage for fear of deportation.

In the 1980s and 1990s the immigration of many sponsored relatives of previous Indian immigrants brought about considerable variation within the community along dimensions such as education, occupation, class and gender experiences. The result was 'chain migration', whereby Indian immigrants became United States citizens and sponsored their relatives, who in turn sponsored other relatives to migrate to the United States. Hence, the demographic composition of the Indian diaspora in the United States in the 1990s changed as immigrants availed themselves of the principle of family reunification in the 1965 Immigration Act. Despite this increasing heterogeneity and diversity of Indian immigrant women's and men's experiences in the 1980s and 1990s, segments of the Indian community continued to hold on to the image of a model minority and tended to avoid acknowledging any issue that would erode this public image of the community. This meant denying the existence of domestic violence, poverty, homosexuality, HIV/AIDS and substance abuse within the Indian community, as none of these fit into the concept of the model minority.

Inattention to social issues, particularly gender- and class-related issues, contributed to the emergence in the 1980s of South Asian women's organisations (SAWOs) that challenged the model minority image. These organisations, though varied in structure, ideology and organisational strategies, began to address the problems faced by women in their community, while also fighting forms of structured inequality, such as, discriminatory immigration laws that indirectly contribute to violence against women. Addressing domestic violence among South Asians, including the relatively large Indian community, became a

focal point of mobilisation for women in some of these organisations. Special attention was paid to the role of immigration status in women's experiences of domestic violence. In the late 1980s and through the 1990s, some of these SAWOs joined forces with other organisations to address setbacks in immigration laws and to provide some relief for abused immigrant women in the immigration laws.

In 1990 pressure from immigrant rights groups and domestic violence organisations led to the passing of the 1990 Immigration Act. This Act provided a slight improvement in legal protection for abused, immigrant, dependent spouses and removed some of the obstacles from the 1986 IMFA. These steps were still inadequate and various organisations within immigrant rights coalitions sought better provisions. The result was the Violence Against Women Act (VAWA), passed in 1994. Under certain conditions, this Act allows an abused, immigrant woman to 'self-petition' for unconditional permanent resident status for herself and her children without depending on the sponsorship of her citizen or Lawful Permanent Resident (LPR) spouse. The Violence Against Women Act 2000 includes more provisions for battered immigrant women and places a greater emphasis on the criminal justice response to domestic violence. However, these laws have not been entirely effective due to deficiencies in legislation and restrictive regulations. Lack of appropriate state support in terms of housing and public assistance for abused immigrant women has been a major impediment to the effective implementation of VAWA provisions.

More recently, the post-September 11 anxiety regarding racial profiling and discrimination and anti-Islamic sentiments has created a sense of fear of accessing government agencies in the South Asian community, particularly among undocumented individuals. The Patriot Act 2001 (26 October 2001), passed in response to the attacks of 11 September 2001, has been a setback, both for the immigrant community and for the movement against domestic violence. This Act gives the government immense authority to track and intercept communications. It allows the government to detain individuals without access to a lawyer and without being charged with a crime. It monitors individuals' political and religious activities and allows for the deportation of resident aliens perceived as threats to national security. These draconian measures have had a negative impact on immigrant rights and the Indian diaspora. In the context of domestic violence, the Patriot Act potentially deters abused immigrant women from seeking help or reporting incidents of domestic violence for fear of deportation or negative consequences for their families. According to Purvi Shah of Sakhi for South Asian Women:

September 11th chilled survivors of violence from speaking out. At Sakhi we noticed that our helpline went nearly silent following the tragic events of September 11. South Asian women feared bias attacks and racism and did not feel safe coming forward to access the courts or social services. They did not believe they would be treated with respect or believed. In addition, women subsumed their own trauma of violence to the trauma of loss the city and country dealt with. The violence in their homes and lives became secondary to the spectacular national violence we witnessed. Not until January 2002 did our call volume pick up.

In addition, we at Sakhi had to inform women about special registration and the impacts that may result if women disclosed abuse. Women feared the police—and from our own experience we knew that women had reason to do so. While women want abuse to stop, they do not necessarily want their abusers to be deported. Who would want the economic breadwinner of a family to be sent away? The anti-immigrant context has not enabled South Asian women to be safe—in fact, it prevents them from accessing justice.[4]

Even though Indians were not included in the special registration, abused Indian women also feared the police and its indirect consequences. It is ironic that at a time when the women's movement has made some strides in addressing domestic violence, the overall political climate in the United States has become more anti-immigrant, indirectly setting back some of the previous gains in efforts to end violence against immigrant women.

Cultural Identity, Family Values and Gender

Just as immigration regulations contribute to domestic violence for Indian immigrant women, so do certain notions of community cultural identity as constructed by the Indian diaspora in the United States. According to Jean Bacon (1996: 17): 'When immigrants arrive in America, they carry with them a worldview grounded in their culture of origin. Likewise, people born and raised as Americans share an understanding

of an American worldview. These two worldviews may be radically different, compelling immigrants to adjust and reconfigure aspects of their own as and when needed. For Indian immigrants, this worldview involves notions of marriage and the family as these are thought to exist in India in contrast to the United States. Despite considerable change in family practices in India, many segments of the Indian diaspora see *the family* as the focal point for their experience of cultural identity and for preserving the ties between 'back home' and the United States.

Marriage and family are important both in the United States and in India, and the relationship between class, race, ethnicity, sexuality and patriarchy is complex and diverse in both contexts. In both countries, there is a sense of cultural pressure to get married at a normatively defined appropriate age and to be part of the normative family. Both societies attribute high value to marriage and have various explicit and implicit criteria that influence societal notions of what constitutes an ideal family (Zinn and Eitzen 1990). Similarly, in both societies various myths and images of the family are constructed that support the interests of the powerful, two of them being the notions of 'family unity' and 'family harmony'. However, as noted, for the Indian diaspora, marriage and family are also seen as points of difference between mainstream American society and Indian society. A major difference in the context of marriage and family is perceived to be the emphasis in Indian culture on the 'collective' interest, as opposed to the greater emphasis on 'individual' interest in the United States. Indian immigrants tend to consider themselves as much more aware than mainstream Americans of the need to put the interests of the family and collective well-being before individual needs.

Marriage to 'our own' is thus perceived by the Indian diaspora in the United States as an important mechanism for maintaining the 'values, beliefs and practices' that define 'us' (Asian Indians) as a model minority. This need to marry within 'one's own community' is also linked to notions of differences in the values and attitudes of 'American people' towards marriage, family responsibilities and divorce. The underlying assumption is that while Indian immigrants may adopt individualist economic values, the retention of Indian cultural values such as 'respect', 'honour', 'shame', 'sacrifice' and placing the 'interest of the family before oneself' provides Asian Indians the stability needed for achieving economic success while guarding against the lack of family solidarity or the 'immoral' values of the West. Such notions ignore the dynamic dimension of cultural change, both in India and the United States.

In this narrowly defined understanding of [cultural authenticity, Indian immigrant women in the United States are the main symbols of cultural continuity. There are both external and internal pressures on them to uphold culture in specific ways, including adhering to culturally prescribed gender roles, despite the reality of changing gender relations in India itself. Through marriage and the maintenance of family unity, the Indian woman becomes responsible not only for family honour, but also for the honour of the Indian community in a foreign society, where immigrants perceive that there is an erosion of family values and a low level of morality. For example, Indians pride themselves on having lower rates of divorce as an indicator of their strong family values and superior morality as compared to Americans. Bix Gabriel of Sakhi for South Asian Women notes: 'As immigrant women in the US, we sometimes take on the responsibility of upholding the image of the "culture", to the mainstream world as well as our immediate immigrant communities.'[5]

For Indian immigrants, racial and class divides in the United States also make it difficult to marry outside their ethnic group. This is compounded by a need to maintain the immigrants' cultural identity and ensure cultural continuity. Most immigrants find that they are caught between their perceptions of the cultural values of their home country and those of the country to which they have relocated. For Indians this conflict is especially visible in the context of marriage.

Forms of Marriage and Violence

Caught in a bind between what are construed as opposed notions of marriage and family, some Indian immigrants return to India to get married; yet others place matrimonial advertisements in ethnic newspapers or make contacts through personal networks and at various ethnic cultural functions of the immigrant community in the United States. Characteristic forms of marriage among Indian immigrants include: (*a*) transnational arranged marriage where the groom seeks a bride from India; (*b*) transnational arranged marriage where the bride seeks a groom from India; (*c*) love marriage, whether transnational or among Indian immigrants within the United States; (*d*) arranged marriage amongst Indian immigrants within the United States; and (*e*) inter-ethnic and interracial marriage. Based on my previous research,

I shall discuss the first three forms and how they factor into women's experiences of marital violence.

In the transnational arranged marriage, where the groom seeks a bride from India, the Indian man in the United States returns to India to marry an Indian woman, usually selected with the help of family members and friends. The underlying premise is that women raised in India will be socialised with strong Indian values, especially around gender relations, and thus better than their Western or Americanised counterparts at promoting family stability and unity. Since issues of sexuality are linked to morality in defining Indian women, many Indian men in the US prefer to marry women from their home country on the assumption that 'Americanised' Indian women will be sexually more promiscuous and independent compared to women raised in India. Often, a groom's concept of a marriage is based on his parents' marriage or their notions of the Indian wife. Talking about Indian men in an issue of *India Today* (1998), Shamita Das Dasgupta says: 'Indian men want their women to be more docile, more passive.' In the same issue, Sital Kalantry writes of men who return to India to seek a more accommodating wife: 'Many Indian men who grew up here were raised by Indian mothers who gave them certain ideas about how things are supposed to be.' Often the images held by immigrant men of Indian women living in India are similar to Western men's choices of 'picture brides' from Asia (Narayan 1995).

In these transnational marriages the match is often mediated by a third party such as a relative or a friend. Sometimes it is done through a 'marriage broker' or through matrimonial advertisements in newspapers. The wording of the advertisement is seen as vital to marketability. Photographs, religion, ethnic group within India, education, colour and family values are all important factors in determining the initial contact between prospective brides and grooms. The groom comes to India to meet the potential bride and, based on the above factors, decides whether or not to marry her. While both women and men may say no to a marriage, for some of the women whom I interviewed, the pressure to get married made it socially difficult to refuse the proposal once the groom had agreed.

Many South Asian men from the US who come to South Asia to marry, perceive themselves as very eligible on account of their location. They come to marry women from their own community who they think will fit the image of the traditional South Asian woman, or who represent 'a good blend of Eastern and Western values'. Since the men come for an

extremely short visit with the express intention of getting married, the whole matchmaking process is done quickly with the help of parents, relatives or friends. There is little or no time for the man or woman to really get to know each other before deciding to marry. Shortage of time and other constraints result in minimal information about the prospective bride or groom, and most of the background work, if any, is done by family and friends. Such inadequate information may later contribute to marital abuse. There is also frequently a mismatch between the woman and man's expectations of each other, particularly the latter's expectation of what the wife's attitude, behaviour and responses to her husband and his family should be. In some cases, these gender role assumptions take the form of power and control by the husband over the wife.

While a large number of such transnational arranged marriages are successful, the practices around such marriages, the assumptions of compulsory heterosexuality, and the control exercised by the husband or his family can make the marital experience extremely oppressive for women. This is particularly the case if they have come to the United States as dependent immigrants, with almost no support structure of their own.

Both structural and cultural factors contribute to the marital abuse that may arise from transnational arranged marriages where the bride is a Green Card holder and returns to her home country to marry an Indian groom. In particular, a husband whose wife is a Green Card sponsor may perceive his traditional notions of male superiority to be undermined[6], and use violence as a means to assert or regain a sense of dominance. This violence may occur either prior to the husband getting a Green Card or, once he has got it, if he feels confident that abusing his wife can no longer jeopardise his legal status in the United States.

Other scholars have also pointed out that among Asian immigrants both women's and men's sense of independence and well-being is under considerable pressure from shifting gender roles and expectations within the immigrant marriage, leading thereby to a higher incidence of abuse (Espiritu 1997: 75; Luu 1989: 68). The institutional, class and ethnic structure of the US does not provide ethnic minority men much opportunity to exercise power in the public realm compared to white, middle-class men. Given the Indian cultural milieu and the structural isolation that immigrants experience in the US, dependent husbands may justify their violence against their wives as stemming from frustration at their ethnic or class disempowerment in the US. However, in my interviews wife abuse seemed to be used as a mechanism to reassert

loss of status and power in a situation where the woman as the sponsor was perceived as having power over her dependent husband.

Why do immigrant women residing in the States 'go back to India' to marry? Though similar in many ways to the men who return, there are some important differences. For men, as noted, a key factor in returning to their country of origin to marry is the desire to find an Indian woman who fits the 'traditional mould'. For women the situation is more complicated, for marriage is seen as enhancing her social status. In addition, many Indian women face pressure to get married to someone from their own community due to the expectations of their immigrant parents and relatives around notions of marriage, culture and community. Some women have led relatively sheltered lives even in the United States and, compared to Indian men, have not had as many opportunities for dating or developing serious relationships, either within or outside the community. Further, many immigrant women who return to India to get married have usually migrated to the US at a later stage in their lives, as a result of chain migration, or come as students; having already spent some time in their countries of origin, they tend to accept the more conservative, patriarchal and rigid family practices that their parents still uphold. The socialisation process within the family, cultural factors and structural constraints combine to persuade immigrant women that marrying within their own community is the best for a long-term commitment, for fulfilling their duty to their parents, and for the future of their own children.

While arranged marriages are the norm, 'love' marriages are increasing among the second-generation (first generation of US born) Indian diaspora in the United States. Love marriages are those where the woman and man date each other and take their own decision to marry. These marriages are problematic in several ways. Given the norm of arranged marriages in Indian culture, the abused woman often feels that she is solely to blame for her choice of partner, that she is partially responsible for her situation, or that significant others will view her predicament in this light.[7]

More recently, changes in technology have modified some of the ways in which Indians find marriage partners, including through matrimonial Websites such as Shaadi.com, and *India Abroad*. However, most marriages among the Indian diaspora still tend to be within the broader Indian community and often involve a spouse from India itself. In general, some form of *'arranged'* or *'introduced'* or *'modern arranged'* marriage (where the woman and man go out socially with each other

for a while before they decide to marry) remains the pattern for Indian immigrants, though there is now a greater acceptance among Asian Indian families of marriage with an Indian (born in India, abroad or in the US) of a different caste or regional background. Given the current size of the Asian Indian population in the United States and the coming of age of second-generation Asian Indian women, an increasing number of marriages are taking place between Indians living in the United States. These include both arranged and love marriages. While there are no statistics on this, anecdotal evidence indicates a slight increase in inter-racial marriages among Indian Americans born in the United States, though it is still frowned upon by large sections of the community.

All these factors—the persistence and reconfiguration of marriage patterns, the perceived cultural dissonance between notions of marriage in American society as compared to those in India, and structural factors surrounding immigration—contribute to the complexity of domestic violence experienced by Indian immigrants. In addition, the divisive ethnic, race and class relations that shape marriage and family in the US not only encourage intra-ethnic marriage, but also contribute to the reconfiguration of marital relations in the immigrant context.

Domestic/Marital Violence

How, then, is domestic violence experienced by Indian women in the diaspora? One of the most important aspects is in relation to immigration issues and the fear of deportation. Although some Indian women migrate independently, many come into the United States as spouses of US citizens or Lawful Permanent Residents (LPR). Prior to the passage of VAWA in 1994, this legal dependency often placed the husband in a position of dominance and control over his wife, since women who left an abusive marriage prior to attaining a Green Card might be faced with the loss of legal immigration status and possible deportation. Today, while there have been some legal provisions on behalf of abused immigrant women, immigration issues continue to pose a problem, particularly for women on the H-4 visa.[8] As Purvi Shah has noted:

> The context of immigration is critical when examining domestic violence in the South Asian diaspora. For those of us in the movement

in the United States, we realise that women, who may have strong support structures (friends, family, and awareness of resources) in their home countries, are often surrounded only by the abuser's family in the United States. This makes women more vulnerable, especially those women who are unaware of their legal rights and have limited English proficiency. In addition, immigration laws often serve as a barrier for women seeking safety. In particular, women on an H-4 visa are bound to their abuser and face a lack of legal remedies. No one, including immigrant women, should be subject to abuse.[9]

Isolation is another extremely important aspect of domestic violence in the Indian diaspora. For Indian immigrant women, especially recent immigrants who come to the United States as dependent spouses, isolation is one of the most painful manifestations of the domestic violence perpetrated against them. In perception and in reality, a woman feels that she is emotionally and socially alone, economically constrained and culturally disconnected. This feeling, and fact, of not belonging are reflected in the woman's poor relationship with her spouse and her lack of social interaction with the extended family, friends and the community. Tanvi Tripathi, working with abused women, says:

> Not having friends or family to go to in times of need is extremely isolating for immigrant women. I believe that the sense of isolation, the pressure to keep violence a secret in the family is much more prevalent for immigrant women here in the US, because these women are frequently on their own without family support and are not sure about the reaction of their community.[10]

The isolation tactics used by the abuser include limiting the woman's spatial mobility, not providing her with access to a bank account, creating all forms of financial dependency, and preventing her from contacting friends and family, even to the point of locking her within the home. For some abused immigrant women the language barrier and gender constraints compound the sense of isolation, which is further increased by the structure of American society, where class, race and ethnic divisions leave little room for social interaction in the complex realities of people's day-to-day experiences. All of this makes domestic violence within the immigrant community appear non-existent. More recently, as noted, the fear of anti-immigrant sentiment has exacerbated this sense of isolation.

⌊Physical abuse and sexual abuse are two other manifestations of marital violence for immigrant women. Physical abuse ranges from pushing and shoving to punching, hitting with the hand and/or with objects. Frequently the bruises are in places where they are not publicly visible. Sexual abuse is manifested through marital rape and through controlling a woman's reproductive rights, as well as in the abuser showing his power and control by having sexual relations outside marriage, making his wife feel sexually and interpersonally inadequate (Raj and Silverman 2002, 2003). Frequently, the abuser's knowledge that the woman is isolated and that he has no social accountability exacerbates the situation.

In most cases intimidation is an integral part of domestic violence. Recent immigrant women feel particularly vulnerable when they have no support system, when the abuser threatens to abandon them, creates problems for their family back home, or, in cases where children are involved, threatens to take them away from the wife or otherwise harm them. A domestic violence survivor says:

> I was with him for 11 long years. I had just finished my law degree when I first moved and had hoped to study further and find a job. But he didn't want me to work. We lived in the suburbs, surrounded by his friends, friends whom we knew as a couple—who thought he was this wonderful, loving, generous human being. All that time he constantly insulted me, and bullied my son and me into doing things that we just didn't want to do. If we didn't, he would fly into a rage. We were both terrified of him. My family in India told me to compromise and stay with him. In the last two years, he would scream obscenities and hit me—with our young son of 5 as witness. When I decided to leave him, Sakhi and the Nassau Coalition helped me find a place in a shelter with my son. I have been coming to Sakhi's monthly support group and that gives me a lot of strength—to know that I am not alone. And most importantly I am discovering who the real me is, and not just the person who was fulfilling his wishes.[11]

⌊The role of family and community is also important in immigrant women's experiences of domestic violence. In the United States marriage is viewed as a relation between two individuals; by extension, domestic violence is attributed to spouses or intimate partners. Within the Indian diaspora, however, the phenomenon is more complex. Cultural values regarding age and gender and relationship-based hierarchies are used by the husband and his family in the United States as a mechanism of power⌋

and control. Immigrant women whose husbands have family members in the United States, but who themselves come as dependents with no local family support, find themselves more vulnerable to abuse from the husband and his family. The social costs of perpetrating domestic violence are reduced and there is little pressure on the abuser's family to be socially accountable. In an important reconfiguration of family power relations in the US context, rather than the parents-in-law, it is frequently the husband's siblings or family members with economic power and/or those who have played a pivotal role in sponsoring family members to migrate who are in a position to perpetrate violence.

The Indian diaspora's investment in the model minority image has also played a role in women's experiences of domestic violence. For many years the community's emphasis on images such as family harmony and model minority meant silence and denial of the existence of domestic violence in the community. This had major consequences for abused women who felt they could not speak 'the unspeakable'— that is, of their experiences of domestic violence. Oisika Chakrabarti explains the challenges within the community:

> For many non-profit organisations, reaching the lower-income, new immigrant Indian community is challenging. Painted by a 'model-minority' brush, the lower-income members of the group are often ignored. Even community leaders prefer to project themselves as the prosperous, thriving immigrant group and refuse to acknowledge the daily challenges of discrimination, harassment, domestic violence and unemployment faced by them. They often suggest that this is faced only by the newer immigrant groups like those from Pakistan and Bangladesh.[12]

The situation is further complicated by the class divisions and informal work relations within the Indian diaspora. Domestic violence is not only within the home between members of the family, but extends to some of the immigrant women who work as domestic workers in the homes of wealthier members of the community and to some of the women who are compelled to seek work illegally. Tanvi Tripathi points out:

> Many of the women who call us do not have access to economic opportunity or have to work illegally. These women frequently find that they face exploitation and discrimination in their workplace. The situation is made more complex as their employers are frequently people within the Indian community.

⎣ Finally, the police and the courts also exacerbate women's experiences of domestic violence through racial, gender and cultural stereotyping (Abraham 2000). The abuse of immigrant women is compounded when the police, courts and the Department of Health are unresponsive or collude with government agencies such as the Immigration and Naturalisation Services. Issues such as lack of official language interpreters in court, ethnic and class biases, and lack of cultural sensitivity in the institutional response can deter women from seeking institutional support to end domestic violence.

Abused women often feel compelled to stay in an abusive relationship since they are economically dependent and cannot easily access public benefits and alternative housing.⎦ The magnitude of the problem and the growing need for services for South Asian immigrant women is attested by Tuhina De O'Connor of the New York Asian Women's Center, one of the earliest community-based organisations and the sole domestic violence shelter programme in New York City that focuses on the diverse needs of the Asian community. She says:

> For the last five years, the New York Asian Women's Center has been offering services to clients of South Asian descent, because no other agency in New York State could offer such emergency shelter. While we had been sheltering a few families over the years at Sakhi's or Manavi's request, we did not have the language/cultural experience to offer the ideal services to these clients. Today, the Center is proud to offer services in five South Asian languages. Approximately 10 out of the 50 employees at the Center and 12 per cent of the clients served are South Asian. Given that South Asians are the most rapidly growing population in the city, we expect that our demand will concurrently increase. The South Asian communities need to be made aware of these 'private' abuses and learn to be more supportive of the women who have the courage to seek help.[13]

While there are no national/state statistics for domestic violence cases among South Asians in the United States, and there is considerable underreporting, we can still get some sense of the problem from the number of calls and cases that Sakhi has received. Over the past 15 years Sakhi has assisted more than 4,700 survivors of violence. Between 2000 and 2003, Sakhi received 1,385 domestic violence related calls and e-mails (Sakhi for South Asian Women 2004). Of these calls/e-mails, 740 were from women of Indian origin and 73 Indo-Caribbean (see Table 12.1). From 1 January through 31 August 2004, Sakhi received 341

domestic-violence-related calls and e-mails. Of these 166 and 15 were from women of Indian and Indo-Caribbean origin respectively. These statistics indicate that domestic violence is prevalent in the Indian diaspora, and that an increasing number of abused women are now seeking help.

Table 12.1 Domestic Violence Statistics, 2000–2004

Year	2000	2001	2002	2003	2004[†]	Total
Total number of DV-related calls/e-mails	285[††]	209*	433*	458*	341*	1,726
E-mails	26	13	41	54		134
Calls from women who have contacted Sakhi previously**	38	12				50
Non-South Asian Women	16	2	19	15	5	57
Indian origin	157	122	227	234	166	906
Pakistani origin	55	37	78	69	52	291
Bangladeshi origin	40	23	58	66	58	245
Sri Lankan origin	1	0	3	0	4	8
Nepali origin	1	0	1	1	3	6
Afghani origin				4	1	5
Burmese origin				2	0	2
Indo-Caribbean origin	14	11	23	25	15	88
Country unknown	1	4	24	42	55	126

Sources: Table compiled by author from annual data provided by Tanvi Tripathi, Domestic Violence Program Director, Sakhi for South Asian Women, Spring 2004; and from Sakhi's 'What Creates Change?', commemorative programme booklet from the 2004 annual benefit gala.

Notes: [†] 2004 numbers are from 1 January to 31 August 2004.
[††] Reflects only new calls received and does not include five calls specifically related to rape/sexual assault perpetrated by someone other than the intimate partner.
* Does not include women Sakhi is already working with.
** Reflects survivors calling after a gap of six months or more.

Addressing Domestic Violence: Sakhi for South Asian Women

A discussion of domestic violence in the Indian diaspora in the US would be incomplete without reference to the strategies of resistance that abused immigrant women use. Often the image of abused immigrant women in mainstream American society is that they are docile or passive

in response to the abuse perpetrated against them. This is clearly not the case, as seen in the words of a domestic violence survivor:

> I came to this country three years ago. I had a typical modern arranged marriage; I had met my prospective husband a number of times before the wedding. Members of my family had visited his family to ascertain their wealth and status, if not anything else. We had a big wedding reception in New Delhi. Soon afterwards, I left India and joined my husband in New York. My nightmare began from the time I stepped into his apartment. When I walked out, the first thing he did was to threaten my family. He said things would be very unsafe for me if I stayed in America. I told him and everyone else that I would not run away like a coward; I would not allow one man to drive me away from a country. He repeatedly told me that if I did not do as he asked, he would have me deported, that I could only stay in this country as long as I was married to him. He would show me letters that he was writing to the Immigration and Naturalisation Service. I walked the streets in a daze, afraid that I would be arrested any moment. I was making very little money. My husband knew that I had no friends or relatives in America; he was waiting for me to go back to him. But I had made a promise to myself. I would live with self-respect and dignity. I would not be subject to humiliation and abuse. Surely there was something better in life. Now I have a better job. A few good friends. I visit my family regularly. I know that I have a right to live in this country and be happy. I am a middle-aged woman, and if I can leave and live with peace at this stage in my life, I know you can too.[14]

Despite the numerous constraints they face, many abused immigrant women use multiple strategies to reduce or end the violence. These include: (a) *individual strategies*, such as, talking, promising, hiding, avoiding, passive or aggressive defence; (b) *using informal sources* of help, such as, family members, neighbours and friends; and (c) *using formal sources* of help, such as, the police, social service agencies, shelters, and lawyers and the court system.

In a span of 20 years, many SAWOs have been established as a part of a growing social movement to address the problem of violence against women in their communities. These include Sakhi for South Asian Women in New York, Manavi in New Jersey, SEWAA (Service and Education for Women Against Abuse) in Philadelphia, Apna Ghar in Chicago, Saheli and Daya in Texas, Sneha in Connecticut,

Chaya in Seattle, Maitri and Narika in California, Asha in Washington DC and many more in other parts of the US.

[Over the years Sakhi has emphasised the importance of the community and policy issues in addressing domestic violence through its programme areas on community outreach, education and policy. The organisation conducts workshops on domestic violence, and participates in community events and festivals, annual parades and celebrations where large numbers of the South Asian community congregate] Each spring they organise an annual 'March Against Violence' in Jackson Heights, Queens, with its large South Asian immigrant population, and distribute leaflets in ethnic neighbourhoods.

[An important strategy has also been to use the media as an outreach tool.] Sakhi gives interviews to the ethnic and mainstream media, publishes a newsletter, *Voices of Sakhi*, which reaches over 6,000 individuals, and has made videos for presentation to various audiences. As one Sakhi coordinator told me:

> I think part of the power of Sakhi's videos is in giving domestic violence a face that looks and sounds and talks like us. The women who speak in the videos come off as stronger for having named the abuse, yet representative of our mothers, sisters, daughters, selves. I noticed that using the videos has sometimes worked towards women identifying abuse much more easily and quickly, as when we did a volunteer training and after watching one of our videos, more than one woman in the group said she could relate from her personal experience. To me, this is the beginning of the community healing or recovery—recognising that domestic violence is everywhere, that none of us is exempt from it and that we are a part of a community of women who have come through abuse—and are not afraid to say so.[15]

[Sakhi also creates and distributes public education material, including brochures and posters in English and Indian languages, and conducts various outreach events in the community, neighbourhoods and schools.] Sakhi's Oisika Chakrabarti points out:

> Often the challenge is creating a community space where domestic violence can be discussed. Doing outreach and education around domestic violence, I often meet community leaders who refuse to acknowledge that domestic violence is of any concern to their community. While they are keen to help the community by hosting

forums on immigration, discrimination, voter registration, etc., they
often refuse to discuss domestic violence and education or services.
One of our strategies to counter this has been to build collaborative
partnerships with the Parent–Teacher Associations in public schools,
with local leaders and smaller civic groups, who invite us to hold
discussions in their neighbourhoods on domestic violence education
and prevention.[16]

Another important strategy has been to develop a 'court interpreters
programme' and tools for cultural sensitivity on immigrant issues
and domestic violence for the New York Police Department, whose
personnel have stereotypes about South Asian immigrants and who are
unaware or insensitive to cultural issues.

While consciousness raising within the community and influenc-
ing policy are an integral part of Sakhi's approach, its strategy has also
been to address domestic violence through service provision. Sakhi
provides women with information about options and rights and crisis
intervention, offers ongoing emotional support, holds monthly support
groups for battered women, provides women and their children with
referrals to counselling, and helps women access public benefits and
other federal and state institutional services. Another important part
of Sakhi's approach has been to develop economic empowerment and
women's health-related programmes as part of its overall effort to end
violence against women. The economic empowerment programme
builds upon women's interests to identify meaningful career avenues
and impart job skills to battered immigrant women. It also provides
English tutoring, assistance with preparing applications, interviewing
skills, referrals to job training programmes, and information about
legal rights on job and labour issues. The programme helps survivors
of violence take greater control over their financial future so that they
can move towards economic independence.

As women's health is an important component of immigrant
women's well-being, the Sakhi's Women's Health Initiative Programme
has been engaged in educating and informing women on violence and
health, and accessing health care through workshops at monthly support
group meetings and through public education material. To enhance its
services, Sakhi has also sought to raise awareness of violence against
women amongst Indian and non-Indian physicians and health providers
by outreach to organisations, hospitals and professional associations.
Through the establishment of a health clinic, Sakhi has developed a

core of South Asian mental health providers and physicians who can serve the needs of South Asian battered women through low-cost or free consultations and examinations.

In all these ways Sakhi has clearly made important inroads into addressing domestic violence in the South Asian immigrant community. As Purvi Shah notes:

> When Sakhi began, people shut their doors to the organisation. Who wanted to admit that abuse is a daily reality across our community? While we still face community rejection and struggle to voice our belief that abuse is unacceptable, a number of community members have emerged as staunch supporters of Sakhi's work. Sakhi has always had a community-oriented focus and it is one reason why Sakhi does so many presentations in the community. Oftentimes, at a community event we coordinate, it is the first time that community members talk about the issue of violence. That is an incredible moment that begins the path to community change. Due to Sakhi's diligent work with the community, we also have significant community support. In fact, today one-third of our small budget comes from the community. It is a sign of their investment in ending violence against women.[17]

Conclusion

Today, more and more organisations are addressing domestic violence and violence against women in their communities. In the past seven years, many of these organisations have come together through networks, conferences and workshops so as to create a larger forum to address the needs of the South Asian immigrant women and to share resources. They have created Web-based resources, built transnational connections with South Asia, held national conferences on violence against women, built coalitions around immigrant rights, and helped influence policies and practices that impact the South Asian diaspora within the United States.

Immigration issues continue to play a critical role in women's experiences of marital violence. Despite positive legal steps through VAWA, H-4 visa status still prevents women from working, exacerbating their vulnerability to partner abuse through spousal dependency (Raj

and Silverman 2004). South Asian women's organisations are engaged in drawing public attention to the recent restrictive immigration policies that may potentially increase women's chances of abuse by limiting their economic autonomy. Barriers in the form of low access to housing and affordable health care, along with the limitations of the judicial system, are also being addressed from the perspective of immigrant women.

[In the last decade the South Asian community, including the Indian diaspora in the United States, has mobilised around other important issues, including health, poverty, religious fundamentalism, gay and lesbian rights, immigrant rights, racial profiling and domestic workers' rights. Today the Indian diaspora in the United States is diverse and transnational. There are an increasing number of organisations committed to political, social and economic engagement—locally, nationally and globally. Organising around issues of marital and domestic violence was the catalyst for change in the 1980s and 1990s. It remains to be seen what key issues will define and redefine the Indian diaspora in the United States in the next decade.

Acknowledgements

Special thanks to Oisika Chakrabarti, Bix Gabriel, Tuhina De O'Connor, Purvi Shah, Tanvi Tripathi and Maria Chaudhuri (of Sakhi for South Asian Women) for their valuable inputs and insights. Thanks also to Taisha Abraham, Cynthia Bogard, Malavika Karlekar, Rajni Palriwala and Patricia Uberoi for their incisive comments. Any errors are my responsibility alone.

Notes

1 For a discussion on violence against women in Asia, see Cheung et al. (1999); also Abraham (2002).

2 The term Asian Indian is used by the census, but they are also popularly called Indian Americans.

3 The census underrepresents the total Asian Indian population since it undercounts the large numbers of undocumented individuals.

4 Purvi Shah, Domestic Violence Programme Director, Sakhi for South Asian Women, personal communication, 2004.

5 Bix Gabriel, Programme Support and Media Production Coordination, Sakhi for South Asian Women, personal communication, May 2004.

6 See Charsley, this volume, for a discussion of similar situations in the context of the UK.

7 However, data collected from a community-based sample of married South Asian women residing in Greater Boston (see Raj and Silverman 2002) revealed no significant relationship between arranged or 'modified arranged' marriage versus love marriage, and the prevalence of intimate partner violence in the current relationship.

8 The spouse and unmarried children (below 21 years of age) of an H-1B visa holder are eligible for an H-4 visa. A person on an H-4 visa cannot legally work unless and until the person obtains from the Immigration and Naturalisation Service a Change of Status to H-1B, a procedure that is neither easy nor automatic. Through the H-1B visa programme, US employers are able to hire foreign professionals for a maximum period of six years, subject to certain specifications. The H-4 visa puts severe constraints on abused women as they are economically dependent and also fear deportation if they leave their abusers.

9 Purvi Shah, personal communication, May 2004. As already mentioned, marital abuse may also occur in marriages where the woman is the Green Card holder and sponsors her husband. The husband may experience a sense of downward mobility and resort to violence against his wife to assert or regain a sense of power.

10 Tanvi Tripathi, Domestic Violence Programme Director, Sakhi for South Asian Women, personal communication, May 2004.

11 Sakhi for South Asian Women pamphlet, 2003.

12 Oisika Chakrabarti, Communications and Community Outreach Coordinator, Sakhi for South Asian Women, personal communication, 2004.

13 Tuhina De O'Connor, Executive Director, New York Asian Women's Center, personal communication, 2004.

14 See http://www.sakhi.org.

15 Bix Gabriel, personal communication, May 2004.

16 Oisika Chakrabarti, personal communication, 2004.

17 Purvi Shah, personal communication, 2004.

References

Abraham, Margaret. 2000. *Speaking the Unspeakable: Marital Violence among South Asian Immigrants in the United States.* New Brunswick, NJ: Rutgers University Press.

Abraham, Taisha (ed.). 2002. *Women and the Politics of Violence.* New Delhi: Har-Anand Publications.

Bacon, Jean. 1996. *Life Lines: Community, Family and Assimilation among Asian Indian Immigrants.* New York: Oxford University Press.

Barringer, H., R. Gardener and M. Levin. 1993. *Asians and Pacific Islanders in the United States.* New York: Russell Sage Foundation.

Cheung, Fanny M., Malavika Karlekar, Aurora De Dios, Juree Vichit-Vadakan and Lourdes R. Quisumbing (eds). 1999. *Breaking the Silence: Violence against Women in Asia*. Hong Kong: Elite Business Services.

Espiritu, Yen Lee. 1997. *Asian American Women and Men*. Thousand Oaks, CA: Sage Publications.

India Today. 1998. 12 January.

Khandelwal, Madhulika. 2003. *Becoming Americans, Becoming Indians: Indian Immigrants in New York City, 1976–97*. Ithaca: Cornell University Press.

Luu, V. 1989. 'The Hardships of Escape for Vietnamese Women', in Asian Women of California (eds), *Making Waves: An Anthology of Writings By and About Asian American Women*, pp. 60–72. Boston: Beacon Press.

Narayan, Uma. 1995. '"Male Order" Brides: Immigrant Women, Domestic Violence and Immigration Law', *Hypatia*, 10 (1): 104–19.

Raj, A. and J. Silverman. 2002. 'Intimate Partner Violence against Immigrant Women', *Violence Against Women*, 8 (3): 367–98.

———. 2003. 'Immigrant South Asian Women at Greater Risk for Injury from Intimate Partner Violence', *American Journal of Public Health*, 93 (3): 435–37.

Raj, Anita, Jay G. Silverman, Jennifer McCleary-Sills and Rosalyn Liu. 2004. 'Immigration Policies Increase South Asian Immigrant Women's Vulnerability to Intimate Partner Violence', *Journal of the American Medical Women's Association*, 60 (1): 26–32.

Sakhi for South Asian Women. 2004. *Sakhi Fact Sheet*. New York: Sakhi.

Zinn, Maxine Baca and D. Stanley Eitzen. 1990. *Diversity in Families*. Needham, MA: Allyn and Bacon.

13

CHILD CUSTODY CASES IN THE CONTEXT OF INTERNATIONAL MIGRATION

Kirti Singh

Introduction

When marriages break down, a host of legal issues arise. These revolve around matters such as spousal and child support, the custody and guardianship of children, and the division of property. In the Indian context, and possibly in most others too, these issues often have a gender dimension since the woman is normally the more vulnerable partner, both socially and financially. When transnational marriages break down they can give rise to certain special problems. Indeed, the phenomenon of deserted wives in non-resident Indian (NRI) marriages has increasingly been a cause for legal concern. There have been many reports of NRI men marrying Indian women and then deserting and abandoning them in India.[1]

Another area of concern, and one which has been increasingly reported since the early 1980s, involves cases of Parental Child Abduction (PCA). In these cases, one parent takes a child away from the other parent with whom the child was living, and escapes/runs away to a different place, even a different country. The issue of parental child abduction is inextricably linked to the issue of migration. In many of these cases, India is the chosen destination, particularly when one or both spouses are Indian. This results not only in depriving the parent left behind of the company of the child but also, perhaps more importantly, in the child being deprived on many occasions of his/her right to live with the primary caretaker and in an environment which s/he is used

to and settled in. Children are thus forced to migrate to an alien place, and this has a deep and often adverse impact on their health and overall development. A number of studies confirm the trauma that such children undergo, and the psychological/physical damage, sometimes irreversible, that is suffered as a result of this deprivation.

The act of abduction and the resultant deprivation and trauma also amount to serious violations of many articles of the Convention on the Rights of the Child.[2] It has been noted that:

> Under the United Nations Convention on the Rights of the Child, all children have the right to maintain regular personal relations with both parents. Abduction by a parent is a denial of this right.[3]

Though either spouse/partner can technically commit the offence of Parental Child Abduction, in most of these cases it is the *male* spouse/partner who is the offender. However, of late some cases of PCA by the mother are also being reported by various lawyers working in the field, through the media, and through legal journals.

The main reasons why a child is abducted in this manner by the partners and spouses (mainly the husbands/fathers) are to evade court decisions regarding custody given to the other parent (with merely visitation rights to the abducting parent), to take revenge on the spouse, and to use the child as a pawn in a matrimonial dispute. Child abduction may be used by the male spouse to establish his power and superiority over his wife. It has been labelled as one of the worst forms of domestic violence and one that is often used by violent male wife-batterers:

> While it is primarily the abducted children who suffer, the abduction is not simply about the children. In domestic violence situations, many studies point out that batterers abuse their partners by threatening to take the children or prove their partners are unfit mothers. The children, therefore, become tools meant to punish one of the parents; usually the mother. In fact, twenty-five per cent of batterers abduct their children. Thus, international child abduction is truly a serious form of domestic violence, [reflecting] ... the desire for control over the other parent. Even Congress recognises that the 'motivation for the abducting parent is pure selfishness—not a love for ... [his or her] children'.[4]

India is being cited as a 'soft' state for cases of PCA, and child abductors see it as a safe haven. Among the main reasons suggested for

this is the fact that India has not signed the Hague Convention (1980) on the Civil Aspects of International Child Abduction (hereafter referred to as the Hague Convention) which seeks to provide a speedy remedy for return of the abducted child to his/her country of habitual residence. As a result, the custodial parent with whom the child was residing prior to the abduction is forced to go through the normal court process by filing custody/guardianship petitions, which typically follow a long procedure before reaching a decision. The parents left behind have also tried to invoke the speedier procedure of filing writs of habeas corpus in the High Courts of the various Indian States and in the Supreme Court of India, since these courts have powers to order a speedy relief in their writ jurisdiction.[5] However, until now, even the writ courts in India have mostly held that they are not bound by the decrees of the foreign courts. The cases, therefore, have to be reheard, resulting in a time-consuming procedure to decide to whom the custody of the child should be given.[6] The courts tend to apply their own interpretations to the principle of the 'welfare of the child', and these are often coloured by varying degrees of gender bias and by cultural preconceptions. All this makes it difficult for a person to recover an abducted child.

Parental Child Abduction is now a fairly well recognised global phenomenon. It has been said that

> Child abduction within Western societies is much more common than supposed and there has been an explosion in the number of cases since the mid-1980s. The exact figures for transnational child abduction are not known. Many parents are reluctant to go to the central authorities. Others are not even aware of the existence of the Hague Convention. The official figures could well understate the problem. Even so, they are alarmingly high. For example, the Bureau of Consular Affairs at the US State Department has worked on more than 8,000 cases since the early 1980s. Congressional Investigators estimate that the number of children affected could easily be in the region of 10,000 per year. (Meyer 2004: 152)

It has also been reported that the number of abductions has grown sharply. In the US in 2003, the Bureau of Consular Affairs recorded a four-fold increase in the number of abductions to foreign countries in the preceding three years.[7] In England, Reunite, the National Council

for Abducted Children, has recorded an 87 per cent increase since 1995. In France, a similar upsurge was recorded by the French Ministry of Justice (Meyer 2004). In another document it has been highlighted that in France in 2000 there were some 500 cases being dealt with by the Ministry of Justice, and between 250 and 300 by the Ministry of Foreign Affairs (Council of Europe 2002). These figures rose every year, not only because of the failure to solve the cases but also because of the increase in migration. The document further notes that, in the United Kingdom, there were 247 child abductions in 2000 (compared to 132 in 1995) and 65 of these concerned countries which had not signed the Convention (mainly India, Pakistan and Libya). Some 1,500 children are abducted in France every year. From Canada, 240 children were abducted in 1993 while 400 applications concerning abduction of children to third countries from Canada were pending (ibid.).

While very little empirical research has been done on the topic in India and there are no statistics available, an increasing number of cases have been reported by lawyers working in the area of family law, through law journals and in the media. Till recently, most of these cases involved the abduction of a child by the father from the mother. In most of the reported cases, the mothers had custody orders from foreign courts or the child had been living with her through an agreement between her and her spouse, but the fathers had deliberately flouted the orders and agreement. In the recent cases reported of mothers resorting to child abduction, their reasons are somewhat different, for instance, to escape from harassment and spousal violence.

In this chapter, I seek to deal with the issue of Parental Child Abduction to India from the country of habitual residence of the child. These are mostly cases of Asian children living abroad. I highlight and examine some Indian cases regarding PCA to show how the issue is being dealt with by the courts. I also examine the various provisions of the Hague Convention which are meant to facilitate the speedy return of abducted children to their country of habitual residence to see whether the Convention adequately protects the rights of the child according to the standard of 'the best interest of the child' set by the Convention on the Rights of the Child (hereafter referred to as CRC). After examining the effects of parental child abduction on the child, I conclude with a discussion of some ways in which this issue might be tackled by the law.

Parental Child Abduction Cases
and the Law in India

In this section of the chapter, I discuss the law and cases of Parental Child Abduction (hereafter PCA) which I have come across during my practice as a family lawyer and some of the cases which are reported in law journals.[8] These cases concern both inter-country and intra-country PCA. In both types of cases, courts in India have reached fairly similar decisions based on their interpretation of the Indian law. As remarked, some of the common factors which have influenced the decisions in both inter-country and intra-country PCAs have been the gender and other biases of the courts and the manner in which they have interpreted the principle of the welfare of the child. In inter-country PCA cases, the Indian courts have had to decide whether they are bound by the custody decisions of the foreign courts and, even if they are not so bound, how much weightage/importance should be given to them. The High Courts and the Supreme Court of India have also had to decide whether they would take up cases of PCA in a Habeas Corpus Petition and therefore decide it in a summary manner, or whether they would ask the Petitioner to approach the appropriate Guardianship and Custody Court. In some cases of PCA, the parent left behind has attempted to file various criminal complaints to force the police to help them in recovering custody of the child. However, the Supreme Court of India has clearly stated that a father, being a natural guardian of his child, cannot be charged with the offence of kidnapping even if he abducts his child who had been living with his/her mother.[9] In the case concerned, a mother had to fight for a number of years in several courts up to the Supreme Court to effect the return of her abducted child, who had been removed from her parents' home in India by her divorced spouse. The parties had been residing in USA and the child had been sent back to India for a while to stay with his grandparents.[10]

Most custody cases are filed under the Guardianship and Wards Act, 1890, unless there is a pending divorce or separation proceedings.[11] This Act is an old British enactment which is now totally inadequate to address these issues. The Act works on the assumption that the father is the natural guardian of a minor.[12] It also states that the court, in appointing or declaring a guardian, 'shall be guided by what consistently with the law to which the minor is subject, appears...to be in the welfare of the minor'.[13] In other words, the Guardian and Wards Act gives equal

importance to the personal law of the minor and to the welfare principle. Apart from this, the Guardian and Wards Act allows for petitions for the return of a minor to his/her guardian's custody if s/he has been removed from the guardian, provided this is in the welfare of the minor. Most cases of PCA are filed under this section if the writ court does not entertain the case. However, the procedure for deciding a case under this section is fairly long, apart from the fact that frequent adjournments of the case on one excuse or the other may cause further delay.[14] The court procedure is thus cumbersome, complicated, lengthy, inefficient and often biased. The Guardians and Wards Courts take a long time in deciding even the interim applications for return of custody during the pendency of the case. As a family lawyer, I have often had to advise my clients to take all precautions possible to prevent such abduction. In some cases, the courts give injunctions, preventing the father from removing the child, but these cases are relatively few. Women are often unaware that they can get court orders to prevent the removal of the child, while they cannot get speedy orders for return of the child once s/he has been taken away by the father.

[Under the Hindu and Muslim Personal Laws also, the fathers are the natural guardians of their children. Section 6 of the Hindu Minority and Guardianship Act, 1956, states that the father is the natural guardian of the son and the mother is the guardian only after the father. The section, however, allows the mother to 'ordinarily' keep children up to five years of age. Under Muslim Personal Law, too, the father is the natural guardian, though the mother can keep the children up to a specified age (normally seven years in the case of boys and till the age of puberty for girls). In one Supreme Court case in 1981 where a one-year old child was forcibly kept by his father[15], the High Court of Punjab held that the custody of the child by the father cannot be said to be illegal, presumably because the father is the natural guardian under the Hindu Law. The Supreme Court, though it disagreed with the High Court and ruled that the case should be decided on the basis of what is in the best interest of the child, delayed the case considerably by asking the Chandigarh District Judge to decide the matter after a proper investigation and then send the matter back to them. Fathers have invariably taken the defence that, under the Hindu Law, they are the natural guardians. Though they normally do not succeed with this defence, they manage to delay the proceedings on this account, as the courts have felt obliged to hear arguments on this issue. It is pertinent to mention that the longer the abduction lasts and the longer the case

takes, the easier it becomes for the abductors. The abductor can take the plea, as he invariably does, that the child is now settled and happy in his/her new surroundings.

Some of the earliest cases that we dealt with were in fact cases of intra-country Parental Child Abduction. Some time in 1980[16], we were approached by the mother of a nine-month old baby boy who had been forcibly taken away from her by the father. The mother, Santosh, had been ill-treated and subjected to violence, and then thrown out of the house. The baby had been forcibly taken away from her. When all efforts, including asking for police help, failed to effect the return of the child, I approached the Supreme Court and the Court directed the father to hand over the child to the mother. This process took a few months.

In the next case which came to All India Democratic Women's Association (AIDWA), however, we were not so fortunate. A young woman called Sumedha Nagpal had been a victim of sustained violence and illegal confinement, and then suffered the abduction of her infant son. Her husband, Gaurav Nagpal, had been married earlier but had concealed this fact from Sumedha. His first wife had tried to commit suicide. The violence against Sumedha started early on in the marriage. After her son was born, an effort was made to drive her out and keep the son. On 1 August 1999, Sumedha's infant son (approximately one-and-a-half years old) was picked up in the park, where he had been taken by his *ayah*. Sumedha was forcibly taken to her husband's maternal uncle's house in Model Town, Delhi. She was confined there for a week from 1 to 8 August while family members tried to get her to sign divorce papers. When she escaped and went to the police station to file a complaint, the police refused to help her. It was only with the intervention of the National Human Rights Commission that an FIR was filed in October of that year, but the police refused to take any action against the husband and the uncle.

Finally Sumedha approached the Supreme Court of India in a writ petition in 2000[17] and asked for the child to be returned to her. Sumedha took the plea that even under Hindu Law the custody of a minor child below five years has to be with the mother.[18] She also made the plea that the child needed her both physically and emotionally, and that the father was not an adequate substitute for her at that age. The Supreme Court, however, refused to hand over the custody of the child to Sumedha. It held that, since the father had disputed Sumedha's plea, the parties would have to give evidence in an appropriate Guardianship proceeding and that the matter could not be decided in a summary manner. The Court further held that Sumedha's plea that Hindu law also gives her

the custody of a child below five years was not relevant, as the Court could not be guided by the rights of the mother in the law but had to take into account the principle of the welfare of the child. The Court was of the view that the welfare of the child dictated that he remain with the father, since 'the trauma that the child is likely to experience in the event of change of custody, pending proceedings before a court of competent jurisdiction, will have to be borne in mind'.

Reacting strongly against this judgement, AIDWA criticised it as totally insensitive and as giving license to any husband in a matrimonial dispute to forcibly abduct a child and keep him or her in his custody. It was further pointed out that the law clearly recognises the right of a small child to be with the mother, since this is absolutely necessary for the nurturing and well-being of the child. In all circumstances, unless the mother is proved unfit, the child has to be in the custody of the mother, and there is no necessity to actually prove that this is in the child's welfare. AIDWA pointed out that, in the case of a matrimonial dispute, the father may try to forcibly remove the child from the mother's custody and then allege that the mother herself had abandoned the child. This was what happened in Sumedha's case. Since there are no laws in India to deal with the phenomenon of Parental Child Abduction, the Supreme Court had in the past exercised its summary writ jurisdiction in these cases.

The perception of the judges was vitally important in these cases. The gender bias of the judges was shown by the fact that they refused to recognise the difference between the primary caretaker (i.e., the mother) and the father who, till then, had admittedly never looked after the child. The delay in return of custody (in this case just a few months) was itself made a ground for refusal. When we last heard from Sumedha, she was still fighting for the custody of her child in the Guardianship Court at the District Court level. It is both strange and shocking that the judges took no account of the delay that would occur during ordinary Guardianship proceedings in the District Court.

Inter-country Abduction

In one of the early cases dealing with inter-country Parental Child Abduction, the High Court of Punjab held that the father should be allowed to retain the custody of a son whom he had abducted from England. In this case, the parties had been married in Punjab according

to Sikh rites and left soon after for England, where a son was born to them. Soon after the birth, however, the relationship between the husband and the wife broke down and the husband even tried to get his wife murdered by a contract killer. However, he was apprehended by the police and subsequently convicted and sent to prison. In spite of this, the wife intervened and obtained a probation order for her husband. In January 1983, after the probation period had expired, the husband removed the boy from England while the wife was away at work, and brought him to India. The wife was working as a factory worker in England, while the husband was a bus driver. She tried a number of ways to get the child back. Coming to India, she made an application before the Magistrate stating that the child had been illegally removed and wrongfully confined.[19] The husband, however, opposed the petition on the ground that he was the natural guardian of the minor child. The Magistrate accepted the contention and dismissed the petition.

Thereafter, the poor wife, armed with directions from the Family Court in England that the child be handed over to her, approached the High Court. However, the High Court judge also dismissed the petition on the ground that the wife's status in England was that of 'a foreigner, a factory worker, and a wife living separately from her husband; that she [had] no relatives in England; and that the child would have to live in lonely and dismal surroundings in England'.[20] The High Court came to the unfounded conclusion that, as the husband had now reformed and his parents were affluent, the child would grow up in an atmosphere of self-confidence and self-respect. Not only was the judge of the High Court obviously gender-biased, he also appeared to have been influenced by cultural-ethnocentric factors and the fact that the woman had a working class job in England. Fortunately, the Supreme Court set aside this decision.[21] Criticising the High Court judgement and its assessment of the father's character, the Supreme Court pointed out that the father was obviously a man of dubious character. His action in running away with the child, after obtaining a duplicate passport for him on a false representation, showed that his experience in jail had not 'chastened' him. The Supreme Court also pointed out that the father had abused the wife's magnanimity in getting him released on probation.

The Supreme Court's judgement in this case deserves special mention on two grounds. First, the Court held that Section 6 of the Hindu Minority and Guardianship Act, which constitutes the father as the natural guardian of a minor, 'cannot supersede the paramount consideration as to what is conducive to the welfare of the minor'. Second, the Court held that, as the boy was a British citizen living in

England, the English Courts have the jurisdiction to decide the question of his custody. The Supreme Court referred to the theory of Conflict of Laws which 'recognises and … prefers the jurisdiction of the State which has the most intimate contact with the issues arising in the case'. The Court held that it was its duty to protect the wife against the burden of litigating in an inconvenient forum. It is also interesting that, while the Court did not categorise the act of the husband as 'abduction', it nonetheless held that the child had been wrongfully brought to India.

In a later Supreme Court case in 1987[22], it was held that since the child's presence in India was the result of an illegal act of abduction, the father (who was guilty of this act) could not claim any advantage. The Court also reiterated that the matter should not be decided on a consideration of the legal rights of the parties, but 'on the sole and predominant criterion of what would best serve the interest and welfare of the minor'. In this case, an Indian father, taking advantage of his weekend visitation with the child had left the United States with his son and returned to India. The custody of the small child had been given to the mother by an American court, while the father had been given visitation rights and spent every weekend (from Friday evening till Monday morning) with him. The child was about seven years old at the time. While the father was Indian, the mother, who was a case worker in the Department of Social Work of the State of Michigan, was an American. (The father and the mother had met while they were both studying at a university in Michigan, USA.) The Court came to the conclusion that it was in the best interest of the child that he should stay with his mother in USA. It based this conclusion on the grounds that the mother had looked after the child from the beginning and that, while the child had stayed in India for a comparatively short time, he had lived most of his life in the US, was doing well in school, and was 'accustomed and acclimatised to the conditions and environments obtaining in the place of his origin in the USA.' The Court also held that the father's conduct did not inspire any confidence that he was a fit and suitable person to assume custody of the child. In this case it is pertinent to mention that, though the Court proceeded to evaluate what would be in the 'best interest of the child' to decide which parent should be given custody, it agreed with the proposition laid down by an English court that 'a court should pay regard to the orders of the proper foreign court unless it is satisfied beyond reasonable doubt that to do so would inflict serious harm on the child.'[23]

In another appeal decided by the Supreme Court in 1988[24], however, it was held that, since India is not a signatory to the Hague Convention,

each case in an Indian court would be decided on merits, keeping in mind the key principle of the welfare of the child. In other words, in this case, the Court held that the order of a foreign court was only one of several factors to be taken into consideration, unless the Court thought it proper to exercise its summary jurisdiction in the interest of the child and came to the conclusion that the prompt return of the child was for his/her welfare.

The case concerned was one of domestic violence, and in this case the child had already lived with the mother for 12 years. The parties had been married in the USA in May 1982, and lived together for 10 months. A child was born to them in March 1983 but the wife, along with her 35-day-old child, was forced out of the matrimonial home. She returned to India in February 1984 after an initial order of custody was given in her favour. Subsequently, however, the husband moved the American court for temporary and permanent custody and got an *ex parte* order[25] in his favour. It is pertinent to mention that the father also filed various petitions in India in addition to the case in the US courts. In one petition in the High Court, he even managed to get the physical custody of the son, then 12 years old, on the grounds that he would be in a position to provide education to the child. However, this only lasted a few days as the son ran away. The Supreme Court held that custody could not be given to the father merely because of the promise of education. It also took into account that the child had stayed with the mother for a number of years and, being now settled in India, could not be disturbed. The Court also considered the father's character, and the fact that the mother and the child had been forced out of their home in the US. Strictly speaking, this case would not have been covered by the Hague Convention since the mother had custody of the child when she left the matrimonial home. The Hague Convention also allows for certain exceptions to its prompt return clause, including a clause which stipulates that return can be refused by the court if the child objects to being returned. In this case the Court had met with the child who expressed his wish to continue staying with his mother and in India.

Following the dicta in the above case, the Supreme Court in a later case held that, though the wife's conduct in removing the children from the US is a relevant fact, this cannot override other aspects relating to the welfare of the child. In the case concerned, the mother had run away with a son who was about seven years old and a daughter who was about three. Once again the father, who was an alcoholic, had been violent with the mother. The husband filed a writ of habeas corpus in the Delhi High Court, and the High Court asked the mother to restore the custody of

the children to the father. The High Court held that the mother had committed a wrong by not taking the American Court's permission to bring the children to India. That is, while the mother had a custody order in her favour, she had not been permitted by the American Court to remove the child from the US without permission. Since the father appeared to be an alcoholic and one of the children was a girl, the Court held that the children should not be separated from each other and that it would be in their welfare to remain with the mother. The Court also took into account the desire of both children to stay with the mother and the fact that the mother had been looking after them well and they were studying in a good school.

In inter-country PCA, it sometimes happens that the parent left behind is unable to retrieve custody in spite of favourable court orders, since it may be difficult to locate the offending parent who might constantly shift jurisdictions and locations to avoid the law. Often the chase itself takes years, apart from court delays. In one case that came to me, both parties were Muslims from Kashmir, India, but had shifted to the UK a couple of years after their marriage. Their child was born in the UK in July 1996, but the marriage broke down and the parties separated in November 2000. The husband, who had left the UK in 2001 to work in Saudi Arabia, visited the UK for a few months in 2002–03 and the mother agreed to allow him to meet the child (C) for a few hours daily. After M (the husband) left UK, he sent a divorce notice to the wife (K) stating that he had an 'absolute right' according to the Sharia to insist that the child live with him. Apprehending that M might try to remove the child from UK and from her custody, K applied to the British Family Court and the Court gave her an order stating that the child will reside with K, the mother, and that M was prohibited from removing the child from K's custody. The order to this effect was served on M at his post box address in Riyadh, Saudi Arabia. M continued to telephone the child and K facilitated the child's contact with his father. In August 2003, M returned to the UK, and K once again allowed him to visit the child and take him out for a few hours each day. Shortly afterwards, on 22 August 2003, M took the child away and did not bring him back. K repeatedly rang M's mobile number but got no response, and she has not spoken to C or seen him since then. In her affidavit to the Court soon after this, K expressed her worry and anxiety for the child in the following manner:

C is only 7 years old and in awe of his father and his authority.... I am desperately concerned for the welfare of my son. C has lived

all his life in the UK with me. He is a nervous and insecure child and very dependent on me. He does not have a close relationship with his father whom he has seen only very irregularly. He does not know his father's extended family. He is unfamiliar with life abroad. He is settled and content in the UK and making good progress at school. He is a child who has only known his mother's permanent and full time care and he will be distressed and indeed distraught at not being permitted to return to me.[26]

Subsequently, K followed M to Kashmir, India, where she approached the British authorities who in turn approached the Indian Government for help. Though M tried to get a custody and guardianship order in a District Court in Kashmir, the Court refused to interfere with the order of the British Court giving custody to the mother, holding that the orders were valid and binding on M. In spite of this, M refused to hand over the child to K and went underground. In sheer desperation the mother moved the High Court of Delhi who ordered the Director General of Police in Kashmir to help in the search for the missing child. The Police however claimed they could find neither the father nor the child, and K does not know if she will ever succeed in locating M.

In a similar case of a Punjabi couple settled in UK, reported recently, Abnash's marriage to Inderjit Singh ended in divorce and a dispute over the custody of their three-year old son, Ajay. Inderjit, the father was granted only visitation rights on weekends by the courts. Not satisfied with this, Inderjit decided to take the law into his own hands and abducted Ajay from England to Punjab. Abnash rushed to Punjab, but was not allowed to meet her small child. She had no option but to petition the Punjab and Haryana High Court for the return of the child. However, Inderjit once again abducted the child, this time to the US where it took Abnash almost four years to trace the child. Finally the US Courts upheld the English Court's decision and the mother and the child were united.[27]

Abnash subsequently helped form an organisation to help parents recover their abducted children from their spouse or partner. In fact several such organisations exist across the world to assist the return of abducted children.[28] For instance, Parents & Abducted Children Together (PACT), an organisation formed specifically to help abducted children return to the parent with whom they were living, sees the phenomenon as a growing one—an inevitable consequence of the sharp increase in transnational marriages, which are as likely to break down as other marriages.

The preceding discussion shows that, in the absence of clear law on the issue of PCA, the courts tend to decide these cases according to their subjective perception of what is in the welfare of the minor. The Indian law on guardianship and custody is itself in need of reform, as it continues to function on patriarchal norms, and even within the country there are no specific civil or criminal laws to deal with PCA. While the Supreme Court has recognised the seriousness of the offence, some other courts tend to view the offence as a relatively minor one. Additionally, the concept of the 'welfare of the child' is itself an outdated and inadequate concept, and should be replaced by the principle of 'the best interest of the child'.

The Hague Convention

The Hague Convention on the Civil Aspects of International Child Abduction came into force in 1980. By 2006, 75 countries had signed or ratified the Convention.[29] The objectives of the Convention are:

(a) To secure the prompt return of children wrongfully removed to or retained in any Contracting State.

(b) To ensure that rights of custody and access under the law of one Contracting State are effectively respected in other Contracting States.

The Preamble to the Convention explains that the rationale behind these objectives is the belief that the best interests of children should be paramount in custody matters. The objective of prompt return is based on the premise that the welfare of children is best served by reversing the effects of abduction as quickly as possible. Three reasons are advanced to justify this stand. First, prompt return will undo the harm often caused to children who are suddenly removed from their regular environment. Second, the knowledge that prompt return will be ordered is likely to deter potential abductors.

Third, the child's interests can best be protected by litigation in the forum of convenience, which 'will usually be the place of the child's habitual residence'. However, certain exceptions have been grafted to the 'prompt return' rule in the Hague Convention, allowing the Court to refuse the return of the abducted child to his/her place of habitual residence. Article 13 of the Hague Convention, which lists these

exceptions, states that the child may not be returned if the person who had custody of the child had agreed to the child going away; or subsequently acquiesced in the child's removal; or if

- there is a grave risk that his or her return would expose the child to physical or psychological harm or otherwise place the child in an intolerable situation;
- the judicial or administrative authority may also refuse to order the return of the child if it finds that the child objects to being returned and has attained an age and degree of maturity at which it is appropriate to take account of its views.

The last exception has been criticised by some lawyers and legal academics as violating a fundamental right of the child as stipulated in the Convention on the Rights of the Child, namely the right of the child to speak and to be heard. The criticism arises for the reason that Clause 3 merely states that the court/administrative authority *may also* refuse to return the custody if the child objects. The authority/court therefore has the discretion to order the return, or *not* to order the return. Critics insist that the clause regarding the child's right to be heard should be made mandatory, requiring that judges must in all cases talk directly to the child. The Hague Convention on parental child abduction has also been criticised as being more concerned with the rights of the parent than with the best interest of the child. This is largely because of the Convention's emphasis on the speedy return of the abducted child, pre-empting a proper enquiry into what the child desires and without reference to the standard of the best interest of the child. In cases of parental child abduction by the father, it is often desirable to immediately return the child to the custodial mother (as the mother is most often/almost always the primary caretaker), but in cases of domestic violence, parental child abduction by the mother is often motivated by her real apprehensions about her continued exposure to violence and about her own and the child's safety in the place of habitual residence.

In one case in the Supreme Court involving the sexual abuse of a child, the judges refused to listen to the testimony of the child. The child had talked to a Child Social Worker in the Crime Against Women Cell in Delhi, and communicated to her by words, signs and drawings that the father had abused her by penetrating her vagina. A doctor's report also showed the child's vagina to be unnaturally enlarged. The Court, however, came to the conclusion that the mother had tutored the

child and interfered with her private parts only to spite the father. It is pertinent that, in this case, the judges began the judgement by stating that 'some eerie accusations have been made by a wife against her husband. Incestuous sexual abuse, incredulous ex facie, is being attributed to the husband.'[30] Indeed, ironically this was one case in which the Supreme Court followed the judgement of a foreign court and paid no attention to the child's detailed account to a social worker of sexual abuse. The Court proceeded on the basis of its own subjective understanding of the nature and extent of child sexual abuse. The child's right to be heard was totally disregarded.

A further exception to the principle of quick return is given in Article 20 of the Convention wherein it is stated that: 'The return of the child…may be refused if this would not be permitted by the fundamental principles of the requested State relating to the protection of human rights and fundamental freedoms.' Thus, a court in a country which is ruled by a democratic Constitution may refuse to return a child to a country governed (for example) by religious personal laws, which do not accord the child certain fundamental human rights. The Convention has also been criticised by some as lacking enforceability in the sense that it does not have a penal clause.[31] In fact, to overcome this, the US, for instance, has legislated a Federal Kidnapping Crime Act (1993), which imposes a punishment of three years' internment. PCA of a child under 16 years of age is also a criminal offence in the United Kingdom, France, Finland, Italy, Luxemburg and Sweden. The penalty in some of these countries is less than in the US, however, the offence being punishable by prison sentences varying from a few months to a year or more (Council of Europe 2002).

A restriction under the Convention also arises from the fact that the Convention has a sort of limitation period of one year for moving an application for the return of the abducted child. If an application is moved after this period, the return of the child can be refused if it is 'demonstrated that the child is now settled in its new environment'.

The Effect of Abduction on the Child

Parental Child Abduction has been called 'Child Abuse' and a 'Human Rights Abuse', and has also been labelled as one of the worst forms of

domestic violence. It has also been recognised that when children are abducted by one parent, he or she often belittles the other parent:

> The children are deprived of one of their parents and their wider family for a long time—sometimes permanently—and their sense of security is threatened. Children are forced to accept a change of country, culture, schools, etc. Even if children are returned, they are marked by the abduction for the rest of their lives....This constitutes a denial of children's rights and is a form of violence, which reduces the child to the status of an object and is tantamount to illtreatment. (Council of Europe 2002)

According to a number of studies, the denigration of the custodial parent by the abductor can induce the child to also denigrate that parent who s/he is not at the moment living with. In her article on International Child Abduction, Catherine I. Meyer explains the situation thus:

> It should not be hard to imagine the turmoil, disruption, loss of trust, fear and anger children must feel when they are taken to another country where the language and culture may be alien and told that they will not be returning home. Suddenly removed from the security of a familiar environment—friends, schools and relatives—abducted children do not understand what is happening or why. The situation is made worse if the abducting parent is hiding from the police or taking precautions against re-abduction. This is the point when children realise that there is a state of war between the two people they need and love most. Then, as so often happens—usually in anticipation of court hearings—if the abducting adult begins the process of denigrating the left-behind parent, or telling their children that their other parent is dead or no longer loves them, they are further confused, distressed and angry. These children have already been traumatised by the loss of one parent. Now their greatest fear becomes to lose the only parent they have left. This is fertile ground for systematic indoctrination by the abducting parent. (Meyer 2004: 159)

Meyer and others cite with approval the research in several child custody cases in the US by a child and forensic psychiatrist who found that an increasing number of children had extremely hostile reactions, bordering on hatred, towards the left-behind parent whom they had earlier loved, and in fact denigrated them during custody hearings.

According to Gardner (2003), the increase in child custody litigation parallels a dramatic increase in a disorder which was rarely seen earlier and which he labels as Parental Alienation Syndrome (PAS). Gardner describes the disorder's primary manifestation as the child's campaign of unwarranted denigration of the parent left behind. It results from a combination of one parent's brainwashing and indoctrination, and the child's own contribution to the vilification process, reflecting the child's fear that s/he will be rejected by the parent s/he is living with if sufficient acrimony towards the other parent is not exhibited. In the late 1980s, the American Bar Association had commissioned a study of seven hundred PAS children (ibid.).

Regardless of the specific terms designed to illustrate the effects of Parental Child Abduction, there is general consensus that children are the casualties in these cases. Nancy Faulkner, another researcher in the field of PAS, quotes other studies indicating that when children are stolen, 'they are used both as objects and weapons in the struggle between the parents which leads to the brutalisation of the children psychologically, specifically destroying their sense of trust in the world around them' (Faulkner 1999).

She also points out that children who have been psychologically violated and maltreated through the act of abduction are more likely to exhibit a variety of psychological and social handicaps. These handicaps make them vulnerable to detrimental outside influences. The deleterious effects of parental child abduction on child victims include depression; loss of community; loss of stability, security, and trust; excessive fearfulness, even of ordinary occurrences; loneliness; anger; helplessness; disruption in identity formation; and fear of abandonment (ibid.).[32]

Conclusion

Parental Child Abduction is an offence which, until now, has not been adequately recognised and addressed in India. In fact PCA often takes place when spouses feel they can escape the law of the country they have migrated to.

Even after 25 years India has not signed the Hague Convention on the Civil Aspects of International Parental Abduction (1980). The Convention specifically provides for the speedy return of abducted

children who are to be returned to the parent they were habitually residing with. Most often, the victims of such abductions are extremely small children who cannot intervene in and stop the act of abduction.

While the Hague Convention is limited in certain respects, it is the only Convention which addresses the issue of inter-country PCA. The limitations of the Hague Convention stem mainly from the fact that it is a gender-neutral document. The Convention does not recognise that women may sometimes run away with their children to escape domestic violence, or jurisdictions in which the laws relating to custody are patriarchal and clearly biased in favour of the male spouse/ partner. The Convention has also been criticised on the grounds that it gives discretion to the judicial or administrative authority not to listen to a child who objects to being returned. However, in spite of these limitations, it is important that India sign the Hague Convention. Otherwise, unscrupulous spouses in custody disputes will continue to take advantage of the situation and engage the other spouse in endless litigation in a foreign country.

Apart from signing the Hague Convention, the law in India also requires amendment to ensure that it gives equal rights to women. This is necessary for all kinds of custody disputes, including PCA cases. At present, Indian personal laws/family laws discriminate against women and do not recognise them as equal guardians of their own children. Women in India are in fact more than equal guardians as they are, in most cases, the primary caretakers. Not recognising them as equal guardians encourages offences like Parental Child Abduction, since abduction is often justified by a male offending spouse on the plea that he is the natural guardian of the child. While the Supreme Court and the High Courts have, time and again, reiterated the principle that the primary consideration for deciding child custody cases has to be the welfare of the child, we still find cases of the courts, particularly the lower courts, upholding the father's position as the natural guardian. This is the reason why the personal laws relating to guardianship and custody, as well as the Guardian and Wards Act, need to be amended to unambiguously state that both the mother and the father are equal guardians. The guardianship and custody laws also need to be amended to engraft the principle of the 'best interest of the child' as the governing principle in all custody disputes, instead of the principle of 'the welfare of the child'. This shift is necessary to emphasise that children also have rights, as well as a need to have their welfare recognised and looked after. The shift in emphasis from child protection to children's rights recognises that children should be seen as human beings with rights—such as the right

to be heard and listened to—and not merely as objects of concern. The Convention on the Rights of the Child lists several of these rights.

India also needs civil and criminal laws which recognise *intra*-country PCA. Section 25 of the Guardian and Wards Act can be amended to more clearly include PCA by mothers as well as by fathers. Presently this section only allows for return of custody to the guardian. This section can also be made mandatory, with certain exceptions along the lines of the Hague Convention. A time limit for the orders for return of the child, in short, the court procedure, must also be prescribed to ensure that the case is decided in a summary and speedy manner. If for some reason, the court proceedings get prolonged beyond the stipulated period, the petitioner should have an immediate recourse to appeal. The need for this arises because, despite the time limit provided for in some laws, the courts do not adhere to these stipulations.

However, as we have seen in the discussion of some relevant cases, some courts tend to be influenced by notions of traditional culture and religion and patriarchal notions regarding the status and role of women in the family. As long as they continue to exist, such notions will hinder the course of justice. An extensive and regular programme of gender sensitisation will be necessary to remedy these notions. In the meantime, however, structural changes in the law will be necessary to at least enable petitioners in custody cases (including PCA cases), particularly women, to approach the courts for justice and to limit the courts' discretion while deciding cases.

Notes

1 Report on NRI Marriage Problems and Draft Convention, September 2004, National Commission for Women, New Delhi.
2 Articles 9, 12, 13, 15 and 16 of the UN Convention on the Rights of the Child.
3 Council of Europe, 2002.
4 Sapone—(21 Womens Rights. L. Rep. 129) 2000. *Women's Rights Law Reporter.* Rutgers, the State University of New Jersey, USA.
5 Under Article 226 and Article 32 of the Constitution of India, courts have the power to issue directions/orders of various kinds. The Writ of Habeas Corpus literally means, 'you have the body'. The Writ is used to ask for the production of a person in court who is in illegal/unlawful custody or detention. It has been traditionally used to get prisoners released from unlawful imprisonment, but more recently has been used, and is continuing to be used, for the release of a person or a child from any unlawful detention by a state party.

6 *Dhanwanti Joshi vs. Madhav Unde* (1998) 1 SCC 112.

7 An Internet site managed by the Bureau of Consular Affairs, US Department of State (on 31 May 2003) showed the number of parental abductions to India as 29 (http://travel.state. gov/family/abduction_Hague_06_attach.html).

8 The cases that I refer to in this Article are based on an exhaustive research of the *Supreme Court Cases Journal* till July 2006.

9 (1993) 2 SCC 6—*Chandrakala Menon and Anr., vs. Vipin Menon and Anr.*

10 Ibid.

11 Applications for custody, maintenance and alimony can also be filed in a proceeding for divorce, judicial separation or the restitution of conjugal rights under the Hindu Marriage Act, the Divorce Act (applicable to Christians in India), the Special Marriage Act and the Parsi Marriage and Divorce Act.

12 Section 19(b) of the Guardian and Wards Act states that the Court will not appoint a guardian of a minor 'whose father is living and is not in the opinion of the Court, unfit to be the guardian of the person of the minor'.

13 Section 17(1) of the Guardians and Wards Act, 1890.

14 Cases get adjourned for a variety of reasons. The respondent's lawyer invariably tries to delay the case on one pretext or the other, including that he wants more time to file his reply; that he is not ready with his arguments; that he is not well; etc. Sometimes the court does not have the time to hear the arguments, or the judge may be on leave.

15 *Veena Kapoor vs. Varinder Kumar Kapoor*, AIR 1981 SC.

16 This was a case which came to the All India Democratic Women's Association (AIDWA) in 1980. AIDWA is a women's organisation with a membership of about 10 million women. While the central office is in Delhi, there are branches in all states. Apart from its other activities, the organisation has legal cells which take up various cases related to women's issues, including cases of all forms of violence, among them domestic violence, sexual assault, sexual harassment, etc., and other family law cases.

17 *Sumedha Nagpal vs. State of Delhi and Ors* [(2000) 9 Supreme Court Cases 745].

18 The proviso to Section 6(a) of the Hindu Minority and Guardianship Act 1956 states that the custody of a minor child who has not completed the age of 5 should ordinarily be with the mother.

19 Under Section 97 of the Code of Criminal Procedure, a Judicial Magistrate can direct that a search be made for persons wrongfully confined and have them produced in Court.

20 (1984) 3 Supreme Court Cases 698—*Smt. Surinder Kaur Sandhu vs. Harbax Singh Sandhu and Anr.*

21 Ibid.

22 (1987) 1 Supreme Court Cases 42—*Mrs. Elizabeth Dinshaw vs. Arvand M. Dinshaw and Anr.*

23 The Supreme Court in Elizabeth Dinshaw's case cited the English Court's judgement in Re H (infants), (1966) 1 AII ER 886.

24 (1998) 1 Supreme Court Cases 112—*Dhanwanti Joshi vs. Madhav Unde.*

25 An order given in the absence of the contesting party.

26 Affidavit of K, in The High Court of Justice, Family Division, UK.

27 *The Tribune*, Chandigarh, India, dated 30 April 2006, reported this case (see http://www.tribuneindia.com).

28 In the Website www.parentinternational.com/resources/worldorgs.htm more than 40 offices of different organisations are listed across 19 countries.
29 Status table as on 13.7.2006 (http://www. hcch. Net/ index_en. php?act=conventions. status&cid=24).
30 *Satish Mehra vs. Delhi Administration and Anr* [(1996) 9SCC 766].
31 A penal clause helps in enforcing the law to the extent that it prescribes imprisonment as a punishment, in addition to the requirement to return the child in a PCA case.
32 See also Hickman and Bernd (2001). This paper also refers to the Parental Alienation Syndrome and the destruction of the child's identity as among the ill-effects of Parental Child Abduction.

References

Council of Europe, Parliamentary Assembly. 2002. 'International Abduction of Children by one of the Parents.' On http://assembly.Coe Int/Docments/working Docs/doc02/ EDOC9476.htm (accessed on 3 June 2002).

Faulkner, Nancy. 1999. 'Parental Child Abduction is Child Abuse.' Paper presented to the United Nations Convention on Child Rights, in Special Session held on 9 June 1999, on behalf of P.A.R.E.N.T and victims of Parental Child Abduction. Available online at www.prevent-abuse-now.com/unreport2.htm.

Gardner, Richard A. 2003. 'The Judiciary's Role in the Etiology, Symptom Development and Treatment of the Parental Alienation Syndrome (PAS)', *American Journal of Forensic Psychology*, 21 (1): 39–64. Available online at http://www.rgardner.com/refs/ar11w.html (accessed on 12 August 2003).

Hickman, Michael and Michael Uhi Bernd, 2001. 'Dynamics of International Parental Child Abduction'. Paper presented on behalf of CRY International at the UNCRC and the Hague Conference on Private International Law, 18 October 2001.

Meyer, Catherine I. 2004. 'International Child Abduction', in Ved Kumari and Susan L. Brookes (eds), *Creative Child Advocacy—Global Perspectives*. New Delhi: Sage Publications.

About the Editors and Contributors

The Editors

Rajni Palriwala is Professor at the Department of Sociology, University of Delhi. She has taught in various positions at the University of Delhi and at the University of Leiden. Her books and edited collections include *Care, Culture and Citizenship: Revisiting the Politics of Welfare in the Netherlands* (co-authored, 2005), *Changing Kinship, Family, and Gender Relations in South Asia: Processes, Trends and Issues* (1994), *Shifting Circles of Support: Contextualising Kinship and Gender Relations in South Asia and Sub-Saharan Africa* (co-ed., 1996) and *Structures and Strategies: Women, Work and Family in Asia* (co-ed., 1990).

Patricia Uberoi is Director of the Institute of Chinese Studies, Centre for the Study of Developing Societies, Delhi. She was earlier Professor of Social Change and Development at the Institute of Economic Growth, Delhi. In addition to her recently published book, *Freedom and Destiny: Gender, Family and Popular Culture in India* (2006), she has edited *Family, Kinship and Marriage in India* (1993), *Social Reform, Sexuality and the State* (1996), *Tradition, Pluralism and Identity* (co-ed., 1999) and *Anthropology in the East: Founders of Indian Anthropology and Sociology* (co-ed., 2007). From 1992 to 2006, she was Co-Editor of *Contributions to Indian Sociology*.

The Contributors

Margaret Abraham is Professor of Sociology and Special Advisor to the Provost for Diversity Initiatives at Hofstra University, New York. She is the Co-President of the International Sociological Association's Research Committee on Women and Society (2006–10). Her research

is published in *Gender & Society, Violence against Women* and the *Indian Journal of Gender Studies*. Her book, *Speaking the Unspeakable: Marital Violence among South Asian Immigrants in the United States* (Rutgers University Press) won the *American Sociological Association: Section on Asian and Asian America Outstanding Book Award* in 2002. She is the co-recipient of a Community Action Research Grant from the Spivack Program in Applied Social Research and Public Policy for a project on 'NIMBYism'. Her current research also includes a study on call centres in India.

Thérèse Blanchet was born in Québec, Canada. She studied anthropology at the Université de Montréal, the New School for Social Research in New York, and University College, London. After conducting fieldwork among the Inuit, north of Québec, she worked in Lesotho, Africa, before moving in 1979 to Bangladesh where she has been carrying out development-related research, mostly under the sponsorship of development agencies. For the last 12 years, her main fields of interest have been brothels, prostitution and slavery, and conceptualisations of childhood and personhood. Since 2000, with the Drishti Research Centre, she has undertaken a series of studies on female cross-border labour migration and trafficking in women. Besides a number of articles and unpublished study reports, she has published two books: *Meanings and Rituals of Birth* (1984) and *Lost Innocence, Stolen Childhoods* (1996), both with the University Press, Dhaka.

Katharine Charsley is a Lecturer in the Anthropology of Migration at the Institute of Social and Cultural Anthropology (ISCA) and Centre on Migration, Policy and Society (COMPAS) at the University of Oxford. She received her Ph.D from the University of Edinburgh in 2003 for research on transnational Pakistani marriages. She then held an ESRC postdoctoral research fellowship in Social Anthropology and South Asian Studies, and a lectureship in Sociology, both at the University of Edinburgh, before moving to Oxford to coordinate the Migration Studies M.Phil. programme.

Delia Davin is Emeritus Professor of Chinese Studies at the University of Leeds, UK, where she was formerly head of the Department of East Asian Studies and of the Centre for Chinese Business and Development of the University of Leeds, UK. She has taught in the Beijing Broadcasting Institute, and was Lecturer at the Department of Economics, University of York. An authority on women, work,

migration and gender relations in China, her publications include: *Womanwork: Women and the Party in Revolutionary China* (Clarendon Press, 1976); (co-author) *China's One-child Family Policy* (Macmillan, 1985); (co-ed.) *Chinese Lives: An Oral History of Contemporary China* (Penguin, 1989); *Mao Zedong* (Sutton Publishing, 1997) and *Internal Migration in Contemporary China* (Macmillan, 1999).

Ester Gallo took her Ph.D in Anthropology, University of Sienna (2004) and has been Marie Curie visiting Ph.D student at the University of Sussex (2002–03). Her doctoral research was about the cultural construction of youth/old age and processes of generational change in Kerala. Her research interests include gender and migration, global domestic labour, kinship and transnational marriages, education and identity. She is currently Research Fellow at the Department of Anthropology—'Uomo & Territorio', at the University of Perugia, Italy. Her book, *A Forbidden Past: Kinship, Memory and the Intergenerational Politics of the Family in Kerala, 1920–2000*, is forthcoming with the Firenze University Press (Florence) and Munshiram Manoharlal (Delhi)

Melody Chia-wen Lu is an Affiliated Fellow at the International Institute for Asian Studies (IIAS), the Netherlands. She has been an activist and worked in several Asian regional NGOs in Taiwan, Hong Kong and the Philippines on the issues of gender, migrants and sex work/ers. She is currently completing her Ph.D research on cross-border marriage migration between Taiwan and the People's Republic of China in Leiden University, the Netherlands. She is the co-editor of *Cross-border Marriage Migration in East and Southeast Asia: Socio-demographic Patterns and Issues* (University of Amsterdam Press, forthcoming).

Kanwal Mand is Research Fellow in the Department of Social Anthropology at the University of Sussex. She is currently working on an AHRC funded project entitled 'Home and Away: Experiences and Representations of South Asian Children'. Prior to this, she completed a three-year ESRC funded research project on transnational South Asian families and social capital. She received her Ph.D from the University of Sussex, focusing on the central role of women in the establishment and maintenance of transnational Sikh households in Britain, Tanzania and the Indian Punjab.

Teresita C. del Rosario is currently a Capacity Building Expert for the Asian Development Bank. She has undertaken training and research for a multiyear capacity building programme to train government officials of the countries in the Greater Mekong Subregion, and more recently, for the Central Asian countries. Her present interests are in public sector reform and the social dimensions of regional cooperation. She holds a Ph.D in Sociology from Boston College and Masters degrees in Social Anthropology and Public Administration from the Kennedy School of Government and Harvard University Faculty of Arts and Sciences respectively.

Ranjana Sheel is presently Reader in the Department of History at Banaras Hindu University, India. She has been Director of the University of Wisconsin College Year in India Programme, Varanasi, and worked at the Centre for Women's Studies and Development, Banaras Hindu University as well as at the BJK Institute of Buddhist and Asian Studies. She has been recipient of a Shastri Indo-Canadian Faculty Fellowship and of the senior fellowship of the Japan Foundation. Her major publications include *The Political Economy of Dowry* (Manohar, 1999). Her current research interest pertains to diasporic studies as well as comparative studies of women's political participation in India and Japan.

Kirti Singh is an advocate and legal activist living in Delhi, currently a Member (Part-time) of the Law Commission of India. She has worked on feminist legal issues for the past 30 years and has specialised in family law, laws related to violence against women, and human rights law. In the past she has been the President of the Janwadi Mahila Samiti, Delhi State, and is also the current Convenor of the legal committee of the All India Democratic Women's Association. She has fought various landmark cases related to women's rights in India and has actively participated in drafting proposals for law reform in various areas related to women. She has also worked with the National Commission for Women in drafting and suggesting amendments in laws. She has written extensively on various legal issues including dowry, sexual assault, children's rights and Muslim and Hindu personal law in India.

U. Kalpagam is Professor at the G.B. Pant Social Science Institute, Allahabad. She is both an economist and an anthropologist. She has written extensively in the field of gender studies and on colonialism.

She has published *Labour and Gender* (Sage Publications, 1994), and has co-edited four books on development issues. Currently she is engaged in an ethnographic project on Urban Mentalities.

Xiang Biao is an Academic Fellow at the Institute of Social and Cultural Anthropology, University of Oxford. He has conducted field research on migrants in China, India and Australia and is the author of *Transcending Boundaries* (Chinese, Sanlian Press, 2000; English, Brill Academic Publishers, 2005), *Global 'Bodyshopping'* (Princeton University Press, 2007), and over 30 papers in Chinese and English on migration and social change. Before joining Oxford he worked at the International Organisation for Migration and Asia Research Institute, National University of Singapore.

Index